Thanks for Typing

Thanks for Typing

Remembering Forgotten Women in History

Edited by
Juliana Dresvina

BLOOMSBURY ACADEMIC
LONDON • NEW YORK • OXFORD • NEW DELHI • SYDNEY

BLOOMSBURY ACADEMIC
Bloomsbury Publishing Plc
50 Bedford Square, London, WC1B 3DP, UK
1385 Broadway, New York, NY 10018, USA
29 Earlsfort Terrace, Dublin 2, Ireland

BLOOMSBURY, BLOOMSBURY ACADEMIC and the Diana logo are trademarks of
Bloomsbury Publishing Plc

First published in Great Britain 2021

Cover image: C. Jarrot, C. G. Wridgway and S. F. Edge at the start of the
Motor-Car Club Championship in 1899. Universal Images Group
North America LLC / Alamy Stock Photo

A catalogue record for this book is available from the British Library.

A catalog record for this book is available from the Library of Congress.

ISBN: HB: 978-1-3501-5006-5
PB: 978-1-3501-5005-8
ePDF: 978-1-3501-5008-9
ePub: 978-1-3501-5007-2

Typeset by Deanta Global Publishing Services, Chennai, India

To find out more about our authors and books visit www.bloomsbury.com and
sign up for our newsletters.

To Vicki and Dan – friends who do a lot of unpaid labour

CONTENTS

FIGURES

CONTRIBUTORS

Arwa F. Al-Mubaddel is a lecturer in English Language and Literature at King Saud University, Riyadh. She specializes in women and gender studies, theories of subjectivity, contemporary British women's literature, and metamodernism. Arwa's research interests also include comparative feminist studies and new/alternative modernities. Her most recent research on traumatic memory in the works of Ann Quin is forthcoming in *Women: A Cultural Review*.

Maria Artamonova wrote her Oxford D.Phil thesis (2008) on Old and Middle English translations from Latin. Since that time, she has been working as an Oxford-based tutor and translator (currently teaching at the Oxford University, Department of Continuing Education). Her teaching and research interests include Old and Middle English language and literature as well as the lives and work of J. R. R. Tolkien and C. S. Lewis, especially their academic legacy and Oxford connections. She is a contributor to *A Companion to J.R.R. Tolkien* (ed. Stuart Lee, 2014).

Karen Christensen is the chief executive officer and founder of Berkshire Publishing Group, and a writer specializing in sustainability and community with a focus on China. She worked for Blackwell Science, Faber & Faber and the T. S. Eliot estate before writing a bestselling environmental handbook. 'Dear Mrs. Eliot', her memoir about working with Valerie Eliot, was a cover story in the *Guardian Review* in January 2005. She is currently working on *Too Near the Flame*, a book about Valerie Eliot, Sophia Mumford and her relationship with these two literary widows and keepers of the flame.

Juliana Dresvina has been part of academic precariat for thirteen years. She is a member of the History Faculty, University of Oxford, where she works on late-medieval devotion and on how people of the past attempted to make sense of their lives in general and their unusual experiences in particular, using a variety of modern methods, such as attachment theory and fanfiction studies. As a break from medieval material, she researches creative activities of Oxford academics and their associates (especially professorial wives) in the twentieth century. With Vicki Blud, she edited *Cognitive Sciences and Medieval Studies: An Introduction* (2020); she is the author of *A Maid with*

a Dragon: The Cult of St Margaret of Antioch in Medieval England (2016), and is finishing a book on attachment and premodern history (2021).

Patricia L. Grosse is Assistant Professor of Philosophy at Finlandia University in the Upper Peninsula of Michigan. Her current book project, *Moving St Monnica's Bones*, traces St. Monnica's presence both in Augustine's texts as well as in her 'afterlife' as a saint in the context of North African and Italian Roman religious life. Her research and teaching interests include philosophy of love, feminist philosophy, Augustine of Hippo and philosophy of pop culture.

Reetta Hänninen is a postdoctoral researcher at the University of Helsinki. In her PhD dissertation she studied Finnish female journalists in the 1930s. Hänninen is one of the three authors of the history of the largest newspaper in Finland, *Helsingin Sanomat*, which was awarded the History Book of the Year prize in Finland in 2019. Her current project concentrates on Maissi Erkko, a forgotten figure in the history of a prominent newspaper family.

Catherine W. Hollis teaches writing in U. C. Berkeley's Fall Program for Freshmen. Her latest publications include 'Emma Goldman among the Avant-Garde' in *Women Making Modernism*, ed. Erica Delsandro (2020). She recently guest edited a special issue of *The Virginia Woolf Miscellany* on book collecting, and is co-editing, with Jeanne Dubino, Paulina Pajac, Vara Neverow and Celiese Lypka, *The Edinburgh Companion to Virginia Woolf and Contemporary Global Literature*.

Julia Bolton Holloway is Professor Emerita and Custodian of Florence's English Cemetery, who published *Aurora Leigh and Other Poems* by Elizabeth Barrett Browning based on research among the manuscripts and first editions. She is both a medievalist and a Victorianist, and also studied Hebrew, Greek and Latin Classics known to Dante Alighieri, Giovanni Boccaccio, Christine de Pizan, Walter Savage Landor and Elizabeth Barrett Browning. She has edited and translated works of Dante's teacher Brunetto Latino, Birgitta of Sweden and Julian of Norwich. She is English, with American and Italian exiles, her doctorate from Berkeley.

Melek Karataş is a feminist, medievalist and final-year PhD student in the Department of French at King's College London. Her research engages feminist and queer theories to consider issues relating to manuscript production and women's art in the fourteenth century. Melek's doctoral thesis, entitled '"Illuminatrix libri jurata": Reading Image and Gender in the Illuminated *Roman de la rose* Manuscripts of the Montbaston Atelier', examines the work of the fourteenth-century illuminator, Jeanne de Montbaston, and puts forward a framework through which to better

represent and apprehend women's contributions to literary and artistic production during this time.

Woohee Kim is a scholar-activist from Seoul, South Korea. Her interest in the Japanese military sexual slavery issue led her to study Korean youth activism on the issue with the support of Davis Foundation's Projects for Peace grant in 2016. Woohee organized protests and protested alongside her youth activist peers during fieldwork for her research project and continues to raise awareness of the Japanese military sexual slavery issue by being involved in activist organizations in Korea, presenting her research at conferences in the United States, and organizing relevant events in the United Kingdom. Woohee earned her MSc in Comparative and International Education with Distinction from University of Oxford and is a PhD student in Education at Harvard University studying Korean youth activists' pedagogical and civic practices.

Eleanor Knight is a writer whose short fiction has been published by Serpent's Tail and also appears in a number of journals. Her libretti have been performed in all sorts of places from the Royal Opera House to the foot tunnels underneath the Elephant & Castle roundabout. She has written for the *Guardian, Independent, GQ* and *Elle Decoration*, and she teaches on the creative writing Master's programme at the University of Brighton.

Irene Kukota holds a Master's degree from the University of Oxford, where she studied art and literature of Late Antique Syria and Byzantium, and an MA in Fine and Decorative Arts from Sotheby's Institute of Art. She was a consultant for the documentary *Shroud of Turin: Material Evidence* filmed by the BAFTA award-winning director David Rolfe and collaborated with the Royal Collection in London and the Icons and Russian Art Departments at Christie's. As an art and culture journalist, she was a London-based representative for the *Art Newspaper* Russia and has worked as a radio presenter and script-writer for a London radio station, also regularly contributing to a number of publications. As a curator, she most recently curated the contemporary sculpture exhibition *Double Jeu* at Les Jardins d'Etretat in Normandy.

Anu Lahtinen received her PhD in 2007 and is an associate professor of Finnish and Nordic History at the University of Helsinki. Her fields of expertise include premodern social and gender history with the focus on the history of Finland and Northern Europe. Her most recent publications include volumes *Dying Prepared in Medieval and Early Modern Northern Europe* (co-edited with Mia Korpiola, 2018) and contributions to volumes *Women in Business Families: From Past to Present* (eds by Jarna Heinonen and Kirsi Vainio-Korhonen, 2018) and *Stepfamilies in Europe, 1400–1800* (ed. Lyndan Warner, 2018).

Rebecca E. Lyons has been, until recently, a Lecturer in the Department of English at the University of Bristol. Her research focuses on Arthurian literature, medieval and early modern women's reading history, and modern publishing history. She was the associate series editor for the 'Publishing and Book Culture' Cambridge Elements series and is the editor of the 'Women, Publishing, and Book Culture' strand of this series. Her most recent publications include two co-edited volumes on *The Academic Book of the Future* and she has a short monograph forthcoming: *Women and Publishing: Penguin – A Case Study* (2021).

Lisa Mullen is a teaching associate in Modern and Contemporary Literature and Film at the University of Cambridge. Her first monograph, *Mid-Century Gothic: The Uncanny Objects of Modernity in British Literature and Culture after the Second World War* (2019), traces the uncanny agency and unsettling intimacy of powerful objects in key texts of the 1940s and 1950s. Her second book will be *Orwell Unwell: Pathology and the Medical Imaginary in the Fiction and Journalism of George Orwell*.

Hanna Navratilova is a historian and Egyptologist interested in historical thought, interdisciplinary history and contribution of biographies to historiography; with doctorates in both history and Egyptology. Navratilova is connecting Egyptology and History in her studies in reception of Egyptian history, from the emic Egyptian uses of the past to modern Egyptian revivals and etic encounters with heritage sites. At present, she is working on graffiti projects at Dahshur and with material from Abydos, and on history of Egyptology projects, such as the biography of Jaroslav Černý. Recent publications include Hana Navratilova et al, *Towards a History of Egyptology*, Proceedings of the Egyptological Section of the 8th ESHS Conference in London 2018 (2020).

Godelinde Gertrude Perk holds a PhD in English Literature from Umeå University (Sweden) and is a Marie Skłodowska-Curie Fellow at the Faculty of Medieval and Modern Languages, University of Oxford, and Fulford Junior Research Fellow, Somerville College, with the EC-funded, MSCA-IF project 'Women Making Memories', which juxtaposes medieval women's writings in four north-western European vernaculars. Her research considers the intersection of holy women's texts, medieval literary theory, material culture and gender history. Publications include contributions to *Cognitive Sciences and Medieval Studies* (eds Juliana Dresvina and Victoria Blud, 2020) and *Medieval Anchorites in Their Communities* (eds Cate Gunn and Liz Herbert McAvoy, 2017).

Nicola Presley is Senior Lecturer in English Literature at Bath Spa University. She has research interests in women's poetry, feminism, post-war literature and digital culture. Her published work includes '"A Buried Land and a

Blazing Source": Ted Hughes and William Golding' in *The Ted Hughes Society Journal* (2018); 'Plath and Television' in *Sylvia Plath in Context* (2019); and 'Plath and Media Culture' in *The Bloomsbury Handbook to Sylvia Plath* (forthcoming 2021). Nicola is New Media Manager for William Golding Limited, and Assistant Editor of *Irish Studies Review*.

Philip Pullen holds a PhD in the sociology of education. He spent most of his working life teaching in further and higher education and also served as one of Her Majesty's Inspectors (HMI). He is a Trustee of the Philip Larkin Society and regularly contributes to the Society's journal *About Larkin*. Recent publications include a contribution to *Writers and Their Mothers* (ed. by Dale Salwak, 2018). Philip is currently working on a literary travelogue based on Larkin places intended for publication in the run up to the 100th anniversary of Larkin's birth in 2022.

Elizabeth Sandie was a senior lecturer in Literature Studies and a fellow of the Centre of Excellence in Teaching and Learning at the University of York St John. She contributed a chapter 'Acts of Attention: The Poetry of UA Fanthorpe' to *Contemporary Poems: Some Critical Approaches*, ed. by Jeffries and Sansom (2000). Her monograph, *Acts of Resistance: The Poetry of U. A. Fanthorpe*, was published in 2009 and she wrote the entry on Fanthorpe for the ODNB. More recently, she has written about social change in *Just One Street* (2011) and is currently working on a sequel. Additionally, Elizabeth is investigating family memoirs and roots in the northern mining communities.

Susan Treggiari is Anne T. & Robert M. Bass Professor Emeritus of Stanford University and a retired member of the Sub-faculty of Ancient History, University of Oxford. Her research has chiefly been on ancient Roman social history. Publications include *Roman Freedmen During the Late Republic* (1969); *Roman Marriage: Iusti Coniuges from the Time of Cicero to the Time of Ulpian* (1991); *Roman Social History* (2002); *Terentia, Tullia and Publilia: The Women of Cicero's Family* (2007); and *Servilia and Her Family* (2019).

Editor's Introduction

Juliana Dresvina

When Bruce Holsinger, a novelist and a professor of English at the University of Virginia, started a series of tweets with the hashtag #ThanksForTyping in 2017, these went viral. The tweets highlighted the perfunctory acknowledgement of wives' assistance in academic works, and demonstrated that even in the twentieth and early twenty-first century wives of male academics – who did significant work towards their husbands' research and publications – rarely got any proper credit and mostly remained anonymous. The hashtag gathered momentum, with people sharing similar references to different female family members of male authors, academic and not, in a number of languages. The phenomenon appeared to be universal, and as the accounts continued to circulate #ThanksForTyping eventually led to a two-day international conference of the same name, which took place at the History Faculty of Oxford University, on 8–9 March 2019.

This book arises out of that conference. In it, we aim to uncover these often marginalized lives and write them into existence, telling fascinating, inspiring and often heartbreaking stories of remarkable women who were in danger of being forgotten and erased from 'his'tory. Many of these stories also discuss the nature of unpaid female labour in the light of centuries of gender inequality. We include chapters on wives, partners, mothers and other women who laboured in the shadows of their famous husbands or male relatives/employers – academics, men of letters, activists – or who carved out careers of their own yet did not receive the attention they merited. Many of these stories and documents are made available in print for the first time.

Over the years there has been a trickle of publications telling the stories of the women behind famous men. Growing up, I heard about the selfless work of Dostoevsky's and Tolstoy's wives: as a future wife, I was urged to admire and imitate them. Anna Dostoevskaya, Dostoevsky's second wife, was trained as a stenographer and came to work for her literary idol, who was twenty-five years her senior; her story was not unlike that of Valerie Eliot. Dostoevsky (unlike T. S. Eliot) took only a month to propose, after which Anna became his accountant and literary agent; yet she also dealt

with Fyodor's gambling addiction, his debts and the deaths of two of their four children – all for the sake of the great man, the keeper of whose flame she became at the age of thirty-five. Sophia Tolstaya famously copied her husband's works – including *War and Peace* – by hand many times, all while carrying and giving birth to thirteen children (and looking after the eight who survived), running the household, acting as Tolstoy's secretary and publisher, writing her own fiction and diaries, and constantly being pecked on by Leo for not sharing his views of rejecting private property and living in the Gospel poverty by physical labour. Both women left detailed memoirs in which they exonerate their husbands on the grounds of their literary genius, without noticing that the 'great man' is not a solitary genius but a construct, propped up by their unacknowledged work of typing, editing, organizing, inspiring, providing emotional support behind the scenes. (No wonder none of my school friends fancied marrying a writer.)

If women habitually responded to male talents with support, nurture and self-sacrifice (European art historians will probably conjure up at this point the numerous images of Milton's daughters), men's reaction to female talents was often far from benign. In this very book we see Frans Hals potentially stealing Judith Leyster's students, Carl Larsson and T. S. Eliot appropriating the work of Karen Bergöö and Vivienne (Vivien) Haigh-Wood, respectively, Lewis Mumford criticizing and intellectually suffocating Sophia Wittenberg and, most alarmingly, Robert Browning possibly murdering Elizabeth Barrett Browning and then attempting to stifle her fame as her literary executive, instead of fostering her legacy like many wives did. Imagine how many more women have been written off or killed off (metaphorically or literally) by men, and how much more work is still needed to recover them.

The trickle gradually became a steady stream. In 1929, Virginia Woolf published her famous extended essay, *A Room of One's Own*, in which she demonstrated how the lack of personal space (so poignantly glossed by U. A. Fanthorpe in 'From the Third Storey'), lack of resources and lack of access to education held women from writing. Woolf's work engendered many responses. One of them, forty-three years later, was Alice Walker's essay 'In Search of Our Mothers' Gardens', which drew attention to just how much more difficult, impossible even, it was to write for black women like Phillis Wheatley, 'a slave, who owned not even herself' (Walker, 1972). Same would apply to serf women of other areas all over the world, such as the Russian Empire, whose emancipation only began in 1861, four years before the abolition of slavery in the United States. 'I thought if I told no one it might not be true,' says Antoinette in Jean Rhys's *Wide Sargasso Sea*; if no one tells the story, it is as if it never happened.

This stream continues to grow. Even those whose interests are far from gender politics have at least heard of the recent blockbusters *The Wife* (2017) and *Hidden Figures* (2016). Books about the women behind the famous men of the past have been bestsellers ever since Martin Jarvis's

controversial work on J. S. Bach's second wife Anna Magdalena, whom he posited as the main creative force behind a number of Bach's famous pieces (*Written by Mrs Bach*, 2011). The book made a splash in the popular media and was also produced as a documentary (2014). Jarvis's work has been followed more recently by *Einstein's Wife: The Real Story of Mileva Einstein-Marić*, by Allen Esterson and David C. Cassidy (2019); *Sontag: Her Life*, by Benjamin Moser (2019); *Eileen: The Making of George Orwell*, by Sylvia Topp (2020). Hallie Rubenhold's *The Five: The Untold Lives of the Women Killed by Jack the Ripper* (2019) focuses not on wives but on victims; however, her approach can also be seen as part of this broadening biographical movement.

This interest in unsung wives or partners throws into sharp relief the habitual invisibility or poor visibility of women in our societies, a phenomenon that extends far beyond the arts. Caroline Criado-Perez's excoriating analysis of the gender bias in the Western world, where almost everything is designed for a man, is titled *Invisible Women: Exposing Data Bias in a World Designed for Men* (2019). Similarly, the interrogation of women's hidden roles in economics raises questions like *Who Cooked Adam Smith's Dinner?*, as the title of Katrine Marçal's 2015 book has it. Looking at the rise of the professional class in the upstate New York in the late eighteenth–early nineteenth century, historian Mary Ryan demonstrates how these college-educated men were lifted and propped in their new position by enormous and often invisible efforts of their mothers and sisters, the efforts which benefited their male relatives not only materially but also psychologically (*Cradle of the Middle Class: Family in Oneida County New York, 1790–1865*, 1981). According to some calculations, the worth of the unpaid labour done by women is a staggering $10.9 trillion (Gus Wezerek and Kristen R. Ghodsee, 'Women's Unpaid Labor is Worth $10,900,000,000,000', *The New York Times*, 5 March 2020). Even when women are paid, the gender pay gap still yawns (Inequality.org), and many chapters in this book, particularly those about M. E. Fitzgerald (by Catherine Hollis) or the women who worked for Penguin (by Rebecca Lyons), illuminate these inequalities. Historically, slave and servant labour facilitated many notable achievements of their more privileged masters and mistresses, and Julia Bolton Holloway highlights just how important – and unappreciated – Elizabeth Barrett Browning's maid Lily Wilson was to the poet. Today, a significant amount of intellectual and artistic work is possible because others, often lower class or migrant women, do paid household labour.

The slow realization of the scope of this unpaid or severely underpaid labour led to further understanding of the other commodity women regularly lack – time. Brigid Schulte described it best in her essay 'A woman's greatest enemy? A lack of time to herself' (*The Guardian*, 12 July 2019), which I read multiple times, quietly sobbing while breastfeeding the teething baby in the dead of night before going to work in the morning. After I told my non-

academic friend how much time I spent doing unpaid research on medieval Russian holy women, who constitute about 4 per cent of all the saints in the region and about whom barely anything is known, especially if they were not from the upper class, he remarked: 'Maybe this is how these women got themselves erased – by serving others.' Who knows how much more Karin Bergöö Larsson (discussed by Godelinde Perk) or Myfanwy Piper (discussed by Eleanor Knight) would have designed and written if they were allowed more leisure?

Today it is painful to read *Madame Curie*, the 1937 bestselling biography of the great scientist by her daughter Eve, who describes with wide-eyed social innocence how the newly-wed Marie was expected to cook, clean, look after her chronically absent-minded husband, do the shopping, housekeeping and accounts, study and work full-time in the lab – only to be mortified by her mother-in-law's comments on the poor quality of her French cuisine, who wondered loudly, 'what on earth they taught the young girls in Warsaw!' All the while, Pierre was deep in thought about physics and 'never even noticed the great effort she made' (141–2). All this is depicted by Eve Curie through the lens of her parents' inordinate love, with an almost saccharine flavour and not a hint of anger at the glaring inequality of their roles and her grandmother's not-so-micro-aggression towards Marie. In this case, as in many others, it is particularly hurtful that it was women who were normalizing this inequality – first Marie's mother-in-law with her remarks, then her daughter in her biography of her mother. The relationship between another iconic couple – Elizabeth Barrett Browning and Robert Browning – was likewise characterized by the many limitations imposed by the husband on the wife, and forms the main subject of Julia Bolton Holloway's Chapter 18 in this book.

In 'Leaf by Niggle' (1945), the work that comes closest to both allegory and autobiography in his oeuvre, J. R. R. Tolkien describes the afterlife journey of a painter, Niggle, whose passion was to lock himself up in a shed and paint his tree. He is later joined by his materialistic neighbour, Parish. Both men have to learn to work together and discover each other's *fortes*: the creativity of Niggle and the practicality of Parish. Later in the story, Parish refuses to move on towards the paradisiacal mountains without his wife – Tolkien's thinly veiled tribute to his life-partner Edith, who receives her own chapter in this volume by Maria Artamonova. I always read this story as Tolkien's metaphor for the splitting he experienced in his life, being on the one hand a scholar, a writer and a creator, locked in his quiet study, and on the other a family man, a colleague and a friend, which imposed very different demands on his limited time on Earth. But how many parts does a woman with aspirations have to split herself into, even today? Despite the popular belief that women are naturally good at multitasking, a number of recent studies suggest that neurologically it is not true – women simply have no option but to multitask. More research will hopefully clarify whether women's superior ability to multitask is

biologically informed or culturally enforced. One more recent notion, emotional labour, is yet another facet of the same social setup: women are usually expected to be default household managers of many thankless tasks for their partners and children: delegating, keeping track of tasks, planning ahead . . . keeping that laundry mountain of Doom under control (see Gemma Hartley, 'Women Aren't Nags – We're Just Fed Up: Emotional labor is the unpaid job men still don't understand', *Harper's Bazaar*, 27 September 2017). It is exhausting; it can leave little headspace for creativity. And at the end of the day it reflects the same damaging belief: that women's time is less valuable than men's, and their lives are disposable. Writing this in spring 2020, in the middle of the COVID-19 pandemic, I, too, have joined the chorus of women who previously relied on institutional childcare and who now feel as if they were thrown back to the 1950s, caught in the never-ending cycle of cleaning, cooking, educating and entertaining, because our time is viewed as cheaper and valued at lower rates. Academic segments of Twitter and Facebook are currently awash with discussions of the data suggesting that during the lockdown, women's productivity plummeted while men's productivity went up.[1]

The assumption of female inferiority still permeates our very cultural fabric. Several years ago I visited the Charles Rennie Mackintosh room in Kelvingrove Art Gallery and Museum, Glasgow. Next to one of the items on display there was a quote from Mackintosh's letter openly stating that he and his wife, Margaret Macdonald, were working on the item together; however, the item exhibited had a label with his name only. At least her husband did not destroy many of her works of art after her death – the fate that befell her sister, Frances Macdonald MacNair. More recently, *A Portrait of Elizaveta Yakovleva*, a much-praised painting, initially identified with confidence as a forgotten masterpiece by Kazimir Malevich, turned out to be by his female pupil Maria Dzhagupova (Konstantin Akinsha and Vanessa Thorpe, 'Rediscovered masterpiece "was actually work of Malevich's pupil"', *The Observer*, 7 April 2019). The basic instinct of an art critic was that it had to be painted by a man. The stories of Jeanne de Montbaston (by Melek Karataş in Chapter 9) and Judith Leyster (by Irene Kukota in Chapter 10) in this volume provide a fascinating variation on the same theme.

This is not to say that a marriage inevitably choked female creativity and stole women's time. Historically, it was a key part of many women's identities and often provided resources and opportunities for their own work, as seen in the examples of Valerie Eliot, Sophia Mumford (discussed by Karen Christensen in Chapter 3) and Ann Golding (by Nicola Presley in Chapter 16). While the excessive emotional investment in her marriage seems to have pushed the already mentally unstable Vivienne Haigh-Wood Eliot over the edge, at least temporarily (as demonstrated by Arwa al-Mubaddel in Chapter 14), a romantic partnership could also be a further catalyst for the already existing inspirations and collaboration, as the career trajectory

of Marie Sargant-Černý demonstrates (in Chapter 7 by Hana Havratilova). Children, too, can be a source of comfort, pride and inspiration, yet it is often forgotten that the same goes for parents, especially mothers, even (or perhaps especially) such mothers as Monnica of Hippo (discussed by Patricia Grosse in Chapter 13) and Eva Larkin (discussed by Philip Pullen in Chapter 17), whose intellectual feedback and emotional support was so important to their sons. Sometimes what looks ostensibly like a woman fighting for the narrow interests of her family becomes a fight for a greater political cause, and can even result in the women, such as Maissi Erko (Chapter 6 by Reetta Hänninen) and Servilia (Chapter 5 by Susan Treggiari), going against certain members of this family. Activism defines the story of Kim Hak-soon (as told here by Woohee Kim in Chapter 8), who reshaped herself as a social justice warrior, recovering her life and her purpose after nearly losing them to profound trauma.

Professional relationships can also bring intense satisfaction once the supporting role, the second violin, is duly acknowledged, as illustrated by the life of Miss Hytti (by Anu Lahtinen) and her part in the leading cultural institutions in twentieth-century Finland. It is no accident that in this collection Finland features twice, since this was the first country in the Western world to allow women various freedoms, including the unrestricted right to vote and the opportunity to be elected as officials (1906). Municipal suffrage existed in the country since at least 1872; from 1915, women were to be accepted to the universities on the same terms as male students. The first female minister in Western Europe, former factory worker Miina Sillanpää, joined the government in 1926, three years before her counterpart in the UK (but nine years after Alexandra Kollontai was appointed a *komissar* to the Bolshevik government of Russia, the first woman in history to become a member of the government). The country's current government is formed of the first-ever all-female coalition.

It appears that female same-sex partnerships, romantic, entrepreneurial or political, were overall more balanced when it came to the distribution of labour and fulfilment of ambitions, although admittedly they, too, suffered a significant degree of invisibility throughout history. A fine illustration to this thesis is the story of Tove Jansson and her partner Tuulikki Pietilä (Tooti), both of whom had successful careers in art, as Boel Westin has recently highlighted in *Tove Jansson: Life, Art, Words: the Authorised Biography* (2014). Chapter 20 in this volume on U. A. Fanthorpe and her partner R. V. Bailey (written by Elizabeth Sandie, with R. V. Bailey's input) provides a somewhat different perspective to the majority of the essays in this book, yet in its exploration of the marginal voice, the devices female authors use in publishing, and the mutual inspiration of literary partners, echoes many of the strands of the collection. This book began with literary labour but gradually expanded to a number of other areas of female experience: family obligations, childbearing and childrearing, bereavement, nursing,

facilitating. However, despite the dramatically different circumstances under which the women profiled in this collection laboured, typing is a labour many of them shared. It is only fair, therefore, that Lisa Mullen's *Epilogue* to this book is dedicated to the cultural relationship between humans and typewriters.

Structurally, we tried to arrange the contributions by topics, but could not entirely get away from the chronological organization within the sections. Despite our best efforts to swim against the tide of collective forgetting, this collection still displays a white Euro-and US-centric, as well as upper-class and middle-class slant. This in many ways reflects the inertia of the traditional academic research interests as well as the availability of the surviving sources: more often than not, the more marginalized group the person belongs to, the more difficult it is to find surviving sources about her. The stories of our book are but separate pebbles on a vast beach of human lives, washed ashore by the whims of recorded memories and the circumstances of our own existence. Initially several chapters were planned to cover a wider geographical range, but unfortunately these could not be completed in time to appear in this collection. As is, the collection highlights how easy it is for women to be invisible in plain sight, in historically the most well-documented and privileged societies. But we hope that this initial volume and its counterparts will help eventually to expand the research into women's stories and bring more of them out of oblivion.

My own emotional investment in the topic of the invisible and forgotten women behind famous men of the past began by mourning the unpainted, the unwritten, the uncomposed, the unachieved, the lives not lived to their full potential and satisfaction, the voices silenced, lost or muffled. A painting by Vera Lane Poole, unknown even to specialists, spoke powerfully enough to inspire me to attempt to rekindle the dying ashes and tell her story loud and clear. Soon I discovered many like-minded colleagues who wanted to do the same for the women whose stories they encountered in their own lives, inspiring story-telling, collaborations, friendships, connections, sharing in unpaid labour – the labour of love. Behind every successful book there is a collaboration, just as behind every successful man there is support, feedback and contribution of mothers, wives, secretaries and others. Besides the contributors, this volume would not have been possible without the feedback from Alex Anokhina, Douglas Bell, Eltjo Buringh, Elena (Alyona) Chepel, Candace Falk, Genevieve Gerrard, Maijastina Kahlos, Antonina Kalinina, Natalia Kim, Stephen Pink, Natasha Romanova, Clare Broome Saunders, Frances Spalding, Ilya Sverdlov, Atty de Waard, as well as the three anonymous reviewers provided by Bloomsbury, without the support from my husband Gábor (Gabi) Györkei, and, above all, without the unfailing help and encouragement from Vicki Blud and Daniel Gerrard, to whom it is dedicated. May this book be our gift to one another and to whoever

is willing to join us in remembering and appreciating women who were fighting for a cause, subverting the circumstances, doing their professional and familial duty or making the best out of what they had – which also required courage and dedication.

Note

1 https://www.insidehighered.com/news/2020/04/21/early-journal-submission-data-suggest-covid-19-tanking-womens-research-productivity

PART I

Secretaries and Editors

Secretarial work has been historically unseen and unnamed. If recorded at all, it is in the acknowledgements to books typed by women like Miss Alli Hytti, secretary and research assistant to Professor Puntila in post-war Finland. While secretaries have often been seen as 'office wives' to professional men, some wives, like Valerie Eliot and Sophia Mumford, were also their husbands' secretaries, channelling their creative energies towards the advancement of their partners' work. Although secretarial employment offered single women a professional identity, the never-ending demands of a job without clear parameters and boundaries between professional and personal assistance could also lead to overwork and exhaustion, as in the cases of M. E. Fitzgerald and Eunice Frost. (Catherine W. Hollis, with Juliana Dresvina)

1

M. E. Fitzgerald

Office Manager to Modernism

Catherine W. Hollis

Unpaid labour is feminist labour. So is underpaid labour. The great interest aroused in social media by the #ThanksForTyping hashtag attests to the persistence of gender and material inequity in art, literature and academia. Particularly in the academy, where we face the crisis of contingent labour and precarious employment, the reliance on unpaid or underpaid work is a significant feminist issue. It is feminist because, regardless of the gender identity of those who perform unpaid or underpaid labour in the culture industries of art, literature and the academy, there is a historic association between women and the economic and social undervaluing of their work. Those who type, organize conferences and review or edit books perform the necessary tasks without which the academy would not flourish, but are often not guaranteed the safe harbour of tenure or a stable multi-year employment contract. The contemporary job crisis in academia makes scholarship on the historic and cultural contexts for the devaluing of women's work all the more relevant.

While the narrative of the male genius and his silent or silenced female collaborator/muse/helpmeet persists across the centuries and in the accounts collected in this volume, the context for this chapter is literary and artistic modernism. A book on the promotion of modernist literature asks *Who Paid for Modernism?* (Wexler 1997). Feminist modernist scholarship answers by acknowledging and drawing attention to the invisible labour of the women who built 'the cultural infrastructure for modernism' (Olson 2017, 29–30). Wealthy women like Peggy Guggenheim, Nancy Cunard or Harriet Shaw

Weaver provided the financial patronage that allowed writers like Djuna
Barnes and James Joyce to focus on their art. Acts of service to modernism
were also performed by middle-class women like Sylvia Beach or Margaret
Anderson, who created venues – The Shakespeare and Company bookstore,
The Little Review – to publish and distribute the work produced by
experimental writers. Without these material spaces, these matrices, created
by women, a modernist work might struggle to be born, as in the infamous
case of James Joyce's *Ulysses*, which Sylvia Beach published and distributed
despite the trials of censorship. Beach's labour in service to the material
production of *Ulysses* was both necessary and undervalued, even by herself.
Upon learning that she would not be receiving any profits from the Random
House publication of *Ulysses*, she infamously said: 'A baby belongs to the
mother and not to the midwife' (Beach 1959, 205).

In this chapter, I categorize a third space where women's work supported
modernist art, literature and culture: the space of administrative and
secretarial support – the office manager, if you will. Someone has to write
and type the fundraising letters, find advertisers, publicize books and events,
mock-up catalogues and programmes, type manuscripts, proofread copy,
do the bookkeeping, manage workflow, sell tickets, raise bail and the
thousand other secretarial and managerial tasks critical for the promotion
and sustenance of modernist art and revolutionary politics. Like many of
the secretaries discussed in this section, M. Eleanor Fitzgerald (1877–1955)
was happy to do all of this and more in service to the political and artistic
visions of other people, but her biography also documents a struggle with
overwork, exhaustion and financial precarity. Fitzgerald is known for two
primary administrative commitments: she assisted the anarchists Emma
Goldman and Alexander Berkman with the publication of two journals of
radical thought, *The Blast* and *Mother Earth*, and she also worked as the
general manager for the Provincetown Playhouse, the experimental theatre
company that produced Eugene O'Neill's early plays. Fitzgerald, or 'Fitzi' as
she was commonly known, is the modernist woman as office manager, and
her service to modernist art and radical politics was well known at the time,
if now obscured.

Fitzgerald's ability to tap into and reflect the most progressive currents of
her age in politics and art is rooted in her childhood religion. Born in 1877,
the oldest of five children in rural Wisconsin, Fitzgerald's sense of mission
and responsibility began in the Seventh Day Adventist Church, to which
her mother was an enthusiastic convert, although her Irish Catholic father
avoided it. Seventh Day Adventism was a millenarian Protestant church,
emerging out of the American 'Great Awakening': it advocated a Saturday
Sabbath, the Second Coming and the importance of holistic health and
nutrition. Fitzgerald's entire professional life bears the traces of this early
millenarian training: she sought work – at first religious and later secular
– in service to a vision of a better world. Fitzgerald's idealism shaped the
many different contexts of her professional life, as is alluded to by the title of

Jeffery Kennedy's excellent biographical essay on her: 'Fitzi: True Believer' (Kennedy 2017, 13).

Fitzgerald began her working life at sixteen as a schoolteacher, but quickly left teaching to train for work as an SDA missionary. She then moved to the SDA's Battle Creek Sanitarium, where she worked in administration and nursing. The Battle Creek Sanitarium, founded by the SDA and owned by Dr John C. Kellogg, inventor of Kellogg's corn flakes, emphasized a healthy low-fat vegetarian diet, outdoor exercise and a variety of what we'd now call spa treatments, like massage, salt scrubs and hydrotherapy. It was a tremendously popular spa for wealthy Americans in the early decades of the twentieth century. A biographical sketch in Fitzgerald's archive suggests that she left Battle Creek and the SDA after being accused of inappropriate intimacy with a married male doctor (Kennedy 2017, 16). Leaving the Adventist church, Fitzgerald then began a successful stint booking lectures for the Chautauqua adult education movement, travelling from town to town organizing speaking tours; she was very successful at this work and became one of the highest paid and best commissioned salespeople.

Fitzgerald became friends with anarchist Ben Capes, who was helping book the lecture tour of his comrade, the infamous anarchist Emma Goldman (Kennedy 2017, 17). A Russian-Jewish immigrant to the United States, Goldman was then at the height of her power and influence as a charismatic and controversial speaker on topics like anarchism, workers' rights and free love. Lecturing in English, Yiddish and Russian, Goldman was frequently met with local resistance (often violent), as well as constant government surveillance on these lecture tours, and would be characterized by the US government as one of the most 'dangerous anarchists in America' (Ferguson 2013, 22). Nonetheless, Goldman's vision of radically egalitarian world, her 'beautiful ideal' (Goldman [1931] 1970, 56) prompted a powerful conversion experience for Fitzgerald that would go on to shape the rest of her professional and personal life. Moving from Adventism to anarchism, Fitzgerald's value system shifted from a belief in a religious Second Coming to Emma Goldman's anarchist 'Ideal' of a truly egalitarian human community here on Earth.

After her anarchist conversion, Fitzgerald quit the lecture circuit to work within the politically radical milieu surrounding Emma Goldman, which included anarchists, socialists, birth control activists and labour organizers. Fitzgerald began booking Goldman's lectures, working as an editor at Goldman's *Mother Earth*, and functioning in general as Goldman's chief factotum, manager, secretary and fundraiser. After Fitzgerald fell in love with Alexander Berkman, Goldman's fellow traveller, she moved with him to San Francisco, where in 1916 they created a worker's magazine called *The Blast*. After San Francisco, Fitzgerald returned to New York to helm the Anti-Conscription League upon the United States' entry into the First World War in 1917, as well as direct and fundraise the amnesty movement for conscientious objectors. When Goldman and Berkman were jailed in

1918 for their anti-Conscription activities, Fitzgerald became their chief fundraiser, raising $150,000 for the conscientious objectors' legal defence fund (Fitzgerald 1950).

In keeping with the communal ethic of their activist milieu, Fitzgerald was unpaid in her work for Goldman and Berkman; their commitment to shared housing and mutual resources meant that everyone's needs would be met collectively, as they united to bring a new, more just world into being. Their 'new type of family' blended love and work, and included Goldman, her lover Ben Reitman (Fitzgerald's ex-partner), Berkman, Fitzgerald and other comrades and lovers involved in publishing *Mother Earth* (Falk 1984, 193). Although Goldman and Fitzgerald were not close, Goldman came to see how devoted Fitzgerald was to Berkman, and by extension, the anarchist cause. Necessary funds were raised by selling books and magazines, by Goldman and Berkman's constant lecture tours, and by fundraising, which Fitzgerald excelled at. Like many utopian living arrangements, it worked well until it didn't anymore. Candace Falk's *Love, Anarchy & Emma Goldman* (1984) remains the best biographical guide to these dynamic romantic and revolutionary relationships.

The communal model fell apart once Goldman and Berkman began serving their two-year jail sentence, beginning in February 1918. By the fall of 1918, while Goldman and Berkman were in jail, and while continuing to manage their legal and political affairs, Fitzgerald sought paid work. As she explained her decision to Berkman: 'I will have a look out for some good paying work of some kind. I certainly need to be getting a little money for my services – it is no small task to keep one's bills paid these days with food sky-high' (Fitzgerald 1918). Berkman criticized her desire to seek a paying job, arguing that it would detract her from political work managing the Amnesty for Political Prisoners campaign and the publication of a Yiddish translation of his *Prison Memoirs of an Anarchist* (originally published in English in 1912). He wrote to Fitzgerald: 'why are you thinking of other work. As I have repeatedly mentioned, one can't divide his energies in different directions without serious injury to every part of the work. [. . .] why you now speak of other work, I can't understand' (Berkman 1918a). Despite Berkman's critique, Fitzgerald began working on a part-time basis for the Provincetown Players, the Greenwich Village theatrical troupe that combined politically radical thought with innovative artistic expression, where she 'generally undertook jobs no one else would or could do' (Barlow 2009, 5) and initially earned $20 a week (Kennedy 2017, 25).

In Berkman's resistance to Fitzgerald's new job, we see the persistence of a gendered attitude towards women's secretarial labour even in the context of otherwise radical politics. Berkman's commitment to anarchism and the labour movement did not preclude his assumption that Fitzgerald's role in both life and politics was to manage his affairs in service to their shared ideals. Ironically, Emma Goldman was also known to demand much from

the people who supported her work, and like Berkman, she also felt that the anarchist fight for a truly egalitarian society justified these demands. Nonetheless, perhaps because of their romantic relationship, Berkman's letters to Fitzgerald from prison take on an admonitory tone at odds with the idea of free and equal partnership. Although Berkman would express sympathy for Fitzgerald's overwork, 'with your added work as theatrical Secretary, I don't wonder you are worked to death' (Berkman 1918b), he also felt that the cause of political amnesty for imprisoned activists in the weeks following the armistice of the First World War was of paramount historical importance: 'If you should even attempt to do a third of the necessary work, you can't hold any other secretaryships. In short, you should cancel everything else' (Berkman 1918b). Fitzgerald's solution seems to have been to attempt to do it all, both the work of supporting the revolution and the work of supporting herself. Although Berkman encouraged her to pay herself a salary as the secretary of the Political Amnesty League (Berkman 1918b), her integrity and commitment to the cause would preclude her using any of the funds for her own support. Fitzgerald's commitment was to raise funds for other people, not for herself; she did this through typing endless solicitation letters to friends and supporters of the anarchist and labour causes and managing the flow of these donations to the imprisoned radicals and their families.

Fitzgerald's scrupulous account books support this assertion. Alexander Berkman and Emma Goldman were deported from the United States in December 1919, along with 247 other people characterized as radical activists in the wake of the Red Scare. Many of the people arrested and deported were recent immigrants to the United States caught in the net of the Espionage Act of 1917 and the Anarchist Exclusion Act (see Wexler 1984, 274, 268). Fitzgerald managed the donations for Goldman, Berkman and the other people awaiting deportation; her heartbreaking accounts carefully balance contributions received against funds given to provide the deportees with food, clothing and even small things like 'needles for Dora Lipkin (including thread)' (Fitzgerald 1919). Although Fitzgerald hoped to accompany Berkman to the Soviet Union as his common-law wife, she was not permitted to do so (Wexler 1984, 271), and the correspondence between Fitzgerald and Berkman becomes strained in the next few years as he and Goldman journeyed from Soviet Russia, to Germany, and eventually to France. Despite the distance between them, Fitzgerald continued to work for Alexander Berkman and Emma Goldman as their US literary agent, as their precarious finances in exile depended upon the sales of their books and articles. Although Fitzgerald would visit both Goldman and Berkman several times in Europe in the 1920s, her intimate relationship with Berkman gradually dissolved, especially after he met Emmy Eckstein, the romantic companion of his last years in France. After Berkman's painful suicide in 1936, in response to prostate cancer, Goldman and Fitzgerald exchanged letters grieving his loss (Falk 1984, 491–2).

In a sense, Fitzgerald had already lost Berkman once before, immediately after his deportation. As the 1920s began, Fitzgerald remained in Greenwich Village and 'converted' again, this time from anarchism to experimental theatre. As in her conversion from Adventism, this new chapter in her life was also illuminated by a sense of mission and service to a greater good. Towards the end of her life, she summed up her transition from political activism to theatrical management as a difference of scale, not purpose: 'I went with the Provincetown Players full-time, feeling that perhaps on a smaller scale (I had been reaching out for the whole wide world) a few could be made conscious of decency, justice and truth' (Fitzgerald 1950). The transition was likely far more fraught at the time, as Fitzgerald blended her work with the Provincetown Players with the arduous and emotionally draining business of helping Berkman and Goldman resist and then manage their deportation. Perhaps assisting the often-fractious theatrical personalities in their work seemed comparatively easy after dealing with the anarchists' trials. Fitzgerald's work for the Provincetown Players continued from 1918 until 1929, as she rose from secretary to office manager to treasurer and finally executive director of the company. As Jeffery Kennedy notes, Fitzgerald was seen as a 'stabilizing factor' and a 'mediator' among the different factions of the group, and she was able to guide the Players through their often combative changes in leadership until its final demise in 1929: 'it really was Fitzi left to helm all aspects of the company' (Kennedy 2017, 30–1, 35–6). Kennedy's essay is the best resource for more on Fitzgerald's time with the Provincetown Players and beyond, as she continued to work in theatrical management throughout the 1930s and 1940s, most significantly for the Edwin Piscator school of method acting in the 1940s. It is hard to say whether Fitzgerald is most known for her work in theatrical management or in support of the anarchist movement. Certainly her professional life attests to how imbricated the worlds of radical art and politics were in the America of the 1910s and 1920s.

In both her support for Goldman and Berkman and through her work for the Provincetown Players, Fitzgerald seems to have felt a sense of mission in service to a greater ideal. This was work she wanted to do. Nonetheless, as a single woman, especially after the relationship with Berkman, she struggled to balance this sense of mission with the need to provide economically for herself; she also struggled – less successfully – with an almost pathological need to take care of everyone around her. Her lifelong friend and eventual executor, Pauline Turkel, summed up Fitzgerald's character in this way: 'Fitzi was generous to everyone but herself' (Avrich 2005, 59). Fitzi's tireless service on behalf of both the exiled anarchists and the Provincetown Players was often praised in psychological terms: Alexander Berkman's comment about 'the great beauty and strength and nobility of your character' (Berkman 1919) was typical. But her overwork, and the price she paid for it in terms of her own physical and mental health, was also generally recognized and universally taken advantage of, as Berkman also recognized: 'Why do others

take it easy when all the work is piled up on you? But I guess it's because of your good nature – as if I also don't pile work on you' (Berkman 1922). Fitzgerald's close friend, the novelist Djuna Barnes, assessed the paradox of Fitzgerald's apparently endless capacity for self-sacrifice in a letter to their mutual friend Pauline Turkel: 'Fitzi works hard (for what, God knows!) and never gets any money herself [. . .] she has in her somewhere a fantastic ambition – what it is, I don't know' (Barnes 1927). The refrain, 'poor Fitzi', marks many of the letters written by her friends throughout the 1920s that comment on her exhaustion.

I would argue however that M. E. Fitzgerald did indeed possess a 'fantastic ambition', and that was to be taken seriously as a professional woman, as a booking and literary agent, fundraiser and executive manager. We can find evidence of her professional identity throughout her archive, held at the University of Wisconsin – Milwaukee. The archive shows us many traces of her professional identity, but very little in the way of self-analysis. Fitzgerald left no diary and wrote more business memos than personal letters. Nonetheless her numerous account books and correspondence records are meticulous: in Fitzgerald's case, we might gain more insight through her methods of accounting and office management than through her words. These documents, I suggest, provide the data that could – once aggregated – open up new terrains of knowledge about both the publication and readership of the *Mother Earth* magazine and the economics of running a little theatre.

The archive contains both her 1922 membership card for the American Federation of Labor's 'Bookkeepers, Stenographers, and Accountants' union, as well as a 1955 record that shows she was a dues paying member of the Association of Theatrical Press Agents and Managers on her deathbed (Fitzgerald Papers). Such documents indicate that Fitzi was not only a labour activist but also a union member for the majority of her professional life, with a tragic twist: in the last years of her life, her friends tried and failed to get funds from the AFL to provide for her medical care. Fitzgerald's archive also documents the multiple and competing claims on her time and expertise from both anarchists and actors. A 1925 letterhead from the Provincetown Players lists Fitzgerald as Manager of the Playhouse, right under Eugene O'Neill in his symbolic role of advisory director, and ahead of her friend Pauline Turkel as business manager. At the same time, as we've seen, Fitzgerald was still working for Alexander Berkman and Emma Goldman as their US literary representative.

The archive also tells us that as a professional woman, Fitzgerald alternated between using the gender-neutral name, M. E. Fitzgerald, and M. Eleanor Fitzgerald. In fundraising appeals, she is M. E. Fitzgerald, and on the legal documents that gave her Power of Attorney for Berkman after his deportation, she is M. Eleanor Fitzgerald. However, in the many, often anxious, business letters Berkman writes to Fitzgerald from exile in Europe, he often addresses her and Pauline Turkel as 'girls': as in 'Dear Girls, Fitzie

and Pauline' and 'now Girls, these are the refusal I have had', despite her formal role as his legal representative (Berkman 8 October 1924). The 'girl' in these letters is certainly a gesture towards the intimacy of their former romantic relationship, but it could also be seen as diminishing the professional extent of her work on his behalf. In Berkman's letter, we see an all too common and persistent gendered attitude towards the labour provided by women in positions of management and administration, that is, the secretarial 'girl'.

Fitzgerald's professional identity was also compromised by the rhetoric of maternal nurturance that was often used by her contemporaries to describe her selflessness. For example, when Helen Deutsch calls the Provincetown Players Fitzgerald's 'foster children', the maternal metaphor envisions Fitzgerald's work as a form of spiritual service rooted in her caring, nurturing, explicitly female qualities (Deutsch and Hanau 1931, 81). Even though she never married or had children, and worked her entire adult life, Fitzgerald's profession is nonetheless contextualized as an act of maternal sacrifice. Cheryl Black comments that Fitzi's 'traditionally feminine characteristics' in terms of the way she 'nurtured and "mothered" the company' may have contributed to her longevity as the manager of this fractious group of artists (Black 2002, 50). Her labour was also described by contemporaries as a spiritual 'vocation', as when the poet E. E. Cummings describes Fitzgerald as 'the incarnation of a mystery – the mystery of individuality' (Cummings 1955). In this obituary notice for Fitzgerald, Cummings also comments on her 'prodigiously generous' nature as it emerged in service to the aesthetic and social visions of others – to Goldman and Berkman, and also to the writers in the Provincetown Players, including Eugene O'Neill, Hart Crane and Djuna Barnes. But, as I have been arguing, portraying Fitzgerald as a secular saint in the fields of progressive social thought and modernist art downplays the pragmatic professionalism of her calling. Although there is a strong through-line in her personal and professional life from Adventism through anarchism, in that she found the best expression of her own ideals through the words, art and actions of the artists and activists her labour supported, she still deserved a living wage for her work.

I am suggesting that M. Eleanor Fitzgerald's 'fantastic ambition' was to support and uplift the people, ideas and causes she believed in, while maintaining her financial and personal independence. In an undated letter to Djuna Barnes, Fitzgerald articulates her most cherished goal: 'my choice ones must have money so they can do their work' (Fitzgerald n.d). Fitzgerald chose to operate behind the scenes to enable the life's work of the activists and artists whose vision aligned with her own. She did this selflessly and with great love, but often at the expense of her own health. The way that her service to modernist art and radical politics was interpreted at the time – as the outgrowth of a nurturing maternal impulse, or the altruistic service of a 'big soul' – aligns her with other women seen as the 'midwives of modernism'. This supposedly laudatory rhetoric of secular sainthood, however, has historically been

used to avoid paying women a living wage. Nonetheless, Fitzgerald's archive documents the high level of managerial and accounting skills she brought to this work.

Like the Finnish secretary Alli Hyyti in the next chapter, Fitzgerald willingly worked in the background to assist the work of others; but I would contend that Fitzgerald's lifelong union membership documents her desire for fair pay and professional respect in the field of secretarial and administrative labour. Fitzie's secretarial work slightly predates the work of the Penguin publishing secretary Eunice Frost ('Frostie') discussed in Rebecca Lyons's Chapter 4, but the two women were similarly seen as midwives to the work their labour helped produce and promote. Finally, I want to push back against the rhetoric of midwifery, maternity and spiritual vocation when it comes to describing women's work and instead to examine how acts of financial patronage, editing, publishing and, yes, office management and fundraising taught modern women professional skills. M. Eleanor Fitzgerald was office manager to modernism, and she was highly skilled (and unionized) in her work, work that was both dignified and essential. In our own time of economic precarity, Fitzgerald's struggle to earn a living wage in what we would now call the non-profit sector testifies to the modernity and relevance of her biography[1] (Figure 1.1).

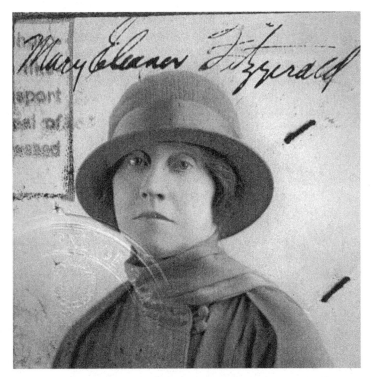

FIGURE 1.1 *M. Eleanor Fitzgerald, Passport photo, 1925 (Fitzgerald Papers, University of Wisconsin-Milwaukee Libraries, Archives Department).*

Note

1 I would like to thank Candace Falk, director of the Emma Goldman Papers
 Project (now the Emma Goldman Papers Public History Project), for offering
 feedback on this chapter and for her continuing life's work assembling, editing
 and annotating the documents contained in the microfilm edition of *The
 Emma Goldman Papers* and in *Emma Goldman: A Documentary History of
 the American Years*, Vols. 1–4. For permission to quote from Djuna Barnes's
 unpublished letter, I am grateful to the Authors' League Fund and St. Bride's
 Church as joint literary executors of the Estate of Djuna Barnes.

Bibliography

Avrich, Paul, *Anarchist Voices: An Oral History of Anarchism in America*. Chico:
 AK Press, 2005.

Barlow, Judith E., ed., *Women Writers of the Provincetown Players: A Collection of
 Short Works*. Albany: State University of New York Press, 2009.

Barnes, Djuna, Letter to Pauline Turkel, *Djuna Barnes Papers*. Special Collections
 and University Archives, University of Maryland Libraries, 1927.

Beach, Sylvia, *Shakespeare and Company*. New York: Harcourt, Brace &
 Company, 1959.

Berkman, Alexander, Letter to M. E. Fitzgerald, 8 September 1918 (1918a), Letter
 to M. E. Fitzgerald, 17 November 1918 (1918b); Letter to M. E. Fitzgerald,
 16 December (1919), *The Emma Goldman Papers: A Microfilm Edition*, eds.
 Candace Falk with Ronald J. Zboray, Alice Hall, with Stephen Cole and Daniel
 Cornford. Alexandria: Chadwyck-Healey, Inc., 1990, reel 62.

Berkman, Alexander, Letter to M. E. Fitzgerald, 21 May 1922 (1922); Letter to M.
 E. Fitzgerald, 8 October 1924 (1924), *Fitzgerald Papers*, University of Wisconsin
 – Milwaukee Libraries, Archives Department.

Black, Cheryl, *The Women of Provincetown, 1915–1922*. Tuscaloosa: The
 University of Alabama Press, 2002.

Cummings, E. E., 'Three Tributes', *The New York Times*, 10 March 1955.

Deutsch, Helen, and Stella Hanau, *The Provincetown: A Story of the Theatre*. New
 York: Farrar & Rinehart, Inc., 1931.

Falk, Candace, *Love, Anarchy, and Emma Goldman*. New York: Holt, Rinehart
 and Winston, 1984.

Ferguson, Kathy E., *Emma Goldman: Political Thinking in the Streets*. Plymouth:
 Rowman & Littlefield Publishers, 2013.

Fitzgerald, M. E., 'Expenditures from Deportation Fund Collected Through
 Office of M. E. Fitzgerald', (1919); Letter to Edwin Piscator, 1 January (1950),
 Fitzgerald Papers, University of Wisconsin – Milwaukee Libraries, Archives
 Department.

Fitzgerald, M. E., Letter to Alexander Berkman, n.d. September (1918), *The Emma
 Goldman Papers: A Microfilm Edition*, eds. Candace Falk, Ronald J. Zboray,
 Alice Hall, with Stephen Cole and Daniel Cornford. Alexandria: Chadwyck-
 Healey, Inc., 1990, reel 62.

Fitzgerald, M. E., Letter to Djuna Barnes (n.d.), *Djuna Barnes Papers*, Special
 Collections and University Archives, University of Maryland Libraries.
Goldman, Emma, *Living My Life* [1931]. New York: Dover Publications, 1970.
Kennedy, Jeffery, 'Fitzi, True Believer: The Legacy of M. Eleanor Fitzgerald', *Eugene
 O'Neill Review* 38 (2017): 13–46.
Olson, Liesl, *Chicago Renaissance: Literature and Art in the Midwest Metropolis*.
 New Haven: Yale University Press, 2017.
Wexler, Alice, *Emma Goldman: An Intimate Life*. New York: Pantheon Books,
 1984.
Wexler, Joyce Piell, *Who Paid for Modernism? Art, Money, and the Fiction of
 Conrad, Joyce, and Laurence*. Fayetteville: University of Arkansas Press, 1997.

2

The Secretary and Her Professor

Alli Hytti and L. A. Puntila

Anu Lahtinen

In the post-war period, the Finnish university positions were mostly in the hands of men, and Contemporary History at the University of Helsinki was no exception. Yet there was one woman, Miss Alli Hytti, who was acknowledged in many memoirs. The later Finnish ambassador Arto Mansala described his experiences in the 1960s in the following way:

> As my university studies proceeded – the exemplary role of professor Puntila and his assistant, doc. Lauri Hyvämäki, became more and more significant. In addition to this, it was very important that the secretary of Puntila, Alli Hytti, who was working at the Finnish Cultural Foundation, took care of the students of the professor. The inspiring personality of Puntila, as well as the scholarship and experience of life of Hyvämäki made a deep impression to me. (Mansala 2015, 18)

In the memoirs, due praise is given to Professor Lauri Aadolf Puntila (1907–1988) as well as to his assistant Lauri Hyvämäki. However, even a third person, secretary Hytti, is mentioned as an important support for university students. Yet the author points out that Miss Hytti was actually working at an independent foundation, not at the university. Who was Alli Hytti and why was she taking care of Arto Mansala and his fellow students?

As is often the case in historical sources, the prominent male opinion leaders are easy to study, while their female assistants are mentioned in passing. It is not hard to find memoirs and biographies that give praise –

or criticism – to Lauri Aadolf Puntila, a prominent and influential figure in Finnish cultural and educational policy from the 1930s to the 1980s. A historian by training who entered politics in his student years, Puntila served in the Information Department of the state and also as the secretary of the Finnish prime minister during the Second World War. In 1952, he was appointed as professor of Contemporary History at the University of Helsinki, and in the 1960s he was elected as an MP. He played a central role in the founding of several important private trusts that now fund Finnish endeavours in the arts and sciences (Eskola 1991, 2006; Tarkka 2004). Professor Puntila has left his mark in academic organizations and foundations, publications and political decision-making, all documented in the 600 files of his personal archives (hereafter referred to as LAPA) in the National Archives of Finland.

Miss Alli Hytti (1920–1999), on the other hand, left no personal archives or publications of her own. She is given only a short praise for her effective, systematic secretarial work in the biographies of Professor Puntila (Eskola 1991, 188; Tarkka 2004, 222), and there are volumes of political history that mention her editorial help (Piilonen 1982, 6). Yet it is difficult to find sources, collections or publications that would give detailed information about her life and work. Little by little, however, when one goes through the LAPA files, one starts to pay attention to the steady female handwriting that is present in so many of the letters and memos. From the margins of to-do lists to letters, blueprints, typescripts and prefaces emerges the life's work of a woman who facilitated the career and academic work of Professor Puntila. The tone of her letters is friendly, her reports and suggestions orderly. The archives of Professor Puntila are permeated by her presence, even though she remains ostensibly in the margins.

For approximately thirty-five years, Miss Hytti took care of typing Puntila's correspondence, his documents and his taped dictations. She typed out and edited manuscripts and final drafts, she took care of translations and copying – as well as ordering of the ironing of trouser creases, watering houseplants, making phone calls, sending flowers of condolence, arranging visas or ordering plane tickets. As her professional correspondence with Puntila (LAPA vol. 126) reveals, Miss Hytti took care of each and every detail that happened to need her attention. It has been suggested that the more powerful the boss of the secretary is, the closer the secretarial duties come to that of a wife (Kanter 1993, 74, 89–90). Indeed, although there was a certain line that was never crossed, the tasks of Miss Hytti were so varied that they very much exceeded the ordinary secretarial work.

This chapter pays tribute to a woman who seldom stood in the limelight. Writing the life story of a person like Miss Hytti requires piecing together information after searches for an occasional notification in a newspaper, a brief mention in a long register and ploughing through one archival file after another. Luckily, there are two of Miss Hytti's interviews preserved in the Archives of the Finnish Cultural Foundation, recorded for historical

research in 1987 and 1994. Her recollections help to put the pieces of the puzzle together, both when it comes to her personal life and her work for Professor Puntila.

Miss Hytti never graduated, never married, never held a leading position. She was living at a time when single women were supposed to work in order to earn a living, not to pursue a career. If we think of her life in terms of what is known about women's education and work in general, Miss Hytti looks like yet another hard-working low-key female clerk toiling in the job market over the course of the twentieth century. Women clerks, stenographers and typists were easily dismissed by contemporaries and even historians as mere interchangeable workforce, sometimes given praise, sometimes pitied for their underrated position (Sundman 1984, 22–3, 35–50; Rahikainen 2001, 34).

When studying the life of a female secretary in the post-war modern world, a historian can hardly ignore the shortcomings of their career, or the pitfalls of low pay and limited career opportunities (Rahikainen 2001, 34). Yet, when Miss Hytti is allowed to speak in her own words, her emphasis is often on the bright sides of her employment. Studying the life story of one female secretary and her male boss, I want to make visible both her agency and the shortcomings of the female secretarial work in mid- to late twentieth century – and, where possible, let her speak for herself.

From Stray to Secretary

Being originally from Viipuri, I was evacuated like everybody else in 1944 [when the Soviet Troops came] – then I wanted to move to Helsinki and to read for a degree – I had a job of sorts, but it was not pleasant and my aunt said that I must quit, it was not a suitable job for me, I was kind of afraid of my employer, the way he was . . .

I had a schoolmate – and she had heard that the Finnish Cultural Foundation needed a trustworthy young employee, someone who would definitely not be a communist sympathizer, and my schoolmate had said that she knows me and I am not a communist, and then I went to talk to Mr Puntila. (Hytti 1987)

The recollection of Miss Alli Hytti, given in an interview in 1994, presents a young woman in her mid-twenties, displaced from her home, trying to earn her living. Daughter to a shipmaster Antti Hytti (Laurent 1940), she had spent her childhood in naval bases and inland port towns in different parts of Finland. Her actual home town was Viipuri (Vyborg) in Karelia, part of independent Finland until 1944, when the territory was ceded to the Soviet Union as part of the terms of peace (Lavery 2006, 129, 134–5). Alli Hytti and her family were among the 400,000 Karelians, some 10 per cent of the Finnish population, who were evacuated and resettled in different parts of Finland in 1944.

According to Alli Hytti's own recollection (Hytti 1987 and 1994), her studies at the university had been interrupted in the 1940s when her parents died. Having thus left without family or connections, she was one of the millions of young people searching their place in the restless post-war Europe. They were often drawn to big cities like Miss Hytti, who was taking courses in stenography in Helsinki while trying to manage in an unpleasant work that she does not describe in detail. It is not clear what was wrong with her previous employer, but one can suspect abuse of threat of sexual harassment coming from him.

Having finished secondary school and having done secretarial tasks in wartime, Miss Hytti was a suitable recruit in the world of secretaries and office employees. The field had become more and more female-dominated both in Finland as elsewhere in Europe and the United States, especially when it came to tasks such as typing. Women entering the office seldom advanced from these posts, while the male clerks of the same age soon started to aspire for managerial positions (Kaarninen 1995, 204–5; Leminen 1999, 184–5; Ranta 2012, 69–70). Many women were not actively pursuing a career. Pia Leminen points out that female clerks had been taught to be 'very humble and obedient colleagues. They did the best they could with no demands for better wages. This attitude helped them to interpret their job as positively as they did' (Leminen 1999, 188).

As mentioned previously, one of the organizations searching for a secretary was the Finnish Cultural Foundation, run by Lauri Aadolf Puntila, then the secretary general of the Foundation. Established in 1937, the Foundation supported Finnish arts and sciences, with Puntila as its primary mover in many ways, personifying the Foundation and what it stood for. The base capital of the Foundation had been provided mostly through popular donations. A total of 170,000 Finns had taken part in the charter collection, with affluent donors joining the effort. Since 1939, the Foundation had been awarding grants to artists and researchers, individual scholars and institutions; today, it is one of the largest foundations in Europe. After a donation made in 1943, the Foundation became the main shareholder of the wealthy Huhtamäki Company (now Huhtamäki Syndicate) and Puntila was the chair of the supervisory board of the company (Tarkka 2004, 212–13).

While the country never suffered direct occupation during or after the Second World War, there was a lot of uncertainty about the future. Having been the secretary to the prime minister and close to many politicians involved in the wartime decision-making (Eskola 2006), Puntila was worried about possible consequences of the war. It was not quite clear whether the Finnish Communist Party would get the upper hand in politics or whether the country would face other kinds of serious turbulence (Lavery 2006, 133–6).

Puntila was not just worried about the hostile remarks that newspapers made about his wartime activities and about the supposed riches of the Foundation. He was worried about the future of democracy in general and

about the Finnish Cultural Foundation in particular (Pohls 1989, 77–82). Hence he wanted to make sure that he was not about to hire a person with latent communist sympathies or a person who would otherwise leak or abuse their insider information. Miss Hytti, evacuated from Karelia, seemed like a safe choice; by hiring her, Puntila would also help at least one displaced person. As Miss Hytti later recalled,

> he wrote very beautiful words about the people living in Karelia in his book [Kenttäpostia 1944, published in 1972], and in a way, reading that, I realized afterwards that probably he saw me as a representative of all Karelians, and that was the reason why he wanted to be so kind to me. (Hytti 1987)

Kind and great – those were the words Miss Hytti chose when describing Professor Puntila's attitude towards the young secretary. Yet when it came to everyday interaction, Puntila seems to have kept his distance and focused on work. Miss Hytti presented other employees of the small Foundation Office as more prone to talking about 'ordinary normal things', a skill that she felt Puntila learned 'only in the last few years'.

From 1 March 1946, Miss Hytti was expected to arrange and archive grant applications, organize meetings and take care of the everyday tasks at the office. In her later recollections, she described her work as interesting, pleasant and full of surprises. When Professor Puntila learned that she knew stenography, he started to dictate his letters to her. A present-day reader might frown upon the growing number of tasks allotted to the secretary. However, the recollections of elderly Miss Hytti from 1994 are those of a person who was happy to train and develop her skills:

> I thought it great fun of course. I became more confident and maybe faster [in stenography]. I remember how [mathematician, Professor] Rolf Nevanlinna came to the Foundation – to dictate his mathematical texts. In a way, the job and my tasks developed around me as the time passed, and I was sometimes allotted most bizarre tasks, which I solved using my own common sense.

The official working hours lasted from 9.00 am until 3.00 pm, although Miss Hytti recollected that when asked, she would arrive earlier, and if needed, she could stay later. According to her own account, she appreciated the mutual flexibility: 'As I had no family to take care of, I could work flexible hours; in return, I could leave the office during the day to take care of my own errands.' She was also inspired by the example of Professor Puntila who was involved in many activities from morning to evening, not paying much attention to the rest: 'I saw how he was working and how much he demanded of himself, then it was easier for me to try and do the same.'

Miss Hytti wholeheartedly devoted her time and energy to her work, offering in her notes multitudinous opportunities to check and correct documents whenever needed. In one note (LAPA vol. 126, n.d.), she wrote that she was planning to be at home around 9.00 pm and thus available if the professor wanted to call and rephrase something in a document they had been polishing.

Miss Hytti did not participate in the decision-making; even the protocols of the official meetings were allotted to others. Instead, she was responsible for arranging the meetings, inviting people and checking that all the necessary equipment was available. Some recollections, albeit dismissed as 'minor things', seem to indicate that she was also loaded with more tiresome routines and that the superiors did not always see the burden of their subordinates. While Miss Hytti enjoyed the company of some female clerks, the influential persons visiting the Foundation were mostly men. According to Miss Hytti's interview, some responses from the supposedly dignified men seem to have been borderline abusive. One of the examples is related to the task of organizing meetings, in which the attitudes of two councillors, male and female, are presented in contrast:

> Professor Puntila had this habit that one [i.e. Miss Hytti] had to call to every participant before the meeting and make sure that they were going to join the meeting. Commercial Councillor Kuusinen often, when picking up the phone, gave a greeting 'at Gotham' [Fin. Hölmölässä]. One was stupefied at first, hearing that kind of an answer. And once he was bedridden, and I called to ask whether he would join the meeting, and he said: 'No, but I can be of help if a bedfellow is needed'. These comments surely got a young girl confused. But it was a minor thing. Councillor of Domestic Science, Katri Laine, was the only one who always informed by herself whether she was coming or not. I think I once told Professor Puntila that Katri Laine would deserve an honorary medal for taking care of it herself. (Hytti 1987)

Councillor Katri Laine (1891–1960) was one of the relatively few women participating in the actual decision-making of the Cultural Foundation. It is possible that she was, by education or by experience, more sensitive to the needs of the secretary, as it was more likely that she had had her share of tedious secretarial tasks allotted to women.

Partners in management

The tasks of Miss Hytti were never limited to one single institution or its administration. In practice, she was first and foremost the secretary of the person – Lauri Aadolf Puntila. Looking at the surviving written lists of assignments (LAPA vol. 126), one can notice that Professor Puntila was always polite; in the 1950s, he was even apologizing for the extra work,

while later on his assignments became somewhat more straightforward, but never rude. As Miss Hytti commented in the 1987 interview: 'At some point I, somehow, just ended up working only for him.'

Between 1952 and 1971, Puntila was also the chair of Contemporary History at the University of Helsinki. He was the dean of the Faculty of Social Sciences in 1962–6 and again in 1970–1 (Eskola 2006). Despite his many other responsibilities, this was the title – and authority of professor – that was most tightly connected to his personality and his public image. This is how the academic tasks also reached the desk of Miss Hytti. She typed letters of recommendation, made reservations and arrangements for Puntila's meetings with colleagues and students, mediated messages sent to him or took care of his loans from the University Library. She was often doing the tasks that were suitable for a research assistant: collecting bibliographies or newspaper clippings, checking footnotes, indexing publications. Thus, and given the mediating position of a female secretary between the distinguished professor and the student, it is natural that Mansala mentioned Miss Hytti in the same paragraph as the academic staff of the Department of Contemporary History.

While Professor Puntila and Miss Hytti met face to face, Puntila was often in meetings or on his way to meetings, or spent the summertime at the family estate in Sääksmäki. Thus, these partners in management regularly communicated via telephone, written notes and all kinds of memos that often arrived via post, sometimes as hasty express deliveries.

The scale of the work is illustrated in polite, orderly letters of assignment, sent by Professor Puntila to Miss Hytti, who then recorded her own remarks about the assigned tasks. In 1958, for example, Puntila wrote to Miss Hytti asking her to circulate the information about his lecture. Puntila was always keen on making the most of every effort, thus he hoped that his lectures would also reach the newspapers and typically sent in a summary to be published. As he was staying on the family estate in Häme, the distribution was organized by Miss Hytti along the following lines, written on 26 June 1958:

> Good Miss [Hytti],
> Once again I have to trouble you with my own business:
> I have promised to give a presentation in Hämeenlinna next Sunday and to send a summary to the newspapers. Would you be so kind as to copy the summary and send it to the following papers [list of newspapers].
> With many a grateful greeting,
> Yours,
> L. A. Puntila
> PS Could you also send five copies to myself.

Professor Puntila had listed the most remarkable nationwide and provincial newspapers in the letter. After receiving the letter, Miss Hytti had written

'23 copies' in the margin and noted the hometown of each newspaper on the side of the titles. The summary was published at least in one paper, Uusi Suomi, on 30 June 1958. During his whole eventful life, Puntila was very active in promoting his presentations, and these letters of assignment help understand how he – and she – managed to handle the volumes of paper related to this work.

In return, the following letter was sent by Miss Hytti (1 February 1974), referring to many scholars as well as to members of several foundations, and giving a hint of the complicated logistics of all the tasks:

Professor Puntila, I hope that your journey was successful in every way, even if the attempts of Otava [publishing house] do not seem to have received the positive response that it was trying to get [abroad]. Professor Nurmio informs that he has read the manuscript of [the Adjunct Professor of Social History, Hannu] Soikkanen and is ready to meet and discuss it. Dr. Salonen inquired concerning a suitable day for the meeting of the board of the Välimäki Fund. [. . .] / M.S.Sc. Maisteri Rautkallio cancels the meeting on 13 February [. . .] flower arrangement has been ordered for the birthday of Councillor Jahnsson. [. . .] Mrs Kuuskoski will give it to you when you go to congratulate her. Unfortunately, I did not reach your Wife on Friday afternoon, so to be on the safe side [chauffeur] Lindgren will come to the airport and bring the post with him.

Miss Hytti kept on working for the Foundation – or Puntila – for twenty years, until 1966, when Puntila was elected MP. The Foundation was not to be associated with party politics, so Professor Puntila moved his desk to the Huhtamäki Company, and Miss Hytti followed him there (Pohls 1989, 422). Miss Hytti describes her decision as follows:

I had been thinking about it, I kind of guessed that I might have to face this sort of decision. Then he asked me, 'now you have had time to sleep on the decision, what do you say – would you come with me?' I said: 'Of course, I have already said that I [will] come with you so it is decided'. I got my payroll from the Huhtamäki Company, but totally committed to work for Puntila. (Hytti 1987)

Miss Hytti had arrived at the Finnish Cultural Foundation in her mid-twenties. In 1966, she was in her mid-forties, single and work-oriented. In the surviving documents Miss Hytti never referred to any alternative life goals after she had started at the Foundation. It is known that she made a study trip to England in the late 1940s, and she may have participated in shorter courses; however, there are no signs of career plans further than the one she had landed on in early 1946. Later, in 1970, when a register of small

biographies of displaced Karelians was published, she was referred to as 'the Secretary of Puntila':

> Hytti, Alli Tuulikki. Secretary, born 23 May 1920 in Viipuri. Alli Hytti is a secondary school graduate and she has taken many courses in languages, as well as a course in stenography, and participated in study abroad trips. She has been awarded a silver service medal for her long-term service as the secretary of Professor Puntila. Her leisure time activities include theatre and opera, reading, outdoor recreation and traveling. The Central Chamber of Commerce in Finland has awarded her the silver medal for 20 years of service. (*Siirtokarjalaisten tie II*, an edited register of people evacuated from Karelia at the end of the Second World War. (1970), 358)

The short biography gives some references of the private life of Miss Hytti. As it is most likely formulated by herself, it also gives a glimpse to what she thought was relevant in her life. The outdoor recreation is also mentioned in interviews, as she reminisced in 1994: 'I preferred to take my holiday in August, if possible, as it was the season for picking berries.' When Miss Hytti refers to her private life in the interviews, she recalls travelling with female friends; she was also good friends with other female clerks at the Foundation.

Nothing is mentioned about potential partners or wishes to have a family. Quite the contrary. In her interviews Miss Hytti noted several times that she was free to commit herself to her work as she pleased. In the 1950s, the Foundation received a small apartment as a donation, and the apartment was offered to Miss Hytti for rent. Given the dire housing situation in post-war Helsinki, as well as out of friendship, Miss Hytti moved there with her friend who had first informed her about the secretarial position in the year 1946. After the parents of the friend had died and the friend moved to their former place, Miss Hytti continued her single life.

Being a single, self-providing female clerk was not uncommon as such. Even if a woman of her generation would have been interested in getting married, the war had taken its toll on the generation of men born in and around the 1920s. For many, marriage was not an option purely for demographic reasons, and for others it was not convenient. The way Miss Hytti speaks about her life seems to mediate contentment with her situation. If there were special disappointments in her personal life, she did not refer to them, and when it came to work, she was committed to what she was doing. Recollections by Miss Hytti echo other autobiographic accounts written by women of her generation. As has been pointed out by historian Heli Valtonen, war, humble living conditions and daily struggles shaped these women's ideas about themselves and what they could achieve and how to be content with what they had (Valtonen 2004, 239).

Miss Hytti also followed Professor Puntila in the 1970s, when he retired from the University and moved to the Yrjö Jahnsson Foundation, yet another private trust that he had been active in establishing. Jahnsson

Foundation is funding Finnish research in economics and medicine up to this day (Zetterberg 1982, 365–81; Tarkka 2004, 208–10). Despite these changes, Professor Puntila and Miss Hytti retained close links to both the Finnish Cultural Foundation and the Huhtamäki Company.

'Our Great Work'

Over decades, thousands of assignments passed across the desk of Miss Hytti. Sometimes Professor Puntila sent his drafts for presentations and essays, and Miss Hytti took the task of copying and mailing them. On occasions Puntila sent her a recorded tape – a speech, an academic text, a letter – for typewriting. According to Puntila's letter to Miss Hytti (1 February 1957), he was apparently compiling material for a longer publication, as he wrote:

> I have been dictating political history on this recorder tape. In the beginning, there is some uncertainty when it comes to dates for example. All news related to a certain day shall be written so that foreign policy, economic policy, domestic policy will be typed on separate sheets. This shall be continued theme-wise from one year to another. Let's make three copies [of the text].

Often, Puntila politely used a special form of a verb that could be translated as 'I presume that you would [be so kind and do . . .]' (Fin. 'tehnette', letters on 9 June 1957 and 19 June 1969). Miss Hytti was polite and formal in her answers, although in later years she would sometimes add a more playful comment. On 14 June 1979, she sent a reminder to the professor that he had to rest as prescribed by the doctor: 'You will remember the advice of Uncle Doctor, won't you! All the Best, Alli Hytti.'

While Miss Hytti never published anything in her own name, some letters like that from 2 July 1962 illustrate that she saw herself as an important facilitator of the project:

> Good Professor,
> Our 'great work' is finished, after all! Here are two copies of it. The copy machine at Huhtamäki was very useful. They seem to use black ink here, while we use grey ink [at the Foundation, where the letter is dated].

Puntila had returned the letter to Hytti, with a short handwritten note in the end: 'Miss Hytti, many thanks!' The great work may have been the polished manuscript of the Political History of Finland (published in 1963) which Miss Hytti must have been typing from dictated tapes for a course handout already in 1959. She might also have been copying one of the countless reports produced by Puntila, related to the cultural policies and university politics of the time. Her reference to 'our great work' also mediates a feeling of being involved in the creative process.

Over the years, Miss Hytti got many thanks for her work – friendly cards were sent to her by the acquaintances of Professor Puntila, she was referred to in prefaces of Puntila himself and other scholars in his research projects, and she received letters and postcards expressing gratitude for her helpfulness. When Leo Tujunen (1910–1988), editor-in-chief of *Suomen Kuvalehti* (the Finnish equivalent of *Time* magazine), sent a delayed (undated) piece of interview to Miss Hytti, he commented, possibly with some hidden envy or a flattering nod to the receiver: 'My apologies for having lost the interview for a period of time; alas, I haven't got such secretarial support.'

Fealty

The many thank-you letters and acknowledgements point to the analysis of Rosabeth Moss Kanter, who famously saw the rewards of the secretarial job as emotional-symbolic. While no actual promotion was to be expected, the secretary identified with the success of her boss, and 'the praise exchanged for compliance with a continual flow of orders' was appreciated to the extent that could even result to praise-addiction. According to Kanter, a secretary could get used to receiving only thanks and praise for diligently carrying out her daily tasks, and thus become afraid of shouldering other responsibilities or searching for promotion to a position where they could face criticism (Kanter 1993, 94–5). While one can appreciate the many thanks and praises expressed to Miss Hytti, one cannot help thinking that the praise was an inexpensive way of compensating for hard work. Thinking about many women discussed in this volume, working themselves to the brink of exhaustion, one has to wonder if the praise was an adequate substitute for higher salaries or career promotion.

Studying the secretaries working in a large American Corporation in the 1970s, Rosabeth Moss Kanter saw the elements of fealty as inherent in the secretarial work. Fealty is a concept used to describe premodern societies where personal relations play a central role. Despite changes over time, Kanter sees similar features surviving in the personal interdependency of the boss and the secretary maintains many old elements. The status of the secretary was based on the status of the boss, and the secretaries were not promoted on their own. The secretaries merely stayed in the service of a boss who received a promotion, and identified with his position and success. Kanter refers to such support staff as 'the private retinue of a patrimonial dignitary' (Kanter 1993, 74–5, 90).

This seems to resonate very well with the position of Miss Hytti: she was, in effect, the private secretary of Professor Puntila and took to heart everything that he represented. Studying the work and career choices of post-war female clerks, Pia Leminen has made observations that resonate with what is known about Miss Hytti. Studying the female clerks in a company,

Leminen found out that female clerks who decided to remain single often were dedicated to their work and had relatively appreciated positions – such as serving as the secretary of a managing director, for example. In the words of Leminen, these post-war secretaries may not have been 'career women in the modern sense', but they were more dedicated to their work than other groups of female clerks (Leminen 1999, 190).

To someone familiar with early-modern household relations, a situation in which a trusted subordinate derives one's worth from the appreciation of one's master or mistress is immediately recognizable (Lahtinen 2007, 31). What also resonates with early-modern practices is the system of delegated power of representation. It was crucial for such a prominent person as Professor Puntila to pay attention to organizations, acquaintances and the relatives of acquaintances. In this effort, Miss Hytti's help was needed. This is reflected in a letter from 9 June 1957, in which Professor Puntila authorized Miss Hytti to send the condolences to the relatives of the late Ale-Einari Riipinen (1902–1957), former editor-in-chief of *Kauppalehti* (Finnish equivalent of the *Wall Street Journal*). Puntila also gave her the mandate to act in his name in similar situations:

> The Editor in Chief Riipinen has passed away. I presume that you will [be so kind as to] send [the relatives] a printed form of condolences. I [also] presume that you will [be so kind and] do the same if other acquaintances of mine die [while I am away].

This mandate reflects the confidence that Puntila had in his secretary: Miss Hytti would certainly know whom to approach with condolences if needed, even without further specification. This dependability resonates with Kanter's observation that a long-time secretary became indispensable because of her unique knowledge of the boss and all the needs related to his work (Kanter 1993, 92–3). In other words, Miss Hytti became an extension of Professor Puntila's professional and social self.

The evidence suggests that Professor Puntila even authorized Miss Hytti to undersign documents on his behalf. On 1 November 1974 Alli Hytti sent a letter to Puntila, reporting, among other things, that she had reproduced Puntila's signature in an official congratulation document. There were also references to ready-made certificates and letters of recommendation that Miss Hytti was trusted to send in the name of Puntila, to support applications of his students and protegees, as in a letter dated 26 January 1968. Allusions to similar practices are present in previous correspondence as well. Sometimes, an official letter of attorney was sent, sometimes there was an indirect polite request along the lines of 'I presume that you will [be so kind as to] put my name [on the document]' (7 June 1958 and 27 September 1970).

The arrangements, again, resonate with the division of labour in an early-modern household, where tasks could be delegated and taken care of by the wife or other trusted persons, and the seal of the head of the

household could be used by other family members. There are some parallels to the tasks of early-modern wives and house scribes of powerful men, who were acting as the informants, 'the eyes and the ears' of the head of the household, and, if necessary, represent him (Norrhem 2003; Lahtinen and Staudenmeier 2010, 110). The system would function very well as long as everybody trusted that everything done was accepted and authorized by the name of the paterfamilias. In the same way, when it came to the ritualized flow of greetings and letters, it did not really matter if another person was pulling the strings behind the 'institution' called Professor Puntila, as long as it helped this institution to thrive.

The variety of secretarial tasks, listed by Kanter and others – the bill-paying, sending of greeting cards, watering plants – clearly transgresses the limits of personal and professional life, as was the case with Miss Hytti and Professor Puntila. This, again, resonates with the phenomena of fealty and very personal ties of trust and dependence typical of the past centuries. The secretaries were seen to carry the human side of the office in a way that reminds of more private relations, which echoes the way in which premodern wives were seen as representatives of the soft side of power, while their husbands represented the strict, punitive side of it (Kanter 1993, 101; Norrhem 2003; Lahtinen and Staudenmeier 2010). In contrast to a number of women discussed in this volume who struggled to combine their family duties with finding time for their own work, (predominantly male) figures of authority like Professor Puntila seem to have enjoyed the support of several women who helped advance his work.

Conclusions

There is no doubt that Miss Hytti was the important facilitator who helped Professor Puntila to make the most of his position and networks. Committed to his work as her work, Miss Hytti was appreciated as a secretary, and received many thank-you notes via mail as well as in published monographies. Yet Miss Hytti did not appear in many interviews, she did not pose for photographers in events, so it takes some time to figure out her role from the margins of the documents in the LAPA and in the files of interviews archived at the Finnish Cultural Foundation.

Miss Hytti started her secretarial work at a moment when working as a typist was seen as a convenient way for an unmarried woman to make a living. By the time she retired, the world had changed a lot, and in the eyes of the younger generations, her work may have seemed more tiresome and oppressive than for the generation of Miss Hytti. A present-day reader can make sour comparisons to the 'secretarial' positions of Professor Puntila and that of his employee. For Puntila, his position as the secretary of the prime minister, for example, provided a springboard to new appointments; he did not have to choose between having a career or having a family. Miss

Hytti, on the other hand, would always remain a secretary. Not even all her contemporaries would have been content with the position.

Miss Hytti, however, did not make such comparisons, at least not explicitly. What she recalls of her life in the mid-1940s demonstrates that she had seen enough warfare and insecurity to appreciate safety. She claimed that she valued an interesting job with pleasant colleagues as well as free time and friends to travel with. She may have found some tasks tiresome; we might feel that she could have been competent for more demanding tasks and promotion of her own. Yet she derived the meaning of the work from the success of her boss. As the very objective of her work was to help Professor Puntila to shine, much of her work remained unseen and unnamed and was expected to stay so. This notwithstanding, an analysis of the LAPA documents confirm that they did not only represent the work of one man but also of one woman who typed her way into academic acknowledgements, whether they were printed, or handwritten in grateful letters.

I would like to thank my research assistant, Sanna Rantahalvari (MA), for archival work and editing; the present-day secretary of the Finnish Cultural Foundation, Renja Pyysing-Willman, for helping an absent-minded professor in the archives; and the editor of this volume, Juliana Dresvina, for her insight and efforts. All translations from Finnish to English have been done by the author of the article.

Bibliography

Eskola, Seikko, *Tiedettä, taidetta, aatetta. Suomen Kulttuurirahasto Suomen kulttuurissa*. Helsinki: Otava, 1991.

Eskola, Seikko, 'Lauri Aadolf Puntila (1907–1988)', in Matti Klinge (editor-in-chief) et al., *Kansallisbiografia*. Helsinki: Suomalaisen Kirjallisuuden Seura, 2006.

Hytti, Alli, *Interview of Miss Hytti to historian Maritta Pohls*. Helsinki: an unpublished manuscript in the archives of Suomen Kulttuurirahasto, 1987.

Hytti, Alli, *Interview of Miss Hytti to archivist Leena Kononen*, Suomen Kulttuurirahasto. Helsinki: an unpublished manuscript in the archives of Suomen Kulttuurirahasto, 1994.

Kaarninen, Mervi, *Nykyajan tytöt. Koulutus, luokka ja sukupuoli 1920- ja 1930-luvun Suomessa*. Helsinki: Suomen Historiallinen Seura, 1995.

Kanter, Rosabeth Moss, *Men and Women of the Corporation*, 2nd edn. New York: Basic Books, 1993.

Lahtinen, Anu, 'Mägde und weibliches Gesinde 1300–1600', in Marjatta Rahikainen and Kirsi Vainio-Korhonen, *Arbeitsam und gefügig. Zur Geschichte der Frauenarbeit in Finnland*. Berlin: BWV Berliner Wissenschaftsverlag, 2007.

Lahtinen, Anu and Johannes Staudenmeier, 'Power and Decision-Making in Early Modern Germany and Sweden: Noble Families and Princely Government', in Cânâ Bilsel, Kim Esmark, Niyazi Kžzžlyürek and Ólafur Rastrick (eds), *Constructing Cultural Identity, Representing Social Power*. Pisa: Cliohres & Pisa University Press, 2010.

Laurent, L., ed., *Suomen merikapteenit. Elämäkerrallisia tietoja.* Helsinki: Helsinki, Merenkulkulaitos, 1940.

Lavery, Jason, *The History of Finland.* Westport and London: Greenwood Press, 2006.

Leminen, Pia, 'White Collars, Light Dreams: Women Clerks in a Finnish Paper Mill Town after the Second World War', in Marjatta Hietala and Lars Nilsson, *Women in Towns. The Social Position of European Urban Women in a Historical Context.* Helsinki and Stockholm: Finnish Historical Society and Stockholms universitet, 1999.

Mansala, Arto, *Kohti kaaoksen pitkää yötä. Kolme kautta Moskovassa.* Helsinki: WSOY, 2015.

Norrhem, Svante, 'Normbryterska eller ansvarstagande hustru?', in Börje Harnesk, *Maktens skiftande skepnader. Studier i makt, legitimitet och inflytande i det tidigmoderna Sverige.* Umeå: Umeå universitet, 2003.

Piilonen, Juhani, *Vallankumous kunnallishallinnossa. Punaisen Suomen Historia 1918.* Helsinki: Valtion painatuskeskus, 1982.

Pohls, Maritta, *Suomen Kulttuurirahaston historia.* Helsinki: WSOY, 1989.

Puntila, L. A., *Suomen Poliittinen historia 1809–1955.* Helsinki: Otava, 1963.

Puntila, L. A., *Kenttäpostia 1944.* Helsinki: Tammi, 1972.

Rahikainen, Marjatta, 'Naiset näkyvät Suomessa tekevän vaikka mitä', in Marjatta Rahikainen and Tarja Räisänen, *"Työllä ei oo kukkaan rikastunna" Naisten töitä ja toimeentulokeinoja 1800- ja 1900-luvulla.* Helsinki: Suomalaisen Kirjallisuuden Seura, 2001.

Ranta, Sirkka-Liisa, *Naisten työt. Pitkiä päiviä, arkisia askareita.* Helsinki: Otava, 2012.

Siirtokarjalaisten tie II. Turku: Nyky-Karjala, 1970.

Sundman, Carola, *Från handelsbokhållare till kontorsfröken. Kontoristyrkets feminisering i Finland under 1900-talets tre första decennier.* Helsinki: Delegationen för jämlikhetsärenden i Finland, 1984.

Tarkka, Jukka, *Kansallinen kolkuttaja: L. A. Puntilan yhteiskunnallinen elämä.* Helsinki: WSOY, 2004.

Valtonen, Heli, *Minäkuvat, arvot ja mentaliteetit : tutkimus 1900-luvun alussa syntyneiden toimihenkilönaisten omaelämäkerroista.* Jyväskylä: Jyväskylä University, 2004.

Zetterberg, Seppo, *Yrjö ja Hilma Jahnsson.* Helsinki: Yrjö Jahnssonin säätiö, 1982.

3

Jumped-up Typists

Two Guardians of the Flame

Karen Christensen

Although they met only once and were born a generation apart on different sides of the Atlantic, Sophia Wittenberg Mumford (1899–1997) and Valerie Fletcher Eliot (1926–2012) had experiences and traits in common, and their trajectories offer contrasting examples of what it means to be the woman behind a famous man. The parallels in their life stories derive from their families' limited expectations for them, their inchoate youthful ambitions and the way they found the larger worlds they longed for only by subsuming their identities in those of the famous writers they devoted their lives to. Their stories offer contrasts, too, and are interwoven because the men they married had many common friends and acquaintances, and even shared a publisher. I knew both women well and find that their stories provide a window into the way women have channelled their ambitions into service to an influential mate.

Imagine first a twelve-year-old Brooklyn girl, the middle child in a Russian-Jewish immigrant family. It is 1913, and time to choose a high school course for Sophia. The family is struggling. There are four daughters and one son. Though the son is not a great student, he nevertheless has charm and can talk the ear off his teachers. Of course he must go to college. There is an older sister who gets top marks and has lofty notions. Next comes Sophia, who daydreams and never gets that coveted A-A-A on her report card. The family decides that she can simply take the three-year commercial high school course and then go out to work. She is not college material. After all, she's pretty and has a rather dramatic style – she will find her way.

A generation later, Valerie Fletcher, a Yorkshire girl from a prosperous, anxious, hard-drinking family, is sent to boarding school near London in 1939. She is bookish and awkward, off in her own world of make-believe. Her grades are poor, and she is told that she is not going to be able to study for a higher certificate (post-war A-levels). She is placed in an English class for the least successful students. One afternoon the teacher plays a recording of John Gielgud reading a poem by T. S. Eliot. She is enraptured. The headmistress later advises, before she leaves school in 1944, that if she wants to meet the famous poet, she ought to go to secretarial college and apply for a job at the publishing firm where he is a director.

No one thought much of either of these young women. No one predicted a bright future. No one saw budding talent or special ability – or even potential for trouble. They were expected to work in undistinguished offices and to find a husband there, or among their family's acquaintances, and settle down to ordinary lives. In spite of their seeming ordinariness, Sophia and Valerie had ambitions that went far beyond their family horizons. They wanted bigger worlds and found them through the men they married.

By marrying Lewis Mumford in 1921 and staying with him through considerable trials, Sophia moved in illustrious intellectual and artistic circles, made regular trips to Europe and was at his side when he was honoured and feted across the United States. He was knighted by Queen Elizabeth II, and had Sophia been British she would have called herself Lady Mumford. A title is one thing Valerie Eliot longed for and never got. But she was fawned over and feted, honoured and given way to, having become rich and powerful in the literary world due to her own shrewd management of the Eliot legacy.

Both women were known for supporting and defending their husbands' work and reputation. Both women were devoted to the last. But when I got to know them in the 1990s, I realized that they paid a price for that devotion. Sophie ended up, in her nineties, wondering if she had underrated her young self and given up too much for Lewis. Valerie never quite got over the fact that she had been viewed as 'a jumped-up typist'.

For each of them, typing had been the key to a new life. The background role that we are considering so often in this volume became part of their identity, so that they seemed to forget their earlier ambitions. Valerie said she wanted to be a writer, and wrote of going to live in the slums to find material. Sophie, once she joined *The Dial*, a literary magazine, was surrounded by eminent writers, which squashed her ambitions in that direction, and she had no notable talents – she complained that people saw only her beauty. But in the late 1950s she began keeping her own 'day book', a rather formal record of her life with Lewis during the 1960s and 1970s when he was greatly acclaimed in Europe as well as the United States. The daybooks were a point of pride when I met her over thirty years later, and the idea of writing a book herself was a source of great contentment during her final years.

Of course, it is risky to impose our notions of what women could or should have been on women who lived in different times or different cultures. Yet equally we should not underrate women who did not accomplish anything great on their own: their love, care and character may deserve acknowledgement just as much as an intellectual or artistic contribution.

Even in my own generation – I was thirty years younger than Valerie, and nearly sixty years younger than Sophia – typing was a worthwhile skill. I got the top UK secretarial qualification, a Personal Assistant's Diploma from the Royal Society of Arts, while I was studying for the Oxford Entrance Exams in 1977. I never had a job as a regular PA, but I made good money temping during the summers, and this took me, as it took earlier generations of women, into publishing. I also learned to type because writers need that practical skill, and both Lewis Mumford and T. S. Eliot were accomplished typists. For them, however, it was the tool of a creative person, not a commercial skill. Interestingly, there are photographs of both men sitting at their typewriters, but no photos of their wives typing. In this chapter, I want to focus on the different ways in which these two wives supported and enabled their husbands' creative work, with their typing and in many other ways as well.

In one interview, Valerie Fletcher Eliot recounted her first meeting with T. S. Eliot, including the detail that she had cut her hand and therefore came to an interview for a typist's position wearing a bandage, making it impossible to take a typing test. Valerie was inventive with her personal history so that may not be true, but it seems that she in some way avoided typing that day. I once interviewed another person who said Valerie told him she had had a broken arm.

It was not her typing speed that made her a successful secretary. Valerie tried very hard to be something of an office wife, protective and nurturing. She tried to vet his visitors, and was charged with writing letters on Mr Eliot's behalf when he was travelling or ill. Long before Eliot paid her any personal attention, he described her as 'efficient'. Others have talked and written of her devotion, her worship of the famous poet. Everyone seemed to consider him a figure worthy of admiration, even adulation, but they found Valerie's devotion rather comical. She was overly officious, and did not make friends with the other secretaries. She had coffee waiting for him, was always willing to stay late, and in every way she tended to his comfort and ease – a perfect office wife.

She understood, better than the other secretaries who aspired to more literary accomplishments, what it meant to protect a man's time, to ensure that he never had to hunt for something, to anticipate his needs. In later years, however, Valerie was haunted by the story of 'Tom and Viv' – Tom Eliot and Vivienne Haigh-Wood, his first wife. She was acutely aware that Vivienne had not come into his life as a typist: she acted, she wrote and she was actually one of her husband's collaborators, as discussed in Arwa

Al-Mubaddel's Chapter 14. Eliot had had Vivienne edit his poems, and tried very hard to get her writing published.

There was an equality there that certainly was not part of his relationship with Valerie. But she considered this something in her favour and told me a story about a time when Eliot had been making fun of a pretentious woman scholar who had 'majored in irony'. 'I told him that I majored in ironing,' quipped Valerie. She wanted it understood that she was proud and content to have been a wife, not a scholar, and that her husband had valued her for her wifely nurturing. But she was exaggerating her domesticity: the young Valerie Fletcher showed no inclination to be merely a housewife. Her secretarial skills were a means to an end, that of finding herself a literary man and being part of the literary world, and her wifely devotion and self-effacement is what gained her the life she wanted.

Her passionate interest in T. S. Eliot and his poetry, according to the story Valerie told in later years, became central to her life and her goals. In 1946, she took the train to London to hear Eliot read at an event at the Wigmore Hall. Also on the programme were John Gielgud, Louis MacNeice, Walter de la Mare, Edith Sitwell and Dylan Thomas (whom Valerie later claimed to have known). She persuaded her parents to let her move to London and apparently wrote to Eliot's firm, the publishing company Faber & Faber, asking if there were any openings for a typist. There were none, but she worked as a secretary for other writers, one of them the novelist Charles Morgan, while living in various bedsits in west London. Those were difficult times in England, with food rationing and limited electricity, but she persisted, even without having a steady, long-term job. There is no indication that she had boyfriends, or close women friends.

In 1949, four years after she had left school, a family friend who knew Eliot let Valerie know that Eliot was looking for a new secretary. She got the job, sharing an office with three other secretaries. The girl from Yorkshire became a faithful amanuensis to the great poet, whose estranged first wife had died in 1947. She seems to have been a happy handmaiden. Her devotion to Eliot was well known at the firm, and the other girls teased her about the way she worked late and always changed into high heels when she went to take dictation. He travelled, often worked from home and was ill a lot. Even when he went to the office, he was a remote, bleak figure. A woman who worked at Faber told me he would turn, pressing himself into the wall, when you walked past in the corridor. Another mentioned how startled she had been when he had greeted her by name one afternoon and said, 'Happy Christmas'.

For seven years, Valerie took the elevator to the top floor of 24 Russell Square, managing Eliot's correspondence and keeping track of his work as a publisher and editor. She got to know his friends; some, male and female, did not like her, but some evidently did because one of them, the story goes, decided to play matchmaker and invited Eliot and his young secretary to stay at her house in the south of France. It is not clear that this ever happened,

but they were certainly brought together. The official narrative is that in November 1956, eight years after Valerie began working at Faber, when she was thirty and he was sixty-eight, the famous poet proposed – by slipping a letter to her into a pile of typing. He claimed he did not even know if she knew his first name when he proposed. Her years of devoted typing were rewarded, in Cinderella fashion, with jewels and silver, evening gowns, a romance for the ages, a lifetime of devotion.

The truth is more complicated.

When I think of Valerie, I think of the years passing. She spent nearly eight years as a secretary at Faber, secretly (or not so secretly) in love with her boss, like the biblical Jacob, toiling and waiting seven years for Rachel to become his wife. She would have had time on her hands when TSE was not there, or was travelling for months. There are surviving letters, typed on Faber & Faber paper, giving glimpses of her working life. She says she took on proofreading for another firm to supplement her low salary, but I have found no trace of her doing more skilled work at Faber – a little proofreading perhaps, or writing comments on book proposals. That was the usual way for a secretary to move up. She does not seem to have attempted this, but it is unclear if it is because no one thought she could do more or because she doubted herself and did not offer. Most of the Faber secretaries had university degrees. Valerie had only a School Certificate, the equivalent of O levels. She would talk about Oxford, which gave some people the impression that she had studied or had a boyfriend there. Her anxiety about her background may be why she never made close friends in the office.

Valerie was an old maid by her parents' reckoning when Eliot proposed, staying in the office longer than anyone else I have been able to trace. Every former secretary I have interviewed made it clear that she longed to get out of the typing pool. Most married after a few years; others pursued other interests, travelled, then married. Anne Ridler became a published poet. Rosemary Goad, who started after Valerie, eventually became a director of the company.

But Valerie – determined, implacable – waited, and typed.

In the end, the patient Cinderella got her reward. And once she was engaged, it was her job to hire and train her replacement. One of the women who worked for 'Tom and Val' told me that Valerie continued to act as a 'private secretary' to Tom, even when he had another secretary hired by Faber & Faber. It was only then that there was talk of her 'editing', always with reference to the possible future publication of his letters. Valerie's devotion was expressed after their marriage not in typing but in other ways. This may reflect the fact that she now saw herself as above that role, but it was also because he was not writing as much, and he never turned to her for advice, or editing, as he had with Vivienne. After his death in 1965, the editing of the T. S. Eliot letters became Valerie's official life's work, interrupted in 1969 by the discovery of the original manuscript of *The Waste Land*, and in the early 1980s by the creation of *Cats* by Andrew Lloyd Webber, a record-

setting musical based on a book of poems for children by T. S. Eliot (Weber 2012).

Over twenty years passed. Valerie was still working on the letters, but nothing had been published and she was becoming known as an impossibly difficult, obstructive guardian of the flame. The centenary of Eliot's birth was approaching, in September 1988, and Faber & Faber were determined to bring out at least one volume of the proposed five volumes of letters. That is why I was hired in 1986 – to work in Valerie's flat, helping to deal with academic enquiries and transcribe and annotate the letters. I had just turned twenty-nine, and had a one-year-old son and a partner who was studying to be an osteopath. I needed a second part-time job and spotted an ad in *The Times*. Faber invited me for an interview and Mrs Eliot hired me on the spot. I was a top-notch typist, with UK secretarial qualifications I'd got as the 'back-up', common in the 1980s, experience in a publishing company, and knew how to use WordStar, one of the primitive word-processing programmes of the day. I also had an English degree, but that did not matter nearly as much as the fact that my son was named Tom and I shared T. S. Eliot's birthday. I was amused to read about Eunice Frost coming to the interview at Penguin 'dressed for Ascot', because I suspect Valerie also liked the way I dressed for the interview. I later learned that she had hired a secretary many years earlier who also wore too-bright and inappropriate clothes to the interview and, like me, shared TSE's birthday.

There was a good deal of routine correspondence with academics, mostly American academics whom she particularly disliked. My impression was that Valerie was perfectly capable of typing her own letters but felt it was beneath her dignity. She would show me the letters she was responding to, letting me read them through, and then she would dictate her replies as we sat in armchairs in the sitting room.

She liked to discuss the phrasing, especially those to academics asking for something. She would often make changes. I would retype some letters three or even four times on a typewriter that sat on a desk behind the word-processing station. After a while, I figured out how to feed her small sheets of stationery into the word-processor's printer (everything was huge and clunky in those days), and then I would not have to retype the whole letter but make the changes and print it afresh. We went through a lot of expensive notepaper.

The rest of the time, we worked on the letters for publication. I would transcribe the originals, handwritten and typewritten, between Eliot and his friends and family. The work of transcription was precise and voluminous, and you can imagine how grateful I was that he had typed many of his letters (we had the carbon copies). TSE learned to use a typewriter very early, and even typed his poems.

Soon after the manuscript for that centennial volume of T. S. Eliot letters was delivered, I left to work on a book of my own, with no intention of spending my life in a literary archive. The first volume of the Eliot letters was

published on time, 26 September 1988, but no further volume appeared for
almost 20 years. This was especially strange because the typescript Valerie
and I delivered was twice as long as the text that appeared in the published
book, meaning that there had been a second volume of text ready in 1988.
There were occasional grumblings in the press about this delay. What
was Valerie Eliot hiding? After answering this question for years, I wrote
a memoir about working with her for the *Guardian Review* (Christensen
2005). Soon after that, Faber announced that a new editor, Hugh Haughton,
had been chosen to work on the letters with Valerie (Carey 2009).

I met Haughton through a mutual friend. He told me that he had started
over entirely, that there was no trace of the typing I had done, all those
hundreds of files saved in the big Wang word-processor. My feeling had
been that Valerie was afraid of being criticized for not being scholarly or
intellectual enough. And she was only sixty, with many years ahead of her.
If she had worked quickly and published all the letters we had then, what
would she have done with the rest of her life? But she couldn't admit either
of those fears, so she created other excuses for delay, the most irritating one
being that we did not know what had happened to a man called Scofield
Thayer.

Thayer had been a classmate of Eliot's at Milton Academy and Harvard;
they were in the same circle in Oxford in the early years of the First World
War, and Thayer was briefly engaged to Eliot's first wife, Vivienne Haigh-
Wood. He was a wealthy manufacturer's son from Worcester, Massachusetts,
and became the owner of *The Dial* in 1918. There were some letters between
him and Eliot which were going into the volume we were working on, but
Valerie became obsessed about whether there might be more and what had
happened to Thayer when *The Dial* closed in 1929. For weeks, when we
were under pressure from Faber & Faber, she used this as a reason that we
would not be able to finish the volume for the centenary. It seemed ridiculous
to me and I came to hate the name Scofield Thayer.

Yet it was Thayer who led me to Sophia Wittenberg Mumford, my second
typist: the seventeen-year-old Sophia Wittenberg was the only employee kept
on after *The Dial* changed ownership in 1918. (Thayer, incidentally, hired
several women as the editor of his magazine, the last of whom was the poet
Marianne Moore; the ambiguity of those women's executive roles provides
a counterpoint to the more conventional stories of Sophia and Valerie, the
two typists who became keepers of the flame.) From the biography of Lewis
Mumford (Miller 1989) I learned that Mumford had met his wife at *The
Dial*, and had been jealous of her relationship with one of the owners, an art
collector named Scofield Thayer. Sophia Mumford was still alive and lived
not far from where I had settled. I wrote to her, saying I would love to hear
about *The Dial* and Thayer. We met, and became close friends in spite of our
sixty-year difference in age. During the year or so before she died, at 97, we
were working on a book about her life. Some of the details in this chapter
are drawn from our weekly conversations.

Sophia was hired at *The Dial* as a transcriptionist (Christensen 2016). She was hired at *The Dial*, she said, when they learned she lived at home and was not, in spite of appearances, a 'Village girl'. When *The Dial* changed hands in 1919, evolving from a political to a literary journal, she was the only person kept on, keeping the place running.

She referred to her beloved bosses as 'the pampered darlings': they were wealthy Harvard men, and the other people hired were generally college educated and from comfortably off families, unlike hers, an immigrant Brooklyn family. Alyse Gregory, for example, had gone to Europe to study music after going to college; Marianne Moore was a librarian. Sophia, however poorly educated, was very capable, and would have been a great asset. The only thing that could have been held against her was her beauty. (She was forced out of her first job when the owner's wife read Sophie's palm and said that she should find other employment.)

The owners of the new 'literary' *Dial* were Scofield Thayer and Sibley Watson, and they seem to have spent a lot of time trying to persuade women to serve as editors, which I suspect was a rather glorified title. I have not found out whether these editors, who were educated women and writers, typed their own letters, as Sophia certainly did, or who actually did the transcription. What is clear is that they gave the women proper professional titles and credit in the magazine. Notices in the May 1925 issue, for example, announced the resignation of Sophia Wittenberg and appointment of Ellen Thayer as assistant editor. In the next issue, we read about Alyse Gregory's resignation and the appointment of Marianne Moore as acting editor. (Thayer himself, who suffered from mental illness, left soon after and never returned. The magazine closed in 1929. The mystery of what happened to him was solved only in 2010, with a biography appearing soon after (Dempsey 2014).)

Sophia Wittenberg was, like Valerie, somewhat out of place in her workplace, but she was no loner. She had poise, beauty and a sense of fun that drew people to her. She would argue with Scofield Thayer and then go to tea at his apartment, under the attentive eye of his Japanese manservant. She seems to have been the one who kept the magazine to schedule, and she was a meticulous proofreader in spite of her lack of education.

What role did she play in Lewis Mumford's work? Her obituary in the *New York Times* says:

> At her death [Sophia Mumford] was writing a book on her life and the work she undertook with her husband, who died in 1990.
>
> After her marriage in 1922, Mrs. Mumford gave up a budding career as an editor of the literary periodical *The Dial* to help further her husband's literary and academic aspirations.
>
> While running a household and raising two children, she served as a sounding board and occasional editor and adviser to a man who took neither advice nor editing easily.

As Lewis Mumford grew more reclusive in old age, her tasks as an editor grew. (Saxon 1997)

That is another myth – that any wife who types is also a quasi-editor. Her role was to create the domestic utopia he required to do his creative work. Like 'Fitzi' in Chapter 1, and secretaries in general, she was to use her empathy and attention to enable him to do his work. What came to matter to Sophia was that he needed her. She repeatedly told the story of how he once said to her as they ate lunch: 'No one knows how much you have inspired my work.'

Admittedly, Sophie was self-effacing, silent in company because everyone was so much better educated than she. She had no fear of arguing with him, but when it came to his writing – and to typing – she recognized him as the creative force, the thinker. Donald Miller, his biographer, wrote to me that 'Lewis typed his first drafts, working from copious hand written and typed notes. He worked at a small typewriter in his monk-like cell at Leedsville. Sophia read and critiqued his work but usually only when it was nearing completion. He shared his work in progress with almost no one. Sophia typed the final drafts.' But I would hardly call her commentary a critique of his work as he accepted no critique. Only when he was very old, and beginning to show signs of dementia, did she try to influence his work. Notably, she argued that he should finish his last book, a memoir, with the last chapter he had finished, just call it quits there. And he did.

But she defended him to the end. Here is a passage from a letter to the editors (19 May 1981) of that last book:

[Lewis and I] are exhausted by the unnecessary effort of checking every page carefully to see if there were reason for your endless queries. We are both at the end of our patience, and upset that so much of Lewis's time should have been so needlessly wasted.

When I next send in more material it will be as Lewis wishes it to appear, and the only queries to be made are those listed before. We both of us will give it a final reading before sending it in and then it will be ready for the printer.

Sophia had to cope with Lewis's need for other women at certain points in their seventy-year marriage, and she drew comfort from thinking about the ways in which he had needed her, as her letter to Donald Miller on 10 November 1995 attests:

The first thing that comes to mind is that of all the functions I might have filled as Lewis's wife, that of researcher is out. Lewis never had anyone do research for him. I did read his manuscripts as he went along, and of course I did proofread and index and do the mechanical jobs – during the latter part of his working life I also clean typed his manuscripts –

sometimes doing chapters over three to five times. But never did I change or alter any part of his work by myself. I might suggest an alteration, or perhaps supply a word I thought more apt – but the decision was his and his alone.

Lucky for Lewis I had good training at *The Dial*, for it was the pride of its editors that no word was changed without the author's consent – and that most rarely.

My greatest contribution was to be there. Lewis would come out of his study at intervals to read aloud a section of what he was working on, sometimes for my criticism, but more often to use me as a sounding board. Reading it aloud made it come clear and he could better judge if he had said what he meant to. That was important to him, and it was a frequent practice, which he kept up until he stopped writing. There was one crucial occasion in 1941 when I proposed to take on a full-time job with a new experimental public school (volunteer) and when I came back in late afternoon after a day's discussion of the project. Lewis was so disconsolate to have been left all alone all day long that I decided against undertaking the work. He needed to feel I was there to be relaxed (also to answer the phone and keep him from interruption). Since he never had a secretary or a researcher to underwrite him or help him, I felt it was legitimate that I should be on hand for those moments when he needed another personality around him.

Lewis claimed that it was Sophia's lack of ambition that was responsible for the way she was subsumed by him, but in early days, before they married, he had shown great awareness of the fact that women's talents were often hidden:

> How long are women going to stand for that sort of thing, I wonder? How long will they be content to remain the butt of a biological joke? And how far is that sort of sacrifice biologically justified? I wonder . . . I left Mrs. Kendall and went home in the bus along Riverside Drive [. . .] and I thought of all the patient, talented women who had hidden their fame under a bushel in order that their husband's light might shine the more brilliantly – there were Jane Carlyle and Lucy Wordsworth for example – and the thought of all these thorny sacrifices made me sad, and I prayed that my masculine conceit might never stay with me long enough to permit me to let such a wrong occur to any woman that I loved. God forbid that any of us should be so wretchedly vain as to add another act to the tragedy of *When We Dead Awaken*. (Lewis Mumford, Letter to Sophia Wittenberg, 5 January 1920)

Those noble ideas seem not to have applied to his own life, nor his own wife, and it is not clear that he ever sent the letter to Sophia. But Sophia always defended Lewis, however self-absorbed he might seem to us. She

said it was her choice to give up work and devote herself to making a home conducive to his writing and thinking. But after Lewis's death in 1990, she began to do a new reckoning, and to entertain the possibility that she might have underrated herself. Here are a few passages from a letter written to her in January 1992 by Ruth Hubbard (1924–2016), a professor of biology at Harvard University – the first woman to hold a tenured professorship position in biology.

I have liked you a great deal ever since we met and, of course, have wondered what it must have been like for a bright and talented and emotional woman like yourself to live not so much in the shadow of Lewis as by his needs and principles, all the while recognizing the importance of his work, but experiencing the ways his needs must have cramped you and kept you not just from experiencing, but probably even from acknowledging, your own.

I don't want to presume to know about your life and perhaps even the sentence I just wrote did too much of that. But I was impelled by your comments that Lewis suggested that you were 'a lazy thinker' and that you 'lacked ambition'. My immediate reaction to that – and please realize that I am not 'knocking' Lewis, whom I began admiring in my early twenties, some twenty years before I met the two of you, and whom I have admired ever since – So again, my reaction to that is (a) that Lewis has unusually high standards of what constitutes 'diligent', or perhaps better, 'thorough' thinking. But (b), and to me more importantly, Lewis needed your ambition and thoughts, as well as his own, in order to become the Lewis Mumford the world knows. There is no doubt in my mind that Lewis would not have been as productive and creative as he was if you had insisted on creating your own productions. And, given the time and place and lack of broad-based support, it would have taken super-human strength, talent, and self-centeredness on your part for you to have told Lewis – in word or action – that, much as you love him, you had more important things to do with your life than to make his creativity possible.

You put yourself down even vis-à-vis me. Just think what you must have done vis-à-vis Lewis. Yet, to go out and 'do your own thing' you would have had to believe that, whatever your contributions would look like compared to his, you had the right to bring them forth, and he had the duty to respect that.

It's easy for me to write those words now, if for no other reason than that I happened to be born a dozen or so years after you [Hubbard was in fact twenty-five years younger than Sophia], which meant that such words and thoughts came my way when I was in my forties, not nearing sixty. It's also made easier because I watched my mother let her life be absorbed into my father's, even though she was a trained musician, music teacher, and physician at the point at which they married. My reaction to watching her was 'never!' And yet, after George [Wald, Hubbard's

husband] became a 'great man', first with the Nobel Prize in '67 and then with his MIT speech in '69, I saw myself slipping into the 'wife' I was expected to be – caretaker, social mediator, political and professional ally, etc. I have little doubt that had it been 1959, instead of 1969, I would have done just that. As it was, women's liberation rhetoric, books, and activities were swirling around my head and under my feet and a few decent jobs were opening up for me and my kind. Without all of that, I would not be sitting at my computer, thinking of myself as a writer and retired professor. I would be shaking test tubes in my husband's laboratory, putting myself down, and angry at my failings instead of at the situation that set me up to fail.

I hope you don't mind the outburst and that it will make it even more urgent for you to tell me how you see your life, our lives, and the world.

Sophia's response was to thank Hubbard for the praise but to argue that she was being misunderstood. She admits to being defensive about people's seeing her as overwhelmed by Lewis, saying that she always stuck to her own principles and followed his only when she was truly in agreement. She insisted that she had not been ambitious – that is, she would not have done something truly significant on her own. Nonetheless, that correspondence a year before I went to meet her seems to have sparked the late-life reassessment that blossomed after she had me to talk to.

Both Sophia and Valerie wanted roles in their husbands' working lives, and in ensuring their reputation and legacy. The saddest thing is that Valerie never seems to have gained the confidence to fulfil her mission of editing the letters. She was terrified of writing, too, and I had to ghost-author the one article she ever published.

Sophia was ninety years old when her husband died. We met a few years later, and for four years were close friends. At some point, the way she was trying to understand her own history led to our collaborating on plans for a book about her life. I bit my tongue when she said, 'I would never want a feminist to write my biography.' She startled me only a few weeks before she died in 1997 by referring to herself as a feminist, something that had obviously become clear during our work together. When she quite suddenly became ill and died, peacefully and at home, I gave up work on the book, thinking I could not finish it without her. It was nearly twenty years later that I saw how her story and Valerie's reflected each other's, and how together their stories elucidate the dilemmas that face women known only as the wives of famous men.

In the course of my research, I have interviewed friends and colleagues of both women – people now in their late 80s or 90s – and come to see that their insecurities combined with considerable ambition led to the paths they took in life. I discovered, too, how very important the book we had planned was to Sophia, especially when in 2018 I went to see a play in which 'Sophia Mumford' is the central character. It was written by a playwright

who interviewed Sophia just months before she died and is a staged reading with five very old women characters.

I cried when I read these lines:

SOPHIA: 'After Lewis died, all I wanted to do was die, too. Now I want to live.'
ANNA: 'You will pardon me if I ask why?'
SOPHIA: 'I'm writing a book, that's why.'
ANNA: 'A book? But you never wanted to be a writer.'
SOPHIA: 'My own book. That's what kind.'

Her book. Her story. Her emotions. Her way of seeing the world. Her words.

All too often women did not find, or record, their stories in their own words. Sophia wanted to do just that. But she was ninety-five by the time we began to talk about a book, and there wasn't time. She did not have the strength.

That is why it is our job to listen, to read and study, open our hearts and imaginations, to hear our foremothers' stories and give them a platform. We can let the world hear their voices.

Bibliography

Carey, John, Review: 'The Letters of TS Eliot: Volume 1: 1898–1922/Volume 2: 1923–1925', *The Sunday Times*, 8 November 2009.

Christensen, Karen, 'Dear Mrs. Eliot . . .', *The Guardian Review*, 28 January 2005.

Christensen, Karen, 'Sophia Mumford Talks about Working at The Dial in the 1920s', Berkshire Bookworld, 27 June 2016; https://www.berkshirepublishin g.com/2016/06/17/sophia-mumford-talks-about-working-at-the-dial-in-the -1920s

Dempsey, James, *The Tortured Life of Scofield Thayer*. Gainesville: University Press of Florida, 2014.

Logan, Suzanne, 'Knowing Women,' directed by Kathleen Isbell, Actors Studio, Newburyport, Massachusetts, 9 March 2018.

Miller, Donald, *Lewis Mumford: A Life*. New York: Grove Press, 1989.

Saxon, Wolfgang, 'Sophia Mumford, 97, Editor and Wife of the Social Historian', *The New York Times*, 2 May 1997.

Sophia Wittenberg Mumford papers MS Coll. 958; Lewis Mumford papers MS Coll. 2, University of Pennsylvania.

Weber, Bruce, 'Valerie Eliot, Poet's Wife and Defender, Dies at 86', *New York Times*, 12 November 2012.

4

Thanks for Penguin

Women, Invisible Labour and Publishing in the Mid-Twentieth Century

Rebecca E. Lyons

Women have played a fundamental role in the evolving story of Penguin – from its inception as a glimmer of an idea in founder Allen Lane's imagination, said to have been prompted during a 1932 visit to his friend, the crime writer Agatha Christie (Lloyd Jones and Aynsley 1985, 13) – through to its current status as the global conglomerate Penguin Random House, publishing '70,000 digital and 15,000 print titles annually' headed by CEO Madeline McIntosh (Penguin Random House Website). Women's involvement in this publishing success story, however, has not always been either clearly visible or fully acknowledged. As has been clearly demonstrated by many of the other chapters in this collection, women's labour has historically been obscured from the record for a number of reasons. Using case studies, this chapter, based on documentary research undertaken in the Penguin Archive in the University of Bristol's Special Collections, will consider some of the reasons for this obscurity in the specific context of Penguin in the middle decades of the twentieth century, and aims to unearth and highlight examples of women's labour during Penguin's formative decades from the 1930s to the 1960s, including in their roles as PAs, editors, translators, secretaries, wives and the countless administrators whose efforts kept the business running on

a daily basis. This chapter celebrates their contribution, and puts forward an alternative picture of the labour behind some of the most iconic paperbacks of the twentieth century, suggesting that the names on the front covers are not the only ones that should be remembered; others also contributed to the success of one of the most iconic publishing houses of the last century.

Eunice Frost (1914–1998)

This chapter must begin and end with Eunice Frost. It is on the extensive 'Frost Files' in the Penguin Archives that most of the research herein has been based – seventy-three boxes of documents spanning around fifty years. Frost's retention of documentary materials throughout her life represents a treasure to the researcher, and the insights into Penguin in this chapter are almost entirely filtered through her experiences and the files that she gathered in her years spent working at the publishing house, and continued to accrue after she had retired. She is perhaps the first and greatest heroine of Penguin. An indicator of her pivotal position in the company's history is the wonderful piece of trivia that 'Frostie', the sobriquet of the iconic Penguin logo, was taken from Eunice's own office nickname. Her role and status at Penguin has been documented in newspaper articles (Wood 2018; 'Obituary' 1998) and in Penguin's own self-reflective publications (Lloyd Jones and Aynsley 1985; Hare 1995), but in this chapter I specifically consider some of the less visible – albeit no less pivotal – aspects of Eunice's and other women's labour for Penguin as evidenced in the Penguin Archives.

Microaggressions, the 'Gender Tax' and Blurred Boundaries

The middle decades of the twentieth century are a particularly rich moment in which to investigate the labour of women, as it saw events and changes on a global scale that had profound impacts on the ways in which women engaged in work activities. 'Both World Wars had lasting social and economic effects on young women's lives', as women stepped into roles left vacant by men serving in the armed forces, and there was an increasing 'centrality of paid work' for these young women (Todd 2005, 6–7). Directly in the centre of this period of change, Eunice arrived for an interview at Penguin for what was probably an administrative or secretarial role sometime in the first five years of its operations in the late 1930s, 'dressed as if for Ascot', wearing a huge cartwheel hat (Morpurgo 1979, 126). Penguin Director Allen Lane saw something in this remarkable woman in her early twenties, and eventually cultivated her as his right-hand person. She went on to rise through the ranks at Penguin to become an editor, and eventually the first female director of the publishing house. In his study of Penguin, Steve Hare

highlights that when Frost first joined the house, the times were challenging for women: 'the publishing world at the time was exclusive and clubbish. Penguin Books were just barely accepted: women were a different matter altogether' (Hare 1995, 32). Some of these challenges become evident in the Penguin Archives, with the documents hinting at the invisible labour required to operate in a milieu filled with sexist microaggressions, which Chester Pierce defines as 'the subtle, stunning, and unconscious put-downs of those in inferior status [. . .] by the group of superior status' (Pierce et al. 1978, as quoted in Lau and Williams 2010, 313). For example, meetings between editors, authors, translators and other associates often took place in relaxed settings – often over a drink – which in and of itself may have precluded some women who may have either felt uncomfortable or improper meeting (often male) professional associates unaccompanied in this manner. This way of working could also create other microaggressions towards women. In the documentary record an author, Alan Steele, invites Frost to meet him at the type of club habitually frequented by gentlemen in London, stating that 'Naturally ladies are not allowed in the main part of the Club, so there is a small private entrance marked "Ladies Entrance", a few yards up the alley-way' (quoted in Hare 1995, 33). Although this is framed by the author as being 'natural', it suggests some of the additional labour required by women to overcome everyday instances of microaggression in their occupational experience. A 'bedfellow' comment to Miss Hytti, reported in Anu Lahtinen's Chapter 2, can serve as another instance of such sexist microaggression, disguised as an awkward joke.

As well as introducing microaggressions, the ways of working mentioned earlier also indicate the blurred nature of the boundaries between work and personal life that impacted on both men and women at Penguin and other publishing houses during this period, creating other forms of invisible labour. A whole oeuvre of work was literally invisible to colleagues, undertaken outside of the office space – in the public or domestic spheres. For Eunice, this invisible labour takes on a peculiarly gendered self-identification, as she refers to herself as a 'literary midwife':

> How did I become a literary midwife? Because there was no one else to hold the baby at the time. Somehow I was expected to take on all kinds of reading, negotiating with authors, agents and publishers in addition to general office administration. I remember that in my very first week, instead of being told what to do, I was expected to do the extraordinary. Allen said 'do you like reading?' and pushed a whole pile of books across his desk. And that's how I learned you had to carry the baby home with you every night. (The Penguin Collector 41, 1993, quoted in Hare 1995, 32)

In contrast to the solitary, isolated, introverted and invisible labour of taking the figurative baby home each night, or the stealthy entering

of gentlemen's establishments using side entrances, there is a sense of extroverted performativity and masculine camaraderie in the files with regard to some of the work undertaken outside of the office by some of Penguin's male employees. A letter from eminent medievalist Derek Brewer to Penguin Editor James Cochrane on 3 July 1966 hints at this: 'Do come and see me in Cambridge when you are here, whether professionally, or for an unprofessional drink.' Cochrane replies on 7 July 1966: 'The question about annotation and glossing I cannot answer until I have had a closer look at the text. Probably these are questions that can be discussed over a drink in Cambridge some time fairly soon.' On 23 September 1966 Cochrane and Brewer arrange to meet each other again in Cambridge – Brewer says he can offer Cochrane a sherry 'if you drink the stuff!' (*The Faerie Queene* editorial file). Evidently both men and women undertook work outside of the office space; however, the nature of this work possibly made women's work less visible (although that is not to say that male colleagues were not also taking 'the baby' home, too).

Additionally, it seems from the documentary record that Eunice was subject to what a line manager once referred to in conversation with me as the 'approachability tax', but we could equally call it the 'gender tax': a phenomenon whereby women are burdened with extra workplace responsibilities requiring the so-called soft skills of communication and emotional intelligence traditionally attributed to women. By the time she had worked her way up through the ranks to become editor and then director, Eunice's responsibilities at Penguin were formidable. The files indicate that they included reading all potential new titles and providing comments on them – suggesting that she was an important gatekeeper, as well as having a significant amount of power and influence over Penguin's acquisitions and future directions. She also travelled and networked extensively and internationally; sourced new agreements with publishers and authors; attended general editors' boards and other meetings; supervised sales figures; line-managed staff; had some responsibility for internal finance and HR issues, and probably much more. There is evidence that, in addition to the phenomenal breadth and volume of this work, Eunice was also subjected to extra duties allocated on the basis of gender. On 27 November 1953, a memo was passed from the other (male) directors at Penguin to Eunice concerning the 'shameful state' of the ladies' toilets, signed by all of the sixty or so female employees at Penguin (Frost Papers, DM1843/1). This letter comes with an attached note from the directors, stating: 'We are sending the attached memo to you *for obvious reasons*, [emphasis mine] but could you please pass it on to whomever you feel should deal with it?' The implied 'obvious reasons' to pass this complaint to Eunice presumably include her gender, but perhaps also hint at a perception about women's skills. In a study of soft skills and polarization in the workplace, Grugulis and Vincent (2009) found that, even in the twenty-first century, that: 'while traditionally "feminine" skills were more widely acknowledged' in workplaces, 'this recognition failed to benefit

the women who exercised them and, in some cases, was used as a justification to confine them to tasks well below their (technical) competence' (598), perhaps in precisely the kind of ways that this memo hints at.

Furthermore, the lack of a clearly defined job description for Eunice's role – 'instead of being told what to do, I was expected to do the extraordinary' – was arguably a double-edged sword, enabling Eunice to gain rich and varied experience, but also justifying a great deal of overwork, despite suffering from recurring bouts of a severe bronchial illness. Letters from colleagues during her incapacitation indicate clearly how 'overburdened' with work Eunice habitually was, such as this one from W. E. (Bill) Williams:

> My dear Frostie,
> I am terribly sorry to hear you've been smitten down – half an hour or so, it seems, after you were bandying words with me on the phone the other day. Yet, ill as you are, I'm terribly glad that they [the doctors] got their hooks into you in time. I'm glad, too, that – once the pain and the dejection are over – you'll be compelled to lie in bed and rest instead of carrying Penguins on your resolute and overburdened shoulders.
> A. L. [Allen Lane] is very sorry for you – yes, for you and not for himself! And your colleagues seem to have been impressing him with the fact that you've been overworking for years at Harmondsworth.
>
> (Excerpt from a letter from W. E. (Bill) Williams, dated 31 January 1941, and addressed to Eunice at the King Edward VII Hospital, Windsor, DM1843/8, Frost Files)

This jovial tone with regard to 'impressing' her male colleagues by 'overworking for years' suggests a strong friendship between the letter's author and Eunice, but also begs the question: if everyone at Penguin was aware of Eunice's overworked state, as this letter suggests – a state, furthermore, which had persisted 'for years' – then why had this not been addressed, and her workload alleviated? Although Eunice may have been a willing participant, this exploitation was frequently detrimental to her health, and even when in recovery from illness, it seems that Eunice was unable to escape work matters entirely. On 24 November 1952 – a year before the toilet memo – in a letter to Frost, Allen Lane expresses extreme concern about her state of health. Lane suggests that she take some time away from the office to go into hospital 'for an overhaul'. He proposes that, from the New Year, she should organize a way to work from home. On the face of it, this seems like an incredibly supportive gesture; however, there seems to be a pattern in the archival material where Eunice periodically works herself into a state of illness, then takes some time away to recover, but during this recuperation period letters from Lane and other colleagues continue to arrive, discussing work matters and asking for her advice. An earlier letter from Allen Lane aboard Cunard White Star RMS *Queen Mary*, to Eunice, who was on a retreat for her health in Switzerland dated 3 May

1949, begins by detailing the sleeping and relaxing he has undertaken while on the cruise, before bringing up work matters:

> I've been thinking a good deal about you [. . .]. There is no denying that you & I bear the bulk of the responsibility for the running of the firm & we mustn't do anything which would jeopardise our fitness to carry on the work. By this I mean take on too many things involving a control of detail by us to the detriment of policy-making & indeed of our own health & nerves.

After this, he goes on to discuss the editorial committee: 'The experiment I made of handing over a certain amount of responsibility to a committee of the staff has not been a success largely owing to the fact that its two strongest members, yourself and A.J.P. have not been at meetings of late.' Full of contradictions, this letter urges Eunice to strike for a better work-life balance, yet also seems rather pointed at times, and may have (unintentionally or otherwise) prompted some guilt on her part regarding the lack of success of the committee mentioned, supposedly due to her absence, or at her own overworked state jeopardizing her 'fitness to carry on the work'. This is a poignant example of further invisible labour on Eunice's part, and a lack of distinct boundaries between work and personal time – even at the expense of her health.

Wives, Secretaries and Administrators

Eunice was far from the only woman at Penguin – as we know from the aforementioned toilet memo, at least sixty female employees at the company were using the ladies' loos in 1953. Her files, along with others in the Penguin Archives, reveal a host of other women both at the publishing house and on its peripheries that contributed to the success of the company with their own invisible labour, including wives, secretaries and administrators. In the editorial file for Edmund Spenser's *The Faerie Queene*, which was published as a modern edition under the Penguin Classics imprint in 1978, there is further correspondence between eminent medievalist Derek Brewer (who was originally contracted to undertake this edition) and Penguin editor James Cochrane. In the event, it was not Brewer, but another scholar – Thomas Roche Jr – who eventually undertook and completed this edition, a detail that is relevant to this chapter for the light that the correspondence shines on the invisible labour of secretaries and wives. On 7 July 1966, Brewer asks Cochrane for around £100 of secretarial expenses, stating that these are for the typing of *The Faerie Queene* project. On 15 July, Cochrane replies hinting that it would be preferable to avoid typing fees altogether if possible. It is unclear from his response whether he is suggesting that Brewer should use unpaid secretarial labour, or undertake his own typing of the mammoth work.

Then, the crux: on 23 October 1967, Brewer admits to Cochrane that he has underestimated the time necessary for secretarial work for the project: 'Dear Mr Cochrane, I have a most embarrassing letter to write, about *The Faerie Queene*. It is now clear that I have hopelessly misjudged my whole time-table this year, and also that of my secretarial assistant.' And then, on 10 January 1968: 'with infinite regret, I must definitely withdraw. I could get no sufficiently reliable help [. . .] everything seems to take three times longer than one expects.' It seems that Brewer is referring to secretarial work in this letter, acknowledging its value – as well as his underestimation of it. In the academic community of the 1960s, where secretaries were still frequently used to type scholars' work, even this academic claims that there is some degree of esoteric obscurity, a lack of understanding – an invisibility – surrounding this type of work. As other chapters in this volume have also highlighted, it is important to draw attention to the (usually) female-gendered nature of secretarial work in the 1960s, but also the ways in which secretaries often played a much more significant role than merely typing. The reason that we do not have a Derek Brewer edition of *The Faerie Queene* seems to be due to the misunderstood, underestimated and under-budgeted value of this invisible, yet crucial, 'women's' work.

As Bruce Holsinger exposed so powerfully in the series of tweets in 2017 that prompted this volume, there was another hugely important, yet also largely invisible (and unpaid) female workforce supporting the work of academic scholars whose names were on the front of monographs, editions and translations – including Penguin's – in the twentieth century: their wives (Forestal and Philips 2018). Such invisible labour is also evidenced in *The Faerie Queene* editorial files. Like Brewer, Thomas Roche Jr also seems to underestimate the importance of women's efforts with regard to completing this work. Roche Jr writes to Cochrane on 8 April 1977:

> There is one small crisis. When Lyn learned that she was not even to be mentioned, there was a minor household crisis. It was not that she wanted the usual wifely credit (which she despises) but that she wanted her professional talents in print since she has in fact done more work than Patrick O'Donnell [Roche Jr's co-editor]. I have inserted a very short paragraph of acknowledgements to be inserted at the end of the note on the text and must insist that it be inserted.

Roche proceeds to request that the following note is included in his acknowledgements:

> My wife, Lyn Vamvakis Roche, has counselled often with rigorous insistence; her knowledge of literature and language has kept us from fatuities, grammatical lapses and errors too embarrassing to enumerate. To say more would be a further embarrassment to me and a diminishing of her real and unacknowledged contribution to this edition.

Here we see that the final acknowledgement published in the book does not equal the level of assistance afforded to Roche Jr by his wife, by his own admission. These two, necessarily brief examples of a secretary and a wife, hint at the broader significant contribution that women outside of the official pay structures and working spaces of Penguin's offices made to the success of the publishing house

> even if the precise extent of this often invisible labour is probably impossible to gauge accurately due to the uneven nature of its representation in the archival material. The labour of wives and secretaries was clearly vital to ensuring the completion and delivery of these texts – yet their contribution is recorded in an ad hoc way, in acknowledgements in books and letters in archives – if it is recorded at all. (Lyons 2019, 157)

Furthermore, as *The Faerie Queene* project moves into its next stage of progress, we see other women at Penguin beginning to leap from the files. A Miss Marianne Velmans takes over production work, a Ms Esther Sidwell is the copy editor, and once published, a Miss P Sadler sends out the complimentary copies to various reviewers and readers. In Eunice's files we see a somewhat disparaging mention of female telephone switchboard operators in a letter received by Eunice, dated 10 May 1939: 'Your young woman on the telephone at Harmondsworth isn't highly intelligent. She told me that I should find you at "Williams Adult Education Society" in London at 11.30am. I am still looking for the number!' (Frost Files, DM1843/8).

However, this legion of women at Penguin was not passive in the face of their labours. An internal document titled 'Notes on staff arrangements 30 November 1954 and 5 December 1954' bears witness to an attempt to replace one Miss Swann, and highlights the need to make improvements to the working conditions and pay of the editorial and secretarial staff:

> Indeed, it has been said to us by some of them (a) that they sometimes feel they are being called upon to subsidise low-priced books for the public at their own cost; and (b) that it almost seems that we take advantage of the fact that they like their immediate superiors and find them pleasant to work with, and for this reason want to give them every possible help, to 'get away with murder'. This, surely, is a very bad state of affairs; they should be recompensed for their work with something more concrete than kind words and smiles, while getting these too in so far as they deserve them [. . .] these conditions are, unavoidably, getting more widely known outside the firm; and they create the impression that Penguins are produced by sweated labour. This accusation, when made, is very difficult honestly to rebut. (Frost Files, DM1843/1)

It is unclear who penned these words (Eunice, perhaps?), but the message comes through unequivocally that there is a perceived pay gap between

secretarial (and editorial) and other staff at the publishing house, and a sense that advantage is being taken of these types of workers – moreover that this group is not content to suffer in silence, and has communicated their grievances to the company at the highest level. This is an important document, as it demonstrates that these workers are aware of the ways in which their own labour is undervalued.

Conclusion

This chapter has not attempted to list all of the women at Penguin and their invisible or undervalued labour – that would require much more space than this piece affords. Rather, it has used a handful of documents from just two of the files in the Penguin Archives to provide some illustrative examples. Even from this small sample, a picture emerges of individual cases that provide a useful provocation to consider further ways in which women's contributions to workplaces and businesses in the mid-twentieth century may have been obscured, as we see women undertaking invisible work; undervalued work; work that undermines their health and takes over their home lives; and work in the face of microaggressions and 'gender taxes' that creates a gender gradient against which the women in publishing must strive, and arguably not on an even playing field with their male colleagues. Furthermore, even women beyond the business itself – wives, external secretaries and other unpaid helpers – also contributed to the success of Penguin during this period. As the self-reflective volume, *Penguin's Progress, 1935–1960* (1960) astutely emphasises: 'Sir Allen picked with such perspicacity the people to join with him in developing the Penguin operation.' He has 'chosen wisely and has been well served' (10).[1]

Note

1 Some of this research was presented at the 'Thanks for Typing' conference in March 2019 in a paper with the same title, and published in an earlier article (Lyons 2019). The previously unpublished material from the Penguin Archive is reproduced by permission of Penguin Books Ltd. All reasonable efforts were made to contact the individuals whose correspondence is quoted here, or to seek permission from their estates where appropriate.

Bibliography

Eunice Frost Papers, shelfmark DM1843/1–73, Penguin Archive at the University of Bristol.
'Eunice Frost, Reminiscence', *The Penguin Collector* 41 (1993), Penguin Collectors' Society.

The Faerie Queene Editorial File, shelfmark DM 1852/D207, Penguin Archive at the University of Bristol.

Forestal, Jennifer and Menaka Philips, 'Gender and the "Great Man": Recovering Philosophy's "Wives of the Canon"', *Hypatia* 33, no. 4 (2018): 587–92.

Grugulis, I. and S. Vincent, 'Whose Skill Is It Anyway?: "soft" Skills and Polarization', *Work, Employment and Society* 23, no. 4 (2009): 597–615.

Hare, Steve, ed., *Penguin Portrait: Allen Lane and the Penguin Editors, 1935–1970*. London: Penguin Books, 1995.

Lau, Michael Y. and Chantea D. Williams, 'Microaggression Research: Methodological Review and Recommendations', in Derald Wing Sue (ed.), *Microaggressions and Marginality: Manifestation, Dynamics, and Impact*. Hoboken: Wiley, 2010.

Lloyd Jones, Linda and Jeremy Aynsley, *Fifty Penguin Years*. Harmondsworth: Penguin, 1985.

Lyons, Rebecca, 'Thanks for Typing: Women's Roles in Editions and Translations of Arthurian Literature in Penguin Classics, 1959–1985', *Journal of the International Arthurian Society* 7, no. 1 (2019): 140–62.

Morpurgo, Jack E., *Allen Lane, King Penguin: A Biography*. London: Hutchinson, 1979.

'Obituary: Eunice Frost', *The Independent*, 18 August 1998.

Penguin Random House Website, 'Our Story'; https://www.penguinrandomhouse .com/about-us/our-story/ (accessed Friday 13 March 2020).

Penguin's Progress, 1935–1960. Harmondsworth: Penguin, 1960.

Pierce, C., J. Carew, D. Pierce-Gonzalez and D. Willis, 'An Experiment in Racism: TV Commercials', *Education and Urban Society* 10, no. 1 (November 1977): 61–87.

Todd, Selina, *Young Women, Work, and Family in England 1918–1950*. Oxford: Oxford University Press, 2005.

Wood, Gaby, 'A Touch of Frost: The Story of Penguin's Secret Editor', *The Telegraph*, 23 July 2018.

PART II

Politicians and Activists

The section discusses the lives of four women whose voices, unlike the voices of their male counterparts, tended to be omitted, yet who carved a niche for themselves against significant odds, either within the systems that did not favour female ambition (such as Roman patriarchy of Servilia's times or Russian Imperialism in Maissi Erkko's case), or while directly fighting against totalitarian regimes and their immediate legacies, as Marie Sargent-Černý and Kim Hak-soon did. It also illustrates a variety of driving forces behind female political involvement – from protecting and advancing one's family interests and achievements to educating the public during the changing and dangerous times to establish a fairer society. (Hana Navrativola and Juliana Dresvina)

5

Backing the Family

Servilia between the Murder of Caesar and the Battle of Philippi

Susan Treggiari

It has long been argued that women of senatorial families had considerable political influence in the late Roman Republic (Treggiari 2019, 217–20). They could not vote or stand for office. But their control of property and rights in private law, including the option to divorce, gave them independence. To exert political influence, however, they had to work *through* men. Such influence tended to be used *on behalf of* men. Family affection was an accepted motive. Influence could be increased by the prestige and popularity of a woman's natal family and husband, by her own reputation and by changing circumstances. Extramarital relationships also came into play. The great Whig ladies of the early nineteenth century in England provide a partial parallel (Treggiari 2019, 292–7).

Background

My protagonist is a woman called Servilia. Born around 100 BC, she came from a patrician family, ennobled by high office, the Servilii Caepiones. Her paternal grandfather had been disgraced and exiled; her father died before reaching the consulship (both were called Quintus Servilius Caepio, the grandfather consul 106 and the father, praetor(?, in 91?), killed in 90;

all dates are BC/BCE. Treggiari 2019 for further details on all the people mentioned). But her maternal uncle, Marcus Livius Drusus (tribune in 91), had been both influential in the Senate and immensely popular with the common people and the Italians (whom he tried to enfranchise). His house, where she was brought up for several years, was a centre of power. She married in succession two second-rate men. But she produced four children. Her son by her first husband was Marcus Iunius Brutus (born in 85), the future murderer of Caesar (I use the consonantal I [Iunius, Iulius] which is more often written as 'J' in English work). Her three daughters by her second husband, all called Iunia, made brilliant matches. One married Publius Servilius Isauricus (consul in 48 and 41) and does not concern us here. Another married Marcus Aemilius Lepidus (consul 46), from a splendid and patrician family. He would side with Caesar in the civil war (49 to 45) and in 43 join Mark Antony and Caesar's adoptive son, whom for clarity I will call Octavian, to form a triumvirate, in effect a dictatorship of three men. The third, known in the family as Tertia ('Third') or Tertulla ('little Tertia'), married Gaius Cassius Longinus, who distinguished himself as a soldier, sided with Pompey in the civil war, but was then reconciled with Caesar, and was promoted to the praetorship by him. It was in his year of office, 44, that, with his brother-in-law and fellow-praetor, Brutus, he conspired to murder Caesar. Modern scholars plausibly credit Servilia with having masterminded her daughters' marriages. It is likely that she had a hand too in the first marriage of her son to another patrician, Claudia, which gave him impressive contacts.

During all this time, perhaps from about 68 BC until Caesar's death in 44, that is during her second marriage and widowhood, Servilia and Caesar were lovers. This was made apparent in 59, when Caesar notoriously gave her a pearl worth six million sesterces (Suetonius *Caesar* 50.2), that is, six times the minimum fortune for a senator a couple of generations later). If an anecdote is true, senators knew all about the affair in 63 (Plutarch *Brutus* 5.3–4, *Cato* 24.1–2).

Servilia could and should have worked on behalf of a number of men. It is likely, for instance, that she (like her younger half-brother, Marcus Porcius Cato) helped get her dim second husband to the consulship. As Maryon Pearson (1901–89, Mrs Lester Pearson) said, 'Behind every successful man, there stands a surprised woman.' It is also probable that Caesar helped her to do this. She is said to have had a maternal authority over Cato (Asconius 19). She was often a member of his council (Plutarch *Cato minor* 30, 32.4–6). For another sister involved with her brother's career, compare Clodia, who was closely involved with her younger brother Publius Clodius Pulcher, tribune 58, and was a channel of communication between him and Atticus in 59 (see Cicero *Letters to Atticus* [henceforth *Att.*] 29/2.9.1, 30/2.12.2, 34/2.14.1, 42/2.22.5, Wiseman 1985, 42–3 [arguing that Clodia was not herself important politically]. Cicero's letters to Atticus are cited by the number given by Shackleton Bailey [1965–70],

Letters to friends by Shackleton Bailey [1977] and *Letters to Brutus* by Shackleton Bailey [1980], followed by the letter's traditional number and the number of the paragraph. I also normally give the place from which Cicero wrote and the date.)

We can conjecture that Servilia was deep in Caesar's counsels and worked in his interests while he was away in Gaul. Her support of one son-in-law, Cassius, is well attested and so is her activity on behalf of the children of Lepidus. In this chapter we will see her chiefly as the adviser and backer of her son. The first marriage of Brutus (perhaps in 55), to Claudia, which I think she helped arrange, would allow him to call upon the powerful Claudii Pulchri and would give him a substantial dowry just when he needed money to stand for election to his first major office.

Topics

Women's influence was deployed in various ways. I will pick out as topics Advice, Persuasion, Administration and Subsidy. For the first two I think of the rights of a constitutional monarch to be consulted, encouraged and warned (Bagehot 1966, 111), or of Wordsworth's poem where he thinks of 'a perfect Woman, nobly planned, / to warn, to comfort, and command' (1896, 1).

Case Studies

The sources on Servilia are at their best after the Ides of March 44. Modern historians may think that the snippets I quote are thin. But they are the best available sources and they are contemporary. There is never any hint in our texts that Servilia had known about the plot to kill Caesar. She had recently (in summer 45) had a serious disagreement with Brutus when he insisted on divorcing Claudia and marrying his cousin Porcia, Cato's daughter. (Because Cato had committed suicide rather than surrender to Caesar and so had become a hero and because Porcia's previous husband, Marcus Calpurnius Bibulus, was also an opponent of Caesar, the marriage indicated that Brutus was distancing himself from the Caesarians.) Here her Advice and Persuasion failed. I would guess she was shocked and saddened that her son and son-in-law were leaders in the assassination of her lover. But we do not have a diary or private letters from her that would tell us of her feelings. Instead, we find that Cicero in *his* letters to his great friend Quintus Caecilius Atticus, and to Cassius and Brutus, pays her a great deal of attention in 44 to 43. After the murder of Caesar on 15 March 44, she swings into action to try to pull Brutus's and Cassius's chestnuts out of the fire.

A Council Meeting

Let me discuss some instances. After the murder, Mark Antony, as consul outranking praetors, seized the initiative. Brutus and Cassius were unable to stay in Rome because of the hatred of the citizens and Caesarian veterans and went to country villas or a house at Anzio. In June, Antony was willing to offer them jobs which would take them abroad. Should they accept? Brutus chaired a meeting at Anzio, to which Cicero was summoned. Women were present, as was normal in discussion of family problems. Here the problem is political. Cicero describes the scene to Atticus:

> I reached Anzio before the sixth hour. Brutus was pleased that I had come. Then he asked me, in front of many people – Servilia, Tertulla [daughter of Servilia, wife of Cassius], Porcia [daughter of Cato, wife of Brutus] – what course I thought best. Favonius was also present [Marcus Favonius, praetor 49, friend of Cato and Brutus, ex-Pompeian, was not an assassin, but joined Brutus and was executed after Philippi – ST]. I gave him [Brutus] the advice I had pondered on my journey, that he should take advantage of the Asiatic grain-commission; there was nothing left for us to do but to ensure his safety; the defence of the commonwealth itself lay in that. When I had started on this speech, Cassius came in. I repeated my opinion. At this point, Cassius, with blazing eyes – you would have said he was breathing out Mars – said he would not go to Sicily. 'Should I have accepted an insult as if it were a favour?' 'So what will you do?', says I. He said he would go to Achaea [the Roman province of Greece]. 'What will you do, Brutus?', I said. 'I'll go to Rome, if you think it's a good idea.' 'I don't think it at all a good idea; you will not be safe.' 'Well, then, if I could be safe, would you like it?' 'Yes, and I would want you to stay there and not to go to a province whether now or after your praetorship; but I do not advise you to trust yourself to the City.' I told him the reasons, which will come into your mind, why he would not be safe.
>
> Then there was a lot of talk: they – and especially Cassius – complained about missed chances and they severely accused Decimus [Decimus Iunius Brutus Albinus, another assassin, proconsul of Cisalpine Gaul (northern Italy) in 44–3. He was the only conspirator in command of troops.] I replied that it was no good crying over spilt milk,[1] but I agreed with them. When I began to say what ought to have been done – and I said nothing new, only what everyone says every day, nor did I touch on the point that someone else [Antony] should have been got rid of – that they ought to have summoned the Senate, have spurred the People when they were burning with enthusiasm, taken charge of the whole commonwealth, – then your lady-friend [Servilia] exclaims 'I've never heard anyone talk like this!' I controlled myself. (Cicero *Att.* 389/15.11.1–2, Anzio (?), *c.* 7 June 44)

Cicero was offended and thrown out by her rude interruption, but it seems to have checked him. It shows how sensitive she was to any criticism of her son, especially if it was justified. We also see that Cicero chose not to make a retort. He goes on:

> But it seemed to me that Cassius will go (indeed Servilia promised to see to it that the grain-commission is taken out of the senatorial decree) and our friend Brutus was rapidly forced to withdraw from his empty remark that he wanted <to be in Rome>. So he decided that the games would take place in his name but in his absence and he seemed to me to want to set out for Asia from Anzio. (Cicero *Att.* 389/15.11.2)

A couple of days later, Cicero confirms this:

> About our friends at Anzio I think I wrote to you clearly enough, so that you would not have any doubt that they were going to be inactive and would take advantage of the insulting favour granted by Antony [the permission to be abroad]. Cassius spurned the grain-commission; Servilia said she would take it out of the senatorial decree. But our friend [Brutus], once he agreed with me that he cannot be safe in Rome, says – and right solemnly – that he'll go to Asia. (He chooses to hold the games in absence.) He says he will go immediately, once he has handed over the equipment for the games to those who will see to them. (Cicero *Att.* 390/15.12.1–2, Astura (?) *c.*10 June 44)

Cicero mentions Servilia's promise casually. He obviously expects her to succeed. He does not expect Atticus to be surprised or shocked by a woman getting a decree altered, despite her lack of constitutional rights. Whether a senatorial decree had already been passed, or whether it was simply under discussion, Servilia's intervention must include using her powers of persuasion on senators. (The words she used, se curaturam ['that she will see to it that', 'that she will take care that'], are paralleled in those Cicero uses about the agents Brutus intends to use to manage his Games, qui curaturi essent ['who will see to them' or 'who will take care of them']. The verb curare ['to take care', 'to administer'] is appropriate, for instance, for a male agent, *procurator*, who might be legally appointed to take care of a Roman's business affairs, for example when he was abroad.) She will have known most of them and known Caesar's intimates extremely well.

Subsidy: The Games of Apollo

We hear no more of the grain commission and it is quite likely that Servilia achieved what she promised. Her other important service to Brutus at this time was to help manage the Games which he had to hold as praetor.

The Games in honour of Apollo featured varied entertainments including theatrical performances – we know of both Greek and Latin tragedies – and involved considerable financial outlay. It was accepted that women, wives and mothers, subsidized the offices of their men from liquid capital, including their obligation to fund such expensive events (*Digest* 24.1.40–2, *Tituli Ulpiani* 7.1; cf. Sallust *Catiline* 35.3). And this is what it seems Servilia did. For we find her being helped by the wealthy Atticus, probably with money and management skills. Cicero writes:

> You will do as you always do and not let down Servilia, that is, Brutus. (Cicero *Att.* 394/15.17.2, Astura, 14 June 44; the explanation given above seems the likeliest, though Shackleton Bailey has some doubts.)

Cicero's wording makes it clear that Servilia is acting for Brutus in his absence, as his effective substitute. She is more than his mere agent. Her wishes and actions are to be regarded as his. The following day he was a little more specific on Atticus's role.

> I understand you are extremely busy with . . . Brutus's affairs, since I suspect that a great share of the care and administration of his games falls on you. (Cicero *Att.* 395/15.18.2, on the road to Tusculum, 15 June 44)

This does not mean that Servilia's share was negligible. She was clearly senior to Atticus in this work, though he may have handled more of the practical details.

Headquarters and Administration

Apart from this task, Servilia managed the gathering of intelligence, sending and receiving letters, and relations with the Senate and individual senators. Her house was Brutus's headquarters in his absence. (His wife, Porcia, who might otherwise have been expected to work for him by administering correspondence and liaising with friends, seems to have been in poor health. She died probably in early summer 43.)

Brutus went off to Greece, gathered an army and seized control. This coup was ratified by the Senate, which had turned against Antony. Cassius went to Asia Minor and then Syria. In spring 43, Cicero moved that Cassius be given a special military command. He argued for this before an assembly of the People, against the wishes of Servilia and of Cassius's own mother and brother.

> Please forgive me for doing what I did against the wishes of your mother-in-law [Servilia]. Being a timid woman, she was afraid that Pansa [the

consul] would be offended. In an address to the People Pansa said your own mother too and your brother had not wished me to propose that motion. But I was not moved by these things, I chose another course: I sided with the public good, as I always do, and with your dignity and glory. (Cicero *Letters to Friends* 367/12.7.1 to Cassius, Rome c. 7 March 43; Grattarola [1990, 157–8 n. 173] rightly takes this as evidence that Servilia was in touch with Pansa. The name of Cassius's mother is unknown.)

It is remarkable that Pansa referred to Cassius's mother in a public meeting, where propriety dictated that women were rarely named or mentioned. It is clear that the opinions of both women had weight, with voters and senators as well as with their sons. I take the ascription of feminine timidity to Servilia as patronizing rather than ironical. Servilia had every reason to proceed cautiously and try not to offend the consul, who had of course been nominated by Caesar, but was taking a moderate line. (C. Vibius Pansa Caetronianus had served under Caesar in Gaul.)

Cassius took over Syria anyway. Brutus wrote to Cassius's wife Iunia and to Servilia, telling them not to publicize this until Cicero thought fit (Cicero *Letters to Brutus* 2/3.3 from Brutus, Dyrrhachium 1 April 43). But the news got out and Cicero had the takeover legalized in late April 43.

The Children of Lepidus and Iunia

Alliances shifted kaleidoscopically. The Senate had turned against Antony, who suffered a defeat at Modena in April 43 and beat a strategic retreat across the Alps, where Servilia's son-in-law Lepidus was governor of Provence and Nearer Spain. On 29 May, Lepidus threw in his lot with Antony. On 30 June, he was declared a public enemy and his fortune was confiscated. His children (two sons and perhaps one daughter: Marcus, Quintus and the possible future wife of Servilius, who was accused of a plot in 30) stood to lose their patrimony. Brutus wrote to beg Cicero to regard *him* as the children's father and persuade the Senate to spare them. Brutus wanted to perform a service to his mother, sister and the children (Cicero *Letters to Brutus* 20/1.13.1 from Brutus, in camp 1 July 43). Servilia and Iunia intervened with Cicero too. He was at first reluctant to oblige them, arguing that, although it was cruel to make the children suffer, this was a necessary deterrent to treasonous fathers:

At that time although I suffered severely in many ways because of the anxious care for the commonwealth that I had shouldered, nothing caused me severer suffering than the fact that I could not yield to the prayers of your mother and sister [Iunia, wife of Lepidus]. (Cicero *Letters to Brutus* 21/20.1–2, Rome early July 43)

But Cicero, at the renewed Persuasion of Servilia and Iunia, decided to be inconsistent:

> I hope you will find out from the letters of your mother and sister how diligently I am working in the interest of your sister's children. In this case I am paying more attention to your wishes . . . than . . . to my consistency. (Cicero *Letters to Brutus* 23/23.13, Rome July 43)

Another Council Meeting

In July 43 Servilia called a meeting. She invited Casca and Labeo, two of the conspirators, an unsavoury financial agent of Brutus (P. Servilius Casca Longus, one of two brothers who were assassins, tribune and then admiral in 43, died at Philippi; Pacuvius Labeo, new man, jurist, close friend and lieutenant of Brutus, committed suicide after the battle; M. Scaptius, financier and *eques*, who handled Brutus's loans to Cypriots), and the senior consular Cicero. She chaired the meeting, just as a consul would chair a meeting of the Senate, and called upon Cicero to speak first and give his opinion about what Brutus and Cassius should do. Cicero writes to Brutus:

> Although I had often urged you in my letters to come as soon as possible to the aid of the commonwealth and to bring your army to Italy, and I thought your friends and family had no doubt about this, I was requested by that prudent and careful lady, your mother, all of whose anxieties refer to you and are consumed in you, to come to her on 25th July. So of course I did it without delay, as was right. When I arrived, Casca was there, and Labeo, and Scaptius. She opened the discussion and asked what I thought. Should we summon you and did we think that would be to your advantage, or would it be better for you to delay and put it off? I replied by saying what I thought, that it would be best for your status and repute for you to come to the aid of the tottering and falling commonwealth at the earliest possible opportunity. (*Letters to Brutus* 24/26.1–2, Rome 27 July 43)[2]

Cicero does not tell us what anyone else said, whether Cassius's wife Iunia was there, or what was decided. Servilia would write to Brutus about all that. All we know is that Brutus and Cassius did not take Cicero's advice, but waited to confront their enemies the following year. By then, Lepidus was in the ascendant again and, along with Antony and Octavian, had formed a triumvirate to take vengeance on Caesar's murderers. The story ends at the battles of Philippi, with the suicides of both Brutus and Cassius (42). Servilia lived on, we do not know how long.

Conclusions

In this brief sketch, I have highlighted the more important texts which allow us to see Servilia taking political action on behalf of Brutus, Cassius and her grandchildren. She masterminded the gathering of information and sending it to Brutus and Cassius, using couriers no doubt from Brutus's staff as well as her own. The ability to do this depended on her wealth and her contacts. She probably sent funds from her private fortune as well as from friends, to support the civil war – we know she was badly off afterwards (Nepos *Atticus* 11.4, Osgood 2006, 84). She helped organize and fund the Games. She kept in close touch with senators and key figures like Atticus and she received and passed on secret information, for instance, from Scaptius and from a slave of a certain Bassus, when they came back to Rome from the East (Cicero *Att.* 416/15.13.4, Puteoli (?) 25 October 44.). All these administrative tasks which she performed herself or through staff to support her son were also the sort of thing a wife might do to back a husband.

As for Advice and Persuasion, we have seen her at two formal meetings, one of which she chaired, eliciting opinions, making her own views felt, and intervening with a solution. There is no doubt that she advised Brutus, tried to persuade him to do what she wanted (as when she opposed his divorce and remarriage), and put her duty to him high on her list of priorities, as Cicero realized. Before the Anzio meeting, Cicero had told Atticus that Brutus was in the habit of doing what his mother advised and was susceptible to her emotional appeals. 'When he follows his mother's advice, or rather her prayers, why should I interfere?' (Cicero *Att.* 388/15.10, Tusculum (?), 5 (?) June 44).

But even skilled politicians like Cicero expected to listen to her. Her promise to get the senatorial decree altered indicates that she would attempt to persuade a number of influential senators and magistrates and expected them to cooperate. Her ability to persuade men outside the family, sometimes face to face, sometimes probably through the women of *their* families, depended in part on her own knowledge and understanding of the political situation. She had been brought up to this expertise. She derived authority from her birth, age and connexions. A reputation for sound character and good sense would help. So would a web of established contacts. Authority, *auctoritas*, was what enabled a male politician to succeed with Senate and People. It allowed him to persuade even when he had no constitutional power to compel. (The emperor Augustus, Caesar's heir Octavian, is the prime example.) Like a man, Servilia had formed friendships and done favours which, she could expect, would be paid back. The success of this sort of authority and of Persuasion – by women among others – is measured by the phenomenon that things get done without the sources telling us how.

I conjecture too that Servilia had the personality to succeed in her appeals. The sources are unhelpful on this. Cicero regarded her with respect. He does not tell us what she looked like. Was she attractive, clever and sympathetic? Could she wind men round her finger? We can perhaps guess,

because Caesar was loyal to her for so long – despite his other mistresses and his wives – that she had exactly what it took to influence other men to help her family.

Notes

1 Shackleton Bailey's phrase.

2 Prudence, practical wisdom, astuteness (*prudentia*) and carefulness, diligence, meticulousness (*diligentia*) are characteristics of good masters of households and statesmen (e.g. Cicero *Letters to Friends* 240/4.14.2, *On behalf of Quinctius* 11; 2 *Verrines* 4.39).

Bibliography

Bagehot, Walter, *The English Constitution* [1867]. London: Longmans, 1915, repr. London: Fontana, 1966.

Grattarola, Pio, *I cesariani dalle idi di Marzo alla constituzione del secondo triumvirato*. Turin: Tirrenia, 1990.

Osgood, Josiah, *Caesar's Legacy: Civil war and the Emergence of the Roman Empire*. Cambridge: Cambridge University Press, 2006.

Shackleton Bailey, D. R., *Cicero's Letters to Atticus*. Cambridge: Cambridge University Press, 1965–70.

Shackleton Bailey, D. R., *Epistulae ad familiares*. Cambridge: Cambridge University Press, 1977.

Shackleton Bailey, D. R., *Epistulae ad Quintum fratrem et M. Brutum*. Cambridge: Cambridge University Press, 1980.

Treggiari, Susan, *Servilia and Her Family*. Oxford: Oxford University Press, 2019.

Wiseman, T. P., *Catullus and His World: A Reappraisal*. Cambridge: Cambridge University Press, 1985.

Wordsworth, William, *Poetical Works*, vol. 3: 1804, ed. William Knight. London: Macmillan, 1896.

6

A Flaming Soul

Maissi Erkko Fighting for Women, Finland and Family Legacy

Reetta Hänninen

Maissi Erkko (1872–1936) was a Finnish political activist and the founding figure in several organizations. What is more, her life was like a well-written drama yet sometimes it seems too exceptional to be credible. She spent her childhood years on an island that also housed a mental asylum, studied abroad in her twenties, married in haste, struggled against the Russian regime by organizing a women's resistance group that smuggled leaflets under the eyes of the Russian authorities. She followed her husband into exile with their three sons and adapted to a new life in New York before returning home to Finland. She was a devoted advocate for the women's rights movement, a patriot and an anti-communist, who nevertheless ended up cooperating with well-known left-wing actors to fight against the rising extreme right.

Despite all the work she did in underground activism and women's rights movements, and even with all the twists and turns she experienced, Maissi Erkko has been overshadowed by her husband, son and grandson. Her spouse Eero Erkko (1860–1927) was a politician, a Member of Parliament, and the editor-in-chief of a liberal newspaper *Päivälehti* (*The Daily Paper*), which later became the *Helsingin Sanomat* (*Helsinki Newspaper*). Her

son Eljas Erkko (1895–1965) carried on his father's work in *Helsingin Sanomat*, which grew to be the largest newspaper not only in Finland but also the Nordic countries. In the 1990s, more than one fifth of the Finnish households subscribed to *Helsingin Sanomat* and it still is the largest daily subscription newspaper in the Nordic countries. Maissi Erkko had a crucial role in the generational handover and it is due to her actions that the Erkko family grew into the most significant newspaper family in Finland. The Erkko family held the newspaper company until the twenty-first century: Eljas Erkko became the owner and editor-in-chief in 1927 and later his son Aatos Erkko (1933–2012) was the owner and publisher of the company, becoming one of the wealthiest persons in Finland.

There are several books and biographies, as well as numerous articles about Eero, Eljas and particularly Aatos Erkko making the wealthy and powerful Erkko men familiar to Finnish readers (Zetterberg 2001; Manninen and Salokangas 2009; Blåfield 2014; Karen 2018). On the other hand, only scant attention has been paid to Maissi Erkko, mainly since she worked behind the scenes and had no role in the editing office. She features in the biographies of her husband and sons, and there are a few popular articles about her, such as one on the website of The Finnish Association for Women.[1] In general, Maissi Erkko is remembered as a brave woman with 'a flaming soul', as an anonymous article celebrating her sixtieth birthday says (HS 4 June 1932). She is seen mainly as a helper to her husband and sons and as an exemplar of an inspirational woman – yet her own voice seems to have been muted. This chapter is aimed at redressing this imbalance, bringing into circulation new sources such as Maissi Erkko's letters, diaries and newspaper archives, to demonstrate that her life had many more dimensions than just the roles of loyal partner or inspiring heroine. It is time Maissi Erkko had the floor so that she finally has her turn to speak.

An Islander

Maissi Erkko, born Holländer, grew up in unusual surroundings. Her father, Johan Fredrik Holländer, was the financial manager of a mental hospital, with his family living on the premises. At that time overseeing the sustainment of the patients and the employees of the asylum required not only financial but also agricultural skills, as the institution was supposed to be virtually self-sufficient.

The asylum was situated on Själö island of the Turku archipelago. The name is Swedish, as most of the residents in the archipelago were, and still are, Swedish-speaking Finns. Själö (Seili in Finnish) used to be a leper colony, transformed into a mental asylum in the seventeenth century. With rare exception, the patients could not leave the island until their death. In 1889, Seili became the only hospital, out of five or six existing mental institutions

in Finland, intended primarily for female patients, operating until 1962 (Turunen and Achté 1983, 93–100).

Growing up on an island among the mentally ill may sound like a grim upbringing; however, little Maissi Holländer had an ostensibly pleasant childhood surrounded by nature, fields, horses and a family with siblings, aunts, second cousins and other relatives. One of her aunts, Sandra (Alexandra) Holländer, even established a career in mental health, having later become the Head Nurse of the psychiatric hospital of Käkisalmi on the Karelian Isthmus. Sandra's obituary described her as 'one of the rare characters to establish [herself in her] own field' (HS 16 July 1936). There was also a community of rural workers as well as a vibrant society on the nearby islands. In the 1890s, the family built a summer cottage on a nearby island, which is still in the family's possession. The relative isolation of Seili, safeguarding the hospital inmates, also provided for Maissi and her family a place of pleasant memories and a sanctuary in a rapidly changing world.

Maissi Holländer attended a Finnish school for girls in Turku, even though her family initially spoke Swedish. At the end of the nineteenth century, it was not highly unusual for Swedish-speaking Finns to change their language usage to Finnish, as the Fennoman movement arose and heightened the status of the Finnish culture and language. This process took place particularly among the intelligentsia that was seeking to find its place under the Russian regime after Finland became a Grand Duchy of Russia in 1809, after Sweden had lost it to Russia as a result of the Finnish War (Jussila, Hentilä and Nevakivi 1999, 57–60).

The unusual childhood setting and its rural nature was likely one of the main factors that affected Maissi Erkko's personality and her attitude towards life. She did not reject manual labour and was not afraid to get her hands dirty. It seems that the hospital environment influenced her own choices. During the time when most women did not work outside the home, Maissi Holländer educated herself and gained an occupation. At the age of eighteen, she moved to Helsinki to study to be a sjukgymnastik (contemporary Swedish term for physiotherapist). After graduating from a school for gymnastic teachers and physiotherapists, Maissi went to Sweden to complete her studies, spending the winter of 1891–2 at the J. Arvedson Institute in Stockholm. There she learned the causes of gout, how to treat diabetes and the symptoms of hysteria; her black notebooks from that time are filled with hundreds of pages of handwritten descriptions of numerous diseases.

An Optimistic Year of Engagement

In June 1893, Maissi Holländer lived in Turku with her family, when she received an unexpected letter. Eero Erkko, a politician and the editor-in-chief

of a liberal Fennomanian newspaper *Päivälehti*, asked her to marry him. The proposal was a surprise to Maissi for they had only met briefly. Despite the spontaneous gesture, Maissi agreed to see Eero. He was twelve years her senior, born in a peasant house in the Finnish countryside, and after years of studying in the University of Helsinki and struggling through lack of funds and odd jobs, landed a job as an editor. Eero was in Turku attending the Church Assembly as a representative of the liberal politicians, promoting the freedom of religion, when he ran into Maissi at a social gathering. Eero wrote to his brother and told him about this sudden turn of events:

> I knew her from the time she was in Helsinki and now, when I met her again in Turku, I found her so delightful that I proposed. She is a fine and proper girl in every way. The more I have learned of her these last days, the more delighted I am. So upright and genuine and spirited at the same time. (Eero Erkko to J. H. Erkko, 4 July 1893)

Maissi and Eero spent a few days together on the island of Seili to search their feelings. After those meaningful days, their manner of speaking became very affectionate and warm. In June 1893, Maissi began her response letter to Eero's proposal with a formal opening 'Respected Sir'; in July 1893, the opening words were 'Eero Darling!!!' (Maissi to Eero, 29 June and 16 July 1893). As soon as Eero sent her a ring in a letter, on 13 July 1893, they were officially engaged.

Yet the couple could not meet very often: Eero was busy with the newspaper in Helsinki and Maissi would not give up her job as a physiotherapist, spending her summer in a health spa in Mariehamn on the Åland Islands. As they did not live in the same city and the telephone connections were practically non-existent, they wrote numerous letters, most of which have survived and kept in the Päivälehti Archives in Helsinki. One can see how two people who were practically strangers got to know each other by writing their thoughts of love and planning their future together, working for the greater good – with visions often idealistic and almost utopian.

Maissi appeared to be deeply passionate about the role of a woman in a marriage. In her letters, she spoke explicitly about wanting to be an active wife and share her opinions with her future husband. She also said that she could not stand the wives who did not participate in their spouses' lives: 'I despise the kind of marriages, where wives have no idea what their husbands are doing', ranted Maissi (Maissi to Eero, 2 August 1893). Her fiancé agreed; he saw political work and the newspaper as a common project. In his letters, Eero even called Maissi 'the second editor in chief of *Päivälehti*' (Eero to Maissi, 28 July 1893). This statement, however, should not be taken literally, as a young woman with no knowledge of politics and with inadequate skills in Finnish language was hardly a candidate for an editor.

They considered themselves two companions who were united not only by love but also an ideology – the ideology manifested in The Young Finnish

Party as a combination of patriotism, liberal views and social reformism. Maissi and Eero were certainly not alone in their ideas of a partnership as at that time a married couple working together for high-minded purposes was a common practice among the young Fennoman intelligentsia.

Troubled Times

During their engagement, Maissi and Eero Erkko had optimistic plans for their future. As their married life began in June 1894, reality kicked in. Family became the main preoccupation as the couple had three sons: Eljas was born in 1895, Paavo in 1896 and Eero Olavi in 1899. Maissi gave up her job as a massage therapist and the family moved to live in Helsinki. Later she recalled the first years of marriage as 'extremely difficult. I was used to hard work, I loved the occupation I had chosen, but my new obligations kept me from continuing.' She felt shy and was ashamed of her lack of knowledge of the Finnish language (Maissi Erkko's diary, 19 February 1929).

Maissi Erkko was responsible for the housekeeping and took care of the children. One of the boys was born with a cleft palate, and doctors had little hope for his survival, causing her acute anxiety. At the age of six months, Paavo went through the first of his painful surgeries but eventually fully recovered. Maissi was with him at the hospital for a week: 'It was miserable to see his pain; his eyes expressed such a deep agony that it hurt me, too. . . . I have been taking care of him and my arms are aching from carrying him around' (Maissi Erkko to J. H. Erkko, 5 July 1896, 23 February 1897).

Maissi's former ideas of being an active wife were buried under her domestic obligations, household duties and long nights with a suffering child. Despite the maid's help, Maissi Erkko lacked both time and other resources to act. The spring of 1899 was particularly difficult. Eero Olavi was born in April and just after that Eljas caught scarlet fever. He was bedridden for weeks and after that he had to remain isolated from other children for a month and a half. Maissi was exhausted:

> My mind feels so heavy that I even don't know how to write. No wonder, we have languished because of these illnesses all spring. First Paavo, then me and now Eljas. You know, I haven't been anywhere for months; I've been like a slave to this illness. (Maissi Erkko to J. H. Erkko, 3 May 1899)

She was constantly tired and felt somewhat neglected when she stayed home with the children, while Eero was in the editing office or planning political strategies in the meeting rooms of fancy restaurants. She recalled later: 'Oh, how I yearned and how many nights I waited, waited until my eyes closed' (Maissi Erkko's diary, 19 February 1929). It was almost as if she went through a transformation from an enchanted fiancée to a lonely, weary – and perhaps somewhat bitter wife, not dissimilar to Edith Tolkien

(cf. Chapter 15 by Maria Artamonova). For Eero, however, Maissi was an important companion, with whom he could share his work concerns and develop his political plans. Whenever they were separated, Eero wrote to Maissi constantly: the Päivälehti Archives alone contain almost 300 letters from Eero to Maissi.

Despite all the hurdles, Maissi Erkko did eventually act like the woman she was determined to be as a young fiancée. The prime stimulus in Maissi Erkko's life was the changing political environment. From 1809 until 1917, Finland was an autonomous part of the Russian Empire and, as the Grand Duchy of Finland, enjoyed considerable autonomy until the late nineteenth century. In the 1890s, however, the Russian Empire began to integrate border states, diminishing their individual privileges by unifying the legislation and Russifying their administration and education in order to centralize its governance and improve military defences against the rising German Empire. This resulted in tightened censorship and any movements against the regime were strictly forbidden (Jussila, Hentilä and Nevakivi 1999, 66–79).

The main question among the Finns was how to react to these new procedures and regulations. Should the Finns resist all acts of Russification or should they adapt to them and wait for the storm to pass? To bend or to fight was the new dividing line in politics. It was sharp and unconditional, and it divided the Fennomans as well. The Old Finn Party was more conservative and wanted to collaborate with the Russians, as the Young Finns demanded resistance to all acts of Russification. Such resistance was mostly passive and non-violent, although with notable exceptions (Huxley 1990; Hänninen 2013).

In May 1902, Maissi Erkko was one of the few women to establish Women's Kagal, a women's resistance movement against Russification. Another founder was Tekla Hultin, an activist from the political group formed around *Päivälehti*, a journalist and the first full-time female editor in the Finnish press. The Women's Kagal produced and distributed forbidden leaflets and organized events to raise funds for the resistance movement. It is hard to reconstruct their actions, as the women did not make notes due to fear of the Russian authorities. The men's Kagal had their minutes of the meetings in Sanskrit but when it comes to women's action, we only have rather unspecific recollections published mainly in the 1920s. It is known though that women smuggled booklets hidden under their petticoats and received secret codes. 'Did you get the recipe?' or 'Did you receive the bulbs?' they asked on the phone, when inquiring about the incoming deliveries (US 24 March 1938).

Exile

The Young Finns were radical in every way. They were quite liberal and promoted women's rights and freedom of religion. Eero Erkko's *Päivälehti* supported the Young Finn Party, anti-Russification and the freedom of

speech. Unsurprisingly, the Russian authorities suspended *Päivälehti* in 1904, which, however, restarted under the name *Helsingin Sanomat* in just a couple of days.

At that time, the Erkko family was not in Finland anymore. The Russian authorities deported Eero Erkko in May 1903, giving him just three days to leave Finland. After spending some time in Sweden and Cuba, he settled in Brooklyn, New York. There Eero Erkko set up a newspaper *Amerikan Kaiku* (*The Echo of America*) for the US Finns. It was uncertain if Eero could ever return home, so Maissi Erkko chose to follow her husband with the boys in September 1903, after selling their pots and pans. They travelled with another Finnish woman and her child, who was also on the way to live with her exiled husband. The journey across the Baltic Sea was dreadful, as a storm hit the ship. Maissi wrote: 'We were sick for 36 hours, both children and adults. Little by little, we got back on our feet and after that everything went better. At the North Sea, the wind was strong but we were all able to breathe some fresh air on the deck' (Maissi Erkko to Dagmar Neovius, 10 October 1903).

In England, they went from Hull to Liverpool, where they had to wait for the RMS *Lucania* to sail, staying in a hotel. Maissi was pleased with their room but described the food as 'gruesome', having to shop for bread, cheese and fruits to cope with unfamiliar foods while they were away from home (Maissi Erkko to Aldyth and Tekla Hultin, 18 September 1903).

The sail across the Atlantic was more peaceful than the beginning of their voyage:

> For the first 24 hours there was a quite fresh breeze and we had the opportunity to admire these wonderful, majestic waves that followed the ship (we had fair wind), the crests were sparkling in different colours and the foam was like a white veil on the top of it all. (Maissi Erkko to Dagmar Neovius, 10 October 1903)

Regardless of these astonishing experiences, the journey made them weary. The trip was long and the conditions cramped; there were two adults, four children and only four beds in their cabin.

> Although we were not sick, we did not have the strength to do anything else than sit in our deck chairs; we hardly even talked to each other. And the kids – they ran around briskly all day, wanting to get an explanation for everything they saw. You can imagine that when one was exhausted and all worn out, it wasn't particularly pleasant (ibidem).

After a long journey across the Atlantic, the family reunited in New York and started their life all over again. The children went to a public school, Eero had his newspaper and a printing house and life worked out even though sometimes their apartment was not that comfortable. In normal

conditions, the rooms were quite warm; however, when it was cold outside, 'the water ices in the cuspidor and the teacups freeze to the saucers', wrote Maissi (Maissi Erkko to J. H. Erkko, 12 January 1904).

In New York, Maissi Erkko was planning to utilize her professional skills as a physiotherapist. She wrote to her brother-in-law that she intended to receive patients to support the family, as the newspaper was not yet profitable (Maissi Erkko to J. H. Erkko, 6 July 1903). Her granddaughter Ritva Erkko Harli (2015) even suggests that during her time in the United States, Maissi Erkko was learning how to give massage treatments for children with polio. Whether she managed to start her practice is still unclear. Her language skills were still inadequate even though she studied English during the summer before. The language was not an insurmountable barrier as there were thousands of Finns in New York, yet the lack of the social network affected her chances for professional employment: 'I have visited some doctors and asked them for patients', Maissi wrote, 'yet it is not easy to get started as a stranger without any recommendations' (Maissi Erkko to J. H. Erkko, 6 December 1903).

For all we know, Maissi never typed like Alli Hytti or Valerie Fletcher, nor did she edit her husband's articles (see Part I of this volume). It is apparent however that she played an important part in the family business, as she managed the subscriptions and accounting for her husband's newspaper company. Maissi Erkko enjoyed her new skills: 'For the first time I am into our commercial affairs, as in Helsinki I could not do it even though I have tried. It is fun; it gives a certain and great satisfaction to life, when you are in charge; should I be left alone, no one will be able to trick me' (Maissi Erkko to J. H. Erkko, 12 January 1904.) She managed without hired help, did the laundry and the ironing, prepared meals and in the evenings, and took care of the bookkeeping. Life was busy but she felt it was meaningful.

Women's Rights Movement

The loss of the Russo-Japanese War in 1905 resulted in political unrest, demonstrations, strikes and unease in both Russia and Finland. The 1905 revolution forced the Tsar to carry out reforms and as result censorship also loosened in the Grand Duchy of Finland. The deported were able to return home: in the same year, Maissi Erkko was back in Finland and continued her work in several associations. In the meeting of the Finnish Association for Women, she lectured on the status of the maidservants in the United States. She was an active member in various women's rights groups and participated in several women's voluntary organizations, picking up where she left before deportation. Previously, she was on a relief aid committee of 1902, helping those who suffered from a massive crop failure; she was also one of the first chairwomen of the local chapter of the Martha Organisation, which provided advice in home economics. She founded

such organizations as The Young Fennoman Club for Women, which was a forum for women to discuss politics. After the years of exile, she continued her work in these associations.

The social and political mobilization of Finnish women had been rising since the late nineteenth century. For middle-class women, the Temperance Movement, the Youth Associations and the Martha Organisation were socially acceptable; for working-class women, the Social Democratic Party was more tempting. All and all, these associations gathered tens of thousands of female members to attend rallies and exercise social activism. Compared to these mass movements, women's rights associations never gained as much popularity, as they were seen to be narrower in their aspirations (Sulkunen 2009, 88–99).

The demands for equal political rights regardless of class or gender were successful, even though there was friction among women's organizations. For bourgeois women, it was not self-evident that working-class women should also be able to vote. Nevertheless, in 1906, the Parliament of Finland was established by the Parliament Act and Finnish women gained the right to vote without regard to their social status. What is more, they also had the right to run for office. This made Finland the first country in the world to give women full political rights, although Finland was not yet a democracy until it gained its independence in 1917, as the Tsar was not willing to cede any power to the Finnish Parliament.

After the first election, 19 of the 200 members of the parliament were women. Nine of them were socialists, six from the Fennomanian party, two Young Finns and one each from the Swedish People's Party and the Agrarian League. Maissi Erkko did not stand for the parliament but she did run for a member of the central committee of the Young Finn Party. She was the only female candidate and she gained the smallest number of votes at the party congress (Zetterberg, 404–5).

Women's suffrage was one of the leading motives in all her work. Maissi Erkko's former acquaintance Ester Ståhlberg, wife of the first president of Finland K. J. Ståhlberg, described her no-nonsense manner of speaking when it came to politics. As the Ståhlbergs and the Erkkos were discussing current issues, Maissi could not hold herself back: 'You men are such sluggards; why don't you just get on with things? Why do you let the scoundrels continue their rackets. . . . If only we women had the chance to hold the reins!' (Vitikka and Vitikka 1987, 63).

Fight for the Family Legacy

Besides all her influence on various organizations, Maissi Erkko had a remarkable impact on the Finnish media and business history, namely she had an enormous effect on the development of the newspaper *Helsingin Sanomat* and the prosperity of the Erkko family. This influence and legacy have long been underrated (Jensen-Eriksen and Kuorelahti, 2017).

From 1908 onwards, Eero Erkko continued his work as an editor-in-chief of *Helsingin Sanomat*. During the 1920s, there was a silent struggle over the shares of the Sanoma newspaper company between Eero Erkko and the National Progressive Party, the former Young Finns Party. The ownership had been distributed among Eero Erkko, the printing house company that pressed *Helsingin Sanomat* and Viivi Kauppila, the widow of a former financial manager of the newspaper. The party was interested in the shares that Kauppila held, for it wanted to steer the newspaper strictly by the programme, as Eero Erkko wished to make it more general interest publication. However, due to the long and trusted relationship between the party and Eero Erkko, the disagreement remained amicable (Manninen and Salokangas 2009, 72–6). Nevertheless, Maissi saw what was coming and repeatedly pushed Eero to buy the shares from Viivi Kauppila, which he did not do (Maissi Erkko to Eero Erkko, 24 and 29 October 1924).

The struggle burst into the open only moments after Eero Erkko died in October 1927. Maissi Erkko was the main agent in a project that aimed to secure the newspaper company for the family. It was due to her manoeuvres that the Erkko dynasty gained most of the shares, as she negotiated on the shares with Viivi Kauppila and managed to finalize the deal before the party members intervened. Maissi Erkko and her sons had to undertake a large joint loan to cover the expenses of the stock trading (Jensen-Eriksen and Kuorelahti 2017, 143–6). In 1928, she held most of the shares, for she had possession of her husband Eero's estate. Combined, the Erkko family held 51.1 per cent of the shares (Manninen and Salokangas 2009, 83).

Despite the majority holding, the struggle was far from over. Maissi Erkko was a board member in the Sanoma newspaper company and there she had to fight against old friends and allies as there were several members of the party on the board. The former president of Finland, a member of the National Progressive Party and a close friend of the late Eero Erkko, K. J. Ståhlberg, visited Maissi before an important board meeting in the spring of 1931. He criticized her for detaching the newspaper from the party and aiming it to please a wider audience, as financial prosperity was required for the Erkko-family independence. Ståhlberg demanded that there should be at least two members of the party steering the newspaper's policy. When Maissi declined, she recorded that Ståhlberg 'turned to me with a proud and mocking face and rubbing his hands together he accused me of making the newspaper into merely business. I answered that it is a large business and we have to manage it according to business principles' (Maissi's diary 25 April 1931).

Eventually, the members of the family occupied the boardroom. Eljas had joined the board as early as 1927 and his mother the following year. Eero O became a member in 1931 and when Paavo joined in 1932, there were four members of the Erkko family on a six-member board (The Annual Reports of the Sanoma Company in 1927–32; Jensen-Eriksen and Kuorelahti 2017, 140–7). Eero O and Paavo were interested in the

family business and contributed to the newspaper even though they worked in different fields. Eero O, who had a degree from the Technical Institute, utilized his skills in chemistry and engineering and regularly wrote for the *Helsingin Sanomat*. Paavo was an agronomist and gave the newspaper agricultural reports (Jensen-Eriksen, Mainio and Hänninen 2019, 74–5).

The oldest brother Eljas, who already had a promising career as a diplomat, was the factual leader of the newspaper – the editor-in-chief and executive director. On his thirty-sixth birthday, Maissi Erkko gave Eljas a tribute by describing him as Eero Erkko's successor and a fighter for free speech. Finally, she made a wish: 'May your paper be the torch that is always burning, always illuminating and always warming' (Maissi's diary, 2 June 1931). Besides praising her son, Maissi also wanted to join the daily meetings at the editing office and participate in the newspaper's policymaking (Maissi to Eljas, 14 June, 4 and 5 July 1930). She put pressure on her son to use his newspaper as an authority and take a clear stand against the rising fascist movements, which it eventually did (Manninen and Salokangas 2009, 103–8; Jensen-Eriksen, Mainio and Hänninen 2019, 281–3).

It is apparent that Maissi Erkko saw herself as a link between the father and son and constantly reminded Eljas Erkko of the liberal and constitutional heritage *Helsingin Sanomat* was carrying. Her world view was shaped by the years of the Russification; thus, the authority of constitutional law and freedom of speech were the leading principles of her political views. She was a patriot and a devoted anti-communist, supporting the 'Whites' during the Finnish Civil War of 1918 as the 'Reds' were mainly members of the Finnish Social Democratic Party; she also supported the Estonians who fought against Bolshevik Russia in the Estonian Civil War in 1919. Since the late 1920s Maissi Erkko also grew to become an active critic of the rising far-right politics and extremism (Zetterberg 2001, 505). The violent outbursts against communists and the attempts to silence freedom of speech reminded her of the times of the Russian oppression (Maissi to Eljas, 14 June 1930).

Unlike his father, Eljas Erkko was not willing to share his ideas with Maissi when it came to business or politics. The newly minted press baron was not pleased to see his mother interfering with the newspaper's alignments. Disagreements escalated, and in 1935 they had an explosive argument. Shouting and yelling, Eljas Erkko banished his mother from the editing office. Later Maissi poured out her feelings to Eljas: 'You did not have the slightest understanding nor the slightest idea that you made my grief twice as hard by denying my participation in the work that was my life's work beside your father' (Maissi to Eljas, 16 June 1935).

Despite the relationship between mother and son remaining strained, whenever people outside the family criticized Eljas Erkko or his policies, Maissi Erkko stood up for her son. Yet Maissi Erkko was pushed aside from activities

at the newspaper and, although living in the same city, she and her son hardly ever met (Maissi's diary, 19 February 1929; Hänninen 2019, 29–33).

An Abandoned Widow

The years of activism and constant battling had defined Maissi Erkko's self-image; however, it seems that this image was shattered after Eero Erkko died. She felt desolate, bitter and forgotten. There was 'no one to talk to, no one to go to and no one to trust'. Old friends closed their doors, almost no one visited or called her and all the old associations were 'dead and buried with Eero'. On special occasions, she felt even lonelier. On Finland's eleventh Independence Day in 1928, a year after her husband's passing, Maissi Erkko stood by the window alone; she saw all the city lights lit and people rushing to parties and blamed her son Eljas for not taking her to the festivities. In her diary notes, she compared her situation to a practice among some Hindu communities, where a widow will burn with her late husband: 'And what does the civilized world do to the widow. . . . She gets burned piece by piece; if there is still some strength left – the bigger is the pyre' (Maissi's diary, 6 December 1928 and 19 February 1929).

Her loneliness may not have been as total as it appears in her darkest moments. Eero O retained a connection with his mother, although Maissi felt that it faded after he got married in 1929. Paavo who lived in the country, visited his mother occasionally and had a warm correspondence with her. What is more, although the tension between Maissi and Eljas rose over the years, Maissi had a chance to spend time with Eljas's daughter Patricia (1924–2001) or Pat. Pat's brother Aatos was born later, in 1933 and there was no real connection between him and Maissi. Pat, on the other hand, spent summers with her grandmother in the archipelago in a summer cottage near Själö. After her marriage in 1953, Pat became known as Patricia Seppälä; she grew to be the strong-minded leader of the picture agency Lehtikuva and she named Maissi as one of her role models. 'My grandmother had a distinct ability to raise children', Patricia recounted in an interview in 1995; 'She talked to me as if I was a grown-up and I was always allowed to take part in adults' conversations as long as I was able to conduct myself' (Eeva 11/1995; Jensen-Eriksen, Mainio and Hänninen 2019, 84–7).

After her husband's passing, Maissi Erkko continued to work in both charity organizations and political associations. In the 1930s, she cooperated with the Slum Sisters of the Salvation Army and even with some well-known Finnish left-wing organizers. She was one of the main figures in a committee that campaigned against the death penalty in 1934 and many of the members, including Maissi Erkko, were soon re-organizing as the League for Human Rights, which was established in 1935, with Maissi Erkko as one of the founders (Vuokila 1999, 20–33).

The Fading Flame

The summer of 1936 was a harsh summer for Maissi Erkko. Her aunt Sandra Holländer was mortally ill and Maissi was with her on Seili, where Sandra was staying with her nephew, Maissi's brother. Watching her dear aunt fade away was saddening and on 7 June, Maissi wrote to Eljas: 'There is nothing permanent in life; everything disappears.' Next day after that, shocking news arrived: Paavo Erkko lost his life in an accident. His sudden death resulted in Maissi's insomnia and worsening heart problems, leading up to her death on 1 September of the same year.

Her friend, novelist Selma Anttila, saw the sudden loss of her son as the last straw that affected Maissi's already poor health. She wrote: 'We as mothers can take a lot but when a child, the light of our life, is taken away from us, then we break; the sunlight fades in the evening of life and falls the long night – the time of great rest' (HS 6 September 1936).

The funeral service for Maissi Erkko brought out a collection of mourners that was a Who's Who gallery of Finnish society in the 1930s. Politicians, including the serving president P.E. Svinhufvud and his wife and members of organizations like The Salvation Army and The Finnish Association for Women, all paid their respects.

Maissi Erkko was also honoured in several obituaries. Their focus was mainly on her work alongside her husband, her vigorous activity against the Russian authorities and campaigns for women's rights. Her posthumous reputation emphasized her strength, the sacrifices she made for her husband and the passion she expressed in her actions. Selma Anttila called her 'a faithful friend and a co-ideologist' whose eternal fire 'has now united with the universe and given its share to the light of life'. For other commemorators she was a 'flaming soul', a loving mother and a hard-working hero (e.g. HS 2 September1936, Naisten Ääni 18/1936). In the second decade of the twenty-first century, the few texts written about her continue to build a solid narrative of a strong-minded young woman, who kept her head and coped in a society that was built for men and threatened by a reign of oppression. There has been little space, however, for her own voice with all the insecurities and inconsistencies, annoying traits or weaknesses that are the components of a human life.

Maissi Erkko lived through the turbulent years of Russification, exile and the fight for women's suffrage. She saw the rise of Finnish democracy, Finland gaining its independence and then descending into a civil war. She resisted the rising right-wing extremists and acted against the death penalty and in favour of human rights. She seized most of the shares of the newspaper company. She never quite gained the position of the matriarch of a media empire, as Iphigene Ochs Sulzberger did with the *New York Times*, but she was more than just a moral support for her husband (Tift and Jones 2000; Nordlund Edvinsson 2015). Maissi Erkko was a significant political

FIGURE 6.1 *Maissi Erkko in the 1900s (photo: Päivälehti Archives).*

actor acknowledged by her contemporaries, and it was her persistent work that laid the foundation for the prosperity of the family and the famous newspaper.

Note

1 https://www.naistenaani.fi

Bibliography

Archives: Päivälehden arkisto (PA) – The Päivälehti Archives; Eero Erkko archive (EEA); J.H. Erkko archive (JHE); Maissi Erkko archive (MEA); Kansallisarkisto (KA) – The National Archives of Finland; Eino Parmanen collection.
Blåfield, Antti, *Loistavat Erkot.* Helsinki: Otava, 2014.

Erkko Harli, Ritva, *Diamonds in the Trees: International Fashion through Diplomacy to Wool Farming Australia*. West Geelong: Echo Books, 2015.

Hänninen, Reetta, 'Kansanvalistusta ja karamellipapereita. Suomalaisten passiivinen vastarinta kenraalikuvernöörin kanslian erikoisjaoston raporteissa 1900–1902' [Finnish passive resistance through Folk Education and Hidden Messages: A Review of the records of the special section of the Governor-General's office in 1900–1902] Master's thesis. Helsinki: University of Helsinki, 2013.

Hänninen, Reetta, 'Kevyt ja pirteä kynä? Naisten ensimmäinen aalto Helsingin Sanomien toimituksessa sotien välisenä aikana' [Light and lively? The first wave of female journalists at Helsingin Sanomat in the interwar period], PhD thesis. Helsinki: University of Helsinki, 2019.

Huxley, Steven Duncan, *Constitutionalist Insurgency in Finland: Finnish 'Passive resistance' against Russification as a Case of Nonmilitary Struggle in the European Resistance Tradition*, Studia Historica 38. Helsinki: Finnish Historical Society, 1990.

Jensen-Eriksen, Niklas and Elina Kuorelahti. *Suuri affääri. Helsingin Sanomien yrityshistoria 1889–2016*. Helsinki: Siltala, 2017.

Jensen-Eriksen, Niklas, Aleksi Mainio and Reetta Hänninen, *Suomen suurin. Helsingin Sanomat 1889–2019*. Helsinki: Siltala, 2019.

Jussila, Osmo, Seppo Hentilä and Jukka Nevakivi, *From Grand Duchy to a Modern State: A Political History of Finland since 1809*. London: Hurst, 1999.

Karen, Lauri, *Aatos Erkko: yksityinen valtiomies*. Helsinki: Otava, 2018.

Manninen, Ohto and Raimo Salokangas, *Eljas Erkko: Vaikenematon valtiomahti*. Helsinki: WSOY, 2009.

Nordlund Edvinsson, Therese, 'Standing in the Shadow of the Corporation: Women's Contribution to Swedish Family Business in the Early Twentieth Century', *Business History* 58, no. 4 (2015): 532–46.

Sulkunen, Irma, 'Suffrage, Nation and Citizenship – The Finnish Case in an International Context', in Pirjo Markkola, et al. (eds), *Suffrage, Gender and Citizenship: International Perspectives on Parliamentary Reforms*. Newcastle upon Tyne: Cambridge Scholars Publishing, 2009.

Tifft, Susan E. and Alex S. Jones, *The Trust: The Private and Powerful Family Behind* The New York Times. Boston, New York and London: Little, Brown and Company, 2000.

Turunen, Sakari and Kalle Achté, 'Seilin hospitaali 1619–1962', in Kalle Achté, Jaakko Suominen and Tapani Tamminen, *Seitsemän vuosikymmentä suomalaista psykiatriaa*, Suomen psykiatriayhdistys. Helsinki: Finnish Psychiatric Association, 1983.

Vitikka, Hilkka and Olli Vitikka, eds, *Ester Ståhlbergin sodan ja rauhan vuodet. Päiväkirja 1935-1947*. Porvoo: WSOY, 1987.

Vuokila, Hanna, *Ihmisoikeuksien ja demokratian puolesta! Ihmisoikeuksien liitto 1935-1939 ja 1949-1952*, Master's thesis. Helsinki: Univeristy of Helsinki, 1999.

Zetterberg, Seppo, *Eero Erkko*. Helsinki: Otava, 2001.

Newspapers and Magazines

Eeva; *Helsingin Sanomat* (HS); *Naisten Ääni*; *Uusi Suomi* (US).

7

Student, Diplomat, Wife, Traveller: A Transnational Life of Marie Sargant-Černý

Hana Navratilova

Introduction

Marie Černý (1899–1991), née Hloušková, was a Czechoslovak immigrant to Britain, subsequently a British subject, and an international traveller, living a transnational life in the twentieth century. Reading about her life is reading a personal story in a century that brought massive changes specifically affecting transnational lives and women. Transnationals and women make decisive contributions to their communities, but remain vulnerable in conflict and crisis now as they were then. Marie's life highlights the value of their contributions and demonstrates that it is possible to go against the odds.

Marie was not just the wife to two publicly known men, but also a woman with her own career – a philologist, educationalist, wartime activist. She was also a mother to two daughters, Naomi McIntosh and Anna Allott, who both had distinguished lives. Lady Naomi McIntosh of Haringey was the first female pro-vice-Chancellor in Britain, at the Open University, a professor of sociology, and the founding senior commissioning editor for educational programming at Channel 4 television (Tuckett 2014), while Anna Allott was active at several academic institutions, specializing in Burmese language and history.

Marie's life showcases changeability and vulnerability, imposed limits, but also active renegotiations of female roles. Beginning as a trailblazing female university student and ending her life as a professorial widow, her

occupational and personal prospects changed repeatedly as she was adjusting and converting her lifestyle, professional activities and career expectations. In a traditional historiographical setting, she would be cast in a supporting role to her husbands. That, however, would miss a more nuanced picture, where she occupied a historical stage of her own. She is not an obvious heroine – and yet she can't be defined as supporting cast.

Marie lived for almost a century, and it was a century of dramatic political, economic and social change. The historical and geographic setting of Marie's life story provided an influential framework. Even a brief comparison of maps of the world in the years of her birth and death would show states and empires that were formed and proclaimed, and then reformed or disintegrated. In a long list of wars, three loom large in Marie's life: two World Wars and the Cold War. In social history, much kept changing – not least the gender relations, but there was no simple forward trajectory of that change. Family relations, structures of economy and power, but also objects of everyday life transformed constantly. Her story matters now because it problematizes the category of nationality, and shows an individual negotiation of gender roles.

Beginnings

Marie was born on 1 October 1899 as a daughter of Anna, née Slouková, a housewife, and František Hloušek, a shoemaker, in the town of Boskovice in Austria-Hungary. Her parents had four children. Of four siblings, only Marie and Anna (b. 1903) survived into adulthood, which was a fairly common ratio in the poorer Bohemian households of the time (Lenderová, Jiránek and Macková 2010, 156–63).

Marie was the first female alumna of the Boskovice grammar school, and the school was to play a major role in her life, as its graduation certificate, the 'maturita', was a necessary milestone for university attendance. Boskovice is a small town, close to Brno, the industrial centre of southern Moravia. It did not have a grammar school until 1900, and when this important institution of secondary education was eventually established, it was only for boys. Girls could attend a few years later, but only as 'private pupils' or 'guest pupils', as they had been defined. The second 'private' female student was the daughter of the headmaster. Allegedly, her mother urged young Marie to study diligently to break away from a life of drudgery, and indeed Marie achieved good grades throughout. In 1917, she is the only girl amid the class photo full of young men in three-piece suits, tucked away in a back row – whether because of a strategic decision of a teacher or her own inculcated diffidence, we don't know. Yet two years later, a determined looking young woman in the finalists' photo sat next to the teachers in the front row, as if mirroring the post-World War recognition of women.

Although some Bohemian girls could attend schools in Prague from the 1890s onwards, Marie's was still a rare case in the smaller, less affluent towns of the Empire. Schooling offered opportunities for female clerks, typists and teachers. These jobs offered a sustenance for dowry-less daughters of Austrian bureaucracy and small entrepreneurs and artisans (Pešek and Ledvinka 1996, 213 and Neudorflová 2001, 85–91). The unmarried woman requiring to earn her own living was the major dynamic force of change (Vošahlíková 1996, 116; Krásnohorská 1881, 17). These young women got a chance to punch above their social weight. By attending such a school, the shoemaker's daughter from Boskovice, whose prospects would have been otherwise framed locally, acquired a chance to ride the wave of the drastic social and political change.

In October 1918, Bohemia ceased to be part of the multinational empire of Austria-Hungary. The making of Czechoslovakia was something of a paradox, as it was promoted at Versailles conference negotiations as an establishment of a national state, but in fact it was a carving of a smaller multinational republic out of a larger multinational monarchical body (Lukes 2011, 894). Change in the new republic's legislation meant that Marie, along with all other young women, no longer had to attend a few select grammar schools to complete her secondary education, as it was now possible to take the final exam in her hometown – a privilege hitherto reserved for young men only. In 1919, she started her course as a student of the Charles University (Univerzita Karlova) in Prague.

She chose the opportunity to study French, alongside theoretical studies in philology and pedagogy, and this led her to further academic, and potential, career openings. The twenties were a time of intense French-Czechoslovak cooperation, and academic exchanges were but one symptom. At the same time the French Institute of Oriental Archaeology in Cairo opened the doors to another student from Prague, at that point unknown to Marie, Jaroslav Černý (Navratilova 2018b), who, just like Marie, at that point had also defined himself as 'non-denominational' in the University records, as opposed to their ancestral Catholicism.

Marie visited France several times. During one of these trips in the mid-1920s she met Thomas Sargant, future justice activist (and the person behind the BBC series Rough Justice, as well as establishment of offices of ombudsmen; Goodhart 2004), six years her junior. In 1925, Sargant, barely twenty, stopped in Montpellier on his European travels. There must have been a relatively rapid romance, as two years later he proposed marriage and tried to convince Marie to move to London with him – despite his parents' concern that their son was not yet ready for such a commitment. Norman Sargant wrote to Marie's parents: 'I think that both Tom and Manya have a lot to learn about love: As soon as I am sure that a strong and lasting love exists between them I will get in touch with you.' Norman Sargant thoughtfully wrote the letter originally in German, so that Marie's parents

could read it without a translator intervening in private family matters. The Sargant family had evidently placed a premium on good education including foreign languages.

Teacher and Mother

Eventually Marie moved to London, and at first had a job at the Channing School for girls in Highgate, North London, where she was teaching French. As Norman Sargant noted to her parents, she was growing accustomed to the 'English life and customs', and was learning English as she went. She married Tom Sargant in Islington on 7 September 1929, she a thirty-year-old woman with qualifications and job prospects, he a twenty-four-year old helping his father in the family business. Consequently, Marie lost her Czechoslovak citizenship and became a British subject, as according to a discriminatory interwar law in Czechoslovakia, women who married foreigners were deprived of their native citizenship automatically. This law was one of several elements of Czechoslovak interwar legislation that had shown a rather complex position of women in the republic (Feinberg 2006), and its effects raise the issue of relations of gender and citizenship (Feinberg 2006).

The Sargants had two daughters, Anna born in 1930 and Naomi in 1933, and continued to live in North London, close to Thomas's parents. Marie also kept visiting her Czechoslovak family in Boskovice, and remained quite close to her sister Anna, Anduli in family parlance. However, her marriage began to founder several years after the birth of Naomi. It was probably in or around 1936 when Thomas Sargant began a relationship with another woman, and the couple separated, Marie initially protesting against a divorce. In 1936 or early 1937, she left the family home in Hornsey Lane and moved with her two daughters to a flat in Shepherd's Hill. She also began to work on her qualifications and enrolled at University College.

Tom Sargant was paying alimony to Marie, and the girls were enrolled in respectable schools. Meanwhile, she had a growing circle of British friends, and simultaneously maintained her Czechoslovak connections. With the Munich treaty and the subsequent German invasion to Czechoslovakia (in 1938 and 1939, respectively), Marie's life between the UK and Czechoslovakia came to an end. She just about managed to get out of Czechoslovakia after a family visit in September 1938, leaving the country in a hurry with her daughters; she was not to see her family for seven years.

War Years

In 1938, she moved her daughters to Harpenden in Hertfordshire, where some of her friends lived, and later (from 1941) the girls attended the boarding school in Saffron Walden. She tried to build her professional

position again as a teacher, but with the outbreak of war she felt she could be of use to the Czechoslovak exile resistance, whose headquarters were situated in London. She began lecturing on various Czechoslovakia-related themes as a volunteer, and soon was determined to become part of the war effort. Within a year of developing more sustained activities as a lecturer, in March 1942, she submitted a memorandum outlining her activities to Dr Max Lobkowicz, minister plenipotentiary to the UK of the Czechoslovak government in exile. In April 1942, her position was made official with a letter stating that the Ministry of Foreign Affairs noted her 'existing propaganda work in British and Allied circles' and named her an 'external collaborator of the Information bureau' with the task of pursuing further educational activities at British schools and in women's organizations specifically. Her monthly allowance was £20, which helped to cover her travel expenses but was not comfortable to live on.

In the same year she finally agreed to the divorce from Thomas Sargant who remarried soon thereafter. By the end of 1942, her roles included a governmental employee, a teacher, educationalist and also, on a personal front, a mother in wartime, and a divorcee. This last element of her status triggered financial instability and perhaps her own emotional insecurity, but she faced no discrimination socially. Marie continued to live at different London addresses, such as Brompton Square or Holland Park, giving the impression that she on occasion lodged with various friends. Perhaps her renewed professional position, her activism – and ultimately a growing self-reliance – gave her the confidence to finalize the dissolution of her marriage. The war trauma inspired her, although this trauma and Marie's response were of a very different kind compared to that of Kim Hak-soon. Marie had the opportunity to be on the fighting side, and the wartime memories were to be laid to rest later.

Marie was contributing, albeit within a governmentally sanctioned position, to the strong list of activities by various Czechoslovak charities settled or established in the UK by the expat communities. Some of the charitable activities, including meetings, lectures or theatre performances, were oriented largely inside the Czechoslovak exile community, but others had a broader remit. These were typically musical performances for British audiences, exhibitions, including of folk culture, and public lectures that could help to dispel the dreaded impact of Neville Chamberlain's words about a 'far away country' and 'people of whom we know nothing' (compare Smetana 2014; Caquet 2018 and Neville 2019). Czechoslovakia was more exotic, and consequently less relevant, than the Empire (Judt 2012, 59). The Ministry of Foreign Affairs found it therefore very useful to inform and educate the British public on Czechoslovak matters. From her office in the Fursecroft Building at the corner of Edgware Road and Brown Street, Marie could easily visit a number of Czechoslovak, British and European organizations of various description, from expat clubs to established charities, with locations spread across London, from Bloomsbury to Ladbroke Grove (Srba 2003, 67–72).

Her objective was targeting the British public and charities specifically. She was in a good position to aim at British women and educational institutions as her previous networking brought her in close contact with schools, and the Women's Institute. In December 1942 she was added to the official panel of speakers of the Women's Institute as a specialist on Czechoslovakia. In terms of her workflow and travel plans, the decision meant, so she was informed, that 'counties would get in touch with you direct when they needed a speaker, and would make all arrangements'.

Her schedule between 1942 and 1945 included attending meetings of the International Women's Service Group, the Czechoslovak Red Cross, for which she had also successfully fundraised, and various local branches of the Women's Institute across London and the Home Counties. Marie's activities were recorded in countless letters, telegrams and references to phone calls that were required to organize her trips. She financed her own travels from her ministry allowance, which was raised to £26 monthly in 1943, and consequently she requested no fees or honoraria from her hosts.

Marie was tireless in identifying potential addressees of her educational work. On the one hand, she was very good at grassroots work, and addressed several rallies of the Girl Guides, approaching thus a younger segment of female audiences. On the other hand, she was in contact with the Czechoslovak section of the BBC – a prominent Slavist and another BBC employee Reginald de Bray was among her friends – and campaigned for major publication projects, such as the 'Spirit of Czechoslovakia' (periodical, printed by the Unwin Brothers). For the latter, she approached Lady Violet Bonham-Carter (Baroness Asquith) and the Duchess of Atholl as potential sponsors. Both noblewomen were well-known opponents of appeasement, and interested in the Czechoslovak situation. It was an intense schedule and it brought Marie in contact with a wide range of social groups and diverse communities, all connected by interest in education, and potentially open to what she had to say about her country of origin. By that time, she must have had an excellent command of English, and an ability to work with a range of British audiences. As a British citizen of Czechoslovak origin, she was in a specific position of a dual allegiance.

In January 1944, during one of her workdays in the Fursecroft, she met a newcomer to London, former employee of the Czechoslovak legation in Cairo, Dr Jaroslav Černý. Černý was a fresh arrival from a diplomatic posting in Egypt, and like Marie had an international – and idiosyncratic – professional trajectory. He was an Egyptologist, a clerk, an accountant and a diplomat (Bierbrier 2012, 110–12).

Collegial meetings in the office led to friendly meetings outside it. In 1944, and 1945, a sort of wartime romance blossomed, easily crossing the boundaries expected for unmarried couples (Herzog 2016). The narratives of wartime sexuality encompass issues of liberation, as well as exploitation and control (Summerfield and Crockett 1992; Delano 2000), but women in wartime were certainly not 'only as the controlled or victimised objects of

male power' (Summerfield and Crockett 1992, 451), and Marie had entered this relationship on her own free will, and maintained it on her own free will, taking care of her own reproduction issues (by using birth control). She was not likely to have been in need of some quid pro quo with Jaroslav, and the relationship was thus based on mutual attraction. Jaroslav later recalled wistfully their time together during the war.

At that point they were living at different addresses and not really involved in one another's private lives on a daily basis, within a shared domestic setting. Marie eventually settled in a leased house at Highgate, having previously changed many addresses in an attempt to escape from the Blitz, while her daughters were still in boarding school and saw their mother only occasionally. At the end of 1945, with the end of the war, Jaroslav left for Prague and for an uncertain future, although his British Egyptological contacts – independent scholar and sponsor of Egyptology Alan Gardiner and professor of Egyptology at the UCL Stephen Glanville – were suggesting a possibility of a longer-term professional engagement in the UK. There were regular letters coming from Jaro (as he was then known to friends and family), roughly with ten days to fortnightly intervals. He demonstrated a clear interest in maintaining the relationship with Marie.

New Partnership

In 1946, Jaro's situation changed substantially with an invitation of the University College London to take a professorial chair, which he accepted. He hoped that a shared life with Marie was now a possibility. He was aware of a new element in their life – cohabitation, and wrote to Marie that while they should be together, they should also retain some of their respective freedoms. However, whether Jaro was actually aware of practical details of a life in a shared household, it was far from clear. So far, he had lived either in diverse serviced living arrangements (such as in excavation houses and camps, in a large household of Alan Gardiner, his British sponsor and mentor, in boarding houses or hotels), or with his mother, who presumably took care of his domestic needs. This did not bode well for settling in with a partner and the partner's children. There was a personal as well as a generational challenge, as Marie's older daughter Anna planned to live with her mother while studying in London.

During 1947, Jaro moved as a lodger of Marie Sargant into a house at 2 St Michael's Terrace in Highgate. Jaro and Marie now shared a household as an unmarried, cohabiting couple. Some friends of Marie were in shock. From their perspective, it was clear that 'M. and Černý must marry as it would not be possible for a university professor to live in such a way'. Her daughter Anna, although she observed the outrage, and was privy to her mother's apparently unusual domestic establishment, took the matters in her stride.

Their lifestyle was considerably influenced by the rhythm of the academic year. Jaro took Marie with him to official functions as his recognized partner, but soon began to suggest that they ought to regularize their position and wed. In a strong contrast to the stereotype of wedding-obsessed women, it was Marie who hesitated, but it was hardly because she would have been averse to commitment. Rather, there was her experience that commitments were not always honoured. Following Thomas Sargant to London, she had completely changed her life, her citizenship and her allegiances, and then was left on her own, to fend for herself with two children to look after. The anger and resentment were likely to smoulder even if she found a way out of her situation, and validated her professional identity and social position.

In addition, Jaro, although he tried hard to fit in the new household, was rather prone to domestic ineptitudes. Debates about food quality were a regular occurrence – Jaro was an epicurean where food was concerned, and found it difficult to cope with continuing rationed supplies. Given his previous living arrangements, he had also yet to discover that domestic chores were not happening by some miracle behind the scenes. Clearly, there was a balance to be found. Jaro had a professional workload of teaching and publishing, a wide network that required extensive correspondence, and prepared for excavation travels in Egypt, which used to be a routine part of his working time, and renewed after the war hiatus at the end of 1949. And he was always prepared to help his new family, but initially chiefly on the same terms as he was used to with his (largely although not exclusively male) friends in academia. He was supportive of Anna Sargant's academic aspirations. As she recorded in her diary in 1947/8: 'Jaro keeps saying . . . he wishes that I had decided to study Egyptology – with my brain', and he was at hand for tackling homework and various assignments, such as Latin and later Czech and Old Slavonic university coursework as she was studying Slavonic languages at UCL.

Essentially, Jaro was not 'house-trained', but he was not hidebound or venerating ideals of dominant masculinity (compare Tosh 1994). Eventually, he could be persuaded to give a hand in domestic chores, but it was a gradual process. Anna was more successful when she was on her own, and simply asked the 'professor' to lend her a hand in the kitchen. Finally, as in the relationship with Sargant, Marie was thinking about the language question. She and Jaro communicated in English, with very occasional use of Czech. Interestingly, in a household full of philologists, this caused some worry regarding potential misunderstandings. 'M. is caught by this language question', observed Anna in her diary in July 1950.

Political situation also did not help anyone's equanimity – in February 1948, Czechoslovakia became firmly entrapped behind the Iron Curtain. Jaro refused to express his support to the new regime, as confirmed by his UCL personal file, or to return to Prague, when asked to renew his passport, and became unpopular with the new totalitarian regime that developed after a Communist coup. He eventually lost his Czechoslovak citizenship,

and remained a stateless person for the rest of his life. His contact with his family in Prague, and any friends and colleagues located there was cut, at least as far as direct personal communications were concerned. Marie's visa to visit her family became increasingly difficult to obtain, she was worried about her parents and sister, and obviously there was no place for her in Czechoslovak diplomatic service under the new system.

For both, this meant that their lives were now firmly anchored in Great Britain, and their Czechoslovak links were in jeopardy. For Jaro, the implication was that he was even more intensely interested in building a home, and that home involved Marie Sargant, as well as her daughters, if they so wished. But Marie was not prepared to accept a circumscribed domestic goddess role, waiting for her man to return from his adventurous travels. Neither was she ready to go into her next marriage without due consideration.

The situation worsened at the end of the 1950s when Jaro Černý had a nervous breakdown. It was his second major mental health problem. The first was framed by imminent danger of a German occupation of Egypt in 1942. The second was likely to be influenced by a build-up of tension related to his loss of the home country, deaths of two close friends in spring and autumn 1950, respectively, and his complicated position in relation to his employer, University College, when he was offered a chair of Egyptology at Oxford at the end of 1950. The domestic uncertainty when he felt judged and not fully accepted by Marie as a secure part of her life was not likely to be of any benefit. In turn, he was also not ready to see the situation from her viewpoint, which was that she was not willing to become a conventional wife, the silent helper. Now, however, she was also expected to be the carer. The winter 1950/1951 signalled a complicated time for Marie and Jaro's relationship, with Jaro's prolonged hospital stay in several mental health units in Maudsley Hospital and in the Bethlem Hospital in Beckenham. They emerged from it in spring 1951, with a help of Anna Sargant, Marie's daughter, on the domestic front, and of Jaro's psychiatrists on the medical front.

Jaro was in the care of Dr Erwin Stengel, who was of a rather firm opinion that attempted suicides – which is how Jaro's breakdowns manifested both in 1942 and apparently in early 1951 – were not those of histrionics or weaklings, but people in need of help: 'The suicidal attempt is a complex behaviour pattern based on a variety of motivations: the wish to die, the desire to attack others, the appeal for help, and the urge to challenge fate (Stengel 1961, 123).' Stengel interpreted suicidal attempts as messages to be decoded and, once 'the individual significance of the appeal inherent in the suicidal attempt' (Stengel 1961, 130) would be established, to be followed by a qualified intervention, including help from friends and family. He refused to accept a narrative that saw suicidal attempts as emotional blackmail, not to be acted upon. Instead, Stengel preferred to see suicide attempts as 'social appeals' to be effectively answered (Stengel 1961, 119–20). This approach

certainly worked in Jaro's case, although details of the therapeutic process are not known.

Marie, eventually, was prepared to give such help, but she wanted to do so on her own terms and not when taken for granted. She consented to marry Jaro, but then Jaro also became better at communicating his needs and expectations, although still prone to flowery small talk language: 'I only wish I might have the privilege to spend the rest of my journey in this world in your company.'

It was an offer of security as well as companionship. With Jaro, Marie was not expected to occupy a position comparable to Miss Hytti's, as Jaro relied on loyal secretaries in his university office. She was to travel with him and participate in his life in a companionate marriage, where the companions may accept different parts, but in a partnership of equals. They appear to have emerged from the crisis with a better idea about their future life. A step towards a shared future involved the wedding in June 1951, where both bride and groom had illustrious witnesses from their respective lines of work. Jaro's best man was Egyptologist Alan Henderson Gardiner, while his counterpart for the bride was Dame Katharine Furse, first director of the Women's Royal Naval Service, who used to represent the World Association of Girl Guides and Boy Scouts at the League of Nations.

It would be then easy to say that the rest is history. Jaro Černý went on to have a distinguished Egyptological career, supported by a devoted, loving professorial wife. Marie did not look for further gainful employment (and she had little opportunity finding any that would make use of her Czechoslovak and British connections), preferring to look after the household in Oxford, staying in touch with her daughters' families and doing what was expected of women in the 'family Britain' (Kynaston 2009) of the 1950s. It is also likely she did feel a sense of profound change, leaving behind a high-powered wartime job; however, the change was originally caused by a political upheaval, not by her marriage. Accordingly, she could easily fade into the background as a supporting figure, to be recognized in obituaries and remembered by friends and family, and forgotten by scholarship, bibliographies and history. But that would mean erasing years of companionship, of shared travels, months in Egypt throughout the 1950s and 1960s. It was a life of travel, framed by the demands of the academic year, sabbatical postings and Jaro's Egyptian fieldwork assignments, so very much dictated by his timetable. But Marie enjoyed the travels, and not only because of sunbathing in Egypt, which was referred to in the couple's letters. She was often with Jaro, and likely to be interested in some aspects of his work, because of her own training in philology and cultural history. She had also her own time and space – for instance when Jaro travelled on his own in the 1950s and 1960s, visiting French and Italian museums, Marie holidayed with her parents in Czechoslovakia (she could travel being protected to a certain extent by her British passport) or in Liguria. Upon one such return, when Jaro was in Paris and Marie in Bordighera, their rendezvous was

at home in Linkside Avenue, North Oxford, and Jaro, being the first to arrive, was tasked with shopping. On other occasions, they met in Paris and travelled back together.

The 1950s and the 1960s found the Černýs also on-board expedition boats on the Nile, when Jaro was asked to help with a UNESCO–supported recording project led by the Egyptian Centre de Documentation (CEDAE). This project was part of a new phase of Egyptian-led international cooperation in Egypt (Thompson 2018; Desroches-Noblecourt 1992). It represented an opportunity to enable international teams from across the world to come back to Egypt, including British and French teams whose position was complicated after the Suez crisis.

Jaro was in a specific position, that of a 'non-aligned' scholar, who did not embody any political camp. As a stateless person living in the UK, he was well positioned to spearhead collaborative projects organized by the Egyptian side but including a strong international aspect. This brought him, alongside German and Italian scholars especially, to Egypt after the Egyptian revolution of 1952, after the Suez crisis in 1957 and again in the 1960s in connection with the Aswan dam campaigns (Navratilova 2018a). Marie's participation was planned as part of his travel packages, recognizing her role that was indispensable to Jaro. In Nubia, she was probably not directly involved in copying the texts and reliefs in the field, but later, in another epigraphic campaign, there came a culmination of their partnership, namely in the epigraphy research in Western Thebes in the late 1960s. There, Marie the philologist was awakened, as she roamed the hills of the Western bank of the Nile opposite the modern city of Luxor. The mission was spearheaded by her own husband and his long-term friend, female Egyptologist Christiane Desroches-Noblecourt, so Marie's place could not have been doubted, but she earned actual respect of her colleagues by her efficiency and attention to detail.

The target was Egyptian graffiti in the so-called Theban Mountain area. These seemingly inconspicuous texts and figures contained names and titles of people who lived in Western Thebes and belonged to a privileged local community of artists and artisans. Their religious interests, work schedules, as well as family relations, can often be gleaned from graffiti. Walking in their footsteps, Marie, Jaro and their Egyptian and French colleagues were mapping an enormous corpus of thousands of texts. Their work was part of a larger project that included aerial photography, and recording of the pathways in the mountainous landscape.

Marie was working as member of an independent mapping unit with the Egyptian colleagues, verifying locations of individual graffiti previously mapped (Černý et al. 1969, VII, 1970, 1971). The Theban cooperation lasted until the end of Jaro's life. The last shared expedition to Thebes took place in spring 1970. Two volumes of the resulting publication 'Graffiti de la Montagne Thébaine' noted the collaboration of 'Mana Černa' using a diminutive form of her name and a Czech suffix indicating a female surname. She is listed as a co-author.

On Her Own Terms

On 29 May 1970, Jaro passed away suddenly, and the date of his death coincided with the date of the Introduction to the first volume of Graffiti de la Montagne Thébaine. After the initial shock, Marie was left in the position of a professorial widow, expected, among other things, to discharge the duty of a guardian and executor of her husband's will and legacy. Because of her professional approach and training, some colleagues expressed a suggestion that she should finish Jaro's unfinished work. Marie, however, did not consider herself her husband's professional heir, nor did she read Egyptian or have these aspirations. The books on the community of workmen of Deir el Medina, as well as the Late Egyptian Grammar, were finished by others (see also James 1971).

She duly took charge of the correct settling of Jaro's will, which involved providing access to his papers to those scholars who wanted to use his manuscripts and finish some of the posthumous work. Jaro's research archive, including large parts of his correspondence, was bequeathed to the Griffith Institute at the University of Oxford. His library was despatched to Prague to support a fledgling Egyptological institute at the Charles University. Marie kept her own family archive, and select parts of it were added to Jaro's archive collection at the Griffith Institute later on. Marie was instrumental in maintaining and preserving this Egyptological legacy, but she left other legacies of her own. Her wartime work was forgotten, which was probably due to political climate in Czechoslovakia which changed only two years before her death, but her daughters Anna and Naomi had full-time academic careers as well as families. Marie was not abandoned, unlike Maissi Erkko, and her husband's network as well as her family surrounded and supported her. She even travelled to Egypt on her own.

In 1991, Marie Černý died in Oxford and was buried next to Jaro Černý at Wolvercote Cemetery in North Oxford, close to Edith and J. R. R. Tolkien, Eleanor Lodge (the first woman recipient of a D.Litt. by the University of Oxford and vice-principal of Lady Margaret Hall), the parents of T. E. Lawrence ('Lawrence of Arabia'), or later arrivals, philosopher Isaiah Berlin and historian Albert Hourani. The Černý tombstone says 'together in the garden of Sennedjem'. This reference to being united in the ancient Egyptian paradise, epitomized by a garden, is a fitting one. Marie chose to be the spouse of an Egyptologist, including being a 'professorial wife', but she did so with an agency of her own as one of her life roles that brought concessions to the dominant image of femininity, but also new opportunities, suggesting a manoeuvring space for female roles that could have been negotiated variously even in the times just before a second-wave feminism. Labelling her as a 'victim' would imply belittling her decisions and the variety of contributions she made to the lives of others. Finally, her life story ought to be recognized as a relevant case for transnational,

'migrant' lives that contributed to more than one country (Deacon et al. 2010), and more than one community. She – like her husband, but on her own terms – is a voice for citizens of nowhere.

Archives

The Griffith Institute Archive, University of Oxford
The Allott Family Archive
The Archives of the Institut Français d'Archéologie Orientale, Cairo
Archives of the Ministry of Foreign Affairs of the Czech Republic, Prague
The National Archives, Kew

Bibliography

Bierbrier, Morris L., *Who Was Who in Egyptology*, 4th rev. edn. London: EES, 2012.

Caquet, Pierre E., *The Bell of Treason: The 1938 Munich Agreement in Czechoslovakia*. London: Profile Books, 2018.

Černý, Jaroslav, Christiane Desroches Noblecourt, Marcel Kurz, Marcel Dewachter and M. Nelson, *Graffiti de La Montagne Thébaine I[,1]: Cartographie et Étude Topographique Illustré*, Collection Scientifique. Cairo: CEDAE, 1969.

Černý, Jaroslav, Aziz A. Sadek, Hassan el-Achiery, Muhammad Shimy and Marie Černý, *Graffiti de La Montagne Thébaine III (1er. Fasc.)-(2ème. Fasc.): Fac-Similés*, vol. 13–14, Collection Scientifique. Cairo: CEDAE, 1970.

Černý, Jaroslav, Aziz A. Sadek, Hassan el-Achiery, A. Chérif, Muhammad Shimy and M. Černa, *Graffiti de La Montagne Thébaine III, 3: Fac-Similés*, vol. 15, Collection Scientifique. Cairo: CEDAE, 1971.

Deacon, Desley, et al., *Transnational Lives: Biographies of Global Modernity, 1700-Present*. Basingstoke: Palgrave Macmillan, 2010.

Delano, Page Dougherty, 'Making Up for War: Sexuality and Citizenship in Wartime Culture', *Feminist Studies* 26, no. 1 (2000): 33–68.

Desroches-Noblecourt, Christiane, *La Grande Nubiade, ou, Le parcours d'une égyptologue*. Paris: Stock/Pernoud, 1992.

Feinberg, Melissa, *Elusive Equality: Gender, Citizenship, and the Limits of Democracy in Czechoslovakia, 1918–1950*. Pittsburgh: University of Pittsburgh Press, 2006.

Goodhart, William, 'Sargant, Thomas (1905–1988), Law Reformer', in *Oxford Dictionary of National Biography*. Oxford: Oxford University Press, 2004.

Herzog, Dagmar, 'European Sexualities in the Age of Total War', in *The Oxford Handbook of European History, 1914–1945*. Oxford: Oxford University Press, 2016.

James, T. G. H., 'Jaroslav Černý', *The Journal of Egyptian Archaeology* 57, no. 1 (1971): 185–9.

Judt, Tony, *Thinking the Twentieth Century*. London: William Heinemann, 2012.

Krásnohorská, Eliska, *Ženská otázka česká*, Epištoly svobody 29 (1881).

Kynaston, David, *Austerity Britain*. London: Bloomsbury, 2009.

Lenderová, Milena, Tomáš Jiránek and Marie Macková, *Z Dějin České Každodennosti: Život v 19. Století*, Vyd. 1. Praha: Karolinum Press, 2010.

Lukes, Igor, 'Mary Heimann. Czechoslovakia: The State That Failed', *The American Historical Review* 116, no. 3 (2011): 893–4.

Navrátilová, Hana, 'Layered Agendas: Jaroslav Černý, Stateless Egyptologist between Decolonization and the Cold War', *Prace z Dějin Akademie Věd* 10, no. 1 (2018a): 53–7.

Navratilova, Hana, 'The Road to Mounira', *Bulletin de l'Institut Francais d'Archéologie Orientale* 118 (2018b): 283–316.

Neudorflová, Marie L., *Charlotta G. Masaryková: sborník příspěvků z konference ke 150. výročí jejího narození, konané 10. listopadu 2000*. Praha: TGM, Masarykův ústav Akademie věd ČR, 2001.

Neville, Peter, *The British Attempt to Prevent the Second World War: The Age of Anxiety*. Newcastle upon Tyne: Cambridge Scholars Publishing, 2019.

Pešek, Jiří, and Václav Ledvinka, eds, *Žena v dějinách Prahy: sborník příspěvků z konference Archivu hl. m. Prahy a Nadace pro gender studies 1993*. Praha: Archiv hlavního města Prahy, 1996.

Smetana, Vít, *In the Shadow of Munich: British Policy towards Czechoslovakia from the Endorsement to the Renunciation of the Munich Agreement (1938–1942)*. Praha: Karolinum Press, 2014.

Srba, Bořivoj, *Múzy v exilu: kulturní a umělecké aktivity čs. exulantů v Londýně v předvečer a v průběhu druhé světové války 1939–1945*, Spisy Masarykovy univerzity v Brně, Filozofická fakulta 344. Brno: Masarykova univerzita, 2003.

Stengel, Erwin, *Attempted Suicide: Its Social Significance and Effects*. London: Oxford University Press, 1961.

Summerfield, Penny and Nicole Crockett, '"You Weren't Taught That with the Welding": Lessons in Sexuality in the Second World War', *Women's History Review* 1, no. 3 (1992): 435–54.

Thompson, Jason, *Wonderful Things*, vol. 3. Cairo: AUC Press, 2018.

Tosh, John, 'What Should Historians Do with Masculinity? Reflections on Nineteenth-Century Britain', *History Workshop Journal* 38, no. 1 (1994): 179–202.

Tuckett, Alan, 'Sargant, Naomi Ellen, Lady McIntosh of Haringey (1933–2006), Broadcaster and Educationist', in *Oxford Dictionary of National Biography*. Oxford: Oxford University Press, 2014.

Vošahlíková, Pavla, *Jak se žilo za časů Františka Josefa I*, Vyd. 1. Praha: Členská knižnice, 1996.

8

Breaking the Silence and Inspiring Activism on Japanese Military Sexual Slavery

Legacy of Kim Hak-soon (1924–97)

Woohee Kim

This is the historical truth that needs to be revealed,
so I decided to come forward.

— KIM HAK-SOON, first public testimony on 14 August 1991 (quoted with the
permission of the War and Women's Human Rights Museum; The Korean Council)

Like many women in this volume whose stories had been left untold, the
women who were forced into sexual slavery by Japanese military during
the Second World War were silenced for decades. This chapter sheds light
on Kim Hak-soon, a survivor and activist who brought public attention to
stories of sexual slavery, violence and atrocities that remained buried for
nearly fifty years. Stories of war are often told through the perspectives of
men and often lack gendered lenses. This is not an exception for the Second
World War and its battles fought in the Asian and Pacific regions, known as
the Asia-Pacific War. Behind the often-glorified stories of male soldiers and

leaders of this era such as US general Douglas McArthur, Japanese emperor
Hirohito, and Winston Churchill, however, remain darker and long-silenced
stories of ordinary women who were never expected to be remembered,
let alone achieve any political or social prominence. Such were the 'comfort
women' who had been forced into sexual slavery by the Japanese military
during the war.

Kim Hak-soon was the first Japanese military 'comfort women' to
publicly testify her experiences on 14 August 1991.[1] Until she came forward,
the history of such 'comfort women' had been silenced for decades. Who
was Kim Hak-soon? How did she break the silence? What legacies has she
left us? This chapter aims to answer these questions by examining Kim
Hak-soon's life and testimonies, the historical contexts surrounding her
experiences, and the influences Kim had on the Japanese military sexual
slavery redress movement. In doing so, I trace the life of one courageous
woman who raised global awareness on the Japanese military sexual slavery
issue and contributed to the heightened international attention on sexual
violence in armed conflicts around the world.

Japanese Military Sexual Slavery System

Between 1932 and 1945, over 200,000 women were forced into sexual
slavery by the Japanese military (Sonen 2012; United Nations 1998).
Women from regions occupied or colonized by Japan, including Korea,
China, the Philippines, Taiwan, Indonesia, Malaysia, East Timor, as well as
the Netherlands and Japan, were taken to 'comfort stations' established by
the Japanese military throughout the battlefields of the Asia-Pacific War.
They were subjected to brutal sexual violence at the hands of anywhere
from ten to one hundred men per day, physical abuse, torture, burning,
stabbing and other atrocities (Yang 1997).

Many women were abducted, coerced or recruited under fraudulent
promises of factory jobs (Chung 1997). Once taken to 'comfort stations',
they had no freedom of movement, residence, or occupation (McDougall
2013). Radhika Coomaraswamy, the United Nations Commission on
Human Rights Special Rapporteur on violence against women, stated that
'the practice of "comfort women" should be considered a clear case of
sexual slavery and a slavery-like practice in accordance with the approach
adopted by relevant international human rights bodies and mechanisms'
(United Nations 1996, 4).

The sexual slavery system targeted the most vulnerable women – women
from low-income and marginalized backgrounds, often in countries that
Japan had colonized – thus standing at the intersections of gender, class,
race and nationality in colonial and patriarchal systems (Min 2003; Sonen
2012). Among the 240 survivors who came forward in South Korea, most
were between the ages of eleven and twenty-nine when they were forced

into the Japanese military sexual slavery system with the average age being seventeen (Kim-Gibson 1999).

The Japanese military systematically built and managed 'comfort stations'. The military had decision-making authority over the recruitment and transport of 'comfort women' and in the establishment and control of 'comfort stations' (Yoshimi 2002). 'Comfort stations' operated under systemic regulations regarding hours of service, hygiene and physical examinations for venereal diseases imposed by the Japanese military. These regulations demonstrate not only that 'Japanese forces took direct responsibility for the comfort stations and were intimately connected with all aspects of their organization, but they also clearly indicate how legitimized and established an institution the stations had become' (United Nations 1996, 6).

The first 'comfort station' was established in 1932 by the Japanese Expeditionary Army in Shanghai, after Lieutenant-General Okamura Yasuji requested a 'comfort station' to be established for the military (Chung 1997). After Japan entered the Second Sino-Japanese War and was internationally criticized for the atrocities committed during the Nanjing Massacre in 1937, the Japanese military further expanded 'comfort stations' (Yang 1997).

Japan established the military sexual slavery system to reduce rape against civilians and lessen anti-Japanese sentiments in occupied regions, decrease the likelihood of soldiers contracting venereal diseases and protect military secrets (Argibay 2003). Masculinist assumptions that normalize male sexual desire as natural instinct and portray women as sexual objects were used in justifying the system and are reflected in the Japanese military's historical use of the term 'comfort women' (Northeast Asian History Foundation 2014).[2]

The history of Japanese military sexual slavery was silenced for almost fifty years after the end of the Second World War. After Japan's defeat in the Second World War, some Japanese military 'comfort women' were killed by Japanese soldiers who feared that the atrocious sexual slavery system would be known to the public if the women were allowed to survive, and others were simply abandoned without being told that the war had ended (Chung, 1997). Survivors who were able to return to their homelands found it difficult to talk about their experiences in patriarchal societies. With values of female chastity still strictly upheld in society, most women experienced intense social stigma. The patriarchal culture 'reinforced the marginality of female body politics such as rape' while sexual violence was cast as an unfortunate personal issue (B. Yoon 2010, 34). Kim Hak-soon, as many other survivors had done, struggled with feelings of 'shame' when she was younger and recounted that all she could do was to shed tears silently (Newstapa 2016).

In addition, geopolitical factors further limited the proper prosecution of Japanese servicemen for crimes against humanity committed in the sexual slavery system. The Japanese military sexual slavery system was not addressed in the International Military Tribunal for the Far East in the aftermath of

the Second World War, although the presence of US military documents that recorded Japanese military sexual slavery such as the Southeast Asia Allied Translator and Interpreter Section report suggests that Allied Forces were aware of the sexual slavery system before the war ended (The Korean Council 2020; B. Yoon 2010). Furthermore, the United States pressured Asian allies not to raise issues of reparations for war crimes committed by Japan, as the country was positioned as an important anti-communist ally for the United States in the Asia-Pacific region (N. Lee 2014).

Breaking the Silence: Kim Hak-soon's Testimony

Kim Hak-soon gave the following public testimony about her experiences as a Japanese military 'comfort woman' on 14 August 1991:

> My name is Kim Hak-soon and I was forced to serve as a Japanese military 'comfort woman'. I was determined to speak after seeing the news [about the Japanese government denying the history of Japanese military sexual slavery]. This is not right. I needed to correct this. I don't understand why they are lying. So I came forward. I was not asked to do this. I am coming forward out of my own will. I am almost 70 now. I am fine with dying as I'm quite old. I was afraid when I first decided to come forward. But at least I wouldn't have any regrets when I die. I will say all that I have really wanted to say. My arm was being pulled and they told me to follow them. I tried to resist as I was afraid. He kicked me and said you will be left alive if you listen to me but if you resist, I will kill you. In the end, I was raped . . . the utterly brutalI can't speak. I can't talk about this anymore. We need to know this [history]. We need to know that this happened in the past. (e-museum of the victims of Japanese military sexual slavery, 2018, translated Woohee Kim)

Kim Hak-soon was born in 1924 in Jilin, China, where her family fled to escape oppression from the Japanese colonial rule over Korea. Her father, who supported the Korean Independence Army, died a few months after Kim Hak-soon was born. After his death, she and her mother moved back to Pyongyang. Her mother worked various jobs and raised Kim Hak-soon by herself while Kim attended a school run by a local church for four years. Her mother remarried when Kim was fourteen. Due to disputes with her stepfather, Kim was sent to a foster family where she was trained for kisaeng (professional entertainers using poetry, traditional music and dance).

Kim graduated from her professional training in 1941, but was not allowed to work as her profession required her to be at least nineteen while she was still seventeen. Her foster father then travelled with her and her

foster sister to China, hoping to earn money there. Upon their arrival in Beijing, they were taken away by Japanese soldiers who suspected her foster father to be a spy. The soldiers told Kim Hak-soon and her foster sister to get on a truck; Kim and her sister resisted but were abducted. She was forced into sexual slavery in a military base in Cheolbyeokjin, near Beijing, at the age of seventeen.

In a testimony she gave in 1991, she tearfully recounted:

> It was just despicable. The Japanese soldiers raped me, one after another. I bit my lips and tried to resist and escape. But then I was caught and dragged back to be raped over and over again. I was so horrified and heartbroken that I could not say a word. I tell myself all the time, 'Don't think about those days.' But when I do, I don't know what to do. (Newstapa 2016)

At the 'comfort station', Kim faced sexual violence by seven or eight soldiers a day and was severely beaten when she resisted. She had to serve soldiers even when she was menstruating, with cotton or pieces of clothes used as a makeshift tampon to stop the bleeding. Many other survivors shared similar stories to Kim Hak-soon's, such as Kim Bok-dong, who had to spend five years at 'comfort stations' in Indonesia, Singapore and China during which she was assaulted by up to fifty soldiers a day, and Chung Ok-sun, who was abducted to a comfort station where she and other Japanese military 'comfort women' were tortured and assaulted, with some brutally killed.

After four months, Kim Hak-soon escaped the 'comfort station'. Although Kim had been looking for opportunities to break free throughout her time in the comfort station, the military base was heavily guarded by soldiers. Even if she passed through the guards, she was in a region foreign to her and did not know the roads. Kim begged a Korean man, a merchant who was wandering around China, to help her, and escaped from the comfort station at around 2.00 or 3.00 am while most of the soldiers were still away on expeditions.

After escaping, she settled in Shanghai with the man who helped her. Having given birth to a son and a daughter in Shanghai, Kim returned to South Korea in 1946 with her family. They stayed in a refugee camp in Seoul for the first three months, during which Kim's daughter died of cholera. After the Korean War, her husband died in a construction accident. While he was still alive, Kim suffered verbal abuse from her husband, who often reproached her for her past, especially when drunk. His insulting remarks, sometimes made in front of her son, left Kim with deep emotional scars. Her son died later of a heart attack while swimming. After the death of her immediate family, Kim sustained a difficult life working menial jobs. She recounted that she had even tried committing suicide but failed.

Kim Hak-soon decided to go public with her account after being infuriated by the Japanese government's denial of the history of Japanese military

sexual slavery. She said, 'hearing Japan say that they didn't mobilize Japanese military "comfort women" on the TV and newspapers breaks my heart' (The Korean Council). Having wanted to share her resentment of what Japan had committed, Kim revealed to a Korean victim of nuclear bombing in Japan that she had been a Japanese military 'comfort woman'. This person connected Kim to the Korean Council for Women Drafted by Japan for Sexual Slavery, an advocacy organization that supported her in giving a public testimony. Her decision to come forward was also prompted by the lack of immediate family members.

On 14 August 1991, Kim Hak-soon stood in front of reporters and publicly shared her story. Her deeply painful account shocked many people who watched her testimony on television. Kim Hak-soon's courage broke decades-long silence on the history of Japanese military sexual slavery. However, disclosing her brutal experiences was not easy. When interviewed for an oral history collection which documented testimonies of many Korean 'comfort women' survivors, Kim revealed that it was difficult for her to bring back those memories when testifying (The Korean Council and The Korean Research Institute for Military Sexual Slavery 2012). In a 1997 testimony, she said:

> I'm just so angry and furious, I don't know how I am going to alleviate this anger. The more I think about it, the stronger my anger and resentment become. I am so furious about the whole thing that I may die from anger. It's probably why I have difficulties breathing from time to time. (Newstapa 2016)

Kim Hak-soon said she felt nauseated at the sight of the Japanese flag, and whenever she heard Japanese military 'comfort women' being mentioned, her chronic asthma worsened and she had difficulty breathing (M. Yoon 2016). Yet the emotional and physical pain that had suffocated her for decades did not stop her from testifying, as the fear of the truth being left untold terrified her more than her fear of the Japanese military:

> After we die, once we all die, I thought no one will be left to say anything after I die. Even to this age, even after all these years what I am most fearful is about how Japanese soldiers kill people. I saw so many killings while I was captured. Having witnessed many people being murdered, I was afraid to speak out when I was younger. But how could I live without saying a word [about what happened]? So that's why I decided to share my story before I die. Even if it meant risking my life. There may be no one else but me to tell the story. That's why. (Newstapa 2016)

Kim donated her lifelong savings of 20 million won (US$17,900) to people from disadvantaged backgrounds and demanded a sincere apology from Japan in her will before passing away in December 1997 (M. Yoon 2016).

Inspiring Activism: Kim Hak-soon's Legacy

After Kim's public testimony of 14 August 1991, 240 survivors came forward in Korea and many more survivors started testifying about their experiences in Japanese military sexual slavery. Jan Ruff O'Herne, a Dutch-Australian survivor who was active in the redress movement, decided to come forward after watching Kim Hak-soon's testimony on television (McGregor 2016). Another Korean survivor, Hwang Geum-Joo, came forward as a survivor herself after watching Kim's testimony (The Korean Council). Kim's testimony sparked a form of #MeToo from Japanese military 'comfort women' survivors around the world.

Behind Kim's historic decision to share her story was the growing public awareness of women's rights and violence against women, which was heightened by the emerging global feminist movement and the sex-torture case of Kwon In-Sook in South Korea (B. Yoon 2010). Kwon had testified against the police in 1986 for sexual assault. Also in Korea, Professor Yoon Chung-Ok of Ewha Women's University presented her research on the Japanese military sexual slavery issue at a conference on sex tourism in 1988, which drew the attention of grassroots women's organizations (S. Kim and Lee 2017). In 1990, thirty-seven women's organizations joined to form the Korean Council for Women Drafted by Japan for Sexual Slavery, now The Korean Council for Justice and Remembrance for the Issues of Military Sexual Slavery by Japan (The Korean Council). Despite the rising research and activism, Japan denied the sexual slavery system. Kim Hak-soon's testimony thus became a crucial turning point in the history of the movement.

After coming forward, Kim Hak-soon sought justice and redress for Japanese military 'comfort women' throughout the rest of her life. On 6 December 1991, Kim, along with thirty-four other plaintiffs including two other Japanese military 'comfort women' survivors, filed a lawsuit in the Tokyo District Court against the Japanese government for human rights violations during the Second World War (Hicks 1995). They demanded (1) an official apology; (2) payment of 20 million yen (US$154,000) to each survivor; (3) a thorough investigation of their cases; (4) the revision of Japanese school textbooks to educate the history; and (5) the building of a memorial museum.

Following the lawsuit, the Japanese government launched an investigation into the Japanese military sexual slavery system. In the subsequent statement made by Chief Cabinet Secretary Kato in 1992, Japan reversed its prior official stance of June 1990 which claimed no responsibility for victims of Japanese military sexual slavery. However, the statement was criticized for denying legal responsibilities and forced mobilization of Japanese military 'comfort women' (M. Yoon 2016). After criticism, Chief Cabinet Secretary Kono released another statement in 1993 with the second conclusion of the governmental investigation, which partially admitted the military's involvement but did not fully acknowledge the state's role in recruiting and managing such 'comfort women', thus evading legal responsibilities again (Amnesty International 2005). These statements were issued by government

officials as individuals and thus did not count as official apologies from the government of Japan. Nevertheless, Kim Hak-soon's legal activism played a key role in pressuring the Japanese government to stop denying their direct involvement in establishing and supervising the Japanese military sexual slavery system.

Kim's lawsuit was the first attempt initiated by former Japanese military 'comfort women' to seek redress through legal proceedings and was followed by lawsuits from Korean, Chinese, Taiwanese, Dutch and Filipina survivors (P. Kim 2020). Kim's case continued to be fought after her death but was dismissed by the Tokyo District Court in 2001. The Tokyo High Court also rejected the plaintiffs' appeal in 2003, stating that while the Japanese government had the obligation to protect 'comfort women' from danger, the plaintiffs' rights to demand compensation have expired. This decision was upheld by the Japanese Supreme Court in 2004.

By 2010, the Japanese judicial system had dismissed all claims brought by survivors of Japanese military sexual slavery for redress, apology and reparations (Abe 2013). However, a small victory emerged in Shimonoseki branch of the Yamaguchi Prefectural Court, which ruled that the Japanese Diet was constitutionally obligated to introduce a law for compensating 'comfort women' and that compensation of 300,000 yen (US$2,800) should be provided to the 'comfort women' plaintiffs (Totsuka 1999). In its ruling, the court stated that 'all of the "comfort women" plaintiffs were brought to the comfort stations through deception and forcefully turned into "comfort women" by rape' and that 'the comfort stations had deep relations with the Imperial Japanese Forces' (Okada 1999, 76). However, the decision was later overturned in the Japanese High Court (P. Kim 2020).

Although scholars have outlined Japan's legal obligations to pay legal reparations for crimes against humanity and war crimes under international law, the Japanese court has failed to provide redress for survivors of Japanese military sexual slavery (Amnesty International 2005; McDougall 2013). In light of such response, survivors and activists around the world organized the Women's International War Crimes Tribunal on 8–12 December 2000. This peoples' tribunal demonstrated the legal responsibility the Japanese Government should take for their war crimes and provided gender-based perspectives that called for an end to the cycle of impunity (Chinkin 2001; Matsui 2001). The movement for justice on the Japanese military sexual slavery issue continues to call for Japan's official apology and legal reparations. Recommendations from international organizations such as the United Nations and the International Labor Organization as well as countries including the United States, the Netherlands, Canada, South Korea, and Taiwan have also demanded the Japanese government to admit, officially apologize and accept legal responsibility for the Japanese military sexual slavery system (Abe 2013).

During her visit to Japan for the lawsuit in 1991, Kim gave testimonies in Tokyo, Osaka, Kobe, Nara and Sakai (Min 2020). In addition to sharing

her testimonies, she performed in a Korean theatre production, where she shared impromptu monologues of her painful past and present. Despite being occupied with the lawsuit and suffering from deteriorating health, Kim put a lot of effort into preparing for the performance and telling 'stories of the unfinished present' she lived through (S. Lee 1995).

Kim Hak-soon also actively participated in the Wednesday demonstrations, held weekly in front of the Japanese Embassy in Seoul since 8 January 1992. The Wednesday demonstrations have become a symbolic representation for peace and human rights and have been attended by many people who wish to join the survivors' fight for justice (M. Yoon 2016). Indeed, the legacy of Kim Hak-soon and other survivors who have raised their voices against this history of injustice and sexual violence continues to fulfil an important educational role and inspires many young students to also take part in the demonstrations.

In 1995, the Asian Women's Fund, which raised compensation money for survivors of Japanese military sexual slavery through private donations of citizens, was launched to address Japan's moral responsibility, rather than legal responsibilities (Amnesty International 2005). However, Kim strongly disagreed with the fundamental principles of the Fund, arguing:

> We are demanding the Japanese government's apology and reparations. But they are refusing to apologize and saying they cannot make reparations. Instead, some Japanese women's organizations will give us two million yens or so that they raised in Japan as consolation funds. That's what Uske Keiko [a leader of a Japanese private organization] has proposed. We cannot agree with this. Never. Why should we take consolation money? For what? No, it cannot be, ever. They need to make proper apologies and reparations. (Newstapa 2016)

Kim further asserted that she did not need any money, as she had a government-subsidized apartment to live in, a place to be buried and stipendiary support from the South Korean government (M. Kim 1996). What she wanted was redress and justice through an official apology and legal reparations from Japan.

In her final public testimony, filmed five months before she passed away in December 1997, Kim Hak-soon said: 'All I want is those bastards [Japan] to apologize for what they did wrong. This is my only wish before I die.' She demanded an 'apology from the Japanese king (*sic*; she deliberately avoided using the word "emperor")' and said she would not die until she heard their sincere apology (Newstapa 2016). Although Kim Hak-soon never received it, her demands continue to echo in the face of Japan's continuous denial of its legal responsibilities.

In 2015, the Korean and Japanese governments announced a 'comfort women' agreement, which entailed the establishment of Reconciliation and Healing Foundation with 1 billion yen (8 million dollars) provided by

the Japanese government in return for a purported 'final and irreversible' settlement of the issue (S. Kim and Lee 2017). The two governments agreed to never bring up the issue again in the international community and to 'deal with' the Statue of Peace, which commemorated the 1000th Wednesday Demonstration and survivors' long-standing activism. The agreement was opposed by many survivors and activist organizations, who pointed out that survivors' voices were not reflected in this agreement. The Reconciliation and Healing Foundation was abolished in 2019 after much controversy, but Kim Hak-soon's demands of justice and redress are still not met.

Kim Hak-soon's courageous testimony brought to light a history that was forgotten and silenced amid patriarchal, sexist, classist and colonial social structures. A little, unknown, unimportant woman became a 'great catalyst' for the movement for justice on the Japanese military sexual slavery issue, having inspired many survivors around the world to come forward, filed a lawsuit against the Japanese government and protested for justice (Shin 2014). Today, her legacy lives on through the widespread activism not only in South Korea but also around the world (Min, Chung

FIGURE 8.1 *Photo of Kim Hak-soon reading her testimony on 9 February 1999 (War and Women's Human Rights Museum); The Korean Council.*

and Yim 2020; McGregor 2016). Younger generations carry Kim's legacy as they forge activism for a just resolution and remembrance of the Japanese military sexual slavery issue – installing statues of peace and organizing memorial events. Kim's spirit continues as Japanese military 'comfort women' and advocates stand in solidarity with other survivors of sexual violence in armed conflicts around the world. One example is the Nabi Fund, created by Gil Won-ok, and the late Kim Bok-dong who were fellow Japanese military 'comfort women' and peace and women's rights activists. The Nabi Fund has supported victims of sexual violence during armed conflict in Vietnam, Congo and Uganda (N. Lee 2014). The movement for justice on the Japanese military sexual slavery issue has contributed to the international community's heightened awareness of sexual violence in armed conflicts around the world and advocated for victim-centered approaches in addressing sexual crimes.

As a forerunner of the #MeToo movement, Kim Hak-soon broke the silence on Japanese military sexual slavery and wartime sexual violence. Her activism has promoted global awareness of sexual slavery, wartime rape and violence against women and contributed to international movements for peace and women's rights. As one of the female survivors of the Second World War atrocities says in her oral testimony for *The Unwomanly Face of War* by the 2015 Nobel Prize laureate Svetlana Alexievich, 'It is terrible to remember, but it is far more terrible to forget'.

Notes

1 This paper preserves the last name-first name order of Korean names, except for that of the author. As most Korean survivors of Japanese military sexual slavery are known in their last name-first name order (e.g. Kim Hak-soon, Kim Bok-dong, Gil Won-ok), I use Kim Hak-soon throughout the article. Kim Hak-soon is also written in English as Kim Hak-sun.

2 Quotations are used around the term Japanese military 'comfort women' to denote the historical use of the term by the Japanese military. 'Military sexual slavery' has been used by activists and United Nations to describe the system. (See Chung 1997, 220–2).

Bibliography

Abe, Kohki, 'International Law as Memorial Sites: The "comfort women" Lawsuits Revisited', *The Korean Journal of International and Comparative Law* 1 (2013): 166–87.

Amnesty International, Still Waiting after 60 Years: Justice for Survivors of Japan's Military Sexual Slavery System (2005), https://www.amnesty.org/en/documents/ASA22/012/2005/ja/

Argibay, Carmen M., 'Sexual Slavery and the Comfort Women of World War II', *Berkeley Journal of International Law* 21 (2003): 375–89.

Chinkin, Christine, 'Women's International Tribunal on Japanese Military Sexual Slavery', *The American Journal of International Law* 95, no. 2 (2001): 335–41.

Chung, Chin Sung, 'The Origin and Development of the Military Sexual Slavery Problem in Imeprial Japan', *Positions: East Asia Cultures Critique* 5, no. 1 (1997): 219–53.

e-museum of the Victims of Japanese Military Sexual Slavery, *Kim Hak-soon Halmŏni chŭngŏn* [Kim Hak-soon's testimony] (2018) [Video], https://www.you tube.com/watch?v=b81Q-z-zZ8w

Hicks, George, *The Comfort Women: Japan's Brutal Regime of Enforced Prostitution in the Second World War*. New York: W. W. Norton & Company, 1995.

Kim, Mi-kyeong, 'Min'gan'gigŭm kŏbuhanŭn Kim Hak-soon halmŏni "wŏnhanŭn kŏn ilbon kongshiksajoeppun"' [Kim Hak-soon refuses privately raised fund, "All I want is Japan's official apology"], *The Hankyoreh*, 15 August 1996.

Kim, Puja, 'The "comfort women" Redress Movement in Japan: Reflections on the Past 28 Years', in Pyong Gap Min, Thomas Chung and Sejung Sage Yim (eds), *Japanese Military Sexual Slavery: The Transnational Redress Movement for the Victims*, 43–69. Berlin: De Gruyter Oldenbourg, 2020.

Kim, Seung-kyung and Na-Young Lee, 'Shared History and the Responsibility for Justice: The Korean Council for the Women Drafted for Military Sexual Slavery by Japan', in Barbara Molony and Jennifer Nelson (eds), *Women's Activism and 'Second Wave' Feminism*, 193–212. London: Bloomsbury Academic, 2017.

Kim-Gibson, Dai Sil, *Silence Broken: Korean Comfort Women*. Parkersburg: Mid-Prairie Books, 1999.

Lee, Na-Young, 'The Korean Women's Movement of Japanese Military "Comfort Women": Navigating between Nationalism and Feminism', *The Review of Korean Studies* 17, no. 1 (2014): 71–92.

Lee, Sung-wook, 'Ilbon'gun wianbu tarun yŏn'gŭng ch'uryŏn kimhaksun halmŏni' [Kim Hak-soon stars in a theater production addressing the Japanese military "comfort women" issue], *The Hankyoreh*, 18 October 1995.

Matsui, Yayori, 'Women's International War Crimes Tribunal on Japan's Military Sexual Slavery: Memory, Identity, and Society', *East Asia* 19, no. 4 (2001): 119–42.

McDougall, Gay J., 'Addressing State Responsibility for the Crime of Military Sexual Slavery during the Second World War: Further Attempts for Justice for the "comfort women"', *The Korean Journal of International and Comparative Law* 1 (2013): 137–65.

McGregor, Katharine, 'Emotions and Activism for Former So-called "comfort women" of the Japanese Occupation of the Netherlands East Indies', *Women's Studies International Forum* 54 (2016): 64–78.

Min, Pyong Gap, 'Korean "comfort women": The Intersections of Colonial Power, Gender, and Class', *Gender and Society* 17, no. 6 (2003): 938–57.

Min, Pyong Gap, 'Japanese Citizens' and Civic Organizations' Strong Support for the Redress Movement', in Pyong Gap Min, Thomas Chung and Sejung Sage Yim (eds), *Japanese Military Sexual Slavery: The Transnational Redress Movement for the Victims*, 71–94. Berlin: De Gruyter Oldenbourg, 2020.

Min, Pyong Gap, Thomas Chung and Sejung Sage Yim, eds, *Japanese Military Sexual Slavery: The Transnational Redress Movement for the Victims*. Berlin: De Gruyter Oldenbourg, 2020.

Newstapa (Korea Center for Investigative Journalism), 'My wish is...' (2016) [Video], https://www.youtube.com/watch?v=BAKT6lZPT4E

Northeast Asian History Foundation, 'The Truth of the Japanese Military "comfort women"'. Seoul: Northeast Asian History Foundation, 2014.

Okada, Taihei, trans., 'The "comfort women" Case: Judgment of April 27, 1998, Shimonoseki Branch, Yamaguchi Prefectural Court, Japan', *Pacific Rim Law and Policy Journal* 8, no. 1 (1999): 63–108.

Shin, Hyon-Hee, '"Comfort women": Living, Harrowing Mark on History', *The Korea Herald*, 17 August 2014.

Sonen, Michele Park, 'Healing Multidimensional Wounds of Injustice: Intersectionality and the Korean "comfort women"', *Berkeley La Raza Law Journal* 22, no. 1 (2012): 269–300.

The Korean Council for Justice and Remembrance for the Issues of Military Sexual Slavery by Japan (The Korean Council), Testimonies, http://womenandwar.net/kr/testimonies/

The Korean Council for Justice and Remembrance for the Issues of Military Sexual Slavery by Japan (The Korean Council) and The Korean Research Institute for Military Sexual Slavery, eds, *Kangjero kkŭllyŏgan chosŏnin kunwianbudŭl* [The Forcibly Drafted Korean Comfort Women], vol. 1 . Seoul: Hanul, 2012.

The Korean Council for Justice and Remembrance for the Issues of Military Sexual Slavery by Japan (The Korean Council). 'A to Z Guide for Just Resolution of the Japanese Military Sexual Slavery Issue'. Seoul: The Korean Council for Justice and Remembrance for the Issues of Military Sexual Slavery by Japan, 2020.

Totsuka, Etsuro, 'Commentary on a Victory for "comfort women": Japan's Judicial Recognition of Sexual Slavery', *Pacific Rim Law and Policy Journal* 8, no. 1 (1999): 47–61.

United Nations, Commission on Human Rights, 'Report of the Special Rapporteur on Violence against Women, Its Causes and Consequences, Ms. Radhika Coomaraswamy, Submitted in Accordance with Commission on Human Rights Resolution 1995/85, 5 February E/CN.4/1996/53/Add.1' (1996).

United Nations, Commission on Human Rights, 'Systematic Rape, Sexual Slavery and Slavery-like Practices during Armed Conflict: Final Report Submitted by Ms. Gay J. McDougall, Special Rapporteur, 22 June, E/CN.4/Sub.2/1998/13' (1998).

Yang, Hyunah, 'Revisiting the Issue of Korean "Military Comfort Women": The Question of Truth and Positionality', *Positions: East Asia Cultures Critique 5*, no. 1 (1997): 51–71.

Yoon, Bang-Soon, 'Imperial Japan's Comfort Women from Korea: History & Politics of Silence-Breaking', *The Journal of Northeast Asian History* 7, no. 1 (2010): 5–39.

Yoon, Meehyang, *25 Years of Wednesdays: The Story of the "comfort women" and the Wednesday Demonstrations*. Seoul: The Korean Council for Justice and Remembrance for the Issues of Military Sexual Slavery by Japan, 2016.

Yoshimi, Yoshiaki, *Comfort Women: Sexual Slavery in the Japanese Military during World War II*. New York: Columbia University Press, 2002.

PART III

Artists and Painters

This section demonstrates how the work of female artists, whether from the fourteenth or twentieth century, is often 'invisible in plain sight' as the editor's introduction observes, yet becomes visible if we know how to look. These women's accomplishments may be physically hidden in attics (as Vera Lane Poole's paintings were) or tucked away in understudied private collections (as Judith Leyster's second self-portrait was), overlooked in scholarship (as female illuminators like Jeanne de Montbaston's were) or appropriated in paintings (as Karin Bergöö Larsson's textiles are). However, once glimpsed, Jeanne's penis-harvesting nun, Judith's self-portraits, Karin's insect and Vera's portrait of her mother and brother arrest our gaze. They open our eyes to the anti-feminist ways those eyes have been taught to see, and redirect that gaze towards the margins (literally, in the case of Jeanne), away from the centre, to discern even more art that has been there all along. (Godelinde Gertrude Perk)

9

Jeanne de Montbaston

An Illuminating Woman

Melek Karataş

In fourteenth-century Paris, illuminated manuscripts were produced for the wealthy classes by a small community of individuals living on and around the Île de la Cité. Home to the French royal court, the foremost university in Europe, and a powerful cathedral chapter, the city had emerged by the end of the thirteenth century as one of the most eminent and proficient centres of literary production in the Western world. Although book production in the medieval period tends to be thought of as a male-dominated profession, contemporary evidence reveals that a significant number of the individuals working in the Parisian bookmaking community were in fact women. Women occupied professional roles at every stage of the book production process: in craft-based roles as parchment-makers and book-binders, in executive roles as booksellers or managers of bookmaking ateliers, and in artistic roles as 'illuminators', producing colourful decorations and miniatures (illustrations of key scenes or characters) luxuriously inlayed with gold leaf or silver. Due to a damning combination of murky historical records and misogynistic attitudes towards women's work in dominant scholarly narratives, however, the extent to which women influenced and shaped literary production during this time is difficult to gauge. Often only appearing in the records as the wives or widows of male bookmakers, women's work was rarely acknowledged in its full capacity.

As such, the illuminatrix Jeanne de Montbaston has become something of a celebrity in the world of feminist medieval studies. Jeanne provides us with a rare example of a documentable female artist who also held authority

within her community as a 'libraire', an individual whose job it was to direct and oversee the production of a manuscript. The atelier that she co-ran with her husband, Richard de Montbaston, was one of the most prolific book production centres in the city and produced a large amount of manuscripts from the early 1330s to 1350s, of which fifty-three survive today. Together, Jeanne and Richard made manuscript copies of a wide array of texts in Old French, including saints' lives, historiated bibles, battle epics, bestiaries and *romanz* (narrative texts in vernacular language), with their most momentous contribution to the literary landscape of the time being their involvement with the reproduction of *Le Roman de la Rose*, an allegorical love poem and medieval 'bestseller' bi-authored in the late thirteenth century by Guillaume de Lorris and Jean de Meun. The Montbastons produced at least nineteen copies of the popular poem during the course of their careers, the majority of which contain gaudy and entertaining illustrations, instantly recognizable for their animated, cartoonish characters and punchy colour palette of bright blue, red and green hues. Jeanne participated in the production of a significant number of the illustrations made in these manuscripts as well as others produced in the atelier, sometimes individually, and sometimes in collaboration with a second, nameless illuminator in the atelier's employ. Together, the two illuminators honed a signature style that attracted the attention of the city's wealthiest patrons, bringing the Montbaston Atelier acclaim and renown in its lifetime, and forging an artistic legacy that would continue to inspire manuscript artwork well into the fifteenth century.

Jeanne and Richard in the Records

If surviving records for individual bookmakers in the medieval period are rare, surviving records for individual women bookmakers are virtually non-existent. All that is known about Jeanne de Montbaston today survives in a single document dating from 1353 – a record of a university oath that she swore on July 21 of that year (Pierrefitte-sur-Seine, Archives nationales, M//68 no. 42). Such oaths were required of all libraires in the city, and essentially allowed them to practice their trade legitimately. Written in a semi-legible script on a delicate fragment of parchment, the record of Jeanne's oath serves to remind us of the evanescent nature of the information it contains; were it not for the survival of this record, it is likely that we should not know of her existence at all.

Jeanne is described in her oath as 'a sworn illuminator of books' ('illuminatrix libri jurata'), a title that is significant for its rarity; she is one of just two bookmakers, and the only woman bookmaker, known to have held such a title. The title attests to her competence and seniority in this role, in which she had been working for some two decades by the time she swore the oath. Jeanne's oath attests to the multifaceted nature of her professional activity: as an illuminatrix, she evidently participated in the production of

artwork in the manuscripts that the atelier was commissioned to make, and as a libraire, she would also have been responsible for securing those commissions. This would have involved liaising with clients, discussing with them what they wanted from the book content-wise and with respect to its material features, and then sub-contracting the necessary number of scribes, illuminators and other artisans needed to get the job done. Jeanne would have provided the materials necessary for the manufacture of the book (parchment, ink, pigment), and meted out and distributed the work between bookmakers.

It is likely that Jeanne participated in some or all of these activities jointly with Richard, whose own oaths (sworn in August and October 1338) describe him as a 'sworn libraire' ('librarius juratus') and 'cleric' ('clericus'), a title used in medieval documents to denote an individual who knew how to read, write and interpret texts (and not necessarily a cleric in the religious sense). The term was ascribed to most (male) booksellers as a formality first and foremost, allowing them to reap the various benefits associated with clerical status. Whereas Jeanne's oath makes explicit her role as illuminator, Richard's oaths do not specify the role he might have fulfilled in addition to that of libraire, and therefore paint an ambiguous picture as to his involvement in the material process of book production. Given that most libraires were proficient in at least one of the constituent metiers of the trade, it is possible that he did play some part in the production process, but the absence of this information in the records makes it impossible to know in what capacity this was, exactly.

Jeanne continued to practice illumination and to run the atelier independently following Richard's death, and may have continued to do so for up to fifteen years. Though we do not know how or when Richard died, exactly, the fact that Jeanne identifies herself as his widow in her oath would suggest that it was around that time, perhaps in one of the scours of plague that swept the city in the mid-century. The oath represents Jeanne's taking the helm of the business, and her becoming officially recognized in the eyes of the university. Crucially, this indicates a continuation rather than an initiation of professional activity; too often we talk of widows taking over from their husbands, or continuing their husbands' work, language that perpetuates the misguided notion that bookmaking women were only assistants to their husbands, as opposed to being bookmakers in their own right. In Jeanne's case, we know that that she had been professionally active for some twenty years before swearing the oath, and that many of the manuscripts that she worked upon, she illuminated independently. She oversaw large-scale illumination projects, with one of the largest commissions attributed to the atelier containing over 100 images executed by the same artist.

Richard as the Anonymous Illuminator?

The exact nature of the working relationship that existed between Richard and Jeanne is difficult to gauge due to the absence of detail in the records

as to Richard's role. Was his role purely managerial, or did he also fulfil an artisanal role in the production of manuscripts in the atelier? Richard Rouse and Mary Rouse (2000) have aimed to resolve such ambiguity by identifying Richard as Jeanne's professional partner – the second, nameless illuminator with whom she often collaborated. Though the designation would neatly resolve the issue of anonymity, it is problematic insofar as is based largely on the assumption that Richard, as a man, would have been more likely to have learned the craft of illumination through formal apprenticeship with a practising illuminator than Jeanne, who is instead deemed to have been taught her craft by a male relative or spouse.

The result of this narrativization is the creation of a gendered hierarchy in which Richard is characterized as the master illuminator, and Jeanne as his less-skilled assistant, a sort of extra set of hands in the atelier that assisted the master illuminator with his more important, more skilled work. We are told that Jeanne did not acquire her skills from the tutelage of a master of the craft, rather, by imitation of the actions of her husband – something that problematically absorbs her artwork into Richard's, and recategorizes it as his. Those images that are perceived to be more competently made are thus attributed to Richard, whereas those images that appear less skilfully executed or that occupy a less important place in the manuscript's visual economy are attributed to Jeanne. There is in fact no empirical evidence to suggest what kind of education Jeanne might have received in illumination, but the fact that she was acknowledged as a sworn illuminator, and that she was commissioned to provide the illuminations for at least twenty manuscripts during the course of her career surely attests to her competence in the role.

If not Richard, then who? Though we cannot know for certain who exactly the anonymous illuminator was, we might look to patterns of work in the wider community to help us think about the relationships that bookmakers had with one another more generally. Scribes and illuminators collaborating on the same manuscript need not necessarily have belonged to the same atelier, since they lived in the same neighbourhood. The ateliers on and around the rue Neuve-Notre-Dame where the Montbastons resided were so small and so close to one another that they were able to reach the ateliers of their collaborators in a matter of minutes. Jeanne and Richard evidently collaborated frequently with other bookmakers in their community, with the largest of their surviving commissions, a richly illuminated crusading anthology made for Philip VI, the king of France, (London, British Library, MS. Royal 19 D I), bearing witness to the combined efforts of at least nine individuals from across the neighbourhood. This sort of inter-atelier collaboration was commonplace and essential to the proper functioning of the trade, and, as such, the collaboration between Jeanne and the anonymous illuminator could conceivably be one between her and another individual who lived and worked in the community.

Invisible Women

Anonymity was a defining feature of literary and artistic culture throughout the medieval period. When we open a book today, we expect to find a title page containing the name of the author, the title of the work, the publisher, and the names of the illustrators, if the book contains pictures. Medieval manuscripts did not usually contain such information. Unless a bookmaker explicitly wrote their name somewhere in the manuscript, the chances of learning who that person was exactly, are extremely low. Even in the rare instance that a manuscript does bear the signature of one of its makers, we are afforded only a fragment of the overall picture, given that multiple individuals would have been involved in its making. This makes the process of identifying the provenance or circumstance of production of a given manuscript a difficult one, with many of those involved in the various layers of the creative process going unnamed and undocumented.

This invisibility is further complicated for women bookmakers by a host of structural inequalities that restrained their autonomy and curtailed their professional development on a wider sociocultural plane. When Linda Nochlin (1971) famously asked, 'why have there been no great women artists?' in her seminal essay of the same title, she argued that social attitudes and institutions throughout history essentially made it impossible for women artists to reach the same level as their male counterparts, by denying them access to training, and by shaping them for domesticated lifestyles. Aspects of Nochlin's argument ring true for the bookmaking women of medieval Paris, and indeed, many women working in urban craft-based professions. Limited access to wealth, the social and legal implications of marriage, household and family responsibilities, to name but a few factors, created barriers for women that their male counterparts simply did not encounter. What this meant for many of the bookmaking women of medieval Paris is that, though actively engaged in professional activities alongside bookmaking men, their work was not recognized in an equal capacity, if recognized at all. There are many examples of women who played active roles within book production simply referred to as the wife of, widow of, mother of, daughter of (insert name of male bookmaker here), qualified in terms of their relation to men before their professional role was acknowledged.

The correlation between marital status and the (in)visibility of women in the (professional) world, is, of course, not a uniquely medieval issue, as this volume demonstrates time and time again. For millennia, women have laboured invisibly in the shadows of their male relations. The case of Jeanne bears strong parallels, for example, to that of the seventeenth-century Dutch painter, Judith Leyster (see Irene Kukota's Chapter 10), whose artistic personality, as the proceeding chapter demonstrates, faded out of view following her marriage to an ostensibly less-skilled (male) artist. Like Judith, Jeanne's visibility is largely dependent on her connection to her

husband, though in her case, this is due to the (arguably) less cheerful event of his death.

The example of women working in exclusively female professions provides an interesting point of contrast to that of mixed gender professions such as bookmaking. Etienne Boileau's *Livre des Métiers* (1268), the first systematized record of professional activities in Paris, reveals five metiers that were exclusively practiced by women – each related to the use and production of textiles. The records detailing the nature of these metiers provide an unusual opportunity to observe the internal structures of urban women's professional activity free from the obscuring presence of men. Simone Roux (1996) has pointed out that the ways in which such women's work was recorded were identical to that of those metiers practiced (mainly or exclusively) by men: women are integrated at every level of the trade (i.e. as workers, teachers and apprentices), and their work was subject to the same quality control checks as those of the ostensibly male-dominated metiers. Unlike the bookmaking women of medieval Paris, the work of these female textile workers was acknowledged in its full capacity for the simple reason that there were no men to overshadow them. This in turn proves that the disparity between the records and the reality of professional conduct is in large part a gendered problem.

It is our responsibility as feminist scholars to try to correct this narrative. It is not the case that women were not competent bookmakers, examples like Jeanne's are testament to this, rather, that their identities are for the most part hidden from view. Unfortunately, it is too often the case that this lack of adequate representation is perceived as an inaptitude, and so 'women's work' is characterized disingenuously as subpar, unskilled or inferior to that of their male counterparts. The narrativization of Richard as master illuminator and Jeanne as his helper is just one example of a wider disciplinary problem that has coloured women artists' histories for centuries: the assumption that men were somehow inherently better, more competent artists than women, the idea that genius itself is a uniquely masculine concept. Throughout the history of art, women's work has consequently been categorically trivialized and devalued.

As a result of the efforts of feminist scholars, attitudes towards women's art and women's work are thankfully changing, and new frameworks and terminologies are being developed through which to make visible the invisible. Caroline Criado-Perez (2019) calls for a resetting of gender bias favouring 'the default male', or the culturally engrained ideology that positions women as a deviation from standard humanity. In the field of art history, the work of Therese Martin (2016, 24) has encouraged scholars to approach medieval artworks from a position of 'dispassionate neutrality'; if the makers of the Middle Ages must remain unnamed, she argues, we should not assume that they were either men or women. The application of emergent technologies and materially oriented methodologies to studies of (women's) histories are further shedding light on medieval women's artistic activity.

Anita Radini's (2019) exciting and unexpected discovery of ultramarine pigment in the dental calculus of a medieval nun buried in a monastery in Dalheim, Germany, supports the argument that women were illuminating manuscripts centuries before the advent of the commercial book trade in large European cities. The pigment, identified by Radini as lapis lazuli, represents one of the most luxurious materials used in the illumination of medieval manuscripts, suggesting that this woman was highly regarded as an artist.

We are getting there slowly, but more work needs to be done to incorporate women's narratives into dominant narratives, and to normalize their place in creative and artistic roles. When we simply alter the types of questions we are asking about women's work, when we challenge the putative assumption that men were inherently better or more competent artists and bookmakers than women, new lines of enquiry open up through which to explore women's cultural agency and experience in a more inclusive, more accurate way.

A Medieval Selfie?

The Montbastons themselves might have left us with some clues as to the nature of their professional relationship. A well-known manuscript copy of the Roman de la Rose made in their atelier (Paris, Bibliothèque nationale de France, MS. français 25526) contains a unique programme of marginalia (decorations or images in the margins of the pages) with hundreds of playful characters and animated scenes, depicting the fantastical to the lewd to, it would seem, the day-to-day. Two sets of images on folios 77r and 77v of the manuscript seem to give us a glimpse into working life in the atelier. The first set depicts a woman preparing coloured pigments by candlelight and a man either writing or preparing parchment to be written on (see Figure 9.1), and the second, a man drawing outlines of letter initials, and a woman applying coloured pigment to initials (see Figure 9.2). It is interesting that, while the female figure in each of the scenes is engaged in activities specifically related to illumination, the preparation of colour in the first instance, and the application of colour in the second, the male figure is associated with more writerly tasks, appearing in both scenes to be engaging in the preparation or production of text. Do these scenes hint towards working life in the Montbaston Atelier? Are we to identify the marginal bookmakers with the real-life bookmakers, Jeanne, Richard and their collaborators? Though it would of course be naïve to interpret the images as true-to-life representations, the realistic details such as the pages hung out to dry in the background and the specialized tools that the bookmakers are using certainly situates the figures in a familiar setting.

FIGURE 9.1 *Paris, Bibliothèque nationale de France, MS français 25526, fol. 77r.*

FIGURE 9.2 *Paris, Bibliothèque nationale de France, MS français 25526, fol. 77v.*

The marginalia in this manuscript contain the hilarious image for which the Montbastons are undoubtedly best remembered today, that of the bawdy nun harvesting penises from a tree (see Figure 9.3). The image has beguiled audiences modern as well as medieval, creating somewhat of a furore among social media users, with thousands of reshares across platforms by viewers seemingly appreciative of its timeless humour. The images have led viewers to speculate upon the hermeneutic activity of the illuminator responsible for their production, and to question the nature of the relationship that illuminators might have had with the texts upon which they worked more generally. For the ardent feminists among us, this has offered the tantalizing possibility that a female illuminator might have been using lewd imagery to comment upon the text's inherent misogyny. The Roman de la Rose is notoriously one of the most misogynistic texts of its time. Situated in the lower margin of the page just beneath a lengthy discourse on women's sexual desire given by the former prostitute-turned-procuress, La Vieille (The Old Woman), the image appears to engage with the text in a complex way. On the one hand, it seems to corroborate much of what La Vieille says about all women being rapacious and sex-crazed – nuns included apparently. But at the same time, the nun looks quite content with her basket and her tree and seems to make clear that she does not need a man to make her happy!

Though we cannot know for certain whether Jeanne was the creator of the phallic masterpiece, or whether it was designed by the other illuminator with whom she collaborated, the possibility of a proto-feminist artist

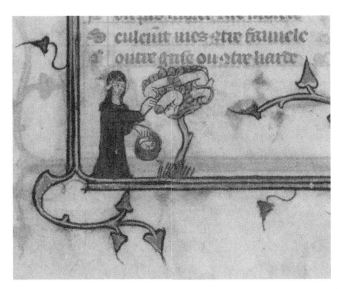

FIGURE 9.3 *Paris, Bibliothèque nationale de France, MS français 25526, fol. 106v.*

painting penis-picking nuns to satirize Jean de Meun's vitriolic diatribes against women is certainly an alluring one. In any case, whether or not we finally conclude that a particular image was made by a man or a woman, it is important that we keep both possibilities in mind. Jeanne represents one of a number of women known to have worked in the Parisian bookmaking community, and one of doubtless many more whose identities cannot be recovered, and as such, serves as a salient reminder that Anonymous was not always a man.

Jeanne de Montbaston participated in the production of a significant amount of the artwork that her atelier created, and as such, exerted a profound influence upon the production and reception of literature in mid-late fourteenth-century Paris. In addition to the weird and wonderful marginalia of the famed Roman de la Rose manuscript, she and her collaborators created images that were witty and provocative, and that engaged with the texts they accompanied in complex ways. Jeanne influenced the ways in which readers understood and engaged with the texts that she participated in making and produced interesting and engaging artwork that is still enjoyed and talked about to this day, nearly seven centuries after she was sat painting by candlelight in her small workshop on the Île de la Cité.

#ThanksForIlluminating!

Bibliography

Criado Perez, Caroline, *Invisible Women: Exposing Data Bias in a World Designed for Men*. London: Penguin, 2019.

Martin, Therese, 'The Margin to Act: A Framework of Investigation for Women's (and Men's) Medieval Art-Making', *Journal of Medieval History* 42, no. 1 (2016): 1–25.

Nochlin, Linda, 'Why Have There Been No Great Women Artists?', *Art News* 69 (1971): 22–39.

Radini, Anita, Monica Tromp, Alison Beach, Emma Tong, Camilla Filomena Speller, Michael McCormick, John Dudgeon, Matthew James Collins, Frank Rühli, Roland Kröger and Christina Warinner, 'Medieval Women's Early Involvement in Manuscript Production suggested by Lapis Lazuli Identification in Dental Calculus', *Science Advances* 9 (2019): 1–8, https://doi.org/10.1126/sciadv.aau7126.

Rouse, Richard H. and Mary A. Rouse, 'A "Rose" by any other Name: Richard and Jeanne de Montbaston as Illuminators of Vernacular Texts', in *Manuscripts and Their Makers: Commercial Book Producers in Medieval Paris 1200–1500*, 235–60. London: Harvey Miller, 2000.

Roux, Simone, 'Les femmes dans les métiers parisiens : XIIIe - XV e siècle', *Clio : Femmes, Genre, Histoire* 3 (1996): 13–30.

10

Judith Leyster

The Artist Vanishes

Irene Kukota

In much the same way as the illuminatrix Jeanne de Montbaston, an able and talented artist, Judith Leyster, grew eclipsed by her artist husband, Jan Molenaer, becoming just a footnote in his biography. It is quite exemplary how a bright, independent young woman artist, a trend-setter in her own right, was promptly erased from art history. The fact that she changed her name to Molenaer and gave up professional painting after her marriage only speeded up the demise of her career. Even in her lifetime, Leyster fell into obscurity, burdened with her duties as wife, administrator and financial manager to her husband, who had numerous debts. While running the household, she also managed her husband's studio: God only knows how many hours she might have spent in front of his canvases, commenting, correcting, contributing – 'the invisible labour' behind the practice of a rather mediocre but prolific artist. #ThanksForPainting, dear.

As Leyster could in no way be viewed inferior to her husband (she was far more accomplished and established for that), the bulk of her oeuvre was subsequently attributed to the Haarlem's leading painter, Leyster's mentor and competitor, Frans Hals. 'Herstory' was almost seamlessly transformed into 'history', with painfully few traces remaining. Similarly to Melek Karataş's article, the story of Judith Leyster is another vivid example of a gendered hierarchy principle, deeply ingrained in scholarly thinking, as the generations of art historians conveniently fell into trap of 'the default male', only to be shocked out of it at the turn of the twentieth century.

The story of Judith Leyster, the outstanding female Dutch painter of the Golden Age, will resonate with many a woman. It is like a typical female experience: a young prodigy, showing considerable promise and starting to fulfil it quite successfully, gets married to somebody more popular, but inferior to her in his talents. She then changes her name and pours all her heart, energy and ability into building up her husband's enterprise, her talent finding an outlet only within a narrow family circle. The appreciation for her husband increasingly grows, while her reputation as an independent professional sharply declines, sacrificed for what is considered a good wife's duty. Sounds familiar?

Leyster's story is among the best-known examples of a 'Disappearing Woman Syndrome' in art history (not as tragic as that of Camille Claudel though). The Disappearing Woman Syndrome has been defined by the psychologist and practising therapist Beverly Engel as a common phenomenon of 'a woman who tends to sacrifice her individuality, her beliefs, her career, her friends, and sometimes her sanity whenever she is in a romantic relationship' (Engel 2000, 2). In this case, after her marriage our heroine managed not only to disappear as an independent artist but to completely drop off the radars of art history, at least for over two centuries following her death. Owing to the continuous efforts of feminist art historians, she has finally started to receive the acknowledgement, she deserves. She is now considered to be the most famous woman painter of the seventeenth century in the Netherlands.

The story of Judith Leyster's rediscovery is worthy of a good fake-or-fortune novel, or a gripping art-fraud film. Alas, even today, when the place of women in art history is getting re-established, she is not particularly well known outside the specialist field. And her proper domesticated past is partly to blame: Leyster was a successful painter who after her marriage to a fellow-artist Jan Miense Molenaer turned into a faithful, dependable wife and mother, soon to be forgotten. She could not be remembered by either a dramatic story of rape, agony, scandal and clamouring success, like her contemporary Artemisia Gentileschi (1593–1653), or of the life at a European court, glamour and influence, like her predecessor, Sophonisba Angiussola (1532–1625), who died when Leyster turned sixteen. Nor did she seem to possess the steely determination of Lavinia Fontana (1552–1614), who continued her career as a much-in-demand artist for popes and nobles with a husband (who acted as her agent) and eleven (!) children in tow.

Nevertheless, the fact that Judith Leyster was able to launch herself as a successful independent artist in seventeenth-century Haarlem is remarkable in itself. She could not boast of having been born into a well-established artistic dynasty (like Gentileschi) or impoverished aristocratic clan (Anguissola). She had no connections in the art world, or among the nobility. She was an entirely self-made woman.

The Young Prodigy

Judith Leyster was born in July 1609, the eighth child of Jan Willemsz, a local weaver and clothmaker. Nine years later, her father purchased a brewery named 'Leyster' (or 'Lodestar' in English). Subsequently, the whole family embraced its new fortune by changing their surname from Willemsz to Leyster in 1603. Despite her wealthy background, young Judith had to begin her artistic career without much financial support: in 1625, her parents had to declare bankruptcy and leave Haarlem. The bankrupted family moved to the town of Vreeland in the province of Utrecht. This caused many art historians to believe that this gave Leyster the opportunity to acquaint herself with the so-called Utrecht Caravaggisti – the artists who had travelled to Rome and became followers of Caravaggio's dramatic style. At least, several of Leyster's paintings exhibit similarly strong contrasts of dark and light. However, the main characteristics of the Caravaggist style of painting had already reached Haarlem, as Leyster was starting her career. Besides, her family was in Vreeland only briefly and had resettled near Amsterdam by the autumn of 1629.

Despite her future prospects seeming uncertain, by the age of twenty-four the young Judith had made her own mark: she was quickly recognized as a rare talent and admitted to Haarlem Guild of St Luke in 1633, thus obtaining the right to open her own workshop and sell her art in the local market. Leyster was one of only two women accepted by the Guild during the whole seventeenth century, the other being Sara van Baalbergen. It is possible that she had studied with the well-established Haarlem portrait and history master Frans Pietersz de Grebber (1573–1649). She was only nineteen when in 1628 the city chronicler Samuel Ampzing in his 'Description of Haarlem' first mentioned Judith in connection with the De Grebber family, as co-pupil of Maria de Grebber, the daughter of the artist. Ampzing praised Leyster as a young talent with a 'good, keen sense' (Ampzing 1974, 370).

Leyster's first independent works *Serenade* and *Jolly Topper* were painted in 1629, four years prior to her entering the Guild. However, her *Self-Portrait* completed in 1630 attests best of all to the early success of her achievement. The 'informalities' of Leyster's manner – its loose brushwork, casual pose, captured mid-turn, as if greeting the viewer, and momentary quality – reflect innovations first pioneered in the 1620s by Haarlem's leading artist Frans Hals (1582–1666). Curiously, for a number of centuries, it was believed that Leyster's *Self-Portrait* had also been painted by Hals. There is no documentary proof, but many scholars follow the existing tradition and believe that she studied with Hals or worked in his studio after completing the apprenticeship with De Grebber. In any case, Leyster was a close and successful follower of Hals's new style and knew him personally: in November 1631, Judith Leyster (mentioned as Judith Jans, the latter being her middle name) was a witness at the baptism of Hals's daughter Maria (Welu et al. 1993).

Leyster's *Self-Portrait* is thought to have been her presentation piece to the Guild of St Luke, as applicants were required to submit their 'master work' in the application process. The painting served as a piece of self-promotion, advertising Leyster's works and her skill as an artist. It features a fashionably dressed young woman sitting in her snow-white starched cap, ostentatious fraise collar and impeccable lace cuffs, holding brush in hand and ready to finish a painting on the easel, standing behind her. Leyster casually turns towards the viewer, ready to engage in a dialogue, with her lips slightly parted, as if to speak. Our glance travels from the beautifully rendered artist's right hand in the foreground to her welcoming, faintly sly, smile. Her nonchalant pose and vivacious expression may point to a quality of *sprezzatura* – the easiness and spontaneity with which the work had been created. It is a self-representation, which demonstrates her artistic freedom, exempt from conventionality and restraint, as ordinarily demanded by a patron (Even 2002).

Self-Portrait also bears Leyster's distinctive signature, a unique symbol, which is a play on her name, or rather the name of her father's brewery 'Leyster' (a 'lodestar', or 'comet', in English) – hence the initials J and L, conjoined into a mysterious monogram, struck through with a five-pointed shooting star. For the Dutch, 'lodestar' signified the leading, or the Northern Star, and could also refer to the Star of Bethlehem. Apparently, Leyster, with her determination and assertiveness, claimed to be a leading star artist, ready to conquer the world.

Therefore, her self-portrait is not a typical painting of a female subject – a passive object of a male gaze – but a programme statement. First, she claims to be on par with other professional male artists, not just an amateur female, working on conventional flowers or insects paintings. She demonstrates her ambition and seriousness by depicting herself working on a genre subject – 'an activity and an art reserved for, or even restricted to male painters' (Even 2002). Furthermore, she breaks the unwritten right-left visual code observed by her contemporaries, and places herself to the privileged heraldic right (viewer's left), reserved without exception for male subjects (in the same manner, female sitters were always placed to the heraldic left (viewer's right). This way Leyster distinguishes herself from other 'ordinary women', masculinizes her image and equates her artistic talents with those of her male colleagues (Even 2002).

However, she does not stop here. Leyster places a fiddler – the male figure in the canvas – to the heraldic left (the female side). The infrared photography analysis demonstrated that she had initially depicted a woman's face, most likely, her own, in the composition, but decided against a self-portrait within a self-portrait and painted the fiddler instead. This way, she was able to

demonstrate her versatility as a portraitist and a genre painter, who could turn her hand to many subjects. As Even suggested, by positioning herself on the heraldic right and the fiddler on the less sought-out heraldic left, Leyster appeared, as if in jest, to defy patriarchal conventions, while also elevating herself to the higher artistic status (Even 2002). Intriguingly, the brush held in her right hand is aimed directly at the crotch of the fiddler in the canvas (the detail observed by the art historian Peter Schjeldahl). Such devices helped Leyster to avoid the unwelcome associations with vanity and luxury, traditionally ascribed to women, thereby promoting her talents and reputation not as a woman painter but as a painter. As a result, Leyster looks even more independent, manly and playfully subversive.

Possibly, Leyster also represented herself as a living embodiment of La Pittura – the art of painting itself. Such visual metaphor was not available to male artists, so she could not miss that chance. Here Leyster continues the tradition of La Pittura iconography, as evident in Giorgio Vasari's *La Pittura, or the Art of Painting* in Casa Vasari, Arezzo, dating to 1542. In a similar fashion, Vasari's fresco features the female personification of La Pittura on the heraldic right, painting a male or female figure on the heraldic left (Even 2002). We do not know if this image was familiar to Leyster, but she seems to have been aware of the tradition. The boldness of Leyster's statement in her *Self-Portrait* also seems to anticipate Artemisia Gentileschi's *Self-Portrait as the Allegory of Painting (La Pittura)* (1638/9).

The freshness of Leyster's image and the fistful of brushes, handled against the palette (the sign of her artistic prowess), suggests a complete mastery of her art. Leyster's wine-coloured dress of rich fabric and pristine collar also seems to celebrate her success and separate her from less sophisticated artisans. After all, this was the time when European painters sought to establish themselves as intellectuals and hoped to see visual arts elevated to the same level as literature, rhetoric or philosophy. With this purpose in mind, they depicted themselves with elegant demeanour, thus emphasizing their sophistication and status. It has also been suggested that Leyster's open, 'speaking' smile makes a subtle reference to the art of poetry in its relationship to painting (Wheelock, NGA, Washington).[1]

Still incomplete, the canvas with the fiddler showcases the genre, for which Leyster had already become well known: the so-called 'merry company' that usually depicted revellers, card players, actors, dancers and musicians. In fact, the fiddler is nothing but a fragment of Leyster's work *The Merry Company*, featuring three young revellers (resembling *commedia dell'arte* characters) and painted in 1629, when she was twenty years old.[2] It was one of Leyster's most popular images, frequently copied by her students – her first major success in the Haarlem art market, characterized by a booming demand for similar scenes.

For the first time in history, the wealthy Dutch middle class, rather than the church or aristocratic patrons, craved luxury status goods, be these tulips of paintings. Even farmers had houses full of art, according to a

1641 diary of the English writer John Evelyn. And they all wished to have a painting fit to their taste which they could understand: light-hearted but with an instructive hidden moral message. Therefore, Leyster, as the only female playing an active role in the open Haarlem art market along with other thirty-something leading male artists of the Guild, had to adjust to the situation by churning out the scenes of daily life, domestic activity and merrymaking (Welu et al. 1993). As she attempted to emulate Frans Hals, Leyster chose remarkably similar themes and subjects, although seduction scenes and women at domestic activities were less typical of Hals. Her versatility, rather than narrow specialism, and willingness to experiment became her strong points. Her works are diverse, appropriating the manner of each professional male in her orbit (Metsu, Ter Borch, Ter Brugghen). Occasionally, Leyster was also commissioned female and children portraits, but such commissions were few, and her major income came from genre scenes.

Although some art historians call Leyster a minor genre painter, she was never just an imitator. She is known for her innovative night scenes, experimenting with subtle effects of light and dark. She was interested in special lighting effects – a passion she shared with Rembrandt, Ter Brugghen (*The Serenade*, 1629), Utrecht Caravaggisti (*The Last Drop*, 1629) and occasionally Vermeer (*Young Flute Player*, 1635). Her artistic trademark were half-length figures looking upwards and viewed from below – a distinctive compositional type that earned her the title 'Master of the Upward Glance' (Hofrichter 1989). It was also Leyster's concentration on psychology of the relationships depicted that set her apart from her contemporaries. She was particularly innovative with genre scenes, presented from the woman's point of view, like her famous *Proposition* (1631), also known as *Man Offering Money to a Young Woman*, now in the Mauritshuis Museum.

The sharp contrasts of light and dark on the woman's blouse and face are reminiscent of Caravaggio. There are just two visible light sources in the composition: the lamp on the table and the glowing foot warmer under the woman's foot (Beranek). The subject is simple: a foreign-looking man leans on a table beside a woman, who is intently sewing, and offers her a handful of coins. On the face of it, it is a typical 'ill-matched union', or 'marriage-for-money' composition, recognizable from the paintings by Lucas Cranach, Albrecht Dürer, Jan Steen and Quentin Metsys. One commonly accepted interpretation of this work (from which it derives its widespread nickname) was proposed by feminist art historian and leading authority on Leyster, Frima Fox Hofrichter (Hofrichter 1975). In the seventeenth century, as well as in today's Dutch slang, the verb 'to sew' stood for a sexual intercourse. And this is exactly the proposition the woman is staunchly ignoring.

This is a novel take on a traditional subject – brothel scenes with procuresses or girls of easy virtue – so popular in the early seventeenth century, where women were usually presented as seductresses and thieves. By contrast, Leyster's composition drew on another type of imagery that showed women

hard at work – the very model of virtue. In *Proposition*, the woman becomes an icon of domesticity, working diligently in the cold, unlit room.

> Even the foot warmer on which she rests her feet to combat the cold has been connected to emblem books – as a symbol of the woman's refusal of the man. One emblem book frames the foot warmer as a woman's best friend, since a man would have to be truly enticing to get a woman to step away from her foot warmer on a cold night. (Beranek)

This is a distinctly female viewpoint and possibly a critical response to the contemporary treatment of the subject.

Leyster was the only known Dutch female artist running her own workshop. Within two years of entering the Painter's Guild, she took at least three male apprentices that she trained as painters. Her studio was located just a street away from the town's central square – a proof of her reputable standing as a professional artist. Early in September 1633, Leyster complained to Hendrick Pot (*c*.1580–1657), who then was dean of the Guild, about a pupil who had left her studio. In fact, it was the artist Frans Hals, who, defying Guild's rules, accepted the student and his tuition fees. The dean of the Guild ruled in Leyster's favour and the student's mother paid Leyster half of the quarter of the annual tuition fee (four guilders) in punitive damages. The Guild's board also ordered Hals to send Leyster's former pupil away or to pay her a fine of three guilders. Eventually, Hals paid the fine and kept the apprentice (Welu et al. 1993). From this incident, Leyster emerges as a strong individual, who could stand her ground. Alas, this incident did not put an end to Leyster's problems with Hals. If only she had known what an evil joke the art history would play on her by attributing to Hals the majority of her best and technically accomplished genre works.

However, back in the 1630s, Leyster successfully played by the rules of masculine art institutions. She was an independent single woman, free from the pressures and demands of a family workshop. Acting as a free player in the open art market, she could artistically experiment and enjoy her modest but real market success. Having received a high-level art training, she could enjoy her place in the standard institutional framework and run her own workshop. In the time when most women preferred to dabble in art as amateurs, she was a respected professional, like any contemporary male artist (Honig 2001/2). By 1636, her successful career had spanned seven years. Alas, it did not last long, for she got married.

The Disappearing Woman Artist

In 1636, at the age of twenty-six and at the peak of her career, Judith Leyster married the fellow-artist Jan Miense Molenaer (1610–1668). She had probably known him as a youngster as he grew up in the house behind

her father's brewery. It is possible that Molenaer was a pupil of Frans Hals, although there is no corroborating evidence. At around 1629, both artists were using the same studio props, which lead to the assumption that Judith Leyster and Molenaer had been sharing a workshop before their marriage, and even that Molenaer was the servant mentioned in the documents recording Leyster's conflict with Hals (Kloek, Online Dictionary of Dutch Women).

At the time of their wedding, Molenaer was one of Haarlem's leading genre painters. However, within months of their marriage, he experienced financial difficulties, caused by the declining art market in Haarlem due to an outbreak of plague in 1635 and 1636 (Welu et al. 1993). The couple decided to move to Amsterdam, which offered more earning opportunities, and stayed there for eleven years.

Predictably for Leyster, very soon painting gave way to domestic responsibilities, the duties of a wife and a mother – after all, she and Molenaer had five children. We do not know exactly, to what extent Leyster contributed to the popularity of her husband's works, but she was involved in the management of his studio and in art dealing. This had certain financial advantages for them both and ruled out competition between the two artists living under the same roof. Leyster assisted Molenaer in investing in real estate and in purchase of their houses in Amsterdam, Haarlem and Heemstede. She continuously dealt with complicated legal and financial matters (such as Molenaer's arrear payments), literally rescuing her husband from ongoing financial challenges. She even acted as attorney on several occasions, also for signing the deed of the house. Obviously, Molenaer relied on her completely in these matters (Welu et al. 1993). Like the majority of loving and devoted wives, she focused on building a strong family business and promoting her husband's name, even if she occasionally had to deal with consequences of his flagrant behaviour. One thing is certain: she gave up painting as a profession for the sake of her family. And we can certainly agree with Christie's Old Master specialist Alexis Ashot that 'this is a great tragedy for the history of art'.

Judith also changed her name from Leyster to Molenaer and from then on signed her paintings with it. After her death, her paintings were inventoried as 'the wife of Molenaer' rather than as 'Judith Leyster', and then subsequently misattributed to her husband (Gaffney 2019). For a long time, the only work known from the period after her marriage was the watercolour *Early Brabantian Tulip* (1643), presumably, done shortly after the birth of her daughter Helena (now in Frans Hals Museum). This led many art historians to conclude that her artistic output completely stopped during her marriage. In any case, 'whenever Leyster's name appears in documents after 1654, it is in a managerial or administrative capacity' (Welu et al. 1993).

In the autumn of 1659, Judith Leyster and her husband were both so ill that on 6 November they had their wills drawn up at their farm in Heemstede outside Haarlem. Judith Leyster died three months later at the age of fifty,

leaving Jan Miense Molenaer with their two children. He survived his wife by more than eight years. Leyster was buried in Heemstede, her grave subsequently lost. In the words of Peter Schjeldahl, 'the boldly creative young artist, ripe with promise, has disappeared'.

This would have been a very sad story, if it ended here. Fortunately, it did not.

The Re-Emerging Master

The name Judith Leyster would probably have never been rescued from oblivion, if not for a scandalous incident that began in 1892, leading to court case on account of an art fraud, involving the Hals painting of a couple, making merry in a tavern. Ironically, Leyster's rediscovery was due mainly to the rehabilitation of Frans Hals. The late nineteenth century was marked by a revived interest in this painter: with his free brushwork style and informal manner, he was seen as a precursor of the French Impressionists and Post-Impressionists and was praised by Vincent van Gogh, copied by Courbet, Manet and Monet. The notorious Parisian auction sale of 1865, when Baron de Rothschild, coveting an exceptionally fine Hals portrait, was outbid by Lord Hertford (the owner of the Wallace Collection and father of Sir Richard Wallace), was actively instrumental in this process.[3] In any case, this became a turning point in raising the artist's critical and art market profile in Europe. In 1888, Hals's painting, previously acquired by Lord Hertford in 1865, was exhibited with the title, the *Laughing Cavalier* at the Royal Academy of Arts in London and became an instant hit. Hals became a new obsession with the rich and sophisticated. The increase in the market value of his paintings also meant a fortune gained or lost in case of misattribution.

Understandably, a Hals masterpiece, 'one of the finest he ever painted', known as *The Happy Couple*, or *Carousing Couple* (1630), was a welcome new addition to Marquis de Castellane's art collection. Known as Boni de Castellane, he was a notorious Parisian dandy and the leading *Belle Époque* tastemaker, who had married an American heiress – an enviable position, by all means. The *Carousing Couple* alluded to the parable about the prodigal son, frittering away his inheritance on prostitutes, – a typical Dutch genre subject, which proved somewhat prophetic in Castellane's case. Intriguingly, the woman in the composition is painted in the heraldic right (viewer's left), thus assuming a more aggressive, predatory role in contrast to her more relaxed male companion. Certainly, this painting could have only been done by an expert male hand.

The work's provenance also pointed to Hals: it was first acquired as a Hals by the English nobleman from Kent, Sir Luke Schaub in Haarlem in the seventeenth century. In any case, the *Carousing Couple* had been attributed to Hals from at least 1758, so Wertheimer, the owner of the painting and the dealer in Bond Street, rested his argument on continuous attribution

of the painting to the Dutch master. In 1885 it was exhibited in London as a painting by Frans Hals. The only puzzling detail was the painter's monogram *JL*, which did not look like a typical signature of the Dutch master. However, Wertheimer could refer to the research of the pre-eminent German authority on the subject, Wilhelm von Bode, director of the Berlin Museum, who ventured the new attribution: noting the 'J' of the monogram, von Bode suggested Jan Hals, a brother of Frans Hals, as the author of similarly monogrammed works.

Perhaps, still in doubt, the buyer and another British art dealer, Lawrie & Co, consulted the art historian Cornelis Hofstede de Groot, then acting as assistant director of the Mauritshuis, who solved the monogram riddle. He put all the pieces together to prove to Wertheimer the true creator of the work. After studying the signature consisting of a conjoined J and L and a shooting star, he announced that the painter was an unknown woman artist Judith Leyster. It was fortunate that Leyster had invented her idiosyncratic monogram, otherwise her works could have never been reattributed to her. As a result, the court case concerning the attribution ensued. The case was finally settled out of court in May 1893 and the painting's price was reduced from £4,500 to £3,500 plus £500 costs recovered by de Castellane. However, no alternate attribution was suggested, and Leyster's name was not mentioned (Welu et al. 1993). The painting was subsequently sold to Baron Basile de Schlichting after Castellane's wife obtained civil divorce (officially, on grounds of infidelity), on having learnt that Boni had spent about $10 million of her dowry. De Schlichting, who was a well-known Parisian art collector of Russian extraction and had naturalized in France, then purchased Leyster's work from Castellane for an undisclosed sum. Eventually, the *Carousing Couple* entered the Louvre collection as part of the Schlichting bequest after his death in 1914 (Jamot 1920).

Following the court case in 1893, Hofstede de Groot published his groundbreaking research about Judith Leyster and reattributed to her seven paintings, six of which had been signed with her distinctive monogram (previously all attributed to Hals) (Hofstede de Groot 1893). She finally regained her identity lost for almost two and a half centuries. Leyster's rediscovery was welcomed by the women's movement at the turn of the twentieth century. The mentions of Judith Leyster began to appear in the books on art history. However, she was not particularly highly regarded. In 1928, a rather debasing suggestion was made by Robert Dangers that Leyster must have been a lover of Rembrandt. Others were questioning her relationship to Frans Hals. However, such ideas were foreign to Leyster's contemporaries and there were no rumours about her illicit liaisons (Welu et al. 1993). Since Hofstede de Groot's pioneering discovery, Judith Leyster had been dismissed as an inferior follower of Hals. Even in 1964, James Laver patronisingly wrote in his work: 'Some women artists tend to emulate Frans Hals, but the vigorous brushstrokes of the master were beyond their

capability. One has only to look at the work of a painter like Judith Leyster to detect the weakness of the feminine hand' (Chadwick 1990, 22).

In the second half of the twentieth century, the scholars were more interested in finding out why Judith Leyster had been completely erased from art history. The feminist art historian Germaine Greer was among the first to observe that by 1661 Judith Leyster had been forgotten to such an extent, 'that De Bie does not mention her in his Golden Cabinet. Her eclipse by Frans Hals may have begun in her own lifetime, as a consequence of her marriage to Molenaer' (Greer 1979, 136). Even in her lifetime, Leyster's works were misattributed to Hals, her monogram being frequently misread or altogether ignored.[4] As Germaine Greer bitterly observed in *The Obstacle Race*, 'unfortunately, prejudice against women means that women painters generally accumulate the worst rather having their best work attributed to others' (ibid). Leyster's *Carousing Couple* was not the only victim of such prejudice: in 1897 the Rijksmuseum acquired *The Jolly Topper* as Hals's, not Leyster's. Meanwhile, mostly in Holland, new articles and studies on Leyster kept appearing throughout 1960s. In the 1970s and 1980s, the research activity shifted to the New World, as feminist art historians sought to reclaim women's history.

In 1979, Germaine Greer offered a new authoritative point of view. According to her, Leyster equalled Hals in certain aspects, with many of their painterly subjects overlapping. At the same time, she was also distinct from Hals, her composition being 'more intricate, the subject more involving'. In Greer's view, Leyster was a more spontaneous painter than Hals, as 'her work is not laboured or elaborated, but swift and brilliant' (Greer 1979, 139, 140). This attitude seems to be more in line with Leyster's contemporaries, who were more appreciative of her gift. In 1648, twelve years after her marriage, when Leyster was not yet forty, the Dutch commentator Theodore Schrevel wrote about her in *Harlemias*: 'There also have been many experienced women in the field of painting who are still renowned in our time, and who could compete with men. Among them, one excels exceptionally, Judith Leyster, called "the true Leading star in art"' (Schrevelius 1754, 290). Schrevel obviously enjoyed the pun he added to underscore his point. Fortunately, the art historians of the twenty-first century tend to share the attitude of Leyster's contemporaries.

'My sense that Leyster was forgotten, dismissed, overlooked, absent, and invisible engendered in me both indignation and a sense of mission. So, my work began as an adventure. I was exploring unknown territory – trailblazing as a historian and a feminist', stated Frima Fox Hofrichter, now the leading expert in Judith Leyster, in her article 'A Light in the Galaxy' (2003, 39). Hofrichter is considered a prime contributor to Leyster scholarship since the 1970s, with articles on specific paintings and catalogue entries that place the artist in the social context of Haarlem society. She has paved the way to new thinking about Leyster and asserted her deserving status. It is also owing to Hofrichter's efforts that two major Leyster exhibitions were

held in 1993 at the Frans Hals Museum, Haarlem, and at the Worcester Museum in Massachusetts, marking the 100th anniversary of the *Carousing Couple* lawsuit, that initiated the reunion of the artist and her work; and in 2009 at the National Gallery of Art in Washington, honouring Leyster's 400th birthday anniversary. Hofrichter also belongs to the circle of scholars who are convinced that there exist more Leysters than had been attributed. And her scholarly intuition has not let her down.

The major shift in Leyster discoveries came about in 2009, when the National Gallery of Art in Washington, DC, and the Frans Hals Museum in Haarlem hosted the exhibition of Judith Leyster (1609–1660), honouring her 400th birthday. In August 2009, a Belgian collector contacted the Frans Hals Museum in Haarlem, intimating that she had in her possession a work by Judith Leyster. Anna Tummers, curator of Old Masters at the museum, confirmed the work as a flower still life signed 'Judith. molenaers 1654'. The painting turned out to be the 'Blompotje van Juffr. Molenaer' (Flowerpot by Mrs Molenaer), listed in the inventory of possessions made up after the death of her husband, Jan Molenaer (in this inventory Leyster was repeatedly referred to by her married name). The newly discovered painting demonstrated that Judith Leyster continued to paint even up to eighteen years after her marriage. Frima Fox Hofrichter commented on the discovery:

> Many art historians have often assumed that Judith Leyster gave up painting upon her marriage. With the discovery of the flower still life and its date of 1654, we now have documentation that she continued her career as a painter. It is likely that Leyster moved to still-lives and botanical studies after her marriage, perhaps to split the market with her husband. (CODART 2009)

In 2016, another sensational discovery came to light – a later Leyster's *Self-Portrait* (1653?) from an English country house was put up for sale at Christie's.[5] The art treasure had been in possession of a British family, whose descendants proved to be oblivious to its value and historical significance.[6] This later work, produced twenty years after the first *Self-Portrait*, now in Washington, was known to have existed by art historians. It had been listed in the post-mortem inventory of Leyster's husband, Jan Miense Molenaer, on 10 October 1668, but its whereabouts remained long unknown. As the painting was offered for sale, it was authenticated by the art historian Frima Fox Hofrichter (although Pieter Biesboer [former curator, Frans Hals Museum, Haarlem] doubted the attribution). 'I have been looking for this picture my whole life', she shared with *The Times*. Unfortunately, Christie's catalogue did not mention how the portrait was signed and whether it was signed by Leyster at all.

The newly discovered painting (a small oval portrait on panel, not canvas) provided a striking contrast to the flamboyant *Self-Portrait* of youthful Leyster. Christie's Old Master expert Alexis Ashot presumed

that it had been painted for Leyster's family. 'She comes out of retirement to make one more masterpiece and depicts herself in contrast to the way she was', commented Ashot (Sanderson 2016). He also added that Leyster impressed him as 'a much more developed artist'. Perhaps with the children grown up and family matters resolved, she decided to resume painting.

Her late *Self-Portrait* shows an older, serious woman looking confidently at the viewer, with the same unstinting gaze. The exuberance and provocativeness of her younger years seem to have gone: it is a woman who had seen life. She no longer seems to be looking forward to the future but accepts the present. At the same time, it is a more intimate and more truthful portrayal of herself that somehow approaches the introspective psychological quality of Rembrandt's works. She depicts herself in a sombre, but fine-quality dress, as befits a respectable married woman.

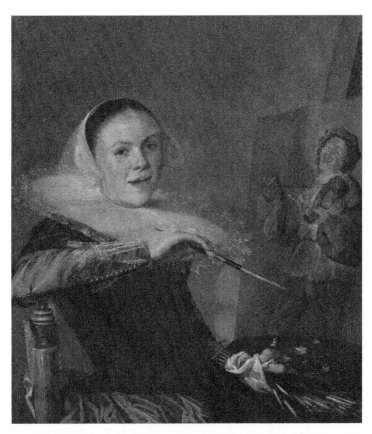

FIGURE 10.1 *Judith Leyster, Self-Portrait, 1630. (Washington Gallery of Art, oil on canvas) Gift of Mr. and Mrs. Robert Woods Bliss 1949.6.1.*

She no longer seems to claim being the equal of men artists, placing herself on the heraldic left (viewer's right): this way, Leyster shows herself to be a gentlewoman as much as an artist. And yet, she is still the embodiment of La Pittura with her brush and palette. Fine clothing also suggests that she is well-off and is still making art with poise and *sprezzatura*, masterly wielding her brush without losing a drop of paint, or not caring if she spatters her fine attire. The choice of dark clothing allows her to show off her artistic virtuosity: the challenging technique of painting in tones of black was highly regarded in the seventeenth century, and in Haarlem it was particularly associated with the style of Frans Hals (Christie's 2016). The folds and shadows in her black dress are also subtly and beautifully handled. As written in the lot essay, 'her proper right hand (as reflected in the mirror) is particularly freely painted, and almost seems to fuse around her brush, in an effect which anticipates one of the greatest of all self-portraits,

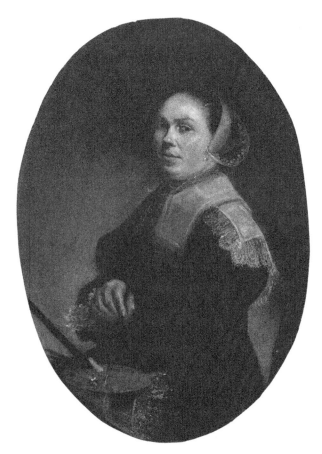

FIGURE 10.2 *Judith Leyster, Self-Portrait*, c. *1653. (Private collection, photo: Alexis Ashot Ltd).*

Rembrandt's *Self-Portrait with Two Circles* (*c.* 1665–9; London, Kenwood House)'.

So far, according to Hofrichter's scholarship, there exist forty-eight authentic works by Leyster, seven problematic works, twelve lost works and eighteen incorrectly attributed works (Hofrichter 1989). However, many of these attributions remain contested. Leyster's surviving works also present a number of critical challenges, because of the inconsistency of her painterly style, some earlier paintings appearing more accomplished than the later ones (Georgievska-Shine 2010). Her pictorial vocabulary is also somewhat eclectic. Obviously, the absence of a corpus of mature Leyster's works makes the research a trying task. It is highly possible that more works by Leyster will be discovered in the coming years, throwing new light on her artistic style and biography. After all, many art historians, museum curators, dealers and collectors now work on restoring this female Old Master to her rightful place in the art historical record.[7] From the 'lady who vanished' she is finally turning into the woman of substance.

FIGURE 10.3 *Judith Leyster, 'Carousing Couple', 1630. Photo courtesy RMN-Grand Palais (musée du Louvre)/Franck Raux.*

FIGURE 10.4 *Judith Leyster, 'Man Offering Money to a Young Woman (Proposition)', 1631, Mauritshuis, The Hague.*

Notes

1 It seems plausible, as the fiddler in this case may relate to the sense of hearing and symbolize music. In this manner, three arts – painting, music and poetry – are present in this painting.

2 In December 2018, the painting sold at Christie's for the record sum of £1.5 million, thus demonstrating an increasing appreciation of Leyster's works among the collectors.

3 It was a sensational auction sale in Paris, when two outstanding art collectors, Baron James de Rothschild and Richard Seymour-Conway, the Marquess of Hertford, were competing for Hals. The work sold for the outrageous sum of 51.000 francs amounting to £2,040 – six times the sale estimate (approximately £255,000 in today's currency).

4 For instance, Leyster's contemporary Cornelis Danckerts (1603–1654) executed the only lifetime engraving of her painting, *Two Children with a Cat*, with the

inscription 'f. Hals pinxit', although the original included her monogram. 'That Leyster and Hals were alive to witness this misattribution makes it all the more troublesome as a gauge of her waning reputation' (Welu 1993).

5 Christie's London handled the sale of the work, which fetched £485,000 ($613,040/€568,905) at the Old Masters Evening Sale that took place on 8 December 2016. It became the world auction record for the artist at that point.

6 The owners of the portrait were not always oblivious to its author. As pointed out by art historian and art dealer Dr Bendor Grosvenor, the family catalogue from 1957 found 'in the attic of the vendor' provided a proof that 'the picture was then known as a Leyster, but half a century later the identification had been lost, providing an interesting puzzle for Christie's specialists'. This testimonial can be viewed as confirming the correctness of Christie's authentication.

7 On a lighter note, in December 2019, Judith Leyster's *Boy Playing the Flute*, 1630s, was included in the CODART Canon as one of 100 Dutch/Flemish masterpieces (as voted by CODART curator-members).

Bibliography

Abrams, Amah-Rose, 'Long-Lost Self-Portrait by Dutch Master Judith Leyster Discovered in English Estate', *ArtNet News*, 5 January 2017.

Ampzing, Samuel, *Beschrijvinge ende Lof der stad Haerlem in Holland* [Roman: Adriaen, 1628]. Amsterdam: N. V. Buijten, 1974.

Beranek, Saskia, *Judith Leyster, The Proposition*, https://www.khanacademy.org/humanities/monarchy-enlightenment/baroque-art1/holland/a/leyster-the-proposition (n.d., accessed 25 March 2020).

Chadwick, Whitney, *Women, Art and Society*. London: Thames and Hudson, 1990.

CODART, 'Unique Painting by Judith Leyster Rediscovered, to be Shown in the Upcoming Exhibition - CODART - Dutch and Flemish art in Museums Worldwide', 12 December 2009, https://www.codart.nl/museums/unique-painting-by-judith-leyster-rediscovered-to-be-shown-in-the-upcoming-exhibition/

Christie's (London), Catalogue accompanying the Old Master and British Paintings Evening Auction on 8 December 2016, Sale 11975, lot 16.

Engel, Bevereley, *Loving Him Without Losing You: How to Stop Disappearing and Start Being Yourself*. New York and Chichester: Wiley, 2000.

Even, Yael, 'Judith Leyster: An Unsuitable Place for a Woman', *Konsthistorisk Tidskrift* 71, no. 3 (2002): 115–24.

Hofrichter, Frima Fox, 'Judith Leyster's Proposition: Between Virtue and Vice', *The Feminist Art Journal* 4, no. 3 (1975): 22–6.

Hofrichter, Frima Fox, *Judith Leyster: A Woman Painter in Holland's Golden Age*. Doornspijk: Davaco, 1989.

Hofrichter, Frima Fox, 'A Light in the Galaxy. Judith Leyster. For Ann Sutherland Harris', in Kristen Frederickson and Sarah E. Webb (eds), *Singular Women: Writing the Artist*. Berkeley: University of California Press, 2003.

Hofrichter, Frima Fox, 'Judith Leyster, 1609–1660', in *The Oxford Encyclopedia of Women in World History*. Oxford: Oxford University Press, 2009.

Gaffney, Erika, 'Judith Leyster, Leading Star', *ArtHerstory*, 28 July 2019, https://artherstory.net/judith-leyster-leading-star/

Georgievska-Shine, Aneta, 'Reasons to go back: Judith Leyster, 1609-1660, National Gallery of Art, Washington', *Early Modern Women* 5 (2010): 261–8.

Greer, Germaine, *The Obstacle Race: The Fortunes of Women Painters and their Work*. New York: Farrar Straus Giroux, 1979.

Grosvenor, Bendor, 'Judith Leyster Self-portrait at Christie's', *Art History News*, 6 December 2016.

Hofstede de Groot, Cornelis, 'Judith Leyster', *Jahrbuch der Königlich Preussischen Kunstsammlungen* 14 (1893): 190–8 and 232.

Honig, Elizabeth Alice, 'The Art of Being "Artistic": Dutch Women's Creative Practices in the 17th Century', *Woman's Art Journal* 22, no. 2 (2001–2002): 31–9.

Jamot, Paul, 'The Acquisitions of the Louvre during the War-II', *The Burlington Magazine for Connoisseurs* 37, no. 209 (1920): 63–5, 68–70.

Kloek, Els. 'Judith Leyster', article in Online Dictionary of Dutch Women, http://resources.huygens.knaw.nl/vrouwenlexicon/lemmata/data/Leyster/en

Sanderson, David, 'Self-Portrait Shows Artist Still Had the Golden Touch', *The Times*, 28 December 2016.

Schjeldahl, Peter, 'A Woman's Work: The Brief Career of Judith Leyster', *The New Yorker*, 29 June 2009.

Schrevelius, Theodorus, *Harlemias, ofte, De eerst stichtinghe der stad Haarlem*. Haerlem: Thomas Fontayn, 1648, rprt 1754.

Welu, James, Biesboer, Pieter, Broersen, Ellen, Groen, Karin, Hendriks, Ella, Hofrichter, Frima Fox, Kloek, Els, Kortenhorst-von Bogendorf Rupprath, Cynthia, Levy-Van Halm, Koos, Noordegraaf, Leo, Van Thiel-Stroman, Irene, Wijsenbeek-Olthuis, Thera, *Judith Leyster: A Dutch Master and Her World*, ex. cat., Frans Halsmuseum, Haarlem, Worcester Art Museum, Worcester, MA (1993).

Wheelock, Arthur K, Jr., 'Judith Leyster', Dutch Paintings of the Seventeenth Century, NGA Online Editions, https://purl.org/nga/collection/constituent/1485; https://www.nga.gov/collection/highlights/leyster-self-portrait.html

11

Textiles Rubbing Us the Wrong Way

A Tour of Karin Bergöö Larsson's Acts of Fibre Resistance

Godelinde Gertrude Perk

Imagine yourself as a tourist in Sweden, visiting the museum Lilla Hyttnäs (also known as *Carl Larsson-gården*), the former abode of painter Carl Larsson (1853–1919) and his wife Karin Bergöö Larsson (1859–1928). Upon entering Carl's studio, your eye is drawn to a low, red table. Modernist in style, it evokes Danish design in its minimalism and clean lines. This apparent modernity puzzles you. Surely, this table originates from IKEA? But no, it was designed in 1906 by Karin, an interior designer and textile artist. Trained in fine arts, she created a *Gesamtkunstwerk* out of the family home, in which her interior design and textiles point to a prescient, pioneering artist. This independence jars with how her husband's paintings present her as a serene Angel in the House or passive Virgin Mary. How might we explain this baffling contrast?

If we continue walking imaginatively through the house, and pause in front of Karin's textiles, we will detect clues there. Take a very close look at her textile art, and mentally place his paintings beside her textiles, and you will catch a glimpse of Karin the rebel. In her textiles, Karin breaks free from her husband's oeuvre, which continuously places her in an idyllic domestic setting. Her textiles both recall and protest against his paintings and their

picture-perfect image of the home, Karin and her designs. Continue staying with the textiles, and we can distinguish the metaphorical threads that pick up and transform ideas and books circulating in the house, especially conceptualizations of gender and the home. Keep gazing at the textiles, however, and you cannot help but notice how inextricably entwined they are with the house, and how they cover up as much as they reveal: Karin also contributes to her partner's problematic ideal.

Tourists, academics and museum curators have strolled through the house before us, and likewise glimpsed the significance of Karin and her work. *Carl Larsson-gården* now acknowledges her essential contribution to the house, which in the past was understood as Carl's brainchild. A Victoria and Albert exhibition in 1997 celebrated both spouses as 'creators of the Swedish style' (Snodin and Stavenow-Hidemark 1997). Art historians and biographers intuit that their oeuvres speak to one another (Andersson 1986, 149; Rydin 2009, 160). They also praise Karin's bold abstract compositions, daring colour schemes, technical innovation and suggestive placing of the textile in the home (Andersson 1986, 107–32; Rydin 1997, 11; Svalin Gunnarsson 2017, 64). Yet if we probe and poke the textiles and their web of connections to her husband's art and contemporary debates, we sense that her textiles do even more. In their modernist critique of Carl's representation of Karin, they unweave and are woven into her partner's and contemporaries' constructions of gender. Biographer Lena Rydin contends that Karin was no maverick (1997, 175), but touch the textiles, and one perceives Karin the rebel. (But the museum prohibits actually touching the textiles and other artefacts!)

Karin Bergöö Larsson

In this chapter, we pause in front of such vibrant designs as the library cloth (Figure 11.1) and *Kärlekens Ros*, The Rose of Love (Figure 11.2). The artist behind them is also the woman behind the Larsson brand. Born in 1859 to an affluent merchant family, Karin attended the Royal Swedish Academy for Fine Arts from 1877 to 1882. After moving to Paris in 1882 to study art at the Académie Colarossi, she met her future husband at the artists' colony at Grez-sur-Loing in July of that year. Carl was then a little-known artist, struggling emotionally, financially and artistically. Their meeting transformed his work and personal life, as did their mutual encounter with French plein-air Naturalism. Shortly after the birth of her first child, Karin gave up painting, for reasons unknown. Her maternal, domestic and hosting duties likely contributed to this renunciation. (In this phase of her life, Karin effectively becomes another example of the 'Disappearing Woman Syndrome' Irene Kukota observes in seventeenth-century Dutch painter Judith Leyster's life in the previous chapter.) After several years in Sweden and France, the rapidly expanding family acquired a cottage and

land in 1888. Called Lilla Hyttnäs and situated in Sundborn, Dalarna (central Sweden), the cottage was soon transformed by the Larssons into a distinctive artists' home. The property was a gift from Karin's father, which encapsulates the socio-economic realities of the Larssons' life and art. Karin's privileged background provided the home. By extension, it made her husband's famous watercolours of this home possible. Similarly, her labour managing the home and family provided the practical preconditions for her husband's success. Only when in her forties, after the birth of her seventh and last child, could Karin dedicate sufficient time to her individual artistic output to commence weaving.

The house and its former inhabitants feature heavily in Carl's work, the result of a suggestion from Karin (Ignell 2004, 4). Domesticity is a central theme in Carl's internationally successful books of reproductions. They bear titles like *Ett Hem* (*A Home*), and show many children playfully but lovingly surrounding an ever-young, angelic mother. All live in close proximity to nature, and dwell happily in a charming, light-filled home that seems more spacious than the cramped rooms you now encounter. Take a step back, and refuse to be charmed by Carl's pleasant world; we then see that these books promote a particular ideal of interior design and family life. In her designs, Karin reveals this ideal to be a cover-up.

FIGURE 11.1 *The library cloth (museum replica). Photo by Per Myrehed, courtesy of Carl Larsson-gården.*

The Library Cloth

Our first stop on this guided tour is the reading room or the library with its mysterious *läsrumsduken* (the library cloth), finished in 1908 (Figure 11.1). This textile both attracts and challenges the viewer's gaze. Drawing the viewer's eye to the work, but also defying that look forms one of Karin's crafty strategies by which she rips up her husband's ideal.

The matter of the work, the medium, is as intricate as its imagery, its content. Let's start with the textile as a textile. A large stretch of white, undyed wadmal (a coarse, woollen cloth) forms the basis. It covers the table almost entirely, which makes the work quite heavy. Karin has sewn woven bands onto the long sides, and a piece of tapestry onto one short side. This piece of tapestry she wove separately on a Gobelin loom (Andersson 1986, 108; Ignell 2004, 5, 6; Rydin 1997, 201; 2009, 117; Sundström 2019, 88). The tapestry is striated and the texture visible. Descending, slanting gaps punctuate the area below the chequered border.

Now, let's turn to the imagery. The segment in tapestry technique on the short side shows several figures: a large stylized, insect-like animal, an apple, a pear and a black-and-white chequered border. A print-like line delineates the insect, apple and pear. The insect clasps the border with large, yellow claws. 'What species is that peculiar creature?' you find yourself wondering. Biographer Iris Andersson would reply it is part insect, part predator, seen frontally but from below (110). The border puzzles too. Several of its white rectangles are only bounded by the black rectangles, which creates an illusory contour. The cloth, then, frustrates your and other viewers' expectations and gaze. In this way, it disturbs the calm of the dream (artist's) home and, in this way, unpicks the ideal many adore in Carl's paintings.

Take a second, more careful look at the images, which will help trace how her art relates to her husband's and the contemporaries'. Do you see how she transforms nature into abstract figures and patterns? In this metamorphosis, the textile evokes Art Nouveau and Jugendstil art, such as that of the Glasgow Girls (cf. Andersson 1986, 110; Högardh-Ihr 2008, 63; Rydin 2009, 130; Sundström 2019, 98): Jessie R. Newbery did likewise (Rydin 2009, 130). Do you also notice how Karin stylizes and delineates the figures? By doing so, Karin amplifies Carl's rather flat, print-like compositions, described as having watercolour-filled, light surfaces (Gunnarsson 1997, 37, 38). She also intensifies his characteristic quality of line, which consists of a slightly stylized, uninterrupted dark line around each figure (Gunnarsson 1997, 37, 38). When studying these metamorphoses, we overhear as it were a visual conversation between Carl's and Karin's oeuvres. I delve into this conversation in the second half of this tour.

These modernist features – the stylized images and the unusual characteristics of the textile – do more than drag the house kicking and screaming into the twentieth century. (Carl, you see, loathed contemporary art). Through them, Karin also asks each visitor: 'Why do you prioritize

sight over touch when studying art?' Her textiles ask this question quite subtly. The library cloth's vivid colours brighten the dark library, and draw all eyes to the work. However, it is difficult to parse the creature: the textile demands that visitors either tilt their head or move closer to piece together the insect. Meanwhile, the punctured, striated texture dares us to feel the cloth. However, according to textile theory, when running our fingers over this cloth, we haptically encounter the limitations of sight. According to curator-theorist Pennina Barnett, striated cloth such as woven cloth 'has a fixed warp which defines its edges and limits This makes it a *striated* or sedentary space of long-distance-vision, form and outline' (185, italics in original). Karin brings viewers in close contact with the striated cloth, and thus reminds them that their vision is both literally and metaphorically limited: she recommends touch instead. The visual illusion and mystifying creature underline Karin's warning. Faced with this sense of mystery, we can

FIGURE 11.2 Kärlekens Ros *(museum replica). Photo by Per Myrehed, courtesy of Carl Larsson-gården.*

only rely on the matter of the cloth to be understandable. In short, just as countless threads run through the library cloth, countless ideas run through it as well, but Karin always makes us focus most on the materiality in the end. In this manner, she disentangles herself from Carl's ideal.

The Rose of Love

Our next stop: another textile in which Karin unstitches her husband's ideal of the artist's home. Passing through Carl's bedroom, we are stopped in our tracks by the sight of *Kärlekens Ros* (The Rose of Love), suspended in the door opening (Figure 11.2). Carl's ideal makes women's various labours imperceptible, but in this design, Karin makes these efforts perceptible by touch.

Finished in 1909, this macramé-like door-hanging or portiere curtain at which you find yourself gazing separates Carl's bedroom from the bedroom belonging to Karin and the girls. Karin has combined kelim and her own knots, as well as an innovative loose warp technique, unknown in Sweden at that time (Ignell 2004, 5; Sundström 2019, 76–8; Rydin 2007, 175). These techniques together create a piece of openwork (needlework with many openings). As a result, both sides of the work are identical. (This is rarely the case with Karin's textiles, and therefore telling). The unconventional choice of material likewise hints there is more to this textile than meets the eye (and hands). The weft is made of wool, but the warp of heavy cotton twine. Touch the portiere, and you will be startled by the coarse texture this combination produces; it is almost evocative of haircloth. Quite a contrast with the attractive composition! There, a stylized, elongated Art Nouveau rose reminiscent of the Glasgow Girls 'Glasgow Rose' grows towards a large sun (Sundström 2019, 98). A minute snake coils itself around the flower's stem, which shows a tiny heart, and colourful waves rise and fall below.

By means of the portiere, Karin invites us to reflect upon the forms of female labour that invisibly make possible Carl's ideal of the home. These forms of labour range from emotional and domestic labour to artistic labour.[1] To begin with, the design faces both Karin's husband's room and that of her daughters, which suggests that the rose is not only an emblem of conjugal love, as Anderson posits (126); it signifies parental love too. By extension, it also refers to the emotional and domestic labour associated with these forms of love. Furthermore, the portiere's imagery and position make it speak to the floral border above it, dedicated by Carl to his wife. It becomes a return gift acknowledging the devotion in the border, which implies emotional labour. The door-hanging also provides privacy to the partners and the different family members, and thereby performs and signifies domestic labour. Finally, the waves cascading below the rose reference Karin's

tapestry *De Fyra Elementen* (The Four Elements) (Rydin 1997, 175). In this way, Karin disentangles her oeuvre from her husband's paintings, which often depict her tapestries: the portiere is both a work of artistic labour and symbolizes it. (Judith Leyster's and fourteenth-century French illuminator Jeanne de Montbaston's work, as discussed in the previous two chapters, show a similar delight in the artwork depicting artistic labour.) However, have a look at the floral border in Carl's recognizable style. You could say that in that border, Carl literally frames his wife's work as his possession and creation, and thus makes her artistic labour invisible. In this manner, the portiere forms part of the artistic conflicts of the home.

Now, walk through the portiere. You will notice that it not only symbolizes these forms of labour but also makes them physically, tangibly present. The coarse texture and the weight of the material fix you and other visitors in the door opening: our physical contact with the cloth is prolonged, and we are forced to pay even more attention to these physical qualities. According to textile thinkers, such a meeting between textile and skin is both complex and powerful. Skin and textile are both fibrous and therefore possess a grain; fibre anthropologist Victoria Mitchell posits that textiles 'are most closely known to us through their relation to the skin' (21). Furthermore, as design historian Jo Turney stresses, 'touch is the only reciprocal sense' (305). To touch Karin's textile inevitably means being touched by it. Because of this resemblance and this reciprocation, we may try to 'read' the cloth with our skin, but the cloth also reads us and our skin. What is more, the coarse grain of the cloth reads us *against* our skin's grain: the portiere rubs us the wrong way. Consequently, the physical contact between the visitor and the textile weaves the different forms of labour onto the visitor's skin, as it were. Its texture makes concrete the toil of these different types of labour. By association, in the portiere Karin also makes tangible her own hands as an artist, but also the hands of a mother and wife: she forces the viewer literally to feel the intense exertion her husband's ideal demands. To Karin, all love is an artwork, but also hard work.

Carl's Gaze

We continue looking at Karin's textiles, but we now mentally place her husband's paintings beside them, and contrast how he paints her and her work with what the textiles suggest. You and I are not the first to look at Karin: Carl did so first in his paintings, and as a result, many see Karin through his eyes. Through her textiles, Karin looks him directly in the eye, and tells him his way of looking at her disempowers her and her work.

First, let us trace how a downward perspective on Karin permeates Carl's work, and examine the effect of this way of looking at Karin. For example, *Ateljé-Idyll* (Studio Idyll), a pastel from 1885, makes her look up adoringly

at the viewer, subjected to and by their gaze. According to critics, such a depiction of Karin turns her into a submissive, self-sacrificing fantasy: Karin is never truly seen as she is, only perceived as an angel or Virgin Mary (Cavalli-Björkman 1987, 40; Rydin 1997, 162). Other paintings hint that such a representation has even more insidious effects. By portraying Karin and her textiles in a particular way, Carl deprives her of artistic agency, and appropriates her creations. The 1909 watercolour *Det Kvällas, God Natt* (Evening Falls, Good Night) epitomizes how Carl overshadows her creatively. In this kitchen scene, Karin's tapestry *De Fyra Elementen* forms the focal point, the work to which the portiere's waves allude. A table guides our eye towards this vibrant design. Surprisingly, Karin has left the room, that is, Carl paints her as absent. She has left behind her writing and sewing tools, and by association abandoned her art. Other critics see Karin as invisibly present, or claim the painting highlights the couple's creative partnership (von Heland 1982, 6; Snodin 1997a, 5). I would disagree, and stress that Carl's active presence dominates the painting. His arm interrupts the movement of our eye towards the tapestry and towards Karin's tools. In doing so, he distracts us when we are drawn to his wife's efforts. Instead, he directs our attention to his work. In this way, he incorporates Karin's work in his. His arm, moreover, signs the surface of the table, marking both the table and the painting as his possession and creation. This signature likewise indicates that all the art we spot in the picture is Carl's property and his accomplishment, just as the watercolour itself is. In sum, Carl's way of looking, which we find in the paintings, appropriates the art in the home, and his wife's art in particular: it suggests that he creates and possesses everything. With that same look, he also subordinates his wife to him.

Now let's mentally put these paintings next to these textiles, and compare Carl's way of seeing with the way Karin recommends. We then notice that in her textiles, Karin picks apart her husband's way of looking. How? Let's start with the library cloth. There, Karin deploys the mysterious insect to criticize the gaze that her husband's paintings teach. She presents the insect from an unusual perspective, which intimates that Carl's gaze is highly constructed. Similarly, to piece together the image, you, I and all other visitors must adopt an unusual physical position. This physical attitude indicates that there is no neutral, 'natural', unconstructed way of perceiving Karin, the house and other inhabitants. Rather, Karin whispers to us, there are only perspectives edged with power struggles. To turn to *Kärlekens Ros*, I have already shown how Karin makes the labour of women's hands tangibly present. By doing so, she fights back against Carl's appropriation of the energy invested in the textiles and the home. When we compare both textiles, we observe that they both fix us in front of them, and make us encounter openings and gaps: the openings in the openwork of the portiere, and the gaps in the tapestry segment. A gap or opening in a textile often offers a perspective. Accordingly, these many openings signify that there is no single, accurate perspective on Karin and her roles of mother, wife and

artist, only innumerable partial perspectives. By means of both textiles, then, Karin protests against her husband's disempowering manner of seeing her.

Two Thinkers: John Ruskin and Ellen Key

We will now briefly get up on our feet again, and, instead of studying the textiles very closely, take in their surroundings as well, especially the library. In the library, we can imaginatively juxtapose the ideas and books circulating there with Karin's textiles. If we do so, we catch a glimpse of how Karin lays bare the assumptions behind her husband's ideal.

In the library, the Larssons may have encountered John Ruskin's ideas in the magazine *The Studio*. The gender politics in Carl's paintings recall the gendered power dynamics in Ruskin's conception of the (artist's) home. A Victorian art critic, artist and writer, Ruskin (1819–1900) was a formative influence on several mid- to late-nineteenth-century movements, including the Arts and Crafts movement and the artist's homes associated with it. An Arts and Crafts spirit suffuses Lilla Hyttnäs (Blakesley 2006, 196–204; Hagströmer 2005, 280; Naylor 1997, 74–85). Ruskin's personal and public gender positions are complex, and his works blur boundaries between gendered roles (see ed. Birch and O'Gorman, 2002; the essays in Nord's edition of *Sesame and Lilies*, 2002). Carl's depiction of Lilla Hyttnäs nevertheless suggests a contemporary's more essentialist understanding of Ruskin.

In Ruskin's ideal, the home is a private sphere. It defends its inhabitants against the 'hostile society of the outer world', as Ruskin insists in an 1864 lecture (2002, 77). In this home, the partners perform different roles that reflect complementary gendered attributes. The husband defends the house, since his mental capacities give him the propensity for 'speculation and invention' and make him 'the doer, the creator' (Ruskin 2002, 77). The wife's duties, by contrast, are 'secur[ing] its order, comfort and loveliness', because her mental powers are 'not for invention or creation' (Ruskin 2002, 88). In another lecture, Ruskin pronounces the woman performing these duties 'a true wife', who 'in her husband's house, is his servant; it is in his heart that she is queen' (Ruskin 1994, 143).

Ruskin's statements reveal several implications of Carl's gaze. First, Ruskin frequently mentions invention and creation, which makes his claims apply to the *fin-de-siecle* ideal of the artist's home. This is, significantly, a male artist's home, in which the female partner lacks artistic opportunities. Second, Ruskin distinguishes gendered spheres and metonymically associates the house and the wife with one another. He thus transforms the wife into her husband's inanimate property, and by association, her art too. Third, the wife is either a servant or a queen. This hierarchical division implies that no 'true wife' would engage in a level exchange of gazes. Her identity depends on her subjecting herself to a condescending regard. Let's

twine these implications together. In Carl's Ruskin-indebted gaze, only one perspective on Karin's and her textiles is possible: that perspective is a disempowering, appropriating look. Any other way of seeing her would threaten his domestic ideal.

Another thinker, Ellen Key (1849–1926), may herself have sat and read in this library. Carl's ideal also draws on her writings. Key was a Swedish writer, feminist educator and family friend. She celebrated Lilla Hyttnäs as 'a home . . . in which with simple means the cosiest and most personal impression' has been achieved (Key 1899, 113; translation my own). Scholars often understand Key as espousing a difference theory of gender, but alternative conceptualizations run through her thought (Ambjörnsson 2012, 223–7).

Key ascribes to nature, objects and women an essential aim. In a collection of late-nineteenth-century essays underscoring the vital importance of beauty for all, she stresses that, in order to be beautiful, each object in the home should fulfil 'that aim for which it exists' expressively and simply (Key 1899, 4; for an English introduction to these essays see Miller Lane 2008). For instance, on a chair, one should be able to sit. Her conceptualization of nature underpins this notion: nature expresses its essential purpose, and consequently is beautiful. Good taste springs from 'a feeling for' or being alive to nature's 'most secret and finest truth' (4). Key attributes this sensibility particularly to women. By doing so, she tacitly ascribes an essential purpose to women as well. Another essay specifies this purpose: women are to be a 'hemlivets konstnärinna' ('artistess of the home life') by creatively inspiring children to learn from nature (Key 1913, 46).[2] Key grounds the essential aim in non-human nature. Consequently, she implicitly presents women as organically growing towards fulfilling this purpose. As a result, Key accidentally obscures the effort that achieving this aim requires. Designing and caring for domestic objects require that women invest energy; providing children or society with the kind of education recommended by Key takes energy as well. By associating women with nature, Key makes this energy expenditure invisible.

Key nevertheless unravels this association between women and nature as well. After she has expounded the 'law' of the essential aim of objects (Key 1899, 3–11), she details how to furnish a house according to these principles. With great practicality, Key advises readers about the use of colours and material (17).[3] She even instructs them how to varnish a plain deal floor! Key underlines that her solutions are affordable to all, and adaptable to individual taste. Editor Claudia Lindén comments: 'by making beauty no longer dependent on wealth, but rather an expression of personal taste, Key turned women in the home into conscious actors' (Lindén 2014, 18).[4] As the level of detail in her recommendations suggests, Key is convinced of the applicability of her advice. This conviction undercuts the apparent gender essentialism in the essays and their class hierarchies (expressed as an aversion to working-class attempts to adopt bourgeois style). Key trusts

all readers to be capable of putting her advice into practice, no matter their intersection of gender, class, ethnicity and other identities.

What does Karin have to say to these thinkers? Contrasting the textiles to their ideas reveals her response. According to Karin, there is nothing 'natural' about Ruskin's and Key's ideals. However, she also picks up Key's subversive thread. We can see this manoeuvre in the mysterious insect in the library cloth. When we study the insect, we adopt and exaggerate the upward gaze of her representation in *Ateljé-Idyll*. By exaggerating that adoring gaze, the library cloth undoes that worshipping look and Carl's condescending regard. Karin thereby defies any categorization of her as either servant or queen. According to her, there are different ways of conceptualizing the relationship between two partners and a house than just a relationship of servitude, possession and rule. Karin comments on Key's recommendations as well. The library cloth creature is quite hybrid: it smudges the lines between human and non-human. The insect's essence cannot be determined, and neither can, by implication, that of its creator. In this manner, Karin indicates that we cannot extract from nature any guiding principles for interior design, human interaction or human self-understanding; she calls into question the assumption behind the ideal. Furthermore, Karin's textiles incorporate various materials and textures and draw attention to the matter of the home. In this manner, Karin suggests that the role of Key's domestic artistess requires emotional and physical effort. This role, she intimates, is an actively chosen position rather than one organically growing from an intrinsic nature. Karin, then, simultaneously denaturalizes Carl's Key- and Ruskin-indebted ideal and unravels its gender associations.

If we once more move through the portiere, we discover that Karin picks even more holes in these thinkers' reflections that inspire her husband's ideal. Karin implies that differently gendered spheres and duties (premises found in both Ruskin and Key) produce tensions between emotional, domestic and artistic labour. If we pass the portiere, we haptically experience these tensions.

Conflicts between limitations and opportunities abounded in turn-of-the-century female artists' lived experience. They particularly struggled to balance different duties expected of women. On the one hand, middle- and upper-class women could pursue a fine arts education. (Karin did so; Vera Lane Poole, around whom the next chapter revolves, did likewise in the early decades of the twentieth century.) Several important figures in contemporary movements were female (Callen 1979). In Britain, female members of the Morris family, May Morris, for instance, contributed significantly to running the 'Firm' and produced several designs (Callen 1979, 11–17). On the other hand, their men's approval was required for them to dedicate themselves to art. Even if female artists were in the relatively privileged position of having access to a studio, they were still expected to successfully juggle the competing demands on their time from family, domestic and social duties, and their art (Thomas 2015).

Karin makes these tensions materially present in the portiere, but also attempts to control them. We can perceive these tensions when we move from Carl's room to Karin's and cross the threshold marked by the portiere. On the level of ideas, we move from the one artist's sphere to another, and from the space demanding a wife's role to the space demanding a mother's role. When we draw aside the portiere to walk through the door opening, the openwork threatens to scatter the rose. This threat points to conflicts between different spheres and roles. Furthermore, the textile makes us complicit in how it fragments the rose. The paintings have taught the spectator an understanding of gendered roles that is indebted to Ruskin and Key. Therefore, the viewer's complicity suggests that these conflicts arise from the gendering of these roles: we bring to the textile the gendering that causes the conflicts, but the textile resists.

Textile theory brings out in detail how Karin controls the conflicts between her different roles. Discussing knitted garments, Turney proposes that by crafting a handmade textile object, the crafter tactically gains control over the recipient. This control, however, comes with the price of sacrificing time also encroached upon by other activities (Turney 2012, 308, 309). In this light, the cloth's fibres index the time that Karin sacrificed. However, she also ventures to control the conflict between different roles. Since the spectator has been imprinted with Carl's gaze by his paintings, he or she effectively stands in for Carl. When we, then, move between rooms, we represent in for her husband doing likewise. When Karin wraps us in the portiere, and stops us in the threshold space occupied by the portiere, she takes control over her husband's haptic experience. In this way, she resists his control over her: she enfolds her husband in a reminder that his ideal forces women to juggle a variety of gendered roles. In this manner, she rips up the assumptions about gendered spheres and duties behind her husband's domestic idyll. In short, she crafts an escape from Key's, Ruskin's and Carl's picture-perfect home.

Veiling Hands

Karin may try to weave her way out of the ideal, but look at the textiles once more: heavy, attached to other objects, they cannot easily be extricated from the home and its ideal. That challenge tells us that Karin cannot help but contribute to some of the problematic effects of her husband's ideal.

Approach the library cloth once again, and we perceive how Karin re-inscribes class boundaries, by depriving observer and subject of the opportunity of a direct confrontational gaze. Mentally assembling the insect poses quite a challenge. Even when we succeed in doing so, it remains unclear whether the creature possesses eyes or not. The creature thus challenges us through touch rather than by sight. Because of the reciprocity of touch, this challenge is less confrontational. What gaze might Karin want to keep in check? The library's size parallels that of the servants' quarters, which

suggests a link between the library cloth and the servants. Carl's paintings sometimes grant servants quite a bold gaze. Examples include the 1904 oil painting *Martina med Frukostbrickan* (Martina with the Breakfast Tray), and the 1904 watercolour *Julaftonen* (Christmas Eve), also showing housemaid Martina. Clad in a long apron reminiscent of Karin's dresses, Martina meets viewers' eyes directly. Spectator and figure are almost on eye-level with one another, connoting egalitarianism. This implication of egalitarianism in the published reality of Lilla Hyttnäs is at odds with its actual reality, to use Barbara Miller Lane's distinction (2007, 219). The Larssons were no social radicals (Snodin 1997b, 112). Although they did not distinguish between a formal and informal sphere in their home, wanting their children around them at all times, they excluded the servants from this breaking down of hierarchies (Snodin 1997b, 112). The textiles, then, restrain servants' bold gaze and the implication of egalitarianism: they remind the servants of the hierarchy in the actual home, not the ideal, with Karin as the lady of the house. Karin, then, complicates working-class women's engagement with her textiles; she excludes them from the tapestries' rebellious enfolding, and discourages them from direct confrontation. In other words, she participates in how Carl's ideal glosses over social inequality.

Let's have one last, long look at *Kärlekens Ros*. I have already mentioned how it makes Karin's hands visible. However, it also conceals others' hands. Because of its complex texture and structure and personal imagery, it is not easily repeatable. It does not lend itself to adaptation easily, either. Weavers can only copy and/or adapt the textile if they can devote sufficient time to exploring the textile's techniques; they also need a high level of education to be alert to the modernist sensibilities of Karin's oeuvre.[5] Only women from a background similar to Karin's would possess these resources. This resistance to adaptation and copying can be glimpsed from how Karin intended another textile, a blanket, to be copied and woven by the women in the village, but such production never developed (Andersson 1986, 125). Traditional and local motifs thread through Karin's smaller embroideries (Rydin 1997, 171; 2009, 6; Sundström 2019, 33–48). Her more elaborate tapestries such as *Kärlekens Ros*, in contrast, bear no traces of the hands that passed on their embodied knowledge to her. These hands include those of the women of Bingsjö, a village in Dalarna, who taught Karin to spin and weave braid (Rydin 1997, 169). In covering up the hands of women from other classes, Karin's textiles reinforce and reproduce particular class boundaries. Karin's textiles veil tensions in her partners' work, which makes her complicit in his problematic idyll.

Conclusion

I would like to conclude our tour of Karin's textiles by considering how her textiles can enrich how we think about fibre art and art in general. Proposing

a 'poetics of cloth', Barnett posits that textiles offer non-linear 'Soft Logics', beyond binary distinctions (e.g. 'male/female'), with such logics constituting 'the realm of the "and/and", where anything can happen' (183). However, Karin's work indicates that textiles do not always give. Her designs suggest that textiles can also mark and constitute boundaries that are not easily transgressed or blurred. The embrace of textiles can be an entrapment; they can enforce complicity and silence subversion. In its materiality, it can burden bodies. Wool itches, for instance; heavy cotton, such as that of Karin's designs, can oppress the bodies of servants tasked with their care. Textiles can threaten physical integrity and well-being: for example, Karin used aniline dyes known to be poisonous (Stavenow-Hidemark 1997, 73). A logic of 'and/and' can cloak the role of textiles in concrete effects of distinctions on lived experience, including social inequality and the environmental crisis. A 'poetics of cloth' should encompass textile rigidity as well.

On a more positive note, Karin also cautions us against moving away from the physicality of the textiles. She warns that when we attempt to analyse her textiles, we move away from their stuffness. When creating such a distance, both viewers and critics easily slip from interpreting the work to appropriating it, and from appropriating it to obliterating it. That is, we risk exploiting and quietening the material. Karin offers a corrective; her fibre art foreshadows weaver and designer Anni Albers's exhortation that 'it is better that the material speaks than that we speak' (39). Karin's fibre art demonstrates that textiles can haptically speak back.

To conclude, this tour has demonstrated that Karin's textiles offer novel models for thinking through the entanglement of living beings, objects and meanings. Ultimately, Karin unravels her husband's tapestry of influences, and weaves viewers, significances and contexts into a more enfolding and inescapable web.[6]

Notes

1 I use 'emotional labour' in the sense that has come to the fore in the last two decades, as exemplified by Rebecca J. Erickson's 'Why Emotion Work Matters'. In this sense, it denotes the emotional support to others and management of others' emotions performed by and expected of women as wives and mothers in heteronormative families, and as colleagues in a wide range of professional environments (see Erickson 2005).

2 Key adds this phrase in a later edition, but the argument is identical across editions.

3 Stavenow-Hidemark outlines Key's ideal home (72). The reader is also recommended to visit Strand, Key's home, which gives material form to her theory of beauty in the home.

4 ('Genom at göra skönhet oberoende av pengar och ett uttryck för personlig smak subjektifierade Key kvinnan i hemmet.') I am grateful to Mattias Dahlkvist for this translation.

5 A twenty-first-century account of creating the replicas currently on display in *Carl Larsson-gården* indicates this resistance (Ignell 2004).

6 I would like to thank Ellen Keys Stiftelse Strand for their residency grant for two weeks at Ellen Key's Strand in May 2019, where part of this chapter was written, Ann-Catrine Eriksson for her comments and suggestions, and Birgitta Persson and Susanne Gregori at *Carl Larsson-gården* as well as Tina Ignell for the personal communications.

Bibliography

Artworks

Bergöö Larsson, Karin:
1) Kärlekens Ros (1909). Original stored by Larsson Family Association, Sundborn (inventory number CL 1). Replica on display in *Carl Larsson-gården*, Sundborn. Photo by Per Myrehed, courtesy of *Carl Larsson-gården*.
2) Läsrumsduken (1908). Original stored by Larsson Family Association, Sundborn (inventory number CL 2). Replica on display in *Carl Larsson-gården*, Sundborn. Photo by Per Myrehed, courtesy of *Carl Larsson-gården*.

Larsson, Carl:
1) Ateljé-Idyll (1885). Nationalmuseum, Stockholm, NMB 191. Nationalmuseum (https://www.nationalmuseum.se/atelj%C3%A9idyll)
2) Det Kvällas, God Natt! (1910). Private collection. Larsson, Carl. Åt Solsidan: en Bok om Boningsrum, om Barn, om Dig, om Blommor, om Allt: Taflor och Prat, Stockholm: Bonnier, 1910
3) Julaftonen (1904). Bonnier Portrait Collection, Stockholm. Snodin and Stavenow-Hidemark (1997), 150
4) Martina Med Frukostbrickan (1904). Ca' Pesaro International Gallery of Modern Art, Venice. Snodin and Stavenow-Hidemark (1997), 50

Texts

Albers, Anni, 'Design: Anonymous and Timeless', in Brenda Danilowitz (ed.), *Anni Albers: Selected Writings on Design*, 34–41. Hanover: University Press of New England, 2001.

Ambjörnsson, Ronny, *Ellen Key: En Europeisk Intellektuell*. Stockholm: Bonnier, 2012.

Andersson, Ingrid, *Karin Larsson: Konstnär och Konstnärshustru*. Stockholm: Gidlund, 1986.

Barnett, Pennina, 'Folds, Fragments, Surfaces: Towards a Poetics of Cloth', in Jessica Hemmings (ed.), *The Textile Reader*, 182–90. London: Berg Publishers, 2012.

Birch, Dinah and Francis O'Gorman, eds, *Ruskin and Gender*. Basingstoke: Palgrave, 2002.

Blakesley, Rosalind P., *The Arts and Crafts Movement*. London: Phaidon, 2006.

Callen, Anthea, *Angel in the Studio: Women in the Arts and Crafts Movement 1870–1914*. London: Astragal Books, 1979.

Cavalli-Björkman, Görel, *Carl Larsson, Porträttmålaren*. Stockholm: Förattarföretaget, 1987.

Erickson, Rebecca J., 'Why Emotion Work Matters: Sex, Gender, and the Division of Household Labor', *Journal of Marriage and Family* 67, no. 2 (2005): 337–51.

Gunnarsson, Torsten, 'Carl Larsson: His Life and Art', in Michael Snodin and Elisabet Stavenow-Hidemark (eds), *Carl and Karin Larsson: Creators of the Swedish Style*, 21–52. London: V&A Publications, 1997.

Hagströmer, Denise, 'Sweden', in Karen Livingstone and Linda Parry (eds), *International Arts and Crafts*, 276–85. London: V&A Publications, 2005.

von Heland, Madeleine, 'Carl and Karin Larsson', in Sarah Faunce (ed.), *Carl Larsson*, 53–66. New York: Brooklyn Museum, 1982.

Högardh-Ihr, Christina, *Karin Larsson och Blommorna i Sundborn*. Stockholm: Prisma, 2008.

Ignell, Tina, 'Karin Larsson'; 'Replicating Karin Larsson's Woven Textiles', *Vävmagasinet* (2004): 2, 3–5; 6–7.

Key, Ellen, *Skönhet För Alla: Fyra Uppsatser*. Stockholm: Bonnier, 1899, (Stockholm: Verdandi 1913).

Lindén, Claudia, 'Förord: Ellen Keys Feministiska Estetık', *Skönhet för Alla*, modernized edition, 7–21. Ödeshög: Alvastra, 2014.

Miller Lane, Barbara, 'The Home as a Work of Art: Finland and Sweden', in *Housing and Dwelling: Perspectives on Modern Domestic Architecture*, 211–20. London: Routledge, 2007.

Miller Lane, Barbara, 'An Introduction to Ellen Key's "Beauty in the Home"', in Barbara Miller Lane et al. (eds), *Modern Swedish Design: Three Founding Texts*, 19–31. New York: Museum of Modern Art, 2008.

Mitchell, Victoria, 'Textiles, Text and Techne', in Jessica Hemmings (ed.), *The Textile Reader*, 5–13. London: Berg Publishers, 2012.

Naylor, Gillian, 'Domesticity and Design Reform: The European Context', in Michael Snodin and Elisabet Stavenow-Hidemark (eds), *Carl and Karin Larsson: Creators of the Swedish Style*, 74–87. London: V&A Publications, 1997).

Ruskin, John, *The Crown of Wild Olive*. London: Routledge/Thoemmes Press, 1994.

Ruskin, John, *Sesame and Lilies*, ed. Deborah Epstein Nord. New Haven: Yale University Press, 2002).

Rydin, Lena, 'Karin Larsson', in Michael Snodin and Elisabet Stavenow-Hidemark (eds), *Carl and Karin Larsson: Creators of the Swedish Style*, 160–83. London: V&A Publications, 1997.

Rydin, Lena, *Karin Larssons Värld: Inredning, Trädgård, Mat, Mode, Textil* (2009).

Snodin, Michael and Elisabet Stavenow-Hidemark, eds, *Carl and Karin Larsson: Creators of the Swedish Style*. Stockholm: Bonnier Fakta, 1997.

Snodin, Michael, 'Introduction', in Michael Snodin and Elisabet Stavenow-Hidemark (eds), *Carl and Karin Larsson: Creators of the Swedish Style*, 1–9. London: V&A Publications, 1997a.

Snodin, Michael, 'Looking at Lilla Hyttnäs', in Michael Snodin and Elisabet Stavenow-Hidemark (eds), *Carl and Karin Larsson: Creators of the Swedish Style*, 88–159. London: V&A Publications, 1997b.

Stavenow-Hidemark, Elisabet, 'A Home of Its Time - but Completely Different', in Michael Snodin and Elisabet Stavenow-Hidemark (eds), *Carl and Karin Larsson: Creators of the Swedish Style*, 53–73. London: V&A Publications, 1997.

Sundström, Eva, *Konstnär, Estet, Nyskapare: En Kvantitativ och Kvalitativ Analys av Karin Bergöö Larssons Broderier och Vävnader på Carl Larssongården i Sundborn*. Uppsala: Uppsala University, 2019.

Svalin Gunnarsson, Elisabeth, *I Min Trädgård Vill Jag Vara Karin: En Praktisk Trädgårdsberättelse från Sundborn*. Stockholm: Bonnier Fakta, 2017.

Thomas, Zoë, 'At Home with the Women's Guild of Arts: Gender and Professional Identity in London Studios, c.1880-1925', *Women's History Review* 24, no. 6 (2015): 938–64.

Turney, Jo, 'Making Love with Needles: Knitted Objects as Signs of Love?', *Textile* 10, no. 3 (2012): 302–11.

12

Canvases in the Attic

Four Generations of the Lane Poole Women

Juliana Dresvina

Despite the work already done by historians on female political, religious or intellectual dynasties – as highlighted, for instance, by Claudia Derichs and Mark R. Thompson, in *Dynasties and Female Political Leaders in Asia* (2013) or by the scholars of the female recusants, such as Marion Wynne-Davies (*Women Writers and Familial Discourse in the English Renaissance*, 2007) and Julie Crawford (*Mediatrix: Women, Politics, and Literary Production in Early Modern England*, 2014) – the female linage is still frequently overlooked as it is harder to trace outside the discipline of biology. What follows is an attempt to retrace, through a series of biographical narratives, an impressive female line of a family where the women were as talented and intellectually astute as the men.

In a quiet corner of Oxford, in the dining room of the president's Lodgings at St John's College, tucked in a corner and unnoticeable at first among portraits of royalty and dignitaries, there hangs a humble painting of a pot with lilies on a window sill. Unremarkable as it may seem, it strikes a careful viewer with its silent sadness, almost despair. The catalogue of the College paintings (which I revised in 2017–18) laconically describes the artist: 'Mrs. Poole was wife of President Poole. Studied art with Sickert – active for only about 8 years (when her husband disapproved of her art). Painting was gift of Mrs Catherine Dupre (daughter of Mrs. Poole) [. . .], 1987' (Figure 12.1).

FIGURE 12.1 *Vera Lane Poole, 'Lilies' (late 1920s), St John's College, Oxford; image: The president and fellows of St John's College, Oxford.*

Practically anyone working as an academic in History, or even more generally in Humanities, has at some point encountered the name Lane Poole, as belonging to a man from this illustrious family. I first did so as a medieval history student reading Austin Lane Poole's *From Domesday Book to Magna Carta*, still an undergraduate classic nearly seventy years after its first publication. Later I discovered the work of Austin's father, Reginald Lane Poole, in his capacity of the Keeper of the Archives at the University of Oxford in the 1910s–20s. My orientalist colleagues still refer to the works of his brother, Stanley Lane Poole, who, inter alia, completed the first volume of the *Arabic Lexicon* begun by his uncle Edward William Lane, another famous British orientalist (whose 'flying carpet' life-size sculpture decorates one of the halls of the National Portrait Gallery in London). The same building houses over 800 works of Stanley's other uncle, Richard James Lane, a popular Victorian engraver. Yet it was Richard and Edward's sister, Sophia Lane Poole (1804–1891), who really started the dynasty by marrying a clergyman, Edward Poole, and later abandoning him – apparently on the basis of his excessive love for books, equal only to his love for strong liquor,

both habits constantly endangering the family budget (see the Lane Poole entries in Oxford Dictionary of National Biography).

In 1842, following the separation, Sophia took her two sons, Reginald and Stanley, with her to accompany her brother to Egypt; she ended up living in Cairo for seven years with Edward and their mother, also called Sophia – hence Edward's affectionate reference to his sister as 'Little Soph' (Thompson 1997, 259). Both women followed the local tradition of wearing the full veil, which Sophia by her own admission hated and only used to gain access to the women-only areas of Egyptian society, such as baths and harems. She did not seem to mind wearing trousers though: 'At home', she reported, 'and when visiting ladies of the middle class, I wear the Turkish dress, which is delightfully comfortable, being admirably adapted to the climate of this country. I have never gone out but in the Eastern riding dress' (Lane Poole 1844, 211). The result of this socializing was an account of her experiences, published as *The Englishwoman in Egypt: Letters from Cairo* in weekly volumes between 1844 and 1846, which made it the first work in English to describe lives of Egyptian women. The front page of the book does not mention her name, stating only that the letters were 'written during a residence [in Cairo] in 1842, 3 & 4 with E. W. Lane, Esq., author of "The Modern Egyptians", by his sister'. It was only after reading the preface that one would find out her name, 'Sophia Poole'. Back in England, Sophia collaborated with her younger son, Reginald Stuart Poole, to produce a series of descriptions of *Photographic Views of Egypt, Sinai, and Palestine* (1860–61). Later she raised the children of her elder son, Stanley (the future Reginald the archivist, who was then nine years old, and Stanley the orientalist), who were left orphaned on his death in 1867. Appropriately for an academic, she spent her last years in her younger son's house by the British Museum.

It is not surprising that, having been raised by such an illustrious grandmother, Reginald the archivist married a remarkable yet undeservedly little-known woman. Rachael Lane Poole (1860–1937) was born Rachael Emily Malleson and raised in London. Her mother, Elizabeth Malleson (née Whitehead, 1828–1916), was herself an extraordinary person. She was the eldest of eleven siblings, and, having been educated mostly at home, became responsible for their schooling, having thus developed her own teaching methods from studying everything she could find on educational theory. After a two-year stint as a teacher at the experimental co-educational Portman Hall School between 1854 and 1856, she worked herself to the point of illness and had to resign. The following year she married Frank Malleson (*d.* 1903), a child of a Unitarian minister like herself, and went on to have three daughters (Rachael being her second) and a son.

Just as Reginald and Stanley Lane Poole were greatly influenced by their illustrious grandmother Sophia, so Elizabeth owed a great deal to her own grandmother, Elizabeth Maguire (née Houghton, 1775–1857). She was born in America to a family of English immigrants from Worcestershire. At

fifteen, she ran off with an Irish army officer, Francis Maguire, the act which caused her to be cut off by her family. The marriage however proved to be both fruitful and eventful. From 1793 on Maguire was stationed in Quebec, and in 1797, while sailing home with her husband's regiment, Elizabeth was captured by the French and imprisoned with two of her small sons – the sole woman among several hundred soldiers. She managed to save the colours of the regiment from falling into the enemy's hands by wrapping them round her curling irons and dropping them surreptitiously in the sea through her cabin porthole. In prison she gave birth to her daughter, with the soldiers making a screen from their military cloaks to allow her some privacy, rats running across her bed. After over a year in gaol she was finally released and returned to England, having to travel part of the journey 'concealed in a dung cart' (Malleson and Malleson 1926, 14), according to her granddaughter. In 1809 Major Maguire was sent to India, where he died of fever in 1811; from then on Elizabeth dedicated herself to raising her grandchildren, of whom her namesake Elizabeth (later Elizabeth Malleson) seemed to have been her favourite.

Committed like her husband to social reform and promotion of education, Elizabeth Malleson was involved with the Working Men's College before founding its counterpart, the Working Women's College (1864), with a broad range of subjects taught for very low fees. There she personally recruited university-trained teachers and, after the Working Men's College refused to merge with it, turned her institution co-educational in 1874. Over the course of her long and active life, Elizabeth campaigned for many other causes, from the repeal of the Contagious Diseases Acts to organizing relief for the Bulgarian refugees who were suffering from Ottoman atrocities. Eventually, after five years of training district nurses, she launched the Rural Nursing Association in 1889, having discovered that the existing Institute of Nursing predominately worked in urban areas, securing support from many doctors and nurses and even overcoming the resistance of Florence Nightingale who was opposed to her venture. The Association was recognized and absorbed by the Institute eight years later.

Unsurprisingly, it was through Reginald Stuart Poole, involved in the same causes as her activist parents, that Rachael met Reginald Lane Poole. Although she never went to a university and was mostly educated at home, Rachael became a connoisseur of portraiture and, sharing her husband's academic interest, of music (later she became one of the founders of the famous Oxford Bach Choir), as well as an efficient administrator. After she and Reginald settled in Oxford in 1883, where he held a number of lectureships as well as a lifetime research fellowship at Magdalen College (C. S. Lewis, himself a long-term Magdalen man, recalls hearing the news of the death of 'the very aged Poole (medieval historian)' over the telephone on a Sunday evening in 1939), she organized three exhibitions of hitherto little-known portraits belonging to the university, the colleges and the city in 1904–6. After that Rachael embarked on a twenty-odd-year long project

of producing a comprehensive catalogue of portraits in Oxford colleges and public institutions, published in three volumes as *Catalogue of Oxford Portraits* between 1912 and 1925. The project grew out of a committee of fourteen, which included several heads of colleges, distinguished professors and one woman, 'Mrs Reginald Lane Poole', who did all the actual work. A recent *Catalogue of Portraits in the Bodleian Library* (2004) still has Rachael Lane Poole as one of the two authors – once again as 'Mrs Reginald Lane Poole'. The other, Kenneth Garlick, then Keeper of the Western art at the Ashmolean Museum, revised and added to Lane Poole's original catalogue and paid eloquent tribute to her efforts in his introduction to the volume.

Rachael Lane Poole dedicated a lot of her time to volunteering in Oxford, including serving on various university delegacies and committees to do with female students. Between 1892 and 1911 she was an important member of the Council of the Association for the Education of Women, acting for some time as its Treasurer and leading it through a difficult period when its finances were 'slender'. In 1926 she was elected a fellow of the Society of Antiquaries – an honour rarely bestowed on a woman – and was finally given an honorary MA degree from Oxford in 1932. The Public Orator, presenting her for the degree in the Sheldonian Theatre, did mention her cataloguing activities, yet greeted her as 'mulier nobis omnibus familiaris Archivorum olim Custodis uxor, filii filiaeque mater vobiscum arte conjunctorum' ('the woman we all know as the wife of the former Keeper of the Archives [and] the mother of the son and the daughter, close associates of yours') (*The Oxford Magazine* 1937, 526). Indeed, with her husband she had two daughters and two sons, the elder daughter being a tutor in Classics in Oxford and the youngest child being Austin Lane Poole (1889–1963), historian and president of St John's College, Oxford, from 1947 to 1957, the author of *From Domesday Book to Magna Carta*, with which our story began.

Yet it is his wife, Vera Ellen Poole (1890–1965), who stands in the centre of this story. As one would expect, her lineage was no less remarkable: her paternal aunt was Helen Bosanquet (1860–1925), a renowned feminist and suffragist, one of the first women to gain first-class honours in the Cambridge Moral Sciences Tripos. Born Vera Ellen Dendy, in Melbourne, Australia, where her father was then a professor of Zoology, she grew up in New Zealand (1894–1903), South Africa (1903–5) and London, after her father Arthur Dendy was employed as professor of Zoology at King's College London (from 1905 until his death in 1925). Her mother was Ada Margaret Courtauld, a great-niece of the textile magnate Samuel Courtauld, her distant cousin being another Samuel Courtauld, the founder of the eponymous Institute and Gallery in London. One of Arthur's sisters, writer and educator Mary Dendy, was a companion of Sarah Ann Cawston, the adopted daughter of Samuel Courtauld Sr, and resided with her in Essex. It was there that Arthur met Ada, who was staying with her relative in the winter of 1887/8. Having accepted his appointment to Melbourne, Arthur Dendy had to move fast with his proposal – and so he did while skating

'with the aid of a lantern' on New Year's Day, 1888 (McLachlan 1935, 206). Since Vera showed significant promise in painting, she studied at the Lambeth School of Art in 1909 and under Walter Sickert in 1910 at his private school in Hampstead; she then spent two years, from 1912 to 1914, in Paris. The painting on the cover of this book, now in the possession of Vera's grandchildren, is believed to be her self-portrait from those years in France. At some point before the First World War she met Austin Lane Poole, since he spent 1914–18 as Second Lieutenant in the Gloucestershire Regiment, when he was wounded; they married in 1916 at the parish church of Vera's parents, Christ Church in Hampstead. Between 1916 and 1922 she exhibited at the new English Art Club. After the war the Lane Pooles settled in Oxford, where Austin was a fellow in History at St John's College (1913–47) and then president of the College (1946–57), and Vera briefly taught at the Oxford School of Drawing. Given Austin's medieval connections, she may have met Edith Tolkien, another woman discussed in this book. In the late 1940s she moved to the Cotswolds, to the village of Blockley (Gloucestershire), while her husband was busy in Oxford, where she died.

What we know about Vera's life comes almost entirely from the fragmentary memories and artefacts preserved in her family. Judging by the surviving paintings and drawings, Vera's artistic circle in the 1910s and 20s ticked all the trendy boxes. Her own art was very obviously influenced by Walter Sickert, her teacher, although she didn't seem to imitate him slavishly nor followed his more risqué topics, having a stronger inclination for landscapes. One of Vera's most Sickertian paintings, 'The Artist's Mother and Jack' (c. 1911, now in the Ashmolean Museum, WA1985.192), despite its homely setting, emanates tension and ambiguity of the relationships between its figures so frequently seen in the works of her teacher. The painting juxtaposes Vera's mother, looking down, with Vera's brother John, standing in the doorway, wearing all black and watching his mother anxiously. John, known as Jack in the family, was born in 1901, and in the picture he looks not older than eleven, which dates the painting to 1911/12. This would explain Jack's black clothes, the distant look on Ada's face, avoiding her son's gaze, and the overall flat, almost graphic palette of the picture – in 1911 one of Ada's daughters, Vera and Jack's sister Mary, died suddenly aged fifteen, which had a devastating effect on the family: a foreshadowing of things to come (Figure 12.2).

As one may expect, Vera had close connections with the Camden Town Group artists such as Henry Lamb and Madeline Knox, although women were eventually excluded from the group. There is a pencil drawing of Vera in the 1920s by Paul Nash, whom she must have known via her London connection and when Nash taught at Oxford between 1920 and 1923. A surviving painting by Vera of Waterloo Bridge with Westminster in the background is accompanied by a watercolour by Madeline Knox (1890–1975), done from the same spot and at the same time, demonstrating that the two women worked together at least on one occasion. Knox, an artist and a

FIGURE 12.2 *Vera Lane Poole, The Artist's Mother and Jack (c. 1911), image*
© *Ashmolean Museum, University of Oxford.*

model, was also trained under Sickert (in London in 1907–10), and he even
left her in charge of his school during her final year of study. Gilbert Spencer
(1892–1979), younger brother of Stanley Spencer, drew a pencil portrait
of Austin Lane Poole in their Oxford accommodation, as well as sketched
in oil the three Lane Poole children in 1930; Spencer must have known
the Lane Pooles through his teaching at Oxford and involvement with the
Garsington Manor group – the residence of Lady Ottoline Morrell, a friend
of Sickert's, a patron of literature and the Bloomsbury Group supporter.
Spencer writes of his painting 'A Cotswold Farm' (1930/1, Sheffield City Art
Galleries, the Chantrey Bequest) that it was 'the result of my many visits to
[Andoversford] in the Cotswolds to stay with [my friends] Austin and Vera
Lane Poole' (Within These Shores 1989, 59). Finally, Henry Lamb (1883–
1960), another associate of Sickert, the Camden Town Group, and Lady
Morell painted a portrait of Vera and Austin's daughter Catherine soon after
the tragic events of 1931.

An article by Drs Gibson and Hobson appeared in *The Lancet* on 5 March 1932:

A small outbreak of scarlet fever began in Oxford about Feb. 8th, 1931, seven cases being reported. [. . .] All the cases were mild. [. . .] With the exception of the two cases which form the subject of this report, all made an entirely uneventful recovery and convalescence. [. . .] *Past history.* – The three children in this family, a girl aged 7, a boy 5, and a girl aged 3, were all healthy children who had hitherto experienced only minor ailments and escaped any of the specific fevers. All three were inclined to have large tonsils and adenoids. They had unusually liberal allowances of fresh food in the form of fruit, salads, milk, eggs, and wholemeal bread, and spent much time in the open air. All were dark-haired and well nourished, with dark eyes and high-coloured rosy cheeks.

History of the cases. – On Feb. 8th the boy, aged 5, contracted scarlet fever, the onset being marked by fever and a sore-throat. All three children had been playing together on the 8th, and the exposure of the two sisters was obvious. The patient and his elder sister had three years previously been given prophylactic diphtheria antitoxin; therefore no anti-scarlatinal serum was administered in either case for the fear of a serum reaction. The younger sister was given a prophylactic dose of anti-scarlatinal serum, and protected. On Feb. 12th the elder sister, aged 7, developed scarlet fever. The two children were then nursed in the same room, the beds being at least eight feet apart. In each case the scarlet fever was of a mild order, the temperature lasting only three days, and in neither case reaching 103° F. at its highest. The initial fever subsided, but both children simultaneously developed an acute bronchitis, introduced by an attendant, and were febrile for a further period of three or four days. There was at the same time some enlargement of the glands under the jaw from the infected tonsils.

On Feb. 23rd, 16 days from the onset of the scarlet fever, the first patient developed hæmorrhagic purpura and was dead in 48 hours, the temperature having been normal for the previous five days and the child's general condition excellent. On March 5th, 21 days from the onset of the scarlet fever, the second patient developed hæmorrhagic purpura and was dead in three days, the temperature having been normal for the previous seven days and the child's general condition excellent. (Gibson and Hobson 1932, 509)

These were Vera and Austin's two elder children, John and Elizabeth. The deaths were thought to have been caused by a streptococcal infection brought in by an agency nurse who did not report that she had been ill; the nurse was employed as it was considered improper for an Oxford professor's wife to nurse her children herself. According to the family memory, Elizabeth allegedly saw the same marks under her own skin at her brother's funeral and realized that she had the infection as well. St John's College chapel still

has a plain plaque on the wall: 'In loving memory of JOHN / Who died 25 February 1931 aged 5 ½ years / and of ELIZABETH / Who died 9 March 1931 aged 7 years / Son and daughter of Austin Lane Poole / Fellow of the college & of Vera his wife / They were lovely and pleasant in their lives / and in their death they were not divided.' This is the only memorial to the children as their father had them cremated and their ashes scattered. Vera, who was a quite committed member of the Church of England, presumably agreed to it.

The double death had a devastating effect on the family and completely soured the relationship between the Lane Poole couple which may well have been troubled before. The last datable picture by Vera is a delicate pencil drawing of John on his deathbed, now at the Ashmolean Museum (there is a copy still kept in the family); after that she stopped painting. It may have been because, as one of her granddaughters surmised, she could not bear to be alone with a picture. But equally, if not more likely, it may have been because Austin, who had previously been hostile to her painting as a frivolous occupation unworthy of a professor's wife, indirectly blamed her for the children's death. No more children or paintings followed. The spouses drifted apart and seemingly never recovered from the loss of their two children. Austin's surviving diary for 1944/5 is dominated by the committee meetings of the Dictionary of National Biography, and dental appointments. Vera, after decades of not painting, eventually produced several dull Cotswold watercolours, as Austin found their subject matter and style less objectionable. The old pictures were packed away, and Austin was heard saying on occasion that he really must burn those canvases in the attic.

Luckily, he never did – or not all of them. Only a handful survive though: two in the Ashmolean Museum, three in St John's College, Oxford, and about a dozen dispersed among Vera's five grandchildren, the children of her only surviving daughter, writer Catherine Dupre (née Lane Poole, 1927–2014). Henry Lamb's portrait of her, painted about 1934 (Figure 12.3), depicts a rosy-cheeked, brown-haired, dark-eyed girl with an unusually adult stare. She married another St John's man, Desmond John Dupre, a musician (Sillery 1994, 136). His mother Ruth Clarkson was also a remarkable woman: she trained as a violinist and went to the United States in her late teens, unchaperoned and with her maestro, yet she gave up playing when she married – one cannot help wondering if her son fulfilled her unrequited ambitions. Apart from three daughters and two sons, Catherine Dupre produced a very successful biography of John Galsworthy, published in 1976 by Collins, and several novels, the first of which, *The Chicken Coop*, appeared in 1967, soon after the deaths, first of her father and then of her mother two years later. In it, she relives her lonely childhood with her estranged parents, whose life is dominated by the 'graves in the woods'. The novel is dedicated to the memory of her brother and her sister, and opens with a quotation from Benjamin Franklin: 'Three may keep a secret, if two of them are dead.' The main character of the novel, teenage Claudia, muses over the death of her siblings:

She tried hard to remember what they had looked like, but her recollection was confused by the profusion of touched-up photographs that stood on Gertrude's dressing table and Benjamin's desk, and only occasionally, when she wasn't thinking of them at all, did she suddenly see what they had really been like. Their image had become encrusted with sentimentality. It is hard, Claudia thought, that one can't think of them without thinking of their death; it's like the piebald horse and its tail. It's impossible to remember one without the other. Their being dead had become the essential thing about them; their being dead had done so much. It had changed Gertrude and Benjamin. It's as if they had stopped, she thought, stopped at the moment of their death; they don't look forward any more. They just wait. And it had changed her too, and made her self-conscious of her existence. She found the fact that she was alive when they were not remarkable, and secretly she felt dedicated and peculiar as though she had been preserved for some special purpose. (Dupre 1967, 28)

FIGURE 12.3 *Henry Lamb, 'Catherine Lane Poole' (1932), private collection (photo: courtesy of Caroline Hartnell).*

FIGURE 12.4 *Catherine Dupre, 'Girl on a Cotswold Wall' (2003), private collection (photo: courtesy of Caroline Hartnell).*

The Chicken Coop ends with a glimpse of hope for the healing and reconciliation of fictional Claudia's parents, Gertrude and Benjamin – the healing which never quite happened to Catherine's parents, the real Vera and Austin. Having done her therapeutic writing, upon retirement Catherine carried her mother's unfulfilled ambition through by retraining as a painter. Her canvases are different in style to her mother's; she prefers frequent homely landscapes interspersed with pictures of her grandchildren in domestic setting. The most striking picture, however, is of a little girl without a face, standing on a low wall of Cotswold stone, her white dress flying in the wind, small, lonely and unprotected yet defiant in the centre of the canvas – the ultimate survivor[1] (Figure 12.4).

Note

1 https://www.catherinedupre.co.uk/girl_on_cotswold_wall.htm. I wish to thank Vera Lane Poole's four grandchildren – Caroline Hartnell, Sophie Dupre, Tom Dupre and John Dupre – for sharing their family history with me, as well as Michael Riordan, Catherine Casley, Stephen Pink and Maria Artamonova for further help with the draft of this chapter.

Bibliography

David, Dewing and Judith Batalion, *Home and Garden: Paintings and Drawings of English, Middle-Class, Urban Domestic Spaces, 1914 to 2006*. London: Geffrye Museum, 2007.

Dupre, Catherine, *The Chicken Coop*. London: Bles, 1967.

Garlick, Kenneth and Rachael Poole, *Catalogue of Portraits in the Bodleian Library*. Oxford: Bodleian Library, 2004.

Gibson, A. G. and F. G. Hobson, 'Haemorrhagic Purpura Following Scarlet Fever: Report of Two Cases in One Family', *The Lancet* (5 March 1932): 509–11.

Harrison, Colin, Catherine Casley and Jon Whiteley, *The Ashmolean Museum: Complete Illustrated Catalogue of Paintings*. Oxford: Ashmolean Museum, 2004.

[Lane Poole, Sophia], *The Englishwoman in Egypt: Letters from Cairo…, in Two Volumes* (1844–46).

Malleson, Elizabeth and Hope Malleson, *Elizabeth Malleson, 1828-1916: Autobiographical Notes and Letters* (1926).

McLachlan, H., *Records of a Family 1800–1933: Pioneers in Education, Social Service and Liberal Religion*. Manchester: Manchester University Press, 1935.

Oxford Dictionary of National Biography. Oxford: Oxford University Press, 2004/2010.

The Oxford Magazine, 29 April 1937 (1937).

Sillery, Valentine, ed., *St John's College Biographical Register 1919—1975* (1994).

Thompson, Jason, 'Edward William Lane in Egypt', *Journal of the American Research Center in Egypt* 34 (1997): 243–61.

Within these Shores: A Selection of Works from the Chantrey Bequest. London: Tate Gallery in association with Sheffield City Art Galleries, 1989.

PART IV

Mothers and Others

This section deals with the women pigeonholed into an age-old definition of 'wife and mother'. Some were forced into the spotlight by their proximity to prominent men, 'more blessed due to the splendour of the thought of her [son/husband/brother etc.]', like Monnica of Hippo; and some were forced into obscurity by that same token, like Eva Larkin. They are still being defined by the roles allocated to them or by clichés forced upon them, like Edith Tolkien. Sometimes, the proximity of a 'great man' only served to sully the perception and memory of these women, as in the case of Vivienne Haigh-Wood (Eliot). They are the silent presences behind the men's work, providing food and financial support, childcare and housework, editing and proofreading, not to mention advice and collaborative assistance, like Ann Golding. (Maria Artamonova)

13

Haunting Augustine

St Monnica as Mother and Interlocutor

Patricia L. Grosse

This is a ghost story. In the decades leading to 421 CE there were a series of apparitions that frightened many monks, priests and laypeople in what was then the Roman Empire. The Bishop of the North African Roman city Hippo Regius, Augustine, shared and analysed the sightings in a series of letters with those who had heard of these apparitions, culminating in his short text, *The Care to be Taken for the Dead*. In this text the sixty-eight-year-old bishop ultimately denies the likelihood of human spirits participating in the realm of the living through a series of soft proofs. His (dis)proof given for the souls of the dead returning to the land of the living because they care for the living is a simple one:

> If the souls of the dead were taking part in the affairs of the living, and they themselves were speaking to us when we see them in our dreams . . . my devout mother would be with me every night, for she followed me on land and sea that she might be with me. Far be it that she should have become for the sake of a happier life [in heaven] cruel to the extent that, when anything grieves my heart, she would not console her grieving son whom she loved so fondly! She never wished to see me sorrowful. (*The Care to be Taken for the Dead*, 13.16, 372)

Knowing his mother Monnica well,[1] Augustine knew that if it were possible for a mother to haunt a son his mother would have done so with vigour. This account of his mother, dead for over thirty years by this point, seems to contradict that which he gives in Book IX of his famous autobiographical text *Confessions*: in the culmination of the autobiographical portion this narrative he calls upon the reader to help magnify his mother's last request to be remembered at the altar of the Lord.

Christianity today would look very different were it not for this fifth-century North-African Bishop. It is said that the Protestant Reformation itself was a battle against Augustine's doctrine of Grace on the one hand and Augustine's Doctrine of Free Will on the other. Christian conceptions of 'original sin' find their philosophical and theological grounding in Augustine's many readings of Genesis. Western attitudes on sex and women are often said to have been mutilated by Augustine's own sexual demons. Augustine's rule of order for his monastic brothers is one that is still practiced today.

Perhaps most important of Augustine's contribution to Christian thought is the focus on community and forgiveness of sins – we are, all of us, likely to fall short of any kind of heavenly ideal in this realm below due to our nature as both non-perfect creatures and descendants of a fallen original pair. Throughout his work Augustine seeks to emphasize the imperfection of the human condition. His thought on this matter is not an invitation to excess, but rather an avowal of human finitude.

The patron saint of theologians, the pre-conversion Augustine was a star in the secular world in many ways: he was a very smart child and as a young adult, he left his small town to study in the major city of Carthage, and eventually became a rhetorician and professor in Rome and Milan. His status as an accomplished rhetorician led him to be able to give a speech to the emperor of Rome himself. Augustine was very ambitious before his conversion and his secular career was on the rise: he was even able to become engaged to an heiress from a wealthy family that would further aid him in his worldly ambitions. All of these things we know from Augustine's *Confessions*.

When the thirty-one-year-old Augustine converted to Christianity in a Milanese garden in 386 CE, he became an example for Christians to follow – a scholar and wunderkind converted through intellectual pursuits and proper study under such luminaries as Ambrose, Augustine gave philosophical grounding for Christian thought. As a boy set on fire by Virgil the poet, as a teen by Cicero the philosopher and as a grown man by the Holy Gospel, Augustine was the perfect catch for the Christian Church of his time period as well as an amazing example for those seeking to convert later in life. (For more on Cicero and his own relationship with important, ignored women, please see Susan Treggiari's excellent Chapter 5 in this volume, 'Backing the Family: Servilia between the Murder of Caesar and the Battle of Philippi'.)

But Augustine is not the Patron Saint of Conversions, his mother is.

Augustine himself claimed he drunk in Christianity with his mother's milk. As will be discussed further, Monnica spent Augustine's entire early life winning him for Christianity. She did this in several ways, most important of which was never giving up on him, even when he converted to a dualistic cult. Monnica was the first person he turned to after his conversion, because in so many ways his conversion of spirit and mind had its first, firmest foundation in his mother's tears. This importance is not often contradicted in scholarship on Monnica. However, Monnica is often separated from discussions of Augustine's religiosity itself. Let us not do so in this text.

The physical traces of Monnica that are left today are few but surprising: there are her bodily relics, housed in a church that bears her name in Rome, a monument erected at her original tomb in Ostia, the port of Rome, soon after the death of her son. There are also some references to her in Augustine's philosophical dialogues, autobiographies, letters, and in the reference to her seeming obsession over his happiness in *The Care to be Taken for the Dead*. For most women of this time period it is nearly impossible to uncover their spirits. However, there is more to uncover in the search for St Monnica's soul.

Her epitaph, which will be quoted in full in the conclusion of this chapter, says that she is more blessed due to the splendour of the thought of her son. Erected in 431 after Augustine's death, it presents her as a kind of an ideal woman for her time: a perfect mother. But Augustine leaves in his work more than just a saint's Vita or a son's memorial. In this chapter we will hunt for St Monnica's ghost, more present than perhaps her son due to her son's devotion.

Such a Good Little Girl: Drunk and Abused

As they were on their way back to Africa, Monnica became ill during a stop-over in the port city of Ostia, near Rome: 'While we were at Ostia by the mouths of the Tiber, my mother died' (Conf. IX.viii.17, 166). Augustine follows this poignant statement with an account of God's 'gifts to her', beginning with her early struggles with alcohol. A strange beginning for a saint's hagiography! Not least because this hagiography has no conversion scene and not much in the way of struggle. Monnica grew up in a Christian household and was a Christian herself until she died. By her son's account, her husband was an angry, abusive pagan who, however, never laid a finger on her due to her own cleverness. She gave advice to women whose sweet-tempered husbands beat them: let your angry husbands calm down before explaining to them how they are wrong. This angry husband she eventually 'won' for Christ through her own patient encouragement.

St Monnica is the patron saint of alcoholics because her son gives a positive account of her descent into a kind of drunkenness and her return to moderation. Augustine emphasizes her struggles with alcohol twice: first

as a child and then as an adult. The initial description of her 'alcoholism' is immediately preceded by one of her as a sober child who wasn't even allowed to drink water during meals. However, she began drinking first a little then a lot of wine as she was sent down as a girl to fill wine from the wine cask. 'How did you cure her?' Augustine asks God. Through the taunts and jeers of the slave girl who would go down with her to the cellar. He writes: 'The taunt hurt. She reflected upon her own foul addiction, at once condemned it, and stopped the habit. Just as flattering friends corrupt, so quarrelsome enemies often bring us correction' (Conf. IX. ix.19, 168). However, this correction did not lead to complete abstention but moderation.

As we know from Book VI of the *Confessions*, Monnica brought to Italy a habit from Africa that Ambrose, the Bishop of Milan disapproved of – in both the Catholic and Donatist households, Africans went to saint's tombs to drink wine, eat meals and 'feast' with the dead. Augustine gives a description of his mother's custom, its relationship with her devotion, the dilution of the wine, and more assurances of her definitely not doing it in order to get rowdy and drunk: 'After bringing her basket of ceremonial food which she would first taste and then share round the company, she used to present not more than one tiny glass of wine diluted to suit her very sober palate. She would take a sip as an act of respect' (Conf. VI.II.2, 91). It would seem that Monnica must have had a reputation for this drinking, as Augustine takes great pains to show that, although she loved her boozy custom, she loved worship more.

At the end of this section, Augustine posits that she likely only took the ban to heart due to her love for Bishop Ambrose, demonstrating in Book VI Monnica's willingness to give up on cherished customs for the sake of following the advice of those whose opinions she respects. Augustine's representation of Monnica in this way is scandalous: she is shown to be a person with flaws who lived in a complex world.

My Mother Was a Saint, a Cook and a Philosopher

We first hear of Monnica in the *Confessions* as a nursing mother. Augustine's tale begins with his reliance on his mother's and nurse's accounts of himself as an infant as well as his own viewing of infants (possibly his son, Adeodatus). The rationality of his infancy is described as one of blind grasping: 'For at that time I knew nothing more than how to suck and to be quietened by bodily delights, and to weep when I was physically uncomfortable' (Conf. I.vi.10, 7). The importance of Monnica's milk as a metaphor for Augustine's imbibing of the Christian faith can be seen throughout the text – and, indeed, in many places in his work. Along with that milk, he claims to have drunk in Christianity.

In the *Confessions*, Augustine emphasizes the great lengths his mother went to in order to follow and support her son: Monnica's devotion is always portrayed in sharp contrast to Augustine's rudeness – he lies to her and abandons her in Carthage when in fact he went to Rome in secret: 'I lied to my mother – to such a mother – and I gave her the slip' (Conf. V.viii.15, 81)! This is depicted not as a clever trick by Augustine but rather as a dirty one. The *Confessions* is a narrative of Augustine's journey towards God's grace, and it is an account of the pilgrimage a dedicated Christian must take. That journey, however, was taken alongside a patient, moderate, loving woman who was willing to change long-held beliefs when confronted with a good enough reason to. Monnica of the *Confessions* is an exemplum who sought to bring others with her on the path to salvation, not just her son.

While Augustine's early life and education was funded by his father Patricius (who died when Augustine was sixteen years old), his life and studies as a young adult were financed by his mother. By the time he was eighteen he had got himself a woman that some, including myself, would call his wife. They had a son together, Adeodatus, and the woman (sometimes referred to as Anonyma A) was a part of Augustine's household. However, it is unclear if the young Augustine ever truly had his own household: he had no lands or properties of his own as they were all held by Monnica after her husband's death. It was her purse strings that allowed for his education and, likely, his financial support for much of his career (though he had other wealthy donors as well). Moreover, it was on Monnica's suggestion that his wife was sent away, and Monnica who arranged the engagement to the young heiress.

After Augustine's conversion to Christianity in Milan, his first stop (after his best friend who was near him at the time) was to his mother. He told her to no longer expect any more grandchildren as he had converted and intended to become celibate. It is not too long after this that Augustine, some friends, some students, his son and Monnica all headed out to stay at a rich friend's lakeside Villa near Lake Como.[2] At this time Augustine would produce the most 'philosophical' of his writings – dialogues in which he stands in as a Socratic figure that engages in dialogue with those who are not quite equal. Except, of course, when his mother is present.

In *The Happy Life*, Augustine begins by asking the question to his interlocutors, 'Do we all wish to be happy?' Upon agreement from the crowd, Augustine follows with the question 'So is everyone happy, then, who has what he wants?'

> At this my mother responded, 'If he wishes for good things and possesses them, then he is happy; but if he wishes for bad things, even if he possesses them, he is unhappy.'
>
> Smiling at her, I said with joy, 'Mother, you have gained true mastery of the stronghold of philosophy. For certainly you were trying to express yourself like Cicero, who similarly dealt with the matter. For, in the

Hortensius, the work he wrote in praise and defense of philosophy, he stated, "Not philosophers, certainly, but those who are prone to argue, say all are happy who live as they wish. That is not true, for to wish for what is not fitting is the worst kind of misery. It is not quite so misfortunate not to attain what you wish as to wish to acquire what you ought not. For greater evil is brought about through a wicked will than beneficial things through good fortune."'

At these words, my mother spoke out so enthusiastically that we, forgetting her sex, might have thought that some great man was seated with us. Meanwhile I became aware of the divine source that flowed through her words.

In this exchange it may seem that Augustine flippantly responds to her serious answer by calling her what other translations call a 'great man'. Elsewhere he refers to her as even a stand-in for the Church itself, as he was very impressed with her responses to the questions being discussed. It is here that, as the classics scholar Catherine Conybeare points out, Monnica is forced to remind her son that she is a 'little woman' (Conybeare 2006, 74). One may wonder if Augustine's initial love for the righteousness of Cicero's *Hortensius* (the now lost text that converted him to philosophy at a young age) could have originated from what his mother had already taught him.

Augustine is the author of these dialogues, and he claims them to be true representations of the conversations that we had during that vacation at the lake. Monnica's gentle reminder of her gender is not least important because Monnica was often near the interlocutors as she was providing them with food, drink or other support. Augustine's leisure at Cassiciacum was financially funded by his rich friend but made materially possible by his mother managing his household. His ability to recover from the chest ailment that sent him onto this retreat was made possible by his mother providing meals and seeing to the needs of his household (his one-time companion and mother of his child had been sent away before his conversion to Christianity).

Monnica would not let herself be turned into a saint while she was alive – she was a mother and a friend and a Christian (and a provider of material necessities). She was not only her ideas, just as she was not only any one aspect of her personality.

This playful Monnica is more serious in the *Confessions*, a text written over a decade after the Cassiciacum dialogues were composed and over a decade after her death. During the time between Augustine's conversion and Monnica's death, their relationship (according to Augustine's account) is depicted as more and more based on equality: while she did manage the household and take care of everyone, she also was an interlocutor in philosophical dialogues. She and Augustine also had a joint vision of heaven. While his conversion may have altered their relationship, it did so in a way that was incredibly uncommon and transformative.

Surprisingly, Augustine's *Confessions* at times reads as more of a biography of his mother than it does an autobiography of his own spiritual journey. This is because Augustine's spiritual journey is intrinsically linked to the devotion of his mother.

Ghost Stories: The Death of St Monnica

In Book IX of the *Confessions*, Monnica is described as, at the end of her life, giving up on a desire she'd had for being buried in Africa alongside her husband Patricius. Waking briefly from the fever that would take her life, she says 'where was I?' After this question, she says, 'Bury my body anywhere you like. Let no anxiety about that disturb you. I have only one request to make of you, that you remember me at the altar of the Lord, wherever you may be' (Conf. IX.xi.27, 173). Are we to believe that place she was before deciding to be buried anywhere was the afterlife? Not too long before this exchange, before she fell ill, she leaned out of a window with her son and approached something like exstasis – an ecstasy more lasting and gentle than that platonic vision Augustine had alone.

'Where was I?' Does it have a religious import? Or is Augustine simply relaying the confusion that surrounds death from such a fever (one such fever would take him too, in another land, with the Vandals at the gates). Where was I? A few paragraphs in the text later we learn that his mother, approaching death, 'did not think of having her body sumptuously wrapped or embalmed with perfumes or given a choice of monument. Nor did she care if she had a tomb in her homeland. On that she gave us no instruction; she desired only that she might be remembered at your altar which she had attended every day without fail' (Conf. IX. xiii.36.177–8). From this passage we learn a few things: embalming and perfuming the dead was once seen as important to Monnica, monuments and epitaphs were important, being buried beside her husband was important and, finally, returning to Africa was important.

Monnica's sacrifice of all of these customs, of all of these intimate ways of life, can be viewed in several ways: she could have wished to avoid the trouble of her sons (Augustine's brother was also present at their mother's death) seeing her as a corpse, she could have recognized that her end was near and that their furlough in Ostia (which was for an undetermined amount of time) would not only just leave her son with a corpse but a putrefying one at that: her own body wouldn't be able to be properly cared for and interred according to the customs of her homeland in any meaningful way. Indeed, as discussed earlier she had already let go of her long-cherished custom of drinking and feasting at tombs, having been convinced by the arguments of Bishop Ambrose. And perhaps she could have legitimately started the beatification process and begun to see worldly customs of burial as outside

of the necessity of religious sacraments. This last view may be that which her son not only believed but also sought to convey with his narrative.

We know that Monnica was buried according to local customs in Ostia (i.e. Italian Roman Customs) due to the place of her death and her wish to not be a bother. According to Augustine's account, Monnica famously cried every night for her son's coming to the Christian faith. She was a terror to priests and bishops wherever she went – visiting them to pray for her son and for advice on his deliverance (Conf. III.12). She participated in the Eucharist every day, feasted at the graves of saints and martyrs and gave advice to neighbours, among other things. And yet Augustine tells us that he gave such a mother only fifteen minutes of his tears after her death.

In accordance with her wishes, Augustine placed no monument to his mother at this time in his life. However, the Roman politician Anicius Auchenius Bassus erected an epitaph over her original tomb around 431, about a year after Augustine's death.[3] This epitaph marked a beginning for a short cult of St Monnica, which ended around when Ostia itself was abandoned as a port. Excitingly, this epitaph was discovered in 1945 by some children looking to play ball. It reads:

> Here the most virtuous mother of a young man set her remains, a second light to your merits, Augustine. As a priest, protecting the heavenly laws of peace, you taught the people entrusted to you with your character. A glory greater than the praise of your accomplishments crowns you both – virtutum mater, more fortunate because of her off-spring. (Buecheler 1894, 1.140 Carm, 670)

This is an interesting monument that focuses on the glory of her son. At this time in Roman history physical funeral monuments to women usually emphasized virtues associated with femininity: here lies my devoted mother, a chaste wife, and a pious woman. Yet here it is not Monnica's status of mother that is emphasized, but the virtues of her son. She is called 'Mother of the Virtues', denoting the high honour given to her due to the memory of her that was provided in Augustine's *Confessions*. Augustine's monument to his mother is neither traditional nor is it exemplary as is Bassus's. The *Confessions* is Monnica's monument, and no funeral monument in Roman (and certainly Christian) history comes close to being its equal (Figure 13.1).

The text *The Care to be Taken for the Dead* contains an extended discussion on what value prayers (at a Christian altar or at the tomb of a saint) have to the dead. Augustine comes to the paradoxical conclusion that, while orations cannot make the good better or the damned less damned, prayers and burial rites are valuable to the piety of the living and the dead. It is in this context that Augustine demonstrates the little likelihood of the dead caring for the living due to his never seeing his own mother's ghost. In this same text Augustine discusses the visions the living have of the dead

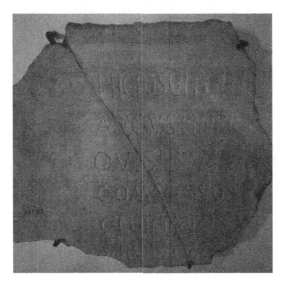

FIGURE 13.1 *St Monnica's epitaph, Sant'Aurea, Ostia, image by permission of* http://www.visitostiaantica.org.

(waking or sleeping) in which the non-present spectre of a loved one gives helpful advice.

Augustine, I think, recognizes his own haunting: while in life she followed him like a shadow, cooking and picking up after him and teaching him Christianity as a child and engaging in debate with him as a newly minted Christian, in death Monnica and her influence remains imprinted on his own work.

What is remarkable about Monnica, and perhaps what sets her apart from the other invisible women of this collection, is that we are given an in-depth account of her by the very person who benefited most from her efforts. Monnica is a different kind of ghost (she's not like those other ghosts). Her personality can be seen apart from her devotion to her son. Her efforts – spiritual, financial, physical, temporal – are acknowledged and shown to be appreciated in a way that exalts her to a status more than just a typist or a cook, as other women have been reduced down to. Indeed, the true violence against Monnica's memory has been done by Augustine's (usually male) readers, who flatten out the multidimensional portrait of her we are given because they see in her something akin to their own (perceptions of) overbearing mothers. The importance of Monnica to Augustine's conversion and thought is overlooked in many ways by the very people Augustine sought to recommend her to.

Do not be afraid of being haunted by St Monnica's ghost, but feel free to pray to her. As Augustine emphasizes in *The Care to be Taken for the Dead*, our prayers to the dead benefit the living far more than they benefit the dead. Please remember her at your altars.[4]

Notes

1 Monnica is more widely known as 'Monica', the common Latinized spelling of her name. I follow other feminist scholars of Augustine in this spelling: the reduplication of the 'n' emphasizes her North African Berber heritage.

2 In this chapter I have not emphasized the importance of Monnica's feeding Augustine. This is in part because it is somewhat unclear if she cooked or if a servant or slave cooked. That said, she certainly served Augustine and his friends meals during this time and, likely, throughout his life. For more on women's overlooked roles as providers of meals, please see in this book the Editor's Introduction and the chapters by Reetta Hänninen, Eleanor Knight, Philip Pullen and Elizabeth Sandie.

3 Or, perhaps this epitaph was placed in the sixth or seventh century by those seeking to support the saint-tourism industry in Ostia, Cf. Boin (2010).

4 I would like to thank Juliana Dresvina and Maijastina Kahlos for their comments on an early draft of this chapter. Parts of this chapter were published in the blog post, 'Monnica, The Patron Saint of Mothers of Disappointing Children (i.e. Philosophers).' Blog of the APA.

Bibliography

Augustine, *Confessions*, trans. Henry Chadwick. Oxford: Oxford University Press, 1998.

Augustine, *The Care to be Taken for the Dead*, trans. John A. Lacy, in St. Augustine, *Treatises on Marriage and Other Subjects*, ed. Charles T. Wilcox. Washington, DC: The Catholic University of America Press, 1999.

Augustine, 'The Happy Life', in Michael S. Russo (ed. and trans.), *Ancient Wisdom for Modern Minds*. Createspace Independent Pub, 2011.

Boin, Douglas Ryan, 'Late Antique Ostia and a Campaign for Pious Tourism: Epitaphs for Bishop Cyriacus and Monica, Mother of Augustine', *Journal of Roman Studies* 100 (2010): 195–209.

Buecheler, Franciscus, Alexander Riese and Ernst Lommatzsch, *Anthologia latina: sive poesis latinae supplementum*. In aedibus B. G. Teubneri, 1894.

Burrus, Virginia, *The Sex Lives of Saints: An Erotics of Ancient Hagiography*. Philadelphia: University of Pennsylvania Press, 2004.

Burrus, Virginia and Catherine Keller, 'Confessing Monica', in Judith Chelius Stark (ed.), *Feminist Interpretations of Augustine*. University Park: Pennsylvania State University Press, 2007.

'Church of Sant'Aurea', Ostia Antica Museum, https://www.ostia-antica.org/dict/s outh/saurea.htm (accessed 26 February 2020).

Conybeare, Catherine, *The Irrational Augustine*. Oxford: Oxford University Press, 2006.

Coyle, John Kevin, 'In Praise of Monica: A Note on the Ostia Experience of *Confessions* IX', *Augustinian Studies* 13 (1982): 87–96

Grosse, Patricia L.., 'Love and the Patriarch: Augustine and (Pregnant) Women', *Hypatia: A Journal of Feminist Philosophy*, Special Issue: *Feminist Love Studies in the 21st Century* 32, no. 1 (2017): 119–34.

Grosse, Patricia L.., 'Monnica, The Patron Saint of Mothers of Disappointing Children (i.e. Philosophers)', Blog of the APA, https://blog.apaonline.org/2019/08/28/women-in-philosophy-monnica-the-patron-saint-of-mothers-of-disappointing-children-i-e-philosophers/ (accessed 26 February 2020).

14

'The Typist Home at Teatime'

Vivienne Haigh-Wood Eliot's Role in Shaping T. S. Eliot's *The Waste Land* (1922)

Arwa F. Al-Mubaddel

Introduction

Insanity, madness, hysteria, anxiety and loss are all words that can describe the composition of *The Waste Land*, but they are words also associated with the people involved in shaping it, especially in reference to (T)homas (S)tearn Eliot's spouse, Vivienne (née Haigh-Wood). She is often remembered as his hysterical and embarrassing first wife, who he legally separated from and had committed to an asylum for the insane. Yet, feminist inquiries into her life, such as Carole Seymour-Jones's *Painted Shadow: A Life of Vivienne Eliot* (2002), portray her as a supportive spouse who helped launch her husband's literary career, acting as his editor and a source of poetic inspiration. Accordingly, I will be exploring Vivienne's marginalized and oftentimes forgotten role in composing her husband's modernist masterpiece *The Waste Land* as Eliot heavily relied on his wife's literary skills and encouragement before his partnership with Pound in editing it.

A Troubled Marriage Yet Successful Literary Partnership

Before discussing her influence in shaping *The Waste Land*, a brief account of Vivienne's life and her marriage to Eliot is necessary to understand the nature of her role. Vivienne suffered from poor health throughout her life, including a form of nervous illness, for which she took opiates (Gordon 2004). Highly interested in the arts, Vivienne painted, wrote prose and poetry, took an interest in ballet (Bloom 2003, 18) and was considered an intellectual and a poet (Miller 1977, 90). She also worked briefly as a governess before she married Eliot, who was a twenty-six-year-old visiting scholar at Oxford, in the spring of 1915, at the age of twenty-seven. Vivienne saw great potential in him as a poet, telling his former mentor Bertrand Russell that she married Eliot to push him to write, but could not do so initially (Gordon 2004). From the outset of the marriage, Vivienne suffered repetitive illnesses, ranging from migraines, loss of consciousness, stomach ailments, and heavy and unpredictable menstruation (V. H. Eliot 2009, 70). A year later after their marriage, Eliot wrote about the overwhelming anxiety he felt and started to feel embarrassed about what he perceived to be Vivienne's flamboyance and vulgarity, while she could not understand his shyness and diffidence. Throughout the first years of their marriage, both suffered from neuroses, panic attacks and bouts of depression, which strained their relationship further, in addition to financial losses that were accrued due to Vivienne's frequent periods of illness and convalescence (Bloom 2003, 19–20).

Vivienne and Eliot's marriage was tumultuous and their union was described as disastrous from a marital viewpoint, yet from a literary perspective it was, as Loretta Johnson writes, a 'temporary marriage of two minds', and a great one at that (1988, 48). Vivienne and Eliot's collaborations spanned almost a decade, from 1915 to 1925, when they influenced each other's work, with Vivienne's most notable contributions being with *The Criterion*, a literary journal Eliot founded and edited, where she and Eliot interchangeably published under the pseudonym F. M., as well as her editing of *The Waste Land* (Johnson 1988, 50–1). Yet this role in the composition of the poem is often neglected or marginalized by critics, who acknowledge Pound's influence as essential in editing the text – to the point that it is described as a collaboration between the two men (Rainey 2005). Indeed, Eliot himself dedicates the poem to Pound, who he calls 'il miglior fabbro', the better craftsman (Scofield 1988, 108). However, before his literary partnership with Pound, it was Vivienne's literary skills and encouragement, her deep dislike of the 'fug and slop' of sentiment, alienation from most people and her predisposition to horror, which encouraged the state of mind which instigated the poem (Gordon 1998, 129). While composing *The Waste Land*, Eliot wrote to Sydney Schiff: 'I have done a rough draft of part III, but

do not know whether it will do, and must wait for Vivienne's opinion as to whether it is printable', thus waiting for her approval before releasing the text (1921, 601). Indeed, when Eliot had a serious breakdown, for which he had to spend time in a psychiatric hospital in Lausanne, he left some parts of *The Waste Land* manuscript and matters regarding literary correspondence in Vivienne's care (V. H. Eliot 1921, 592). As Harold Bloom clarifies, Eliot's alliance with Vivienne 'was more than symbolic: she was part of his work' (2003, 172). Vivienne wrote letters for Eliot; her approval was of outmost consideration while he was writing *The Waste Land*, and he credited her, during that time, with doing all the thinking for him; Vivienne herself would declare that: 'I am his mind' (Bloom 2003, 172).

Eliot's second wife and executor of his literary estate, Valerie, who was his secretary at Faber & Faber before their marriage after Vivienne's death, would later express her acute awareness that Vivienne had entered Eliot's life as more than a typist, as Karen Christensen discusses in her Chapter 3 on Valerie Eliot in this volume.

With the publication of 'The Waste Land Facsimile' in 1971 by Faber & Faber, Vivienne's influence was made clear due to her numerous annotations and comments on the manuscript. Her editing style comes across as non-imposing in comparison to Pound's sharp editorial strokes.

Perhaps it is the drafts of the second section of *The Waste Land*, titled 'A Game of Chess', which is included in its entirety as page 11 in 'The Waste Land Facsimile' (1971), that shows most of Vivienne's impact. In the first instance, many of Eliot and Vivienne's friends read this part as a description of their marriage (Scofield 1988, 101–11), with Pound commenting on this section writing 'photography?' (Eliot 1971: 11–13). Indeed, the torment of their marriage, their problems with communication, their irreconcilable differences, their co-dependency and sense of futility provide the personal and psychological backdrop of this section (Gordon 1991, 10). The main characters of this part are an upper-middle-class couple, a neurotic wife and a less talkative, timid husband, who mirror Vivienne and Eliot's own relationship.

It is also here that Vivienne's ear for dialogue becomes evident. In the beginning, Vivienne changes the title from 'In the Cage' into 'A Game of Chess', to emphasize the kind of language games couples play. She also praises the following section which is a conversation between a man and woman: 'My nerves are bad tonight. Yes, bad. Stay with me . . .' by writing 'WONDERFUL' (Eliot 1971, 11). The next dialogue beginning with 'Do you know nothing?' is also commended by her and both are included in the published version of *The Waste Land*. In addition, Vivienne also changes the wording by inserting the word 'bottle' after hot water in line 60 of this section, so that it becomes: 'The hot water (bottle!) at ten.' Line 85, which originally was: 'It's that medicine I took in order to bring it off' becomes more conversational with Vivienne's changes which turn it to: 'It's that pills I took to bring it off' (Eliot 1971, 13). Moreover, line 164 of 'A Game of Chess' first read: 'You want to keep him

at home, I suppose', yet Vivienne crosses out this line and inserts: 'What you get married for if you don't want to have children' (Eliot 1971, 13), which Eliot incorporates in subsequent drafts and the published version. Vivienne also encouragingly writes 'splendid last lines' for the ending of the section. She then makes the following note to Eliot: 'Make any of these alterations – or none if you prefer. Send me back this copy and let me have it' (Eliot 1971, 15). These amendments Vivienne suggests prove her to be a master of dialogue and dramatic one-liners, and also shows the non-imposing and non-intrusive nature of her influence; her suggestions were taken up by Eliot and published in the finalized versions of the poem.

Thus 'A Game of Chess' was heavily annotated by Vivienne, and she can be regarded as the co-author of this section. The narrative movement and dialogue here is 'the site of the poem's substantial experimentation with narrative form', and the female and working-class voices that Vivienne helps shape are central to the meaning of *The Waste Land*. The 'goodnights' at the end of this section are made more colloquial by Vivienne striking out the 'd', so that they become 'goonight', the lines being a quote from Shakespeare's Hamlet where Ophelia bids the ladies 'Goodnight' (Emery-Peck 2008, 332, 343). This creates a layered narrative, different voices that clash and intersect, but also provide authenticity, mimicking 'candid personal communication' (ibid). Vivienne invests a great deal of herself into the making of the poem, yet her collaboration is often overlooked and her influence is overshadowed due to her eccentricity and troubled personal history and because of Ezra Pound's later literary involvement with Eliot.

Ezra Pound's Masculine Operation on 'The Waste Land Facsimile'

In contrast to Vivienne's editing, Ezra Pound takes a more forceful approach to the manuscript, in what can be described as a masculine operation, with Vivienne being associated with the hysteria of the text, her influence diminishing once Pound enters the scene. In 1954, introducing Pound's literary essay, Eliot describes him as one who would 'cajole, and almost coerce, other men into writing poetry well' (Bradbrook and Scott-Kilvert 1972, 27). Although Pound propagated Eliot's work, his relationship with Eliot is described as one of 'domineering patronage', with Pound urging Eliot to suppress his religious poetry and continue on with the 'Sweeney' poems that were explicitly violent against women (Pinkney 1984, 58). Pound sought to establish with Eliot a culture of 'machismo' which entails 'a virulent anti-feminism' which was expressed in Pound's and Eliot's correspondences, which demonstrate a homosocial and misogynist literary relationship as they both shared a dislike of women writers and an aversion to literary salons hosted by women (Pinkney 1984, 58). Eliot and Pound envisioned an elitist masculine

literary salon where women were excluded and where literary men can find a sanctuary from the 'femininity' of contemporary life (Koestenbaum 1988, 120), and also revolted 'against what they saw as the effeminate influence of women writers as well as the prominence of women in the literary marketplace as publishers and patrons' (Lamos 1998, 55–6; something C. S. Lewis and J. R. R. Tolkien managed to achieve about a decade later in The Inklings). The publisher Eliot sought out for the publication of *The Waste Land*, John Quinn, also participated in this aversion to women's literary writing. Quinn at one point describes female literary writing as 'excrements' and 'menstruation' with the 'mental stink of a natural skunk' (Koestenbaum 1988, 120). It is this kind of sexist mentality that will later underlie the omitted Fresca passages in *The Waste Land* drafts.

What is more is that Vivienne becomes the embodiment of hysteria, symbolizing a monstrous and transgressive femininity. Pound diminishes Vivienne's influence in editing *The Waste Land* by writing over her notes, neglecting to acknowledge them in any way. Eliot also expresses an uneasy attitude towards hysteria and sees it as a solely female attribute. Eliot's short prose poem entitled 'Hysteria' (Eliot 1925, 34) narrates a scene from the point of view of a man who, in a restaurant with a woman, witnesses her outrageous and bawdy laughter, and feels consumed by her frantic movements and gaping mouth, 'until her teeth were only accidental stars with a talent for squad-drill'; he is 'drawn in by short gasps, inhaled at each momentary recovery, lost finally in the dark caverns of her throat, bruised by the ripple of unseen muscles'. The woman's laughter is a sign of her sexual agency or 'phallicism' and it ridicules the male speaker who is both sexually and creatively impotent. The over-gaping mouth of the woman is aggressive in signifying overarching sexual power (Lamos 1998, 84). For Laurie MacDiarmid, 'Hysteria' 'oozes physicality' as the violent laughter and shaking breasts make the woman's body vulgar (2003, 41). Here, Koestenbaum (1988, 117) and Lamos (1998, 82) identify the speaker of the poem with Eliot himself; they argue that the poem is Eliot's own personal experience with Vivienne who mortified him by blatant public displays of emotion. Hence, the poem reflects Eliot's own hysteria and his anxieties with female sexuality. To escape the woman's hysteria, the speaker attempts to regain control through writing, which serves as a phallic power move in that by writing the women's disease, he can write her own end and through a master narrative to counteract the confusion and feelings of being overwhelmed by the woman's unbridled public outburst (MacDiarmid 2003, 45).

Thus, Vivienne's 'hysteria' and *The Waste Land* are both related 'editorial events', as Eliot left both his wife and the poem's manuscript in Pound's care to un-burden himself of 'hysterical presences' in 1916, before he went to Lausanne to be treated for his mental and neurological illnesses (Koestenbaum 1988, 120). *The Waste Land* facsimile denotes Eliot's own mental breakdown, with Ezra Pound's editing turning it from a chaotic and hysterical rambling to a powerfully disjunctive poem (Koestenbaum 1988, 120). As Eliot's own mental breakdown was a condition of the poem's composition, his affliction

can be read as a form of male hysteria and implies that there is something 'feminine' about his emotional paralysis and barren condition while he was composing *The Waste Land* (Koestenbaum 1988, 123). This may explain why Pound finds fault with the initial drafts of the poem and changes them drastically, cancelling out most representation of female subjectivity, as the initial drafts portray a feminine mental state, attributed to Vivienne, which in turn compromises the mental quality of masculinity. Thus Pound attempts to cure the poem of its hysteria by expunging from it the central representations of femininity, masculinizing the poem's core. This corresponds to Pound and Eliot's project in creating a revolution in poetry as a 'phallic act', which may in part be the reason why Pound advises Eliot to omit the initial epigraph for the poem, in which the speaker cries: 'The horror! the horror!' since it may be considered to be an 'emasculating' cry of terror.

Yet, despite what was initially considered by Pound as an effeminate text, the male ego does occupy an assertive space in the drafts of *The Waste Land*. In unpublished verses, Eliot writes:

I am the Resurrection and the Life (I)
I am the things that stay, and those that flow.
I am the husband and the wife
And the victim and the sacrificial knife
I am the fire and the butter also.

<div align="right">(Eliot 1971, 111)</div>

These lines deal with the speaker's all-encompassing self-referent ego-libido which may also be described as a narcissistic libido. From a psychoanalytic viewpoint, the narcissistic libido which is directed inwards to the self cannot always be distinguished from the object-libido in which is directed to someone or something outside a person's self (Freud 1905, 16). Eliot had anxieties about his own masculinity, confiding to his friend Conrad Aiken in a letter: 'I should find it very stimulating to have several women fall in love with me — several because that makes the practical side less evident. And I should be very sorry for them too' (MacDiarmid 2003, 49). This male bravado shows a narcissistic and self-serving ego, which, in contrast to the threatening presence of the hysterical woman in 'Hysteria', is overarching and occupies central space.

Rewriting and Striking Out Fresca, the Scribbling Woman, in 'The Waste Land Facsimile'

'The Waste Land Facsimile' also shows that the drafts of 'The Fire Sermon' began with seventy lines that were unpublished. These lines give details of

'the white-armed Fresca' who is 'aroused from dreams of love and pleasant rapes'. Fresca has just woken from bed, and summons her servant Amanda to bring her a tray of 'soothing chocolate' and 'simulating tea' but before having her tea, 'Fresca slips softly to the needful stool / Where the pathetic tale of Richardson / Eases her labor before the deed is done'. Fresca then slips back into the sheets of her bed where she has her breakfast as her 'hands caress the egg's well-rounded dome'. Fresca then tends to her letters where a friend asks her about her 'manoeuvers' and 'new lovers'. Finally she leaves her bed for a 'steaming bath' where the French perfumes 'disguise the good old hearty female stench' (Eliot 1971, 23).

Initially, Fresca was a character Vivienne wrote about under the initials F.M. (pseudonym Fanny Marlow) for *The Criterion* (vol.2:7, 1924). The lines that occur are almost identical to the ones in *The Waste Land* drafts, yet the 'amorous' Fresca here is 'aroused from dreams of love in curious shapes', not Eliot's original shocking and sadistic 'pleasant rapes'. The movement of Fresca is also different in the end: in Eliot's verse she moves to the bath, whereas in Vivienne's version, she sits in her boudoir contemplating different works of art. Valerie Eliot, the editor of 'The Waste Land Facsimile', explains that it was actually Eliot who wrote these verses under Vivienne's name, and as editor of *The Criterion*, it amused him to print what he saw as a 'few poor verses'. It cannot be definitely known who thought of the Fresca character, but it is safe to infer that both Vivienne and Eliot were involved in her construction.

Another disturbing aspect about Eliot's verses of Fresca is that they may be attributed to a male voyeuristic speaker, a peeping-tom who takes pleasure in seeing Fresca go to the bathroom and sit on a stool. There is a perversion here with a fixation of seeing the female and invading her privacy. Here, I infer Freud's description of the act of seeing, as he was a contemporary of Eliot and his theorization was widely influential, in describing seeing as an act derived from touching, with visual impressions being what mostly excites a person sexually. When interested in the beauty of the sexual object, the act of seeing is considered normal to some proportion; however, this pleasure in looking, termed by Freud as 'scopophilia', becomes a perversion if it is restricted only to looking at private parts, or if it is connected with overriding disgust, such as people who look on at excretory functions (Freud 1905, 165).

Having Fresca wake up from 'dreams of pleasant rapes' suggests the speaker's sadism. The female becomes for the narrator a site of a repulsive violence, implying that women do not have the morality nor the principles in which they can recognize the violence directed at them (Potter 2015, 139). The rapes are described as pleasant because, for Eliot's speaker, the female body does not recognize violence in a sexual act due to its insatiable appetite. As such, the tone of the speaker in the verses about Fresca is 'as uncertain as a boy's voice that is breaking – they crackle with Freudian implications' (Bradbrook and Scott-Kilvert 1972, 19). The narrator describing Fresca can be read as a 'psychoneurotic' who shows a high degree of sexual repression,

and an intense resistance against the sexual instinct with feelings of shame, disgust and morality. A psychoneurotic that also has scopophilic perversion may be more disposed to cruelty as his symptoms involves that he suffers for controlling his behaviour (Freud 1905, 169). In scopophilia, the person's eye is directed to an erotogenic zone, most likely being the skin. This happens in the Fresca verses, as the only physical description of her mentioned by the speaker is bare white-arms; her hands 'caress' the egg's white domes as she is having her breakfast. Furthermore, the speaker's propensity for cruelty is evident in the way he describes her as 'bruised and marred' and as a 'doorstep being dung by every dog in town' (Eliot 1971, 127). The speaker, by evoking this image, wants to reduce Fresca into something base, disgusting and undesirable.

Fresca is further condemned for being a scribbling upper-class woman with 'indolent' intellectuality. She is vilified for being a degenerate social prostitute who satisfies and indulges 'perverse' conflated desires, namely prostitution and excessive reading and writing. Fresca self-indulges herself with writing and this indulgence is associated with her promiscuity and the act of eating itself. In the fourth leaf of 'The Fire Sermon' draft, a scribbling woman, who may or may not be Fresca, is introduced again. Eliot inserts new verses of 'The typist home at teatime, who begins / To clear away her broken breakfast' which continue on for three stanzas, four lines each. Pound recommends cancelling out these, noting that they are 'not interesting enough as verse to warrant so much of it' and that they are 'inversions not warranted by any real experience of metre'; for the third stanza he writes a brief 'not good' (Eliot 1971, 45). However, the cancellation of these verses is most likely to be an objection to a female writing, seeing as that makes her a phallic woman in a poem where the men are emasculated and sterile. Eliot and Pound have already shared a dislike of women writers and female literary salons and if they propose to achieve an elitist masculine tradition in their poetic revolution, there would be no place for a woman writer in their verse. Ultimately Fresca is cancelled out entirely, with Pound crossing out more than half of the lines related to this character, instead focusing on the next section.

Julia Bolton Holloway in her Chapter 18 in this volume discusses how Robert Browning channelled his aggression towards his wife, Elizabeth Browning, through his writing. The same can be said of Eliot's writing, as Lyndall Gordon argues that his anti-feminist, condemning stance in writing Fresca is related to his own anger at Vivienne who had a brief affair with his mentor Bertrand Russell (see also Maddrey 1979); from then on, the women in Eliot's poetry are portrayed as seductive and predatory. Fresca seems to bear a resemblance to Vivienne, who liked to scribble, paint and enjoy the fine things in life (Gordon 1998, 125). James Miller supports this reading, arguing that, like Fresca, Vivienne was an intellectual and a writer, and that the character of Fresca corresponds to descriptions of Vivienne at the time (1977, 90). The deep hostility that is expressed in Fresca's sections

'are written by a man who hates women, and feels only revulsion at their physicality' (Miller 1977, 88). Like the speaker of 'Hysteria', the descriptions of Fresca attempt to repel readers against her.

In the same manner, Vivienne becomes a figure of repulsion and hysteria from the outset of their marriage to the end of her life. After the publication of *The Waste Land* and his soaring popularity as an intellectual, Eliot started to develop religious sentiments that Vivienne did not share. With his subsequent conversion to Catholicism in 1926, Eliot shunned Vivienne and they were distant until he sent her a request for a permanent separation in 1932, while he was in the United States giving lectures at Harvard University (Chuda 2014, 10–11). During this time, he also rekindled his relationship with Emily Hale, a woman he was in love with before moving to England and marrying Vivienne, although their relationship remained platonic (Haldar 2005, xv). However, Vivienne refused Eliot's request for separation and met it with desperation, frantically pleading for his return, and asking his colleagues and friends if he could speak to her (Pasachoff 2017, 75–6). Her efforts persisted for five years, but Eliot avoided her at all cost, until, at the summer of 1938, she began wandering the streets in distress and was picked up by the police. Her brother Maurice, with Eliot's approval, had her then committed to a sanitorium until her death in 1947 (Thakur 2010, 188). Lyndall Gordon would later report that on his deathbed Maurice Haigh-Wood 'confessed that he, with Eliot, had signed the order, much to his later regret, for when, after some years abroad, he saw his sister again in 1946, he was convinced that she was sane as he was' (1988, 77). Her case, I would argue, is that of a distraught woman, unable to understand the abrupt end of her marriage, who tried to get her estranged husband's attention through flagrant displays.

Nonetheless, however torturous their marriage was, Vivienne's positive impact on Eliot's literary career should be given more attention and critical significance; the majority of T. S. Eliot biographers and most critics have marginalized Vivienne's role as she was stigmatized for being rejected by Eliot and his friends or for her mental and physical illnesses (M. C. Johnson 2005, 48). Certainly, there is a double standard at play as Eliot was called a tortured genius and granted time to be treated for – and recover from – his mental breakdowns, whereas Vivienne was deemed 'hysterical'. Despite the many agonies both she and Eliot suffered through their marriage, Vivienne Haigh-Wood Eliot must be given due credit for her role in shaping the modernist masterpiece that is *The Waste Land*. Not only was Vivienne Eliot's editor from the initial drafts of the poem, she also helped create the poet, and was a writer in her own right.[1]

Note

1 A forthcoming book titled *The Fall of a Sparrow: Vivien Eliot's Life and Writings* by Ann Pasternak Slater will be released by Faber & Faber on November 2020. Slater's biography attempts to give a balanced account of both

Vivienne and Eliot, and is perhaps groundbreaking as it includes, for the first time, Vivienne's sole writings, carefully distinguished from Eliot's writing, thus highlighting her as a writer.

Bibliography

Bloom, Harold, *T.S. Eliot*. Philadelphia: Chelsea House Publishers, 2003.

Bradbrook, Muriel Clara and Ian Scott-Kilvert, *T. S. Eliot: The Making of The Waste Land*. Essex: Longman, 1972.

Chuda, Anthony, 'The Poet and the Pressure Chamber: Eliot's Life', in David E. Chinitz (ed.), *A Companion to T.S. Eliot*, 3–15. Chichester: Wiley-Blackwell, 2014.

Eliot, T. S., *The Waste Land: A Facsimile and Transcript of the Original Drafts Including the Annotations of Ezra Pound*, ed. Valerie Eliot. London: Faber & Faber, 1971.

Eliot, T. S., 'Hysteria (1925)', in *Collected Poems 1909–1962*. London: Faber & Faber, 1974.

Eliot, T. S., 'Letter to Sydney Shiff; Friday night [4? November 1921]' in Valerie Eliot, Hugh Haughton and John Haffenden (eds), *The Letters of T.S. Eliot, Vol.* I 1898–1922 [1988], revised edn. London: Faber & Faber, 2009.

Eliot, Valerie, Hugh Haughton and John Haffenden, eds, *The Letters of T.S. Eliot, Vol. I 1898–1922* [1988], revised edn. London: Faber & Faber, 2009a.

Eliot, Vivienne, 'Letter to Henry Eliot; Wednesday 11 October 1916', in Valerie Eliot, Hugh Haughton and John Haffenden (eds), *The Letters of T.S. Eliot, Vol.* I 1898–1922 [1988], revised edn. London: Faber & Faber, 2009b.

Eliot, Vivienne, 'Letter to Ezra Pound; 27 June 1922', in Valerie Eliot, Hugh Haughton and John Haffenden (eds), *The Letters of T.S. Eliot, Vol.* I 1898–1922 [1988], revised edn. London: Faber & Faber, 2009c.

Eliot, Vivienne, 'Vivien Eliot to Charlotte C. Eliot; 8 April 1917', in Valerie Eliot, Hugh Haughton and John Haffenden (eds), *The Letters of T.S. Eliot, Vol.* I 1898–1922 [1988], revised edn. London: Faber & Faber, 2009d.

Emery-Peck, Jennifer Sorenson, 'Tom and Vivien Do Narrative in Different Voices: Mixing Genre's in The Waste Land's Pub', *Narrative* 16, no. 3 (2008): 331–58.

Freud, Sigmund, *On Sexuality: Three Essays on the Theory of Sexuality* [1905], trans. James Strachey. London: Penguin, 1991.

Gordon, Lyndall, 'Eliot and Women', *T.S. Eliot: The Modernist in History*, 9–22 (1991).

Gordon, Lyndall, 'Eliot [née Haigh-Wood], Vivien Haigh [Vivienne]', in *Oxford Dictionary of National Biography* (2004).

Gordon, Lyndall, *T.S. Eliot: An Imperfect Life*. New York: Vintage, 1998.

Haldar, Santwana, *T.S. Eliot: A Twenty-First Century View*. New Delhi: Atlantic Publishers, 2005.

Johnson, Loretta, 'A Temporary Marriage of Two Minds: T.S. and Vivien Eliot', *Twentieth Century Literature* 43, no. 1 (1988): 48–61.

Johnson, Melissa C., 'The Muse Writes Back: Vivien Eliot's Response to High Modernism', *Philological Quarterly* 84, no. 4 (2005): 451–78.

Koestenbaum, Wayne, 'The Waste Land: T.S. Eliot's and Ezra Pound's
 Collaboration on Hysteria', *Twentieth Century Literature* 34 (1988): 113–39.
Lawrence, Rainey S., *Revisiting the Waste Land*. New Haven: Yale University Press,
 2005.
Lamos, Colleen, *Deviant Modernism: Sexual and Textual Errancy in T.S. Eliot,
 James Joyce, and Marcel Proust*. Cambridge: Cambridge University Press, 1998.
MacDiarmid, Laurie J., *T. S. Eliot's Civilized Savage: Religious Eroticism and
 Poetics*. New York: Routledge, 2003.
Maddrey, Joseph, 'The Beginning of Wisdom 1915–1920: Vivienne', in *The Making
 of T.S. Eliot: A Study of the Literary Influences*. Jefferson: MacFarland and
 Company, 1979.
Miller, James E., *T.S. Eliot's Personal Waste Land: Exorcism of the Demons*.
 University Park: Pennsylvania State University Press, 1977.
Pasachoff, Naomi, *Reading and Interpreting the Works of T.S. Eliot*. New York:
 Enslow Publishing, 2017.
Pinkney, Tony, *Women in the Poetry of T.S. Eliot: A Psychoanalytic Approach*.
 London: Macmillan, 1984.
Potter, Rachel, 'Gender and Obscenity in The Waste Land', in Gabrielle McIntire
 (ed.), *The Cambridge Companion to The Waste Land*, 133–46. Cambridge:
 Cambridge University Press, 2015.
Rainey, Lawrence S., *Revisiting the Waste Land*. New Haven: Yale University Press,
 2005.
Scofield, Martin, 'The Waste Land (1922)', in *T.S. Eliot: The Poems*, 108–36.
 Cambridge: Cambridge University Press, 1988.
Seymour-Jones, Carol, *The Painted Shadow: A Life of Vivien Eliot*. New York:
 Nan A. Talese/Doubleday, 2002.
Thakur, Pradeep, 'T.S. Eliot', in *The Most Important People of the 20th Century-II:
 Artists and Entertainers*, 179–92. Punjab: Pradeep Thakur and Sons, 2010.

15

Edith Tolkien in the Eye of the Beholder

Maria Artamonova

Like the images of Dante's Beatrice and Petrarch's Laura, the image of J. R. R. Tolkien's wife Edith Mary Tolkien (née Bratt) has been absorbed into his mythology and transformed by association with it. Most Tolkien aficionados first encounter the name as the inscription on the joint tombstone in Oxford's Wolvercote Cemetery: 'J.R.R. Tolkien – Beren; Edith Mary Tolkien – Lúthien.' The invocation of Tolkien's most famous star-crossed (but ultimately death-defying) lovers creates a romantic aura around the figure of Edith Tolkien and somewhat pre-defines the way she is approached by Tolkien fans. The quotation from Tolkien's letter to his son Christopher in which he says about his wife 'she was (and knew she was) my Lúthien' (*Letters* No. 340, 420) is often cited to support this association and tempts readers into a search for parallels between the story of a fateful love affair involving an Elf-maid and a mortal Man and the story of Edith and John Ronald Reuel's meeting, courtship and long marriage.

Over the past years, the Tolkien family and the Tolkien Estate have been consistently and strictly protective of the privacy of Tolkien's immediate relatives. To this day, Humphrey Carpenter's definitive biography (1977) has remained the main and often the only source of information about the family, supplemented by the *Letters of J.R.R. Tolkien*, the *Tolkien Family Album* and the seemingly exhaustive *The J.R.R. Tolkien Companion and Guide* (Scull and Hammond 2006). While justified on many grounds, this cautious approach has turned Edith into a figure akin to a member of a royal family; the little that is known about her is meticulously analysed, and the rest is supplemented based on certain social norms, backgrounds and expectations, as well as the agenda pursued in specific studies or

interpretations. This chapter makes no attempt to uncover any new facts about Edith Tolkien's life, although historical and genealogical studies have recently been shedding new light on the family. While this chapter was in preparation, the latest exploration of Edith's early life, 'J.R.R. Tolkien's inspiration for Lúthien: the "gallant" Edith Bratt' by Nancy Bunting and Seamus Hamill-Keays (2019), came to my attention. Its value in providing additional biographical information and challenging long-standing views is undeniable. However, what is equally important is to understand how the perception of the world-famous writer's 'gallant' companion developed over time, however realistic or fictionalized it might be.

The aim of this study is to evaluate the way Edith Tolkien has been described and presented in memoirs, letters, biographies and recently on the big screen ('Tolkien' 2019) in order to gain a clearer understanding of the changing attitudes and expectations regarding women in general and women associated with 'great men' in particular. As Nicole duPlessis stated in her article which uncovered the attitudes present in the Carpenter's authoritative biography of Tolkien which has had a considerable bearing on attitudes towards his wife, 'the positioning of Edith Tolkien in Tolkien scholarship as a controversial figure – an elf-maid, a shy, mousy figure, a non-intellectual, an aspiring pianist with thwarted ambitions, a victim of spousal neglect, an invalid, a shrewish, nagging wife – deserves consideration' (duPlessis 2019, 40). My own purpose digresses from duPlessis' in that I do not attempt 'to understand Edith Tolkien as an individual and a woman' (*ibidem*), but rather to consider her public image as a reflection of the attitudes that have come to shape it, both during her lifetime and, subsequently, after Tolkien had gained a global celebrity status.

The role of women in Tolkien's life and fiction has long preoccupied researchers, particularly since generation after generation of scholars and fans alike have had to tackle the criticisms first raised in an early review of *The Lord of the Rings* ('No religious spirit of any kind, and to all intents and purposes no women', quoted by Carpenter 1977, 223). Some recent publications, especially the excellent collection *Perilous and Fair: Women in the Life and Works of J.R.R. Tolkien* edited by Brennan Croft and Leslie Donovan (2015), go a long way towards establishing the multiple ways in which women were relevant in Tolkien's life, academic career and legendarium. Tolkien scholars acknowledge that women are often marginalized in the vast tapestry of Tolkien's Middle-earth: whole races, such as Ents, seem to have accidentally mislaid their females, and others, such as Dwarves or Orcs, are described as overtly male. One male character after another is described as widowed, orphaned or otherwise sundered from the female side of his family. On the other hand, the margins of Tolkien's world are every bit as vibrant and diverse as those of medieval illuminated manuscripts. Women may be few and far between, but most of them are highly significant characters. While the most noticeable ones might be the

aloof queenly figures (like Galadriel) or rebellious characters (like Éowyn or indeed Lúthien), we find women in various roles and functions in the legendarium, with far more of them mentioned in *The Silmarillion* and other legends of the First and Second Ages than in *The Hobbit* and *The Lord of the Rings* put together. Here is a short and incomplete summary of these characters and roles:

1. Women as wise and powerful rulers (Melian, Galadriel)

2. Women as active participants rather than passive onlookers (Lúthien, Éowyn)

3. Women as bearers of a divine truth (Andreth, the character of the 'Conversation between Finrod and Andreth' [Tolkien 1993], who essentially foretells the coming of Christ)

4. Women as equal partners of their male counterparts (the Valar; the Elves)

5. Women as matriarchs (Hobbit women especially, from Bilbo's mother to Gollum's nameless grandmother)

6. Failed and forced marriages (Aldarion and Erendis in *Unfinished Tales*; Aredhel and Éol in *The Silmarillion*), and so forth.

If we turn to Tolkien's life, it has too often been presented as an entirely male-dominated world. There is some justification for this: his school, sports, university, military service, his closest circles of friends from the school-time T.C.B.S. to the Inklings were all to a large extent male-only. Indeed, he behaved like a typical man of his time and social standing in separating his deep intellectual relationships with other men from his family ties or professional connections. But all is not as it seems in this picture of a 'man's world'.

In his personal life, Tolkien was surrounded by influential women from the start: his mother Mabel brought him up and instilled in him the love of the two things that became the pillars supporting his entire life: languages and the Catholic faith. His aunt Jane Neave, with whom he had a lifelong bond of respect and affection, was one of the best-educated women of her time, a person of many professions and talents, equally capable of gaining a degree in science, conversing with Tolkien (on equal terms) about English literature and running her own farm. She was such a formidable force that she has been suggested as one of the prototypes of Gandalf. By her own admission, Tolkien's daughter Priscilla was brought up on exactly the same terms as her three brothers and given the same chance of an education and career (Scull and Hammond 1111).

Professionally, as we are reminded by John Rateliff's paper 'The Missing Women: J. R. R. Tolkien's Lifelong Support for Women's Higher Education' (Croft and Donovan 2015, Kindle Locations 883–4), Tolkien was far from being locked in a male-only ivory tower. As an Oxford academic,

he interacted with many prominent female scholars, from Elizabeth Mary Wright to Helen Gardner. He taught female undergraduates from early on (U. A. Fanthorpe, featured in this volume, was a student of his), and some of them went on to build their own careers inspired by his prolific ideas on Old and Middle English language and literature (e.g. Mary Salu or Simonne d'Ardenne). Even the publication of *The Hobbit*, which paved the way towards Tolkien's literary fame and the writing of *The Lord of the Rings*, was brought about by Tolkien's students and friends Elaine Griffiths and Susan Dagnall, who deserve as much claim to fame as midwives who brought Tolkien's work into the world as C. S. Lewis who famously referred to himself as one (Dagnall's role can perhaps be examined in the context of publishing as a common female profession at the time – see Rebecca Lyons's Chapter 4 in the present volume). Many of Tolkien's female students also became friends, and given his habit of teaching from home, they formed a bond with the entire family.

It is all the more remarkable that Tolkien's lifelong companion and soulmate, his wife Edith, seems to be a largely silent presence in these discussions of women in his life. She was 'there' all the time, but the mark she left is hard to pinpoint with accuracy. Instead, a number of 'mythological' interpretations have become quite persistent, attempting to pigeonhole her into a convenient category that suits the current observer's agenda. Let us consider these interpretations one after another.

The Romantic Heroine

At the start of this section, it is worth quoting a long excerpt from Tolkien's letter to his son Christopher some months after Edith's death in November 1971, discussing the placement of the name *Lúthien* on her gravestone:

> I hope none of my children will feel that the use of this name is a sentimental fancy. It is at any rate not comparable to the quoting of pet names in obituaries. I never called Edith Lúthien – but she was the source of the story that in time became the chief part of the Silmarillion. It was first conceived in a small woodland glade filled with hemlocks at Roos in Yorkshire [. . .]. In those days her hair was raven, her skin clear, her eyes brighter than you have seen them, and she could sing – and dance. But the story has gone crooked, & I am left, and I cannot plead before the inexorable Mandos.
>
> I will say no more now [. . .] For if as seems probable I shall never write any ordered biography – it is against my nature, which expresses itself about things deepest felt in tales and myths — someone close in heart to me should know something about things that records do not record: the dreadful sufferings of our childhoods, from which we rescued one another, but could not wholly heal the wounds that later often proved

disabling; the sufferings that we endured after our love began – all of which (over and above our personal weaknesses) might help to make pardonable, or understandable, the lapses and darknesses which at times marred our lives — and to explain how these never touched our depths nor dimmed our memories of our youthful love. For ever (especially when alone) we still met in the woodland glade, and went hand in hand many times to escape the shadow of imminent death before our last parting. (*Letters* No. 340, 11 July 1972)

This is a poignant and revealing letter which is a perfect illustration of the way Tolkien's 'nature expresses itself about things deepest felt in tales and legends'. Looking back on their life together, he focuses on the more mythological aspects: the tragic childhood and the unlooked-for 'rescue', the image of a singing and dancing maiden with raven-black hair and bright eyes that would not be out of place in a medieval love poem or a nineteenth-century Romantic painting. And, finally, the association between Tolkien's own life story and the great Tale of Beren and Lúthien, which gradually emerged through many versions and rewritings from a first draft composed in 1917 (Tolkien 2017, 27ff) to the *Lay of Leithian* written in the 1920s and to further prose and verse versions that he kept returning to for the rest of his life. A search for autobiographical elements in *The Tale of Tinúviel*, the early version of the story of Beren and Lúthien included in *The Book of Lost Tales* (Tolkien 1984), would be pointless in all but the broadest possible sense in that it is a story of a love affair which is initially doomed but finally becomes a reality despite overwhelming odds, including death itself. But the reverse is not necessarily false. These days, the story of Ronald and Edith has become somewhat overshadowed by the fictional union of an Elf-maid and a mortal Man, to the extent that the gravestone inscription is sometimes seen as a key to interpreting their relationship.

It is a well-known and well-researched fact that Tolkien's view of life and art was broadly consistent with a 'Romantic' sensibility (see Eilmann 2017 and others). His works show numerous traits and attitudes that are largely inherited from nineteenth-century Romanticism. In later life, as he became a medieval scholar, he was of course aware of the medieval tradition of courtly love that fed eighteenth- and nineteenth-century Romanticism in many ways (and, incidentally, became the subject of his closest friend's C. S. Lewis's seminal – if these days increasingly challenged – work *The Allegory of Love*). The description of Edith in Letter No. 340, provided in hindsight, after a long life together, harks back to a romantic perception of her that was evident in the early days of their courtship, separation and marriage and can be gleaned in the letters and poems of this period.

The image of Edith is inextricably entwined with the first quickening of Tolkien's mythology. Their love for each other is compared in his early poem to 'two fair trees', 'deep-rooted in the soil of Life, and tangled in sweet growth' (Carpenter 1977, 74). In another poem, the two of them are

described as embarking 'down the paths of firelight dreams', two children seeking the Cottage of Lost Play, an enchanted place of comfort and healing, where the legends of the Elder Days were recounted (Garth 2003, 72). Edith was Tinúviel dancing before the bewildered Beren as she appeared before her husband in the summer of 1917 as they were miraculously reunited, having escaped the deathly peril of the Great War and now looking forward to a new life. She copied the early manuscripts of *The Book of Lost Tales* in her ornamental handwriting, thus leaving her own personal imprint on them. It is not reported that Edith copied or typed any of Tolkien's later work.

The orphans meeting by chance and falling in love, the separation enforced by Tolkien's inexorable guardian, the attempts to build separate lives for themselves, Tolkien's writing a letter proposing to Edith on the stroke of midnight marking his coming of age and independence, their eventual marriage, the bitter parting and reunion after his return from the Western Front – all of these elements are now part of the 'Edith mythology', recently taken in new directions in the loosely biographical movie *Tolkien* (on which more later).

Embedded as it is in undisputed facts of Tolkien's early life and consistent with his own wishes expressed in the earlier quoted letter to Christopher, this 'romantic' approach is not entirely unjustified. But it has to be acknowledged that a lot of biographical detail is lost along the way: from the very legitimate reasons Tolkien's guardian had for prohibiting their union before his protégé had even secured a university place for himself to the rationale behind Edith's decision to marry another man – and, more importantly, the day-to-day reality of their early life together amid the seemingly endless privations and relocations of his long convalescence and job search ahead of the safe haven offered by the OED position offered to Tolkien in 1918.

The romantic view of love envisages only two outcomes: one is irrevocable separation (by death, distance, social barriers, etc.), and the other is the 'happily ever after'. The romantic story of Edith and Ronald dwells on their early life and then proceeds straight to their final years: they were married, had four children and never parted for the rest of their lives. The story wraps up with the inscription on the gravestone, echoing the leap over the 'lapses and darknesses' referred to in Tolkien's letter.

The Unhappy Ever After

The period that follows the blissful wedding is one that is usually left outside the framework of romantic narratives. It is also a period that generates its own mythology, associated with imagery which is the opposite of the 'radiant maiden' images which tend to accompany the love and courtship period. The transition from enchanting maiden to 'loathly lady' is age-old and has been invoked since the Antiquity to this day. The urban mythology

much proliferated in the twentieth century (and beyond) casts 'the wife' as a tragicomic figure of ridicule and occasionally contempt, the dreaded apparition in hair curlers and dressing gowns, waiting to sink her claws into the hapless male who strives to escape to the safety of the pub, his study, his shed or the company of his male friends – much to her annoyance.

It is not at all surprising that Edith Tolkien has become enmeshed in this mythology as well. Following marriage and permanent settlement in Oxford after a period of wartime wandering, a short Oxford interlude while Tolkien worked for the OED, and his stint at the University of Leeds, the way Edith Tolkien is mentioned in biographical writings seems to change course. DuPlessis provides a detailed account of how biographers, following Humphrey Carpenter's lead (see Carpenter 1977; Garth 2003; Edwards 2014, and others), have been portraying the Tolkiens' marriage as strained and occasionally deeply unhappy, with him favouring his university duties and his male friends (most particularly C. S. Lewis and the Inklings), and her growing increasingly resentful and jealous of his time.

Tolkien continued to develop his own mythology, but it was now mostly shared with his friends and children rather than his wife. No mention is made of Lúthien, Arwen or any other similar characters in the context of Edith and their marital relationship; indeed, the character from Tolkien's legendarium that begins to be relevant is Erendis, the unhappy estranged wife of a Númenorian prince from a story written in the 1960s and published in the *Unfinished Tales*. She grew bitter and resentful of her husband's continued absences and sea voyages and 'fearing the Sea, and begrudging to all ships the felling of trees which she loved, she determined that she must utterly defeat the Sea and the ships, or else be herself defeated utterly'. Unable to succeed in this all-or-nothing mission, 'though she strove to hide it, and would talk with him of his old ventures and of his hopes and designs, she watched jealously if he went to his house-ship or was much with the Venturers' (Tolkien 2010, 183).

Viewed from a certain male perspective (especially widespread in academic circles of the time), marriage and family life, even if happy and fulfilling, was often considered a distraction. A wife, unless she was an academic herself, was firmly ensconced at home; any 'intrusions' into male conversation or work-related matters were at best 'stoically' tolerated and at worst bitterly resented and rebuffed. The subtle hints that Edith was not at Tolkien's level intellectually (whether because of insufficient ability or inadequate schooling) and could not therefore satisfy his need for deep intellectual engagement which was served by his male friendships, are pervasive in Tolkien scholarship (see duPlessis for a thorough discussion).

We have no accounts of Edith attempting to share in her husband's academic or creative life like many women featured in this volume (see Chapters 1, 2 and 16 by Hollis, Lahtinen and Presley), perhaps in some unofficial secretarial capacity or as a reader or editor of his writings. He did his own typing now, occasionally outsourcing it to his children and later to

professionals when he could afford them. Although there are indications that running an Oxford professorial household was not something she felt comfortable with, at least initially, there are no records of her trying to get out of this 'compartment'. Tellingly, much of what we hear about her at this stage in their lives relates to her health (even that is portrayed as yet another distraction to drive Tolkien away from his work and writing) and childbirth. Interestingly enough, Tolkien's relationship with his children – he was a devoted and involved father by all accounts – is hardly ever presented as a distraction from his writing or his other duties.

Edith's very existence in Tolkien's life was enough to produce anxieties. On the milder end of the scale, we have the reaction of Tolkien's school friends, the T.C.B.S., when they finally learned that their friend was engaged in 1915. Although Tolkien allegedly objected to a 'compartmented life' (Garth 2003, 100), this is precisely the kind of life he and his many contemporaries ended up leading. The T.C.B.S. members knew one another's families and often interacted socially in mixed company, but there was still a deep anxiety attached to the idea of 'losing' Tolkien to domestic life. At best, this was a feeling familiar to anyone who wants to spend some time in the company of a dear and rarely seen friend but is forced instead to engage in small talk with their family member (of whatever age or gender).

On the more extreme end of the spectrum, we find the reactions of C. S. Lewis and his brother Warren, some of which were reported by their friends and some have survived in their letters and diaries. Lewis famously resented any intrusion of women into his friendships and repeatedly lamented occasions on which he was forced to maintain an awkward conversation with a wife instead of engaging into a stimulating discussion with her husband. Despite his unorthodox liaison with Mrs Moore, a woman of an older generation who sought to uphold the traditional views on women's role in relationships but rarely practised what she preached,[1] Lewis was openly insisting on his rights as a friend coming before any other engagements his friends had, which caused understandable tensions in their marriages. Warnie Lewis, notoriously uncomfortable around women, had no doubts that 'of all the men I have ever met, poor Tolkien is the most unfortunate' (Kilby and Mead 1982, 173). Tellingly, this outburst relates to an episode when Tolkien was ill in bed and Lewis went to visit him at home and – oddly enough – 'found Madame there, so could not have much conversation with him'!

It has to be said that neither Tolkien nor his biographers ever go to such extremes as the Lewis brothers did in portraying his marriage as altogether miserable and his wife as a grasping harpy eager to deny him his rightful intellectual pleasures and tie him to her apron-strings. Lewis's notorious short story *The Shoddy Lands* (Lewis 2017a) reveals a darker and truly misogynistic side of this mistrust of women and especially other men's wives, turning the woman into a Shelob-like, monstrous, gigantic creature,

intent only on sucking a man into her 'shoddy' world and stripping him of anything that constitutes his personality.

Interestingly, in their later lives, already after the gradual decline of the bonds between the Inklings, both Lewis and Tolkien produced fictional portrayals of women which differ remarkably from such attitudes and represent attempts to come to terms with the nature of the conflict between traditional male and female roles. Tolkien's Erendis taught her daughter, the future Queen of Númenor, an attitude to men which is a cross between Amazon and Feminist, openly challenging the world of 'men, those heroes of old that they sing of – of their women we hear less, save that they wept when their men were slain' (Tolkien 2010, 199). In C. S. Lewis's *Till We Have Faces*, we find an incredibly nuanced and poignant portrait of his female protagonist, Orual, who is shown in one scene making an uneasy peace with her arch-rival, the wife of her general Bardia, whom she had previously seen as an interfering and selfish crone seeking only to lure the man home and away from 'his work, which was his life . . . and all his glory and his great deeds' (Lewis 2017b, 125).

'The Proud and Opinionated Princess'

It is inevitable that the third view of Edith Tolkien, increasingly apparent in recent explorations of her and her husband's lives, would be almost the inversion of the one presented earlier. Where the traditional male-centred view would see her as a distraction and him as a henpecked husband, the opposite view would be to see her, instead, as a victim – whether of her time or of her marriage. Apocryphally, there have always been speculations of what 'female Inklings' would have been like or to what extent the 'women among the Inklings' had to suppress their own creative potential in order to cater to the men.[2] When it comes to Tolkien, these speculations are not based on a solid foundation of fact. There is no doubt that Edith contributed to the marriage in many meaningful ways, from the fact that she had a solid income early on when Tolkien had little to none (Bunting and Hamill-Keays 2019), to the many sacrifices she had to make for him, moving house as many as twenty-two times during the war years, giving birth to her children in less-than-ideal temporary lodgings, and neglecting her health while providing the care and support that he needed during his convalescence and early career. There are indications that she had felt comfortable with her Anglican faith and community so she never quite warmed to Catholicism the way her husband was hoping for. But the idea, for instance, that she gave up on a promising musical future in order to become a wife and mother, while not entirely implausible, does not seem to hold water. Whatever skeletons the cupboards of the house in Northmoor Road may have contained, Edith Tolkien was not a Vera Lane Poole (see Dresvina in this volume).

Another way of reimagining Edith and her relationship with Tolkien has recently been offered by the movie adaptation of their early years, entitled simply *Tolkien* (2019). The film is a free biographical interpretation focused on Tolkien's experience in the First World War. It also casts Edith as a key character, played with vigour and charm by Lily Collins. It would be safe to say that this portrayal is typical of many recent period dramas or biopics which have characters who seem to long desperately to live in a different time, as if they were thrown into an earlier historical period by a terrible mistake. Edith in the movie is profoundly unhappy with her role as a companion in a boarding house; she is keenly aware of her inadequate education and is envious of Tolkien when she realizes how much intellectual pleasure he derives from his studies and his circle of friends, the T.C.B.S. This pleasure is denied to her by social norms and later by Tolkien himself as he suddenly becomes jealous after introducing her to his friends and seeing a kernel of affection forming between them. She is also an accomplished musician and an ardent Wagnerian, stifled by the drawing-room tunes she is made to perform ad nauseam. Tellingly, as Edith tries to help Tolkien develop one of his tales, she casts herself as a 'proud but opinionated princess' at its centre: a description that would definitely suit a character like Lúthien (unnamed for copyright reasons) but which also, in tune with the times, avoids any mention of her beauty or other physical characteristics and focuses instead on her mind and opinions. This is echoed in Tolkien's profession of love for her when he comes to talk her out of marrying another man in the climactic scene of the movie: 'You are the most remarkable spirit I have ever met. You have courage and resourcefulness, talent, you're proud, maddeningly, wonderfully so; and you are cunning and vibrant and completely alive' (*Tolkien* film script).

Unfortunately, for various reasons the film completely fails to address the 'ever after' question, despite pointing out some potential tensions between the protagonists. After Tolkien and Edith marry, they are shown in a serene Oxford setting surrounded by their four children. The question of Edith's happiness and suppression of her intellectual ambitions and potential, raised in the earlier scenes, seems to have resolved itself into a generic image of marital bliss.

The three images described earlier are nothing but cultural and social clichés which have been applied to numerous women over time. A radiant maiden, a man's guiding star; a nagging shrewish wife who seeks to trap her husband in her own shoddy world; a talented, ambitious woman imprisoned by social conventions and patriarchal society which does not allow her to reach her full potential – all of these stereotypes are of necessity Procrustean. In applying them to Edith Tolkien and in researching the ways they have been applied to her in the past, we need to be aware of the environments and attitudes that these generalizations reveal. Whether she or her family wanted it or not, Edith Tolkien has been in the spotlight which seeks to illuminate anything that could be relevant for understanding her husband's

writings. She deserves her right to privacy, but she equally deserves to be understood in the context of her time and her own individual story, rather than becoming a token of attitudes ultimately produced by 'the eye of the beholder'. It is to be hoped that when and if more archival materials see the light of day, future studies and general attitudes will not be as constrained by stereotyping as they are at the moment.

Notes

1 There is the infamous episode, recorded by an indignant Warnie in his diary, when Mrs Moore overheard that Tolkien was unable to make a meeting with Lewis because of his domestic arrangements and 'went off at full cry: "Perfectly ridiculous, any woman who had been decently brought up knew better than to come between a man and his men friends . . . a man should begin as he intends to go on: once you give way to a woman you have to keep on giving way to her . . . a woman should never interfere when men want to have a talk . . . to expect a man to hang about the house doing things for her is absurd" etc. etc. Only Molière could have done this scene justice' (Kilby and Mead 1982, 145).

2 See *Women Among the Inklings*, ed. by Fredrick and McBride, for a more focused exploration of the Inklings' relationships with the women in their lives; as duPlessis cautions, their account of Tolkien's life is largely derived from Carpenter (duPlessis 2019, 42, 56). It is ironic that the only 'Inkling wife' who had an independent creative life was Joy Davidman Gresham Lewis, and she was utterly irrepressible.

Bibliography

Bunting, Nancy and Hamill-Keays, Seamus, 'J.R.R. Tolkien's Inspiration for Lúthien: The "gallant" Edith Bratt', *Journal of Tolkien Research* 8, no. 1 (2019), https://scholar.valpo.edu/journaloftolkienresearch/vol8/iss1/9 (accessed 29 February 2020).

Carpenter, Humphrey, *J.R.R. Tolkien: A Biography*. London: George Allen & Unwin, 1977.

Croft, Janet Brennan and Leslie Donovan, eds, *Perilous and Fair: Women in the Life and Works of J.R.R. Tolkien*. Altadena: Mythopoeic Press, 2015.

duPlessis, Nicole, 'On the Shoulders of Humphrey Carpenter', *Mythlore* 37, no. 2 (2019): 39–74.

Edwards, Raymond, *Tolkien*. London: Robert Hale, 2014.

Eilmann, Julian, *J.R.R. Tolkien, Romanticist and Poet*, Cormarë Series No. 36. Zurich: Walking Tree Publishers, 2017.

Fredrick, Candice and Sam McBride, *Women Among the Inklings: Gender, C. S. Lewis, J.R.R. Tolkien, and Charles Williams*. Westport and London: Greenwood Press, 2001.

Garth, John, *Tolkien and the Great War: The Threshold of Middle-Earth*. London: HarperCollins, 2003.

Kilby, Clyde S. and Marjorie Lamp Mead, *Brothers and Friends: The Diaries of Major Warren Hamilton Lewis*. Cambridge: Harper & Row, 1982.

Lewis, C. S., *The Dark Tower and Other Stories*. London: HarperCollins, 2017a.

Lewis, C. S., *Till We have Faces: A Myth Retold* [1956]. London: HarperOne, 2017b.

Scull, Christina and Wayne G. Hammond, *The J. R. R. Tolkien Companion and Guide*. Vol. 2: *Reader's Guide*. London: HarperCollins, 2006.

Tolkien (film script), https://subslikescript.com/movie/Tolkien-3361792 (accessed 21 October 2020).

Tolkien, J. R. R., *The Silmarillion*, ed. Christopher Tolkien. Boston: Houghton Mifflin, 1977.

Tolkien, J. R. R., *The Book of Lost Tales, Part Two*, ed. Christopher Tolkien. London : Allen & Unwin, 1984.

Tolkien, J. R. R., *Morgoth's Ring: The Later Silmarillion*, ed. Christopher Tolkien. London: HarperCollins, 1993.

Tolkien, J. R. R., *The Letters of J. R. R. Tolkien*, ed. Christopher Tolkien [1981]. Glasgow: HarperCollins, 1995.

Tolkien, J. R. R., *Unfinished Tales of Númenor and Middle-Earth*, ed. Christopher Tolkien [1980]. London: HarperCollins, 2010.

Tolkien, J. R. R., *Beren and Lúthien*, ed. Christopher Tolkien. London: HarperCollins Publishers, 2017.

16

'Why Aren't There More Women in Your Books?' Ann and William Golding

Nicola Presley

The history of the publication of William Golding's *Lord of the Flies* is almost as well known as the novel itself; the book made its way through rejections from numerous publishers, before being plucked from the slush pile by Charles Monteith at Faber & Faber. What is less known, however, is the role that Golding's wife Ann played in the creation and writing of the novel. Having read adventure stories to their children in the early 1950s, Golding complained that the narratives were unrealistic, and said, 'Wouldn't it be a good idea if I wrote a book about children on an island, children who behave in the way children really would behave?' (Carey 2009, 80). Ann thought this was a great idea and told him to do it. Her influence on Golding's writing was not restricted to encouraging him to develop *Lord of the Flies*; indeed, as seen from an examination of Golding's manuscripts and unpublished journals, Ann had a huge impact on his published work. Golding was famously sensitive to criticism throughout his career; he rarely read reviews, and often left the country after the publication of his books. However, he valued Ann's opinion above all others, and this chapter seeks to trace and acknowledge Ann's impact on Golding's work, inspired by the #ThanksForTyping hashtag as discussed by Juliana Dresvina in her introduction to this volume. Although John Carey included some of Ann's contributions in his 2009 biography of Golding, this is the first work to foreground her role in the development of his writing career. I take a mostly chronological approach in examining the Golding archive to demonstrate

Ann's consistent involvement in Golding's published works, and her role in supporting him more widely through professional and family life.

Golding met Ann Brookfield, who worked as an analytical chemist, in 1939, when both were engaged to other people (Carey 2009, 75–6). He later fictionalized this meeting in his 1959 novel *Free Fall*, where Ann is represented by the character Taffy:

> She was dark and vivid. She had the kind of face that always looks made-up, even in the bath – such black eyebrows, such a big, red mouth. She was the prettiest girl I ever saw, neat in profile, with soft cheeks and two dimples that were in stunning contrast with her tenor voice and scarifying language. (140)

Ann and Golding fell in love and they married five months later. Their son David was born in 1940, shortly before Golding joined the navy, and daughter Judy followed in 1945. Judy recalls that her parents 'were always by far the most important people in the world to each other, bar none, absolutely none' (J. Golding 2011, 7). However, the separation during the early years of the marriage was particularly difficult for Ann, who was left to care for David, who had been born with club foot. She was isolated in the small village of Bowerchalke, Wiltshire, away from her family, until she moved in with her parents-in-law in Marlborough. They had initially been disappointed that Golding had rejected his fiancée in favour of Ann, and had not attended the wedding. But they stepped in to help in this time of need, and John Carey writes that they became 'reconcile[d] to their son's marriage' (80). Ann's determination, and this support, meant that David entirely recovered from his disability.

After the war, the Goldings settled in Salisbury, where Golding was a school teacher, and Ann later also taught part time. Golding had been unsuccessful in having his early prose work accepted by any publishers (Macmillan had published a volume of his poetry in 1934), until Ann encouraged him to write *Lord of the Flies* (1954), initially entitled *Strangers from Within*. The typescript Golding sent to Faber was quite different to the final published novel. Charles Monteith remembers that the opening pages 'described a nuclear war [. . .] they contained, initially, no characters at all' (57). Monteith has thus been credited for seeing the potential in the book, and for helping Golding shape it into its final form. This typescript no longer survives, but the first manuscript draft does, and interestingly, this manuscript is much closer to the novel's final form. Golding notes comments from Ann throughout the draft in the margins, which were added as he was writing and revising. On the second page he writes: 'Ann suggests they could first notice absence of grownups.' 'They' refers to Ralph and Piggy, the earliest characters introduced on the island, who appear after a brief description of war and subsequent plane crash. Clearly, Ann felt that the fact that the boys are all alone on the island needed to be highlighted much

sooner, and indeed, this is the central theme of the novel. In Golding's draft, Piggy asks later: 'Is there any grown-ups with us?' In the published version, this occurs on page 2, with a slight change to the way in which Piggy speaks: '"Aren't there any grown-ups at all?" "I don't think so."' (2). Golding chose to ignore her suggestion while preparing the typescript, but Monteith's subsequent views align with Ann's. This hitherto unnoticed contribution deserves to be noted and her comments on the manuscript contributed to the success of the novel.

Ann also commented on the characters of Jack and Roger, two of the 'hunters' in the book, and the most feared. On the pages for what became Chapter four, 'Painted Faces and Long Hair', Golding has noted: 'Ann thinks of Jack as obviously lonely, what about Roger?' As the leader of the hunters, and Ralph's main rival, Jack has tended to receive most of the critical and popular attention as the villain of the novel. But Roger's quiet cruelty and act of premeditated murder make him by far the most chilling character. In the same chapter, Roger begins to explore the limits of the freedom on the island and starts to antagonize one of the smaller boys: 'Roger stooped, picked up a stone, aimed, and threw it at Henry – threw it to miss. [. . .] Yet there was a space round Henry, perhaps six yards in diameter, into which he dare not throw' (64–5). Roger is so far constrained by the conventions of proper behaviour. As the novel develops with the refrain of '*Kill the pig. Cut her throat. Spill her blood*' (72), events become much darker. The murder of Simon can be blamed on the boys as a group as he stumbles into their fireside dance on the dark beach. But it is Roger who bears all the responsibility for the final death. In the showdown between the hunters and Ralph and Piggy, he begins dropping stones on Piggy from above, this time not aiming to miss. Eventually, 'with a sense of delirious abandonment', he pushes the 'great rock' onto Piggy (200). Ann's curiosity about Roger's motives and personality demonstrate her intuition and must surely have influenced Golding's development of the character.

Ann's practice of commenting on the drafts of Golding's writing continued throughout his second novel, *The Inheritors* (1955). Less well known than *Lord of the Flies*, *The Inheritors* features a group of Neanderthal people who are threatened by the emergence of homo sapiens. Since the central characters mostly communicate through imaginary pictures in a kind of shared telepathy, rather than through language, this can be a challenge for the reader while comprehending the events of the narrative. Ann's notes allude to this potential problem in the first draft, in which she frequently requests a clearer explanation when the Neanderthal people communicate. For example, in the early part of the novel, Lok instinctively knows what the matriarch of the group, 'the old woman', is carrying as they emerge from hibernation. Ann told him that she thought 'people would get lost' and that Golding did not 'clearly say that Lok <u>smelt</u> what the old woman carried'. The published version makes this clear: '[Lok] turned again outwards to where he smelt the old woman's burden' (16). Ann also criticized the

characterization of the Neanderthal people, with Golding writing, 'Ann thinks generally I am making them to too [*sic*] nearly perfect. Suggests I ought to make Mal stoical instead of wombly weak.' And indeed, in the finished novel, Mal faces his death with stoicism. The people share a picture from Mal and understand his 'dull conviction' that '[t]omorrow or the day after' he will die (29). He is also able to recognize the threat from the new people when one of the family goes missing and indicates to them that '[t]here is the scent of another' (57). This elucidates Mal's strength as the protector of the family, despite his suffering and the weakness of his body.

Golding did not always follow Ann's advice. Fa, the main female character, is the most resourceful and intelligent member of the group of Neanderthals. She almost invents the concept of farming when she visualizes plants growing near the waterfall, and suggests to the others that they could carry water in shells: 'I am by the sea and I have a picture. This is a picture of a picture. [. . .] I have a picture of the people emptying the shells by the sea' (52). On the manuscript Golding has noted that 'Ann says Fa should say "We are lucky by the sea. We can drink out of shells there"'. Ann obviously felt that Fa's 'picture' was not clear enough for the reader, although Golding did not add her suggestion that Fa should state that they were lucky. It is likely that he felt that the characters would not have an awareness of our concept of luck, and indeed, luck seems to diminish Fa's achievement of imagination. Lok is unable to understand Fa's vision, but the old woman replies: 'That is a new thing' (53). Fa's intelligence and strength may well have been inspired by Ann herself, and the struggles she endured when Golding was in the Navy. Ann's determination to free David of his disability is reflected in Fa's resolve to recover the two children stolen by the 'New People'. She tracks the children to the humans' camp and comes up with a plan to take them back. Lok is unable to understand what is happening, so she takes charge: 'Do what I say. Do not say: "Fa do this". I will say: "Lok do this"' (107). In recognition of Ann's support, Golding dedicated *The Inheritors* to her.

By 1961, Golding had published two more books – *Pincher Martin* (1956) and *Free Fall* (1959) and his writing career was going from strength to strength. This was in no small part down to Ann's role in supporting and encouraging him. As Judy Golding writes '[i]t was she who answered the phone, read his contracts as well as first drafts of his writing, and chose who would come to lunch' (100). Ann and Golding were both able to give up their teaching roles in order to focus full time on literary pursuits, and this was helped by the phenomenal success of *Lord of the Flies* in America in the early 1960s. Golding was invited to lecture across America, accompanied by Ann. The punishing schedule made it more difficult for him to write, and he found it challenging to complete the manuscript for what was to become *The Spire* (1964). Only one manuscript page of *The Spire* survives, so it is not possible to trace Ann's thoughts on the book's development. However, we do know that she was just as involved in the writing and revision process from letters Golding wrote to Charles Monteith. In one, he suggested *An*

Erection at Barchester for a potential title, although Ann had demurred, and warned him that Faber would not be able to use it (Carey 2009, 263). In another letter about the tortured construction of the novel, he tells Monteith that Ann is 'as confused as he is' after reading the multiple drafts, with different timelines (Carey 2009, 272).

A 1966 letter to Monteith about a new manuscript contains a line which demonstrates the closeness of Ann and Golding's working relationship. He writes 'Ann and I have now written and read three successive versions of the thing' (Carey 2009, 296). This elucidates how Golding thought of them as a pair of writers and editors, whose collaboration produced the books that bore only his name. The latest manuscript was a section from *The Pyramid*; the novel as a whole was inspired by Ann urging Golding to write a memoir. The archive holds the manuscript for the third part of *The Pyramid*, which relates the story of a music teacher called Bounce, who lives a rather lonely and bitter life. Golding notes that Ann thought 'this opens up a ghastly version of thousands upon thousands of maiden ladies doing this sort of thing – not even teaching in a school – but shut away, confined'. In typical fashion, Ann was forthright with her criticisms; a page of the manuscript indicates that 'Ann's attention wandered'. He made a change to the end of the novel based on Ann's views. After Bounce's death, the protagonist Oliver goes to her house, and is chilled by her absence and the stillness of the dwelling. In the original manuscript, Golding had written 'The room was silent and the butterfly gone already', but his annotations read that 'Ann thinks the butterfly [is] too much'. The published version still features the butterfly, but the insect is now used to reflect the quietness of the room, in an act of showing, rather than telling: 'The thing beat mindlessly with frayed wings among the cobwebs on the pane. I ran forward to wrestle with the sash; but the maimed thing fluttered to the floor and lay there motionless' (259).

After the publication of *The Pyramid* in 1967, Golding began suffering from alcoholism and writer's block. With the exception of a collection of three short novellas, published as *The Scorpion God* (1971), he did not produce a finished manuscript until the late 1970s. This period, which Golding called his 'crisis', is documented in his unpublished journals. These provide a rich resource for understanding the relationship between Golding and Ann, and also offer further evidence of her impact on the development of his writing. The journals were originally designed as a dream diary, with the early entries mostly retelling Golding's dreams and his own interpretation of them. Ann frequently appeared in these, which prompted him to comment: 'It's odd how Ann seems always to be there in my dreams, sometimes appearing overtly: but often just a presence. [. . .] Ann appears to be crowned queen of all femininity in the unconscious.' Golding wrote in these journals until the night before his death, and his and Ann's every-day life is documented there, in addition to his writing progress. Just as she did with his manuscripts, Ann also read his journal entries, and Golding once again recorded her

comments. On 23 February 1989, he wrote: 'Ann says she figures in my journal as a woman who does nothing but get her hair done. Well, my goodness, she holds not only me but the whole place and family together! That should be written in letters of gold.' In fact, and in opposition to Ann's tongue-in-cheek remark, the journals absolutely attest to the importance of Ann's role, and he alludes to their partnership throughout. One of the most striking moments is Golding's note about being awarded the Booker Prize in 1980: 'And so it happened! We have won the Booker prize!'

Indeed, without the support of Ann, Golding may never have written another novel. As he attempted to break through his writer's block, Ann was encouraging about early drafts, and unstinting in her belief that he would complete a novel. In 1975 he writes, 'Ann has read some abortive chunks of a novel, given it as her opinion that it is good (tho' I shall never finish it) and said I should be capable of writing another novel without question'. Golding was actually working on two separate narratives by this point, although writing two such different stories was probably detrimental to progress, borne out by the length of their gestation. One of these became *Rites of Passage*, which won the Booker, and entirely reinvigorated Golding's career. The drafts are messy, and somewhat difficult to follow, but there is evidence of Ann's influence. *Rites of Passage* is set in the early years of the nineteenth century, and features a group of British people sailing for Australia. Golding was a keen sailor and used this knowledge to create a convincing image of life on a ship. However, Ann warned him that she found some of his descriptions hard to follow, essentially advising him to consider how a non-expert reader would find the text. While it is difficult to trace exactly what changes Golding made, the finished novel certainly seems to accommodate this suggestion. A key event in *Rites of Passage* is the disgrace of passenger Reverend Colley, who is despised by his fellow travellers, and eventually dies after retreating to his cabin through shame. Golding experimented with the right moment to reveal what prompted Colley to sink into his depression – Colley had in fact got drunk on the ship and performed fellatio on one of the sailors in the fo'castle. On one of the early drafts, Golding noted that 'Ann believes the sexiness of Colley's stay in the fo'castle was given away far too early'. In the final version, the real story of what happened that night is revealed five pages before the end of the novel, providing a good deal of suspense for the reader. It seems clear that this was prompted by Ann's advice.

The other manuscript that Golding worked on during this time of crisis was *Darkness Visible* (1979), titled in draft as *Here Be Monsters*. *Darkness Visible* is Golding's most mysterious novel, which he consistently refused to discuss throughout his lifetime. The idea for the story had come as early as the 1950s, and it is clear that he never forgot it (Carey 2009, 367). His journals show that he picked it back up again in 1973, although progress was slow. The novel is divided into three sections; the first focuses on Matty, a mysterious character who struggles to fit into society. The second

is entitled 'Sophy' – the name of Golding's first female narrator – and relates the story of Sophy Stanhope, an intelligent manipulator who constructs an elaborate kidnapping plot. The final section ties Matty and Sophy's stories together, and Golding's attempts to bring these narratives together caused him the most difficulty. It is impossible here to demonstrate all of Ann's work in helping Golding with the task, due to the sheer number of drafts, her many annotations and the complicated plot of the novel. But it was Ann who solved the problem of the reconciliation of the two strands. Golding had originally intended that Sophy would kill the kidnapped boy, since he wanted to show the depravity she was capable of. But the death of the victim would mean that Matty could not carry out his rescue, and this was the act that would complete the novel. Ann suggested that Sophy could *imagine* murdering the boy, and Golding noted that 'Ann has turned up two ideas which seem good – implied mental disintegration of Sophy rather than her death, and her vision of cruelty rather than the fact'. Sophy's vision still allowed Golding to demonstrate her brutality, and indeed, the published description shows her delight in torturing the child: 'She thrust [the knife] with all the power there was, deliriously; and the leaping thing inside seized the knife so that the haft beat in her hand' (379). *Darkness Visible* won the James Tait Black prize for fiction in 1979, a triumph for Golding and Ann.

He continued writing throughout the 1980s, publishing *Close Quarters* (1987) and *Fire Down Below* (1989). These novels continued the story begun in *Rites of Passage*; taken together they are known as *The Sea Trilogy*. Ann continued to make suggestions for amendments, which Golding recorded. Away from the trilogy, he also published *The Paper Men* in 1983, a book about an ageing alcoholic writer, and his struggles with a would-be biographer. It is tempting, of course, to read *The Paper Men* as an autobiographical novel; a temptation that Ann was concerned about. He notes in his journal that Ann says he has to 'establish very clearly' that he is not the protagonist. He wonders whether he can do that by having his character 'meet Ann and Bill Golding on his travels', although this doesn't happen in the final version. By 1990, Golding was struggling with writer's block again, and on the night before his seventy-ninth birthday, Ann told him that '[w]hat you have to do is publish a new novel in a years [*sic*] time'. Despite his (and her) age, Ann recognized, as Carey notes, 'the only thing that made him unhappier than writing was not writing' (499).

At a reading in 1992, Ann asked him a question as a member of the audience: 'Why aren't there more women in your books?' Carey reports that Golding 'laughed, shifted from foot to foot, and said something like, "Well, yes, there aren't many, are there. People are always asking me that"' (508). Shortly after, he wrote his final novel *The Double Tongue*, published posthumously, which is his only book to feature a sole female protagonist, Arieka. In the novel, Arieka says: 'I understood a little more of what a girl was' (11), suggesting that Ann's comment had given him the push he needed to develop the character. Ann's love, support and intelligence

enabled Golding to have a phenomenally successful career as a writer, and her influence on the work of William Golding deserves to be recognized and celebrated. As a final word, Golding himself acknowledged the importance of Ann in a heartfelt entry in his journal:

> It might be a good thing to record in an unbritish [*sic*] way here, how much I love her, and how much she has done for me, from bed to books. For I would never have been as happy in the one with someone else, nor have written the others with someone else – or indeed written anything.[1]

Note

1 Excerpts from William Golding's journals and manuscripts appear by kind permission of William Golding Limited. Also, many thanks to the Special Collections team at the University of Exeter.

Bibliography

Carey, John, *William Golding: The Man Who Wrote Lord of the Flies*. London: Faber and Faber, 2009.

Golding, Judy, *The Children of Lovers: A Memoir of William Golding by His Daughter*. London: Faber and Faber, 2011.

Golding, William, *Lord of the Flies*. London: Faber and Faber, 2011 [1954].

Golding, William, *The Inheritors*. London: Faber and Faber, 2011 [1955].

Golding, William, *Free Fall*. London: Faber and Faber, 2013 [1959].

Golding, William, *The Pyramid*. London: Faber and Faber, 2013 [1967].

Golding, William, *Darkness Visible*. London: Faber and Faber, 2013 [1979].

Golding, William, *Rites of Passage*. London: Faber and Faber, 2013 [1980].

Golding, William, *The Double Tongue*. London: Faber and Faber, 2013 [1995].

Monteith, Charles, 'Strangers From Within', in John Carey (ed.), *William Golding: The Man and His Books: A Tribute on His 75th Birthday*, 57–63. London: Faber and Faber, 1986.

17

'You'll Say That Mum Is at the Bottom of All This'

The Untold Story of Eva Larkin

Philip Pullen

In this chapter I want to demonstrate the underlying and generally understated importance of Philip Larkin's mother, Eva, to his life and poetic output. 'You'll say that Mum is at the bottom of this', Larkin wrote in a letter to his long-term lover, Monica Jones, in 1957, while seeking to explain his reasons for not wanting to marry her, and, in part, Monica's assumption may well have been true. Larkin's most significant relationship was with his mother and lasted for all but eight years of his life, shaping, enabling and constraining it in equal measure. Nevertheless, the full story of her significance and biographical relevance has yet to be told.

It is not surprising, given his protestations, poetic or otherwise, about what parents do to their offspring that Philip Larkin's own family background should have formed a key area of biographical interest. However, as a researcher, what strikes me most forcibly about all of the Larkin biographies to date is the almost complete absence of a mother's voice. For the most part, Larkin's biographers have been overly preoccupied with presenting a detailed examination of his father, Sydney – emphasizing his public role as a city treasurer in Coventry, his dubious enthusiasm for National Socialism in the 1930s and the impact that his admiration for the more progressive elements of English literature may have had on his son. By contrast, Larkin's mother, Eva, is presented as a shadowy, background figure with little curiosity expressed about her story and the very real contribution she made to her

son's literary successes. Even where some account of her life has been given, this has generally been sketchy, stereotypical and of questionable accuracy.

Most of the descriptive detail regarding Eva Larkin has been acquired second-hand, chiefly from the perspective of her son, in accounts written during his adolescent years or in letters to his long-term lover, Monica Jones, in later life. The fact that both of these sources contain ambiguities and contradictions has often been underplayed. It is well known that Larkin was sometimes an unreliable witness to events in his own life or, at the very least, creatively imaginative in their recollection. Alongside this, little note has been taken of Eva's own perspective on her life and certainly no proper consideration given to the factors that helped to shape it. Undoubtedly this has a lot to do with the biographical focus and the taken-for-granted assumptions underpinning it. These have led to the selective use of the vast Larkin archive located in the Hull History Centre which contains much material relating directly to Eva Larkin.

Every archive has its hidden corners: content that has been overlooked, inadvertently or otherwise; items that have not been fully catalogued or pieced together sufficiently to reveal a bigger pattern. This feature is reflected in other chapters of this volume, for example in the analysis of the Penguin Archives relating to Eunice Frost. In this particular case, a wealth of material relating to the life of Philip Larkin's mother had been wholly or partially neglected. Perhaps most significant in this respect are the 8,000 plus letters, postcards and telegrams that Philip and his mother exchanged between each other from the time he went up to Oxford in 1940 to shortly before her death in 1977. This collection constitutes a vast epistolary dialogue that not only reveals the strength and significance of the relationship between mother and son but also provides powerful insights into Eva's own life experiences. Moreover, these letters prove to be even more powerful when combined with other equally neglected items lurking in the archive, such as photographs, personal diaries and audio recordings. As in the case of Valerie Elliot, what they reveal is a truth more complicated than the 'official narrative'.

Until very recently, the Larkin family letters were not easily accessible and the bulk of them remain uncatalogued in the archive. Anthony Thwaite took a deliberate decision to exclude them from his 1992 edition of Larkin's correspondence while a year later, the first Larkin biography by Andrew Motion made only fleeting reference to individual letters. It was to take a further twenty-five years before an edition of these letters would be published, edited by Larkin's most recent biographer, James Booth. While this publication undoubtedly throws some valuable new light on the mother-son relationship, there is, nevertheless, much that is still to be uncovered. In a similar way to Maissi Erkko, we find that Eva's voice, where it exists, has often been muted and distorted.

Inevitably, by definition, any edition of literary correspondence will only offer a selective number of letters, based on certain criteria for selection. In this case, for perhaps understandable reasons, the bulk of the letters included

in Booth's edition is heavily biased towards one side of the conversation, that of Philip Larkin himself. Of the 607 complete letters reproduced in the volume only eleven were written by his mother and these appear in an appendix. While short extracts from many more of Eva's letters are included as footnotes, these function mainly as a means of providing necessary contextual detail. The overwhelming consequence is that Eva's voice, as reflected in her correspondence, is still not properly heard and, at worst, from her perspective actually ends up becoming seriously decontextualized. It takes a very perceptive, skilful and dogged reader to piece her story together in a way that does not end up repeating or building upon the stereotypes from the earlier biographies. Sadly, too many critics have fallen into this trap. Writing in *The Times*, for example, Roger Lewis produced a welter of misrepresentation coupled with cheap attempts at comic effect, concluding that it was, 'almost entirely impossible to overstate Eva's degree of banality'.

> Widowed in 1948, Eva, as nervous and wheedling as Old Mother Riley, was thin, sour, with flat crinkled hair and an unwelcoming furious face. She fretted endlessly about nothing – unannounced visitors, unexpected phone-calls, unaccompanied travel. Eva was confused and puzzled by rain, gusts of wind, thunderstorms, doing the hovering and putting a plug on an electric fire. (Lewis 2018)

Reviews like this merely repeat the earlier biographical shortcomings. They show no proper understanding of Eva's circumstances or the value and significance of her relationship with her son – a relationship that lasted for all but eight years of his life. In an earlier publication (Pullen 2018), I attempted to address these shortcomings by revealing how 'the shared conversation' between Eva and Philip Larkin, particularly following the death of her husband, became the most vital part of both their everyday existences. In addition, Eva's letters reveal an acute struggle to establish and cope with a new identity – that of a widow, at a time when that status was much more circumscribed than it is today. They show someone trying to cope with a lost identity, attempting bravely to overcome her loneliness, and the problems of having to live alone. Viewed in its entirety the correspondence reveals the symbiotic relationship between mother and son – each needing the other for different but related reasons. Combined with other items in the Larkin archive, Eva's correspondence, in a similar way to the personal correspondence of many of the women whose lives are reassessed in this volume, provides strong clues to a proper understanding of her own biographical background and the ways in which her personal history directly influenced some of her son's literary achievements. Most importantly, they help to tell her own story in her own words.

One question that might legitimately be asked at this point is whether Eva Larkin would have wanted to have her story told. Unlike her husband, and despite the growing fame of her son within her own lifetime, she lived a life completely free of the public gaze and was to all intents and purposes

a private person. Nevertheless, there are indications that she might possibly have wished for a little more recognition. Some of her letters to Philip reveal a childhood ambition to become a writer and that on more than one occasion she had made an attempt to write her life story. The small notebook in which she made a draft copy remains intact, although it is only a few pages long and does not progress beyond her childhood years. Like Sophia Wittenburg, Eva struggled to find the time and the strength to complete more than a scrap of her biography, where, crucially, she had begun to record her story in her own words. However, combining this with her general correspondence and other documentary and photographic material contained in the archive it is possible to carry that story forward to her later years.

Eva Larkin's family origins span the East of England, the Midlands and the North. She was born in Littleborough, Lancashire, but soon after her birth the family moved to her father's county of origin, Essex, and she spent her childhood days in Theydon Garnon, a village near Harlow most of which has now disappeared under the M25. Her account of her childhood is full of carefree images and an obvious love of the countryside:

> On the whole I had a most happy childhood. Our house, which was semi-detached, had a lawn at the back separated from a large field owned by our butcher; and many, many happy summer days my brother and I spent there. Sometimes chasing butterflies with butterfly nets or gathering flowers from which we made peep-shows from the petals.

Eva's father, William Day, was a civil servant, working mainly in customs and excise and his career development was the reason for the moves to and from Lancashire. He had started his working life as a pupil teacher in London but quickly moved in to the civil service and held posts in several parts of the British Isles, including Dublin, Dumfries and Hammersmith. He had met Eva's mother, Emily, while working in Coventry and they were married in 1883 in St Michael's Church, later to become Coventry Cathedral.

By her teens the family had moved back to Lancashire, to the town of Leigh where Eva attended Leigh Grammar School, becoming one of the first girls to do so. Here she would continue to live with her family until marrying Sydney Larkin, a local authority accountant from Lichfield, in August 1911. Eva's brother, Arthur, two years her junior, also attended the Grammar school in Leigh and, like his father, became a pupil teacher prior to taking up a post in an elementary school nearby Ashton-Under-Lyne. Arthur's death in 1943, apparently of a burst appendix at the relatively young age of fifty-three, removed him almost completely from the shared conversation – there is surprisingly little reference to him in Eva's correspondence and he remains something of an enigma. However, Eva maintained a close friendship with his widow, Nellie, for the rest of her life.

According to Andrew Motion, on leaving school Eva 'briefly considered becoming a librarian, then like her brother took up teaching for a while'

(Motion 1993, 5). However, none of the archival evidence backs this up and Eva makes no reference to it in any of her correspondence. Her own accounts suggest that she spent most of her late teens and early twenties working in the family home supporting her mother who suffered increasingly from ill health. Emily Day had a diabetic condition; she developed gangrene and died in 1934 following an unsuccessful operation to remove her leg. By her own admission, Emily was to have an even more profound effect on her daughter's life. It was through her that Eva would be introduced to her future husband.

Much of the biographical record concerning the nature of Sydney and Eva's relationship and how they came to meet one another has come from Philip himself. He described the occasion in a letter to Monica Jones in August 1953:

> He met my mother on the beach at Rhyl. He was there for 3 days only, on a cycling tour, but before leaving he had a picture of them taken together & exchanged addresses [. . .] & despite a separation of several years his intentions didn't alter. (Thwaite 2010, 106)

Beyond this account, the precise nature of the meeting has never been properly examined. However, by drawing on some more of the relatively untouched archive material, it is possible to throw a lot more light on this undoubtedly important meeting, and, at the same time discover some surprising and significant clues about its lasting poetic influence on Philip Larkin himself.

The revelations begin with the discovery of a photograph lodged in the archives – that of an Edwardian family posing on a bench. Eva has written on the back of it, 'The year I met Daddy'. Other biographical sources indicate that this was therefore taken in 1906. Eva is on the extreme left and on the extreme right wearing the straw boater is her brother, Arthur. He is seated next to their mother, Emily. I initially assumed that the man sitting next to Eva was her father, William Day, but it is much more likely to be Sydney Larkin. Comparison with other photographs, including a portrait of Sydney also taken in August 1906, there is a striking similarity, particularly in the facial features and drooping moustache (Figures 17.1 and 17.2).

Another neglected source of archival information tells us even more about this meeting. In May 1961, Philip tape-recorded a conversation with his mother in his Pearson Park flat in Hull. The recording has rarely been heard in its entirety and it holds some vital secrets. At one stage in the conversation the pair are discussing holidays and Eva's visits to North Wales. Philip asks her mother if it was at Rhyl 'where you met Daddy?' Eva goes on to recall the event in some detail. On the day in question, she had gone in search of her mother along the sands of Rhyl Bay. She knew she would probably find her, she tells Philip, at 'Mr Cheetham's'.

Mother would go out in the morning and buy what she thought we would like for lunch and buy pie, lovely pies from the confectioners and then bring some cream in with it, and then give the chops or whatever it was to the landlady to cook. And then off she'd go to Mr Cheetham and listen. [. . .] She'd be there all morning and then go in for lunch. And that's how I met Daddy, you see. I went to look for Mother.

Like many during the Edwardian era, Emily Day took a deep interest in 'mind reading'. Astrology and various forms of fortune telling attracted her, and she had passion for phrenology, the theory that a person's character could be determined on the basis of the shape of the human head. By the early 1900s it had become a popular source of seaside entertainment.

Arthur Cheetham was, among other things, a phrenologist who gave lectures on Rhyl sands. He was also a pioneering film maker (his is the oldest surviving footage of an Association Football match – Blackburn Rovers versus West Bromich Albion in 1898) – and in 1906 he had just opened the first cinema in Rhyl.

Eva's description of her first encounter with Sydney is astonishingly graphic.

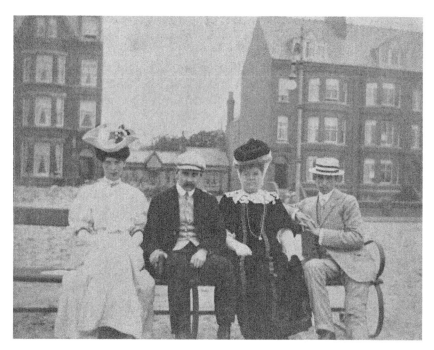

FIGURE 17.1 *'The year I met Daddy': the Day Family in 1906 (Images: The Philip Larkin Estate and Hull History Centre).*

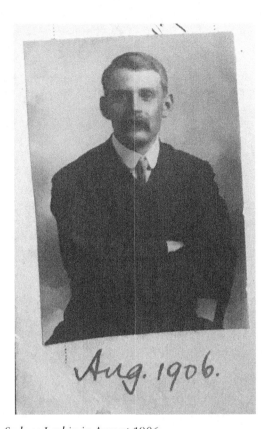

FIGURE 17.2 *Sydney Larkin in August 1906.*

I stood on the fringe of the crowd, just idly listening, and Daddy was there listening. He said to me, 'They're all in league I expect [. . .]' And I said, 'I don't think so!' Like that, as if I'd known him for years. He said that was what surprised him, that I spoke so naturally as if I'd known him ages, instead of glaring at him and thinking, 'Well, fancy speaking to me, a stranger!'

When the crowd dispersed, Eva was surprised to find Sydney by her side:

I found him walking along with me and I thought, 'Oh dear!' And then he asked me where we were staying and all that, and said he was on a cycling tour. And I never thought any more about it until the next day and I was reading on the prom. And there he stood, looking at me and I looked up and the shadow fell over the book I was reading, which was *Wuthering Heights.* 'Hmmm,' he said, 'you don't know me this morning'. And I said, 'Well you've changed your clothes'. And then he saw my initials at the front, 'E. E. D.' and he couldn't guess what they stood for. And when

I said, 'Day', he said, 'Oh there was a character in Hardy named Day. Fancy Day.'

Over the next couple of days, the couple spent a considerable amount of time in each other's company and on the last day of his holiday, Sydney somewhat reluctantly met up with Eva's mother, who had insisted on being introduced to the young man Eva had been 'going out with'. According to Eva it was not an easy first meeting. She describes his first reaction as one of wanting to turn tail and run.

> I saw him turn on his heels! . . . And I thought, 'Oh dear, that's finished it now, if he sees Mother's coming in sight.' [. . .]. I didn't fancy it really. I thought he'd think [. . .] I'd brought her specially to trap him as it might be [. . .] And I saw him turn swiftly around and walk the other way and then he came back again. I think it must have upset him a bit and he tried to calm himself.

Eva's recollections of this encounter clearly stayed with her son. Years later he would recall these events with veiled precision in his poem 'To The Sea' composed after a seaside holiday visit to Southwold with his mother in August 1969. An early draft of the poem directly evokes both the photograph taken in Rhyl and the presence of Mr Cheetham.

> Earlier than war, when by a quack's terrain,
> On some Welsh beach my parents met,
> In the huge Edwardian lower middle class
> Innocent in boaters under grape-dark skies.

Although these lines were not retained in later drafts, the completed poem still carries a hidden and powerfully resonating biographical reference. Larkin, as narrator, recalls the time when his parents were listeners 'to the same seaside quack'.

The picture Larkin painted of his parents' life together is extremely negative. Essentially, he saw them as temperamentally unsuited and describes how their initial, high romantic ideals soon gave way to coldness. He told Monica Jones that he could not recall his parents 'making a single spontaneous gesture of affection towards each other' (Thwaite 2010, 106). However, a slightly different perspective emerges from Eva's own accounts, expressed in her correspondence and in the tape-recorded conversation, particularly in the memories recollected in widowhood. Perhaps with a degree of selective idealism they reveal far more positive examples of conjugal togetherness in their relationship – the enjoyment of visits to the cinema and theatre together, particularly after Sydney retired, and happy recollections of the conferences and dances they attended together.

Letters written by Larkin's parents reveal further glimpses of these more positive aspects in their relationship. In a letter written in 1944, for example, Eva tells her son about recent outings to the theatre:

> Last Thursday, Daddy and I went to Stratford on the little 'Alpine Train', and after a nice little tea at the 'Cobweb Café' we sat in deckchairs branded with U.S.A. on the green in front of the theatre. Daddy read and I dozed and watched the folk in turn. We had booked seats for the evening performance of *Midsummer Night's Dream*. We liked it very much indeed and hope to see *As You Like It* and possibly *Volpone*.

In a much earlier letter, written to Eva in 1916, Sydney Larkin displays a surprising degree of sensitivity and emotional response that is out of keeping with most of the biographical accounts of his character:

> Many thanks for your sweet letter received today. . . . I am sure it would be impossible for any man to be blessed with a wife more loving and thoughtful than you are and I try, even if I do not always succeed, to show my appreciation.

A poem such as 'To The Sea' indicates ways in which Larkin drew upon his family history for literary effect. Other poems owe a similar debt to his relationship with his mother. 'Mother, Summer, I', for example, completed in 1953, makes reference to Eva's lifelong fear of thunderstorms, a constant theme of her correspondence with Philip. Here he has her holding up 'each summer day, lest swarms of grape-dark clouds are lurking there'.

'Reference Point', written three years later, has its origins in one of Larkin's many weekend visits to Eva's house in Loughborough, and opens with a dramatized scene in which his mother hears the sound of him playing jazz records in another room, 'idly, / Wasting my time at home, that you / Looked so much forward to'. The origins of the poem did not completely unacknowledged by Larkin. 'The one about you saying "that was a pretty one" is being broadcast early in February', he told Eva in a letter in January 1956, 'you never thought, when you said it, that you'd be repeated over the BBC, did you?'

In 'Hospital Visits' Larkin recalls the death of his father from the perspective of his mother and reflects the fact that in February 1948 Eva had fallen and broken her wrist only weeks before Sydney died in Warwick Hospital. It is a poem full of the images of impending loss and anticipated widowhood:

> Thereafter night and day
> She came both for the sight
> Of his slowing-down body
> And for her own attending,

And there by day and night
With her blithe bone mending
Watched him in decay.

'Long Sight In Age' moves on to personify Eva's state of widowhood and
other poems such as 'The Old Fools' and 'Heads in the Women's Ward' owe
themselves to Philip's experiences of his mother's failing health and the stark
reality of institutional care which he observed when visiting her in a hospital
ward and nursing home. In these direct biographical ways Eva Larkin clearly
had an influence on her son's creative output. But also reflected in the long
years of their correspondence is a broader, more generic source of influence
that underpins so much of Larkin's poetry and in particular its association
with everyday human experiences and the emotions they generate in
us. Time after time the letters reveal what Josephine Hart referred to as
'the significance of small events and their defining pressure on individual
psychology' (Hart 2012). Clive James, perhaps the most perceptive of the
reviewers of the family letters, makes a similar observation, claiming that
the correspondence between mother and son acted as a means of continually
'restoring [Larkin's] supply of the precious ordinariness that she represented'
and a way of catching 'the more nuanced tones of everyday life' (James
2019, 89–90).

Beyond her existence as a poetic muse, it might also be argued that Eva
Larkin also provided her son with an important source of psychological
support and encouragement in relation to his work as a writer. Throughout
her life she approached Philip's work from a position of extreme pride,
coupled with a strong level of emotional engagement. It would be wrong
to argue that Eva offered a genuine critical eye to Larkin's creative output,
Monica Jones was far more effective in that respect, but she was certainly
his biggest champion and a continual source of encouragement. 'Well, I have
read "Jill" and I like it very much indeed', she wrote in November 1946,
following the publication of Larkin's first novel. 'I think it is beautifully
written and some parts are deliciously fresh and pleasing [. . .] The bow-tie
episode is very good, also the point where Jill takes shape in his mind. I felt
very sad over the many times she eluded John and wished so much for a
happy end to all his worries.' By contrast, his father's comments were more
elliptical. 'The story reads true', he told his son, 'I think, and that is a test
which generally satisfies me.' For Eva, there would always be a much more
personal, emotional and even empathetic connection with her son's writing,
such as when she first read a proof copy of his second novel later that year
'When I read in "A Girl In Winter" that Miss Parbury "moved her head on
her long neck, like a timid animal" I did wonder whether you were thinking
of me.'

Evidence suggests that Eva's capacity for literary engagement was much
stronger than that of her husband and it is tempting to attribute Philip's
own emotional sensitivity directly to his mother's influence. Writing to her

in 1955, he told her that he could never remember anything of the kind of letters his father used to write: 'They were very short and dry, weren't they? And slightly ironic.' Eva was quick to agree: 'Yes Daddy's letters were usually short and to the point. He never wasted words on non-essentials.' Nowhere is this more obvious than in her responses to Thomas Hardy, the author that Sydney Larkin admired so much and whose novels and poems he had first introduced to his wife-to-be. Philip had once deprecated his mother's interest in Hardy, telling Monica Jones that she had learned snatches of Hardy's poetry 'simply to please my father' (Thwaite 2010, 106). The archival evidence suggests that there is more to it than that. Even before Sydney died Eva was quoting Hardy confidently in her correspondence to Philip, in ways that showed how much she could associate with him. 'I hope, you too, will feel the benefit of the little change', she wrote in 1944, just after he had made a home visit from Oxford, 'and will have like Thomas Hardy in his poem, "In The Seventies", a certain inward vision that will cast a magic light on your goings to and fro – do you know this one? I think it is a marvellous one and not usually quoted.' In another letter from February 1958, a spell of cold weather that had brought with it terrific gales and squally showers that seemed to last all day reminded her of Hardy's poem 'The Homecoming' with its 'gruffly growling wind on Toller downland'. One line was particularly apposite to her own situation: 'And lonesome was the house, and dark: and few came there.'

Eva Larkin died in 1977 at the age of ninety-one. The last five years of her life had been spent in a nursing home just outside of Leicester. For the majority of these years she suffered from dementia and was unable to maintain the shared conversation with her son, especially by letter. The sudden and sustained loss of her capacity to communicate in writing makes for very painful reading. Larkin visited his mother regularly and kept up a daily stream of correspondence, telling her of his world and sending colourful picture postcards of animals and places he had visited. Sometimes, during his visits, he would also bring her old photographs to help her recall the past, including, perhaps, the ones taken in Rhyl. But summer had faded and would never return.

Within eight years of her death Philip Larkin himself would be gone. Weeks after his mother's passing he had finally completed his great and uncompromising poem about death, 'Aubade', perhaps his greatest poetic achievement. After that, there was little more for him to say, and no mother to say it to.

Bibliography

Booth, James, ed., *Philip Larkin Letters Home 1936–1977*. London: Faber and Faber, 2018.

Hart, Josephine, *Life Saving: Why We Need Poetry – Introductions to the Great Poets*. London: Virago, 2012.

James, Clive, 'Philip Larkin Letters Home 1936–1977', in *Somewhere Becoming Rain – Collected Writings on Philip Larkin*, 84–92. Basingstoke: Picador, 2019.

Lewis, Roger, 'Larkin's letters to the "Old Creature"', *The Times*, 20 October 2018.

Motion, Andrew, *Philip Larkin: A Writer's Life*. London: Faber and Faber, 1993.

Pullen, Philip, 'No Villainous Mother – The Life of Eva Larkin', in Dale Salwak (ed.), *Writers and Their Mothers*, 81–95. Basingstoke, Hampshire: Palgrave Macmillan, 2018.

Thwaite, Anthony, ed., *Selected Letters of Philip Larkin*. London: Faber and Faber, 1992.

Thwaite, Anthony, ed., *Philip Larkin, Letters to Monica*. London: Faber and Faber, 2010.

PART V

Poets and Writers

In her essay 'Hospitalspeak' (2000), U. A. Fanthorpe observes how Wordsworth tells a story of a marginalized character 'in such a way as to subvert the values of the society, including presumably those of the poet. The marginal ones come out on top' (34). This section, more than anything else perhaps, is about women writers giving voice to the marginalized and the muted – slaves, gypsy women, opposition activists (Elizabeth Barrett Browning), avant-garde artists, servants, ghosts (Myfanwy Piper), psychiatric patients, hospital cleaners, tortured historic landscapes (U. A. Fanthorpe) – while finding their own voice, not only pushing against societal expectations of their days but also battling their own insecurities. (Juliana Dresvina)

18

'Murder, He Wrote'

Elizabeth Barrett and Robert Browning

Julia Bolton Holloway

It was the great Victorian love story. But was it? Elizabeth Barrett Moulton Barrett ('Ba' being her nickname to her family and to Robert, 'EBB' elsewhere), was born on 6 March 1806 to a family of Jamaican slaveowners and Scottish slave traders in County Durham. Robert Browning was born 7 May 1812 to a family who owned slaves in St Kitts. He was poorer and younger than she, although he never discovered her true age. Both could claim African American connections, and Robert was part Jewish. She would love her husband's Judaism (on which he drew for *Bells and Pomegranates* and 'Rabbi Ben Ezra'), and also, cognizant of her African links, work intensely for the abolition of slavery, while Robert would strive to become the proper English gentleman: his official biography (1891) by Mrs Sutherland Orr, Frederick Lord Leighton's sister, denied his exotic ancestry. Kate Field, the Brownings' friend, relayed eye-witness information to Lilian Whiting, who in turn handed the baton to Jeannette Marks, who in 1938 published all this material, combined with careful research in the Caribbean, as *The Family of the Barrett: A Colonial Romance*, while Charlotte Porter and Helen Clarke had edited her *Complete Works* in 1900. Elizabeth died in 1861, Robert in 1889. In life, she had been more renowned than he; following her death, his ascendancy eclipsed her fame. She was more brilliant than he, having studied Latin, Greek and Hebrew as a child.

Robert Browning's *The Ring and the Book* declares: 'But Art may tell a truth / Obliquely.' In Italy, murder mysteries published in paperback, are called *gialli*, yellow books. In June 1860, Robert had bought at the San Lorenzo Market 'The Old Yellow Book' – a gathering of documents bound in vellum about a trial that took place in Renaissance Arezzo, where a husband murdered his wife. Robert brought that book home joyously, tossing it up in the air and catching it in front of the great gold-leafed framed mirror in the *salone* of Casa Guidi, their Florentine residence. Elizabeth, however, was not amused with his obsession, begging him to put the book away. Then Robert wrote his magnum opus, hiding his truth, obliquely, in plain sight. Ernest Jones, Freud's friend and colleague, observed that

> the occurrence of a dream within a dream (when one dreams that one is dreaming) is always found when analyzed to refer to a theme which the person wishers 'were only a dream', i.e. not true. I would suggest that a similar meaning attaches to a 'play within a play', as in Hamlet. So Hamlet (as nephew) can kill the King in his imagination since it is 'only a play' or 'only in play'. (Jones 1949, 101)

Similarly, Robert turned damning legal documents of fact into time-deflecting poetry and fiction, ringed within the frame of the mirror in Casa Guidi at its beginning and ending.

Let us therefore turn the tables on Robert and in this essay investigate his wife's death, as if in such a *giallo* as he bought, compiling the documents in the case, hypothesizing that Robert gave Elizabeth an overdose. Peter Dally's 1989 study clearly shows that the dosage of the pain-reducing drug Elizabeth was prescribed had become far too high. Robert's poetic themes so often involve husbands who kill their wives (*The Ring and the Book*, 'My Last Duchess') or their mistresses ('Porphyria's Lover'), while Andrea Del Sarto, the eponymous subject of another of Browning's dramatic monologues, feels that his wife, Lucrezia Del Fede (his model for the Madonna), has prevented him from becoming a Michelangelo, Raphael or Leonardo. Meanwhile, the text that attracted Elizabeth to Robert in the first place was his youthful *Paracelsus*, a poem that celebrates the inventor of her beloved – and deadly – laudanum.

Elizabeth is remembered today for her *Sonnets from the Portuguese*, which she wrote to Robert, creating of themselves the icon of ideal married love: they now lie asunder, she in Florence, he in Westminster Abbey. She prophesied their romance by referring to his *Bells and Pomegranates* in her *Lady Geraldine's Courtship*, then crafted the sonnet cycle while keeping it secret from Robert because of his tactlessness concerning women's writing. She played, fugue-like, with the silk-weaver's song, 'God's in His heaven, All's right with the world!', from Robert's *Pippa Passes*, in that sung by the child beneath Casa Guidi's windows of *Oh Bella Libertà*, in Part I, presenting their own child Pen, in *Casa Guidi Windows*, Part II, a poem

censored by the Austrians – just as were the red, white and green of the then forbidden Italian national flag she defiantly used for her Casa Guidi *salone* (*Arabella*, II.9). In *Aurora Leigh*, her bestselling epic poem/novel romance, which Ruskin proclaimed as better than Shakespeare, Elizabeth again presents their child, this time as a pomegranate, paying further tribute to Robert's *Bells and Pomegranates* (*Aurora Leigh* VI.562–5). She filled the Wimpole Street love letters to Robert (1845–6) with references to poppies and to Aaron's biblical robes, embroidered with bells and pomegranates – Aaron's wife, Elisheba, being also an Elizabeth. These letters Pen published in 1900, following Robert's 1849 publication of Elizabeth's *Sonnets from the Portuguese*.

The story of the Petrarchan sonnet cycle is heart-rending: at first they lingered in secrecy, owing to Robert's hurtful gaslighting; then, when Elizabeth finally had the courage to show them to him, it was Robert, acting as her literary agent, who profited from their sales. Robert later told Julia Wedgwood – who would abruptly distance herself from him – of seeing them for the first time in the summer of 1849, following Pen's birth, during their stay in Bagni di Lucca:

> Yes, that was a strange, heavy crown, that wreath of Sonnets, put on me one morning unawares, three years after it had been twined, – all this delay because I happened early to say something against putting one's loves into verse; then again, I said something else on the other side, one evening at Lucca, – and next morning she said hesitatingly 'Do you know I once wrote some poems about you?' – and then – 'There they are, if you care to see them', and there was the little Book I have here – with the last Sonnet dated two days before our marriage. (Curle 1937, 99–100)

In Sonnet XVIII, Elizabeth offered Robert a lock of her hair, mentioning she had thought that they would instead have been cut by the 'funeral shears':

> I never gave a lock of hair away
> To a man, dearest, except this to thee,
> Which now upon my fingers thoughtfully
> I ring out to the full brown length and say
> 'Take it' – My day of youth went yesterday –
> My hair no longer bounds to my foot's glee,
> Nor plant I it from rose or myrtle tree,
> As girls do, any more. It only may
> Now shade on two pale cheeks, the mark of tears,
> Taught drooping from the head that hangs aside
> Through sorrow's trick – I thought the funeral shears
> Would take this first; . . . but Love is justified –
> Take it, thou, . . . finding pure, from all those years,
> The kiss my mother left here when she died.

Following the deaths of her mother and her brother Edward, heir to the Jamaican slave estates, Elizabeth had already received a gift of a 'therapy' dog from her friend, Miss Mitford. The spaniel Flush was so like Elizabeth that he virtually became his owner's alter ego. He went with her when she and Robert eloped, realizing he must keep silent on the stairs of Wimpole Street. Later at Vaucluse, the site of Petrarch's residence, he dashed across the waterfall, being baptized, as Elizabeth said, 'in Petrarch's name'. The English climate suited him; Italy's did not. Poor Flush was to lose his curls to mange, and eventually die and be buried in Casa Guidi's cellars – to be resurrected by childless Virginia Woolf in her *Flush: A Biography*. But by then Elizabeth had her other and most miraculous alter ego, the baby Pen, whom she kept in long curls and who imitated her even to writing a 'great poem' in 1855, with a heroine named Lucy Lee, for which Jamaican mogul John Kenyon paid him a guinea. Elizabeth, the cripple, in constant pain, could bask in the energy of Flush, forever running away, and in Pen on his beautiful pony, relating to them as surrogate selves. She even told her sister Arabella that she and Robert confused their names, addressing the child as Flush, the dog as Wiedeman, suggesting that this was no longer proper, now that Pen had been baptized in the Swiss Evangelical Reformed Church (*Arabella*, I.264).

When Pen was born and Robert's mother Sara Ann Wiedeman died in March 1849, Robert seems to have had a mental breakdown, similar to the one just before the elopement, and which was also repeated at the time of Elizabeth's death. We catch him, depressed, saying gravely to Elizabeth, in 1850: 'Suppose we all kill ourselves tonight' (*Arabella*, I.290). Elizabeth had one successful pregnancy with Pen, but also suffered four miscarriages, endangering her life. The doctors counselled that she and Robert practice celibacy – which cannot have helped their domestic relationship. We find Elizabeth jokingly mentioning Robert's quarrelling in an 1852 letter to Arabella (*Arabella*, I.545). She also reflects their strong disagreements in the arguments between Romney and Aurora. Her money – which came from her poetry, her inheritances and from the slave and convict ship, the 'David Lyon' – was supporting the entire household: husband, child, servants, dog and an addiction to laudanum, yet she was not allowed to have access to it. Robert and Elizabeth increasingly argued over Pen, whom Robert wanted to be English, and Elizabeth wanted 'to be an intelligent human being, first of all. Time enough for national distinctions!' (*Arabella*, I.289). In a letter to her sister Arabella in 1860, Elizabeth quotes from an American newspaper, the *Boston Daily Evening Transcript*, mentioning her ahead of her husband:

> Another figure one is almost sure to meet on his little pony at four or five in the afternoon in the . . . Pincian. With his long light curls, and his gay little cap with a red feather stuck in the side. I do not know a more interesting sight or a more lovely boy. As he trots up the avenue with his father, or followed by his groom, all who know him delight to greet

him. His mother wrote 'Aurora Leigh' and his father is the author of 'Paracelsus'. (*Arabella*, II.463)

In June 1858, Sophia Peabody Hawthorne described further quarrelling at Casa Guidi: 'Mr Browning introduced the subject of spiritism, and there was animated talk. Mr Browning cannot believe and Mrs Browning cannot help believing' (1872, 344–7).

If we read 'Andrea Del Sarto' as a mirror of his marriage, jealousy seems to have seized hold of Robert, paralysing his poetic career. Robert writes of the past, Elizabeth of their present. Elizabeth's was the social, political and prophetic voice to the world: her poem, *The Cry of the Children*, effected changes in child labour laws when it was read in the English parliament; it made her name popular in Russia in the early 1860s and directly inspired Nekrasov's poem of the same title. In his anti-imperial address to the Piedmont Chamber of Deputies in 1852, Massimo D'Azeglio quoted from *Casa Guidi Windows* on the death of Charles Albert of Sardinia, a hero of the Italian Independence War, while Francesco Dall'Ongaro, who likewise fought for Italian independence with pen and sword, translated Elizabeth's poem 'A Court Lady', written about the noble Princess Belgioioso who worked in Garibaldi's hospitals (before Florence Nightingale became a nursing icon in Britain).[1] In *Runaway Slave at Pilgrim's Point*, Elizabeth champions a black slave who murders her child; likewise, in *Aurora Leigh*, she champions a self-taught single mother, Marian Erle, a gypsy. Both women are victims of rape. Robert was a social climber; Elizabeth a liberationist.

A justified jealousy seems also to have afflicted Elizabeth: for instance, when Robert lied to her that she was forbidden entry to the private library of Gabinetto Vieusseux on account of her sex, and its newspapers, safe from the Grand Duke's and the Austrians' censorship, consequently had to be filtered to her through Robert, who was not sympathetic to her political ideals (Kenyon 1899, I. 442). In March of 1859, Queen Victoria arranged that the Prince of Wales meet Robert while in Rome, rather than Elizabeth, another source of discontent for Elizabeth. She had escaped from the sickroom of Wimpole Street, presided over by her father Edward, who was mourning the loss of his slave wealth, to find herself still physically helpless, still enclosed in sickrooms, and now presided over by Robert, who carefully monitored her letters, her guests, their conversations and administered her tincture of laudanum drop by drop, steadily increasing the dosage. Living under double censorship, political and spousal, Elizabeth caught glimpses of the freedom Madame de Staël, Frances Trollope, George Sand, Félicie de Fauveau, Margaret Fuller and Harriet Hosmer enjoyed. Yet she kept the vows she made to Robert that fateful morning on 12 September 1846 in St Marylebone Church – to love, honour and obey. She upheld for both of them the ideal of poetic love in lawful matrimony. When she was proposed as Poet Laureate, she considered Robert the worthier nominee.

But an unjustified jealousy afflicted her over Lily Wilson. Lily was her faithful maid who witnessed her marriage to Robert, who procured her the laudanum she had been prescribed by physicians from childhood and who limited the doses, stopping them almost altogether to allow the successful pregnancy with Pen. When Lily – married in haste to Ferdinando Romagnoli, first in Florence, in a Church of England service, and then in Paris, in a Catholic one – bore another child, the Brownings dismissed Lily, leaving one child in England, the other in Italy, and separating husband and wife. Lily became paranoid about her husband living with Annunziata, her replacement. She would later, at Robert's arranging, take in the irascible poet Walter Savage Landor as her lodger in Via della Chiesa. Elizabeth knew Aeschylus' work in Greek, which she translated; in her Sonnet V, Elizabeth wrote of Agamemnon's children, and Lily called her two sons, so tragically raised apart, Orestes and Pylades, planning to call a daughter, if one were born, Electra. It was dangerous for Elizabeth that Lily (yet another alter ego, her given name also being Elizabeth) was no longer with her to protect her and carefully limit her laudanum dosage.

Elizabeth Barrett Browning was only fifty-five when she died, though she pretended to be ten years younger. She packed into those fifteen Italian years the writing of an epic poem longer than Homer's 'Odyssey', alongside her marriage and bringing up a son. In May of that year, Hans Christian Andersen visited the Brownings, commenting on how ill Elizabeth looked (*Arabella* II.536). Her last poem, 'North and South', was about him, since Robert, the child Pen and his young friends played Robert's *Pied Piper of Hamelyn*, processing through the rooms, and listened to Andersen's *Ugly Duckling*. In the last letter published by Frederic Kenyon, which breaks off unfinished ('Robert tears me away'), we witness exhaustion (II.448–50). But Baylor publishes a further revealing final letter with instructions to 'Messrs Boddington & Co' to sell the 'David Lyon', the ship used to transport African slaves to the Americas and English convicts to Australia, whose profits in the past had purchased her laudanum. There is something very troubling about this letter written – perhaps under coercion – by Elizabeth, on 15 June 1861.

Robert felt Elizabeth's poetic gift was spent. In a letter to her brother George, written from Asolo on 22 October 1889, he wrote: 'the publication of "Aurora Leigh" preceded by five years the death of its writer – who was never likely to produce such another (*sic*) work.' Robert was her literary agent during their marriage and, following her death, was undoing her fame by re-publishing her worst poems (*Selections* 1866, 1872, 1889). Apart from the 'David Lyon' ship money, Robert held the purse strings of all her earnings, her inheritances and John Kenyon's munificent bequest to them.

But one of those last disparaged works, 'A Musical Instrument', illustrated by Frederic Leighton, is of interest as a meta-poem, a statement about her poetic craft and life. It is also a poem in which Elizabeth takes up a theme she has often used before, drawing on her classical and

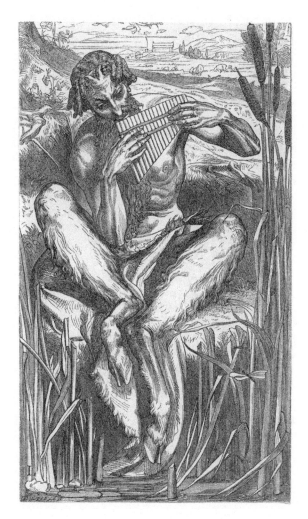

FIGURE 18.1 *Frederic Leighton, 'The Great God Pan'*
(*Cornhill Magazine*, 1860).

Christian learning – the 'Great God Pan'. Pan is a chimaera, part beast,
part man, related to centaurs, satyrs and fauns; EBB used to speak of
Flush as 'Faunus' too. Her poem echoes Milton on the death of the pagan
gods in 'The Morning of Christ's Nativity', both of them borrowing from
Plutarch's *De oraculorum defectu*. Nathaniel Hawthorne noted that in his
own *roman à clef*, *The Marble Faun* – which was also written with much
help from his wife, artist Sophia Peabody Hawthorne, yet credited to him
alone – Robert is Donatello, the Faun (Figure 18.1). Frederic Leighton
illustrated the poem for the July 1860 *Cornhill Magazine* (175–9), which
published both the engraving and poem together:

What was he doing, the great god Pan,
 Down in the reeds by the river?
Spreading ruin and scattering ban,
Splashing and paddling with hoofs of a goat,
And breaking the golden lilies afloat
 With the dragon-fly on the river.
He tore out a reed, the great god Pan,
 From the deep cool bed of the river:
The limpid water turbidly ran,
And the broken lilies a-dying lay,
And the dragon-fly had fled away,
 Ere he brought it out from the river.
High on the shore sat the great god Pan
 While turbidly flowed the river;
And hacked and hewed as a great god can,
With his hard bleak steel at the patient reed,
Till there was not a sign of the leaf indeed
 To prove it fresh from the river.
He cut it short, did the great god Pan,
 (How tall it stood in the river!)
Then drew the pith, like the heart of man
Steadily from the outside ring,
And notched the poor dry empty thing
 In holes, as he sat by the river.
 . . .
Yet half a beast is the great god Pan,
 To laugh as he sits by the river,
Making a poet out of a man:
The true gods sigh for the cost and pain, –
For the reed which grows nevermore again
 As a reed with the reeds in the river.

The verse about cutting the reed evokes *The Runaway Slave at Pilgrim Point*, in which slaves slash the sugar cane with their machetes. Robert, like Pan, would swim in the river at Bagni di Lucca, and that was where she shyly presented her clandestine sonnets to him, which he promptly marketed. In Pythagorean teaching there are two kinds of musical instruments: the harp, which is Reason, and the wind instrument, which is Nature, concerned with the world of procreation and sexuality (Holloway 1981, 2000). Yet in this poem Elizabeth seems to be speaking of her life and its thwarted sexuality as a sacrifice – which is killing her – made for the sake of her art. In its verbal echoes the poem is very close indeed to her magnificent translation of African Apuleius's *Cupid and Psyche*, the section where Pan rescues Psyche from her suicidal despair, telling her to love innocently. But it is now re-written, tending away from the Apuleian version towards that of

Ovid, where Pan seeks to rape a nymph, who becomes a reed which he then mutilates to make his instrument upon which to play.

Elizabeth leaves further clues about this poem's meaning. Thomas Adolphus Trollope in *What I Remember* (1887, II. 175–9) describes finding, enclosed among Isa Blagden's letters, at her death, one from Mrs Browning which is of the highest interest.

. . .

Dearest Isa, – Very gentle my critic is; I am glad I got him out of you. But tell dear Mr Trollope he is wrong nevertheless.

. . . There is an inward reflection and refraction of the heats of life . . . doubling pains and pleasures, doubling therefore the motives (passions) of life. I have said something of this in Aurora Leigh. Also there is a passion for essential truth (as apprehended) and a necessity for speaking it out at all risks, inconvenient to personal peace. Add to this and much else the loss of the sweet unconscious cool privacy among the 'reeds' . . . which I care so much for – the loss of the privilege of being glad or sorry, ill or well, without a 'notice'. . . . Yes! and be sure, Isa, that the 'true gods sigh' and have reason to sigh, for the cost and pain of it; sigh only . . . don't haggle over the cost; don't grudge a crazia, but . . . sigh, sigh . . . while they pay honestly . . .

But he is a beast up to the waist; yes, Mr Trollope, a beast. He is not a true god.

And I am neither god nor beast, if you please – only a

. . . Ba [EBB's childhood nickname].

We can see that Frederic Leighton, friend to both Robert and Elizabeth, has brilliantly understood her poem in his engraving. When he designed Elizabeth's tomb a year later, he seemed not to refer to Pan or to the other chimaera, but instead only to have it abound with harps – Greek, Hebrew and Christian – in reference to her great learning from her early childhood in Classics, the Bible and theology, combining his Hebrew harp of Exodus with the broken slave shackle of the Abolitionists. Yet Leighton's first, Greek harp has two confronting faces: one serene, the other distorted, which at first I thought signified Tragedy and Comedy, though I was uneasy about that identification. Then, one morning, I visited the Giardino Torrigiani in Florence, close to Casa Guidi, where Elizabeth would go and which Leighton would know, and where Isa Blagden and Frederic Tennyson, the Poet Laureate's brother, would also stay. And there it was, the god Pan, a bust upon a stele, one side of his face distorted, the other serene, the two profiles on the Leighton harp. On its stele are garlands and panpipes.

Towards the end, Elizabeth was deeply affected by her sister Henrietta's death from cancer, the final blow being the death of Camille Cavour, the architect of unified Italy which shattered EBB, just days before her own. Robert was wanting to see his father and sister who were living in Paris

(his father had lost a legal suit for breach of promise to marry a widow following the death of his wife, and was obliged to live on the Continent in exile or else be incarcerated). EBB's doctor, the Pole Gresanowski, warned Robert in Rome that Elizabeth could by no means make this journey to Paris, and Elizabeth wrote sadly to Arabella on 11 June this news (II.536–8), concerned for its effect on Robert. She had hoped her brothers could come to meet them there. On 15 June, she again wrote to Arabella, with more vivacity, embarking on a long discourse on Christianity, including discussing her opposition to the Church of England and such dogmas as the Thirty-Nine Articles (II.541–2). Robert, despite knowing of this letter, still gave her a shoddy Church of England burial instead of burying her by rites of the Swiss Evangelical Reformed Church into which she had had Pen baptized, and which to this day owns the 'English' Cemetery where she is buried.

Kate Field, the young American journalist, gave an eye-witness account in two letters written to her aunt of Elizabeth Barrett Browning's death and burial. On 29 June 1861, she described how they went to Casa Guidi to see Elizabeth's emaciated corpse, her hair shorn, like Pen's, and repeated Robert's blame of Dr Wilson (Dr Gresanowski having been absent from Florence) for his wife's death (Whiting 1902, 134–7). I do not recall it being said anywhere else that not only were Pen's curls cut off but so were Elizabeth's: that mirror-image identity, so crucial to the mother, shorn by the 'funeral shears'. Kate Field's narration matches that of Henry James in *William Wetmore Story and His Friends* (II.61–5), and by other contemporary accounts which quote Robert saying at the time that Dr Wilson had prescribed too much morphine. Elizabeth in her drug-induced euphoria was reported as speaking of the bedroom curtains as hung with Hungarian colours (Marks 1938, 657, quoting James, II.61–5), of red, white and green, the same as the Italian colours she had used for the windows of Casa Guidi in defiance of the Austrian laws. Dr Wilson was opposed to laudanum and would not have overdosed her. Dr Gresanowski, of the fine bedside manner, was an enabler (Whiting 1902, 134–7; Dally 1989, 194–5). Robert was knowledgeable about these opiate drugs, more so than Elizabeth, and it was he who counted and administered the drops after Lily Wilson was dismissed from service. In all these accounts, the common source is Robert, the sole witness to Elizabeth's death.

Field describes the chaos of the funeral, conducted on 1 July 1861 and badly carried out (Whiting 1902, 137–8). The English Cemetery's archives concerning Elizabeth Barrett Browning's burial give more clues. Two ledgers were created contemporaneously, and a third listed burials in temporal order, copied out in 1877 from the previous records; likewise an alphabetical register. Further ledgers give the burial expenses, the duplicate receipts for these funeral expenses and the receipts for the payments to the grave-digger. None of these give Elizabeth's status, though this is mandatory, as married, nor her parentage, and not even her proper age. In all the documents this is given incorrectly as '45', rather than '55'. We recall that she did not tell her

husband she had visited the Battlefield of Waterloo immediately following Napoleon's defeat, although she described a child loosed upon that same battlefield in *Aurora Leigh*. Nor does her tomb give her birth date, only that of the year of her death: O+B+1861. Her initials are given, E+E+B, but not her name, as if Robert penny-pinched on the payment to the stonemason, who would have charged for every letter.

As for the funeral expenses, Signor L. Gilli, Inspector of the Cemetery, receives 271 paoli for the funeral of Elizabeth Barrett Browning, out of which he pays a tax to the English Church of 113 paoli. Further payments are made to the English Pasteur: 108 paoli for conducting the service, and 10 paoli for his carriage. Further payments still are made for him to have crepe for his hat and gloves. But Elizabeth's religious leanings, from Pen's christening through to her last letter to Arabella, clearly show she would have wanted to be buried by the Pasteur of the Swiss Evangelical Reformed Church – not by that of the Church of England. Other than for a pauper's funeral, this is the lowest amount paid at this time for an adult funeral. Those of Charlotte, Countess of Strathmore and Kinghorn, and of Theodore Parker cost more than 1,000 paoli each.

Ferdinando Giorgi, Master Mason, is paid a total of 760 lire toscani from Signor L. Gilli for the burial of sixteen persons, the first of which is #737, Elizabeth Barrett Browning's. Normally, Ferdinando Giorgi is paid 45 Tuscan lire a burial. He receives 90 Tuscan lire for EBB's burial, number #737, because he has to dig two graves – which means the Swiss Evangelical Church this time only received 68 paoli. The digging of two graves is puzzling. Had Robert had one dug for himself when his time came? Had another body been found in it while digging the first? The answer to this question can perhaps be found in Mrs Sutherland Orr's *Life and Letters of Robert Browning*. Orr notes that in September 1861, Robert wrote from St.-Enogat, near Dinard, where he was staying with his father and sister, two months after Elizabeth's burial, to request Isa Blagden to arrange for his wife's body to be moved from one grave to another, as this was required for the subsequent placing of the monument designed by Leighton (Orr 1891, 395–6).

Earlier, Elizabeth had noted Robert's great fear of cemeteries. He had refused, for instance, to go to the funeral and burial of his first cousin, James Silverthorne, the other witness at their wedding (*Arabella* I.490–1, 494). Mrs Orr similarly observed this of Robert and remarked of this letter: 'The dread expressed in this letter . . . connects itself with an habitual aversion for the paraphernalia of death, which was a marked peculiarity of Mr Browning's nature' (366–7), noting that he never visited Elizabeth's grave. Nathaniel Hawthorne likewise vividly described Browning's – and Donatello's – horror of death.

Robert, who wrote poetry on the ordering of tombs and who was himself indulging in sculpture with William Wetmore Story, rather than writing poetry, at the end of Elizabeth's life, allowed Frederic Leighton to design

Elizabeth's tomb, and Francesco Giovannozzi to carry it out. Leighton had studied at the Accademia di Belle Arti and would become president of the Royal Academy. His earliest triumph had been his painting of what Elizabeth had already described in *Casa Guidi Windows*, the 'Procession of Cimabue's Madonna from Borgo Allegri to Santa Maria Novella', a huge canvas purchased by Queen Victoria when he was twenty-four. Leighton also illustrated George Eliot's *Romola*, including the despicable Tito's return home to her, which both author and artist set in the house of Elizabeth's friend, Seymour Kirkup, on Via dei Bardi, Oltrarno (later obliterated in the Second World War bombings).

Robert who – after the initial years of marital bliss – would, like Tito, often go out at night, leaving Elizabeth at home, left Florence with young Pen immediately after the funeral, accompanied by Isa Blagden. He proceeded to write *The Ring and the Book*, the Aretine and Roman trial account in verse about spousal abuse and murder, as if it were his own confession. We might read Caponsacchi-Robert as Elizabeth's rescuer from the bondage of Wimpole Street, Franceschini-Robert as her husband who constantly quarrelled with her publicly over politics, over spiritualism, over their child. Robert administered Elizabeth's laudanum, following her loyal maid's dismissal; as the author of *Paracelsus*, the inventor of laudanum, he was fascinated by the drug and may have knowingly overdosed her, while blaming Dr Wilson for doing so. He carefully explained to everyone, as if it was a mercy killing, that she was unaware that she was dying, only that she was in a state of euphoria from the drug, with himself the sole witness. She did not die haemorrhaging from the lungs with tuberculosis (Dally 1989, 194–5).

Leighton's tomb for Elizabeth is a magnificent monument. Elizabeth's fellow poet Emily Dickinson wrote 'The Soul selects her own Society' to it (Holloway 1983), and the Abolitionist Frederick Douglass visited it on 11 May 1877 (Library of Congress). But Robert never saw it, and never returned again to Florence. Pen did, however, when he was living in the Torre di Antella while seeking to make Casa Guidi a museum, searching out memorabilia of his parents which upon his death were all dispersed in auction sales. Leighton did return to Florence and did see the work in progress, and was deeply angered by the changes made to his design by Francesco Giovannozzi and tolerated by Count Cottrell, Robert's close friend. Lilian Whiting's biography of *Kate Field*, who had been present at that funeral, tells us of that explosion, Christmas Day, 1864, nearly three and a half years after the funeral (Whiting 1902, 157). (Figure 18.2)

Count Cottrell, granted his title by the Grand Duke of Lucca for his services as Chamberlain, had refused to go to the English Cemetery for the burial of one of his children, Carlo Lodovico, and Robert exceptionally officiated for him as chief mourner (*Arabella*, II.322–3). In some of the earlier *Letters to Arabella* the relations between the Cottrells and the Brownings became decidedly strained, for Mary Trepsack had had her

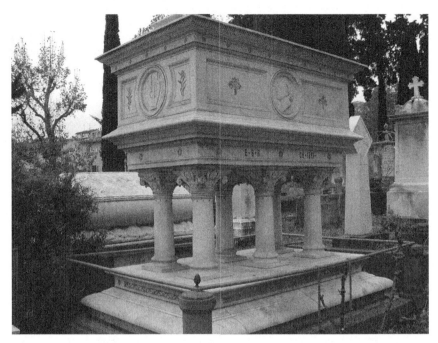

FIGURE 18.2 *Elizabeth Barrett Browning's tomb, Cimitero degli Inglese (The English Cemetery), Florence (photo: Julia Bolton Holloway).*

life savings conned from her and lost in a bankruptcy by the Cottrell relatives, partly through Robert's conniving, while Elizabeth desperately tried to get reparations paid to her, even as she obeyed Robert by keeping secret from her brothers his involvement in the case (*Arabella* I.268–9, 271–2, 286, 305, 311, 349–50). Mary Trepsack was the beloved freed slave in the Barrett Moulton Barrett entourage, who had paid for the publication of Elizabeth's second magnum opus, *The Essay on Mind*, in 1826 (Elizabeth's first magnum opus, *The Battle of Marathon*, was begun when she was eleven, and was privately printed by her father in 1820). Robert now put Count Cottrell in charge of overseeing his wife's tomb in Florence.

Browning writes, in 1866, to George Moulton-Barrett, Elizabeth's younger and favourite brother (284–5) about the monument:

> . . . if my circumstances had only allowed me to put up a wooden cross, that would have sufficed. But I was fortunate in the sympathy of Leighton, and so, I hope, have been able perhaps to manage that the little which is done, is on the whole well done. I could not be on the spot and care for the execution personally – and mistakes were made at first which have been rectified since: but, by the photographs, I judge that Leighton's work is adequately rendered, – and we must be content.

Elizabeth's absence from her own tomb is strange. There is no medallion portrait of her, only an ideal figure of Poesy, and we learn from Robert's letter to Isa Blagden (19 January 1863) that the Italians, through Cottrell, sought to pre-empt Leighton's design, and that Robert himself decided against having her portrait:

> I have determined at last that the central medallion shall be appropriated, not to a Portrait, but to an ideal head of 'Poetry': a portrait proves to be impossible, – one, that is, which we would accept: there is nothing to be done but submit to a necessity – for any playing with the truth there would be hateful to me. (185–6)

Later Robert told Frederic Leighton (20 August 1863) that he had sent portraits of Elizabeth to him. Finally he wrote to Isa (19 October 1864) about Leighton's explosion concerning the badness of the execution, speaking of the portrait medallion as altered, the head no longer to one side, no longer with spaniel locks, as she described in Sonnet XVIII, to falsely 'better' it:

> It was fortunate indeed that I was saved from the addition to my annoyances which I should have had to bear had my journey been to Florence. Leighton writes to me that nothing can be more impudently bad than the execution of his designs. . . . The Profile is 'less slovenly than the rest', though open to many objections – 'the hair, with that designing of which I took great pains, is entirely different: the fellow had the coolness to say that he thought I had probably done the thing hastily without nature, and that he had put up a plait, and done the thing afresh himself (if you could see it!) – also, in the ear, "ho cercato di migliorare!" he added that he had obtained from . . . Count Cottrell the sanction to improve these parts of the work – let us hope there is no truth in this. Cottrell says he saw all the criticism I make, himself – but that he thought it better to leave them to me to make, as the mischief was irremediable' – On the contrary, Cottrell wrote to me that it was 'extremely well-executed', – and as he paid up the last instalment, though not due till the work was really erected, I have no sort of remedy. Don't say one word about this – I won't have any wrangling over – literally – the grave. (194–5).

Leighton had other errors changed, but Robert connived at the false portrait medallion on the most visible part of the tomb. Not only is Elizabeth's name absent from her tomb, but so also is Frederic Leighton's, while 'FRANCESCO.GIOVANNOZZI.FECE' in great capitals is sculpted onto its base. It is a tomb to which the 'Ba' – the Soul, according to the Egyptian *Book of the Dead* – lacking image or name, would be unable to return. A double dying, a double murdering. One wonders who paid for the tomb?

Most likely Leighton, so deeply disturbed that his homage to Elizabeth was thus countermanded into the oblivion of her name and her likeness.

On it there are no lines from her poems. In place of her name there is just E+B+B; no birth date, only the death date O+B+1861. However, it seems from his sketches that Leighton conceived it not as a classical sarcophagus so much as a medieval saint's tomb, with space under it for pilgrims to enter, like Edward the Confessor's Tomb in Westminster Abbey. When Elizabeth was preparing herself for the elopement with Robert, she dared to go outside, to take walks, and on one of those walks visited Westminster Abbey and its Poets' Corner, where her husband would come to be buried far apart from her. This is how she described it, on 31 July 1846, observing a tomb of another great Puritan poet:

How grand – how solemn! Time itself seemed turned to stone there! . . . we stood where the poets were laid – oh, it is very fine – better than Laureateships and pensions. Do you remember what is written on Spenser's monument – 'Here lyeth, in expectation of the second coming of Jesus Christ'.[2]

Notes

1 Margaret Fuller, the American journalist and women's rights advocate worked with Cristina Trivulzio di Belgioioso in the Roman hospitals during the siege (Deiss 1969); Elizabeth based her character of Aurora on Margaret (Holloway 1995, 467–8). Interestingly, Elizabeth Barrett Browning disliked the subsequent Nightingale-worship stating, quite rightly, that the same men, who extol women who nurse, belittle women who are thinkers and writers. If a hospital nurse is the best application for a talented woman, observed Elizabeth, 'then woe to all us artists!'.

2 This study relies on primary materials: the archival documents (mostly unpublished) of the Swiss Evangelical Reformed Church, the Hawthornes's *Diaries*, the Letters, and the detailed biographies of the Brownings written with contemporary knowledge by Mrs Sutherland Orr. Her official *Life and Letters of Robert Browning* (1891) features a frontispiece of Pen's painting of his father holding 'The Old Yellow Book'; it provides copies of letters supplied to her by Miss Sarianne Browning (being specifically commissioned to deflect the suspicion concerning Robert's ancestry as Jewish, which Mrs Orr tackles in her first paragraph). Members of the Jamaican Barrett family have presented important books to the English Cemetery's Mediatheca 'Fioretta Mazzei' on EBB's Jamaican slave-holding background. More recent scholars, among them Marjorie Stone, continue instead Robert's suppression of their mixed-race background, though the National Portrait Gallery likeness by Michele Gordigiani, painted in 1860, carefully documents EBB's Créole features, as did also William Page's 1854 portrait of Robert. I concur with Elizabeth's honesty in celebrating their rich mixed-race heritage.

Bibliography

Artom Treves, Giuliana, *The Golden Ring: The Anglo-Florentines 1847–1862*, trans. Sylvia Sprigge. London: Longmans, Green, 1956.

Assheton Barrett, Robert, *The Barretts of Jamaica: The Family of Elizabeth Barrett Browning*. Winfield: Wedgestone, 2000.

[Barrett Browning, Elizabeth], *Selections from Elizabeth Barrett Browning's Poetry*, ed. Robert Browning. London: Smith, Elder & Co., 1866, (1872), (1889).

Barrett Browning, Elizabeth, *The Complete Works*, ed. Charlotte Endymion Porter and Helen Archibald Clarke [1900]. New York: AMS Press, 1973.

Barrett Browning, Elizabeth, *Aurora Leigh and Other Poems*, ed. John Robert Glorney Bolton and Julia Bolton Holloway. London: Penguin Books, 1995.

Barrett Browning, Elizabeth, *The Works of Elizabeth Barrett Browning*, ed. Sandra Donaldson et al., 5 vols. London: Pickering & Chatto, 2010.

Barrett Browning, Robert, ed., *The Letters of Robert Browning and Elizabeth Barrett Browning 1845-1846*, 2 vols. New York and London: Harper & Brothers, 1898.

Browning, Robert, *Dearest Isa: Robert Browning's Letters to Isabella Blagden*, ed. Edward C. McAleer. Austin: University of Texas Press, 1951.

The *Brownings' Correspondence: An Online Edition*, https://www.browningscorrespondence.com/

Curle, Richard, *Robert Browning and Julia Wedgwood: A Broken Friendship as Recorded in Their Letters*. New York: Frederick A. Stokes Company, 1937.

Dally, Peter, *Elizabeth Barrett Browning: A Psychological Portrait*. London: Macmillan, 1989.

Deiss, Joseph Jay, *The Roman Years of Margaret Fuller: A Biography*. Crowell: New York, 1969.

Donaldson, Sandra, *Elizabeth Barrett Browning: An Annotated Bibliography of the Commentary and Criticism, 1826–1990*. New York: G.K. Hall, 1993.

Douglass, Frederick, *Diary (Tour of Europe and Africa)*. Washington, DC: Library of Congress. https://www.loc.gov/item/mfd.01001/

Faulkner, Raymond O. and Carol Andrews, *The Ancient Egyptian Book of the Dead*. Austin: University of Texas Press, 1990.

Hawthorne, Nathaniel, *The Marble Faun, or the Romance of Montebeni*. Boston: Ticknor and Fields, 1860.

Hawthorne, Sophia Peabody, *Notes on England and Italy*. New York: Putnam, 1872.

Holloway, Julia Bolton, 'The Asse to the Hare: Boethian Music in Chaucer', in Michael Masi (ed.), *Boethius and the Liberal Arts*, 175–86 (1981); repr. in *Tales within Tales: Apuleius through Time*, ed. Constance S. Wright and Julia Bolton Holloway. New York: AMS Press, 2000.

Holloway, Julia Bolton, 'Death and the Emperor in Dante, Browning, Dickinson and Stevens', *Studies in Medievalism* 2, no. 3 (1983): 67–72.

Holloway, Julia Bolton, 'Robert Browning's "Andrea Del Sarto" as Double Self-Portrait', http://www.florin.ms/AndreaSarto.html

Holloway, Julia Bolton, *White Silence: A Virtual Guide to Florence's English Cemetery*, http://www.florin.ms/WhiteSilence.html

Hood, Thurman L., *The Letters of Robert Browning*. London: John Murray, 1933.

Jones, Ernest, *Hamlet and Oedipus*. New York: W.W. Norton, 1949.

Karlin, Daniel, *Robert Browning Elizabeth Barrett: The Courtship Correspondence*. Oxford: Clarendon Press, 1989.

Kenyon, Frederic G., ed., *The Letters of Elizabeth Barrett Browning*. New York: Macmillan, 1899.

Leighton, Angela, *Elizabeth Barrett Browning*. Brighton: Harvester, 1986.

Lewis, Scott, ed., *The Letters of Elizabeth Barrett Browning to Her Sister Arabella*, 2 vols. Waco: Wedgestone Press, 2002.

Marcus, Julia, *Dared and Done: The Marriage of Elizabeth Barrett and Robert Browning*. London: Bloomsbury, 1995.

Marks, Jeannette, *The Family of the Barrett: A Colonial Romance*. New York: Macmillan, 1938.

Schornhorst, Gary, 'Kate Field and the Brownings', *Browning Society Notes* 31 (2006): 35–58.

Shore, Joseph and John Stewart, *In Old St James (Jamaica): A Book of Parish Chronicles*. Kingston: A.W. Gardner, 1911.

Stone, Marjorie, *Elizabeth Barrett Browning*. Basingstoke: Macmillan, 1995.

Stone, Marjorie, 'Elizabeth Barrett Browning', in *Oxford Dictionary of National Biography*. Oxford: Oxford University Press, 2004–10.

Sutherland Orr, Mrs [Alexandra], *Life and Letters of Robert Browning*. Boston: Houghton, Mifflin, 1891.

Timko, Michael, *Robert Browning and Magari: A Faint Show of Bigamy?* Waco: The Armstrong Browning Library, Texas, 2006.

Trollope, Thomas Adolphus, *What I Remember*. London: Richard Bentley, 1887.

Ward, Maisie, *Robert Browning and His World: The Private Face*. London: Cassell, 1968.

Ward, Maisie, *The Tragi-Comedy of Pen Browning, 1849–1912*. New York: Browning Institute, 1972.

Whiting, Lilian, *Kate Field: A Record*. Boston: Little, Brown, 1900.

Whiting, Lilian, *A Study of Elizabeth Barrett Browning*. Boston: Little, Brown, 1902.

Woolf, Virginia, *Flush: A Biography*. London: Hogarth Press, 1933 (with endpapers of EBB in London and Florence by Vanessa Bell).

19

Golden Myfanwy

The Domestic Goddess Who Turned the Screw

Eleanor Knight

Married to one of Britain's most prolific twentieth-century artists and librettist to its most celebrated composer, critic and dramatist Myfanwy Piper was at the heart of British modernism for decades. Conspicuous in her lifetime for the formidable and generous intellect that made her such a valued collaborator, she has, reputationally, as time passes, begun to fade away behind the Great Men with whom she is associated: she was John Piper's wife, Benjamin Britten's librettist and adapted the works of Henry James for the stage and was hailed (largely by the man himself) as John Betjeman's muse.

Like that of many women who have juggled creative lives with family and domestic work, Myfanwy Piper's professional output is haunted by a ghost portfolio, the what-if works of a parallel, less interrupted working life. It's tempting to wonder that if only she hadn't had so much else to do, she might have written more, achieved more: indeed, the introduction to this volume asks just that of all the women featured here. The inference is clear: while her husband John's prolific output[1] remained discrete from family life, Myfanwy's work necessarily took a back seat. Poor her. Career suicide. The dreaded pram in the hall.

But isn't it more honest to look at Myfanwy Piper's achievements holistically? Instead of thinking of her work getting done in spite of everything else she had to do (and she was a very busy woman) here is an opportunity to ask if all aspects of such a life can't be regarded, in the round,

as art – a life that encompassed dazzling scholarship, influential criticism, facilitation of the work of others, childrearing, home-making; a life whose very modus operandi was interruption and which, I hope to demonstrate, led to one of the most significant artistic collaborations of the mid-twentieth century, Benjamin Britten's chamber opera, *The Turn of the Screw*. I offer here not a comprehensive biography of Myfanwy Piper (for that, look no further than Frances Spalding's superb *John Piper, Myfanwy Piper: Lives in Art*, 2009); this is, rather, an appreciation of the way in which Myfanwy's combined intellectual, artistic and domestic talents, her confidence of taste and her ability to put herself in the service of others, led to her most enduring creative achievements. I hope also to demonstrate that while childrearing and housekeeping are regarded traditionally as 'feminine' roles, that is not in any way to say that they are separate from or inferior to creative work. That is an economic distinction. Male artists and writers are missing an opportunity if they think that domestic life is not examinable life.

Mary Myfanwy Evans was born in London in 1911. Her mother was English and her father, a dispensing chemist, was Welsh. The three of them lived above their shop in England's Lane, Hampstead. Keen on art and books, Myfanwy attended the North London Collegiate School and from there, in 1930, won an exhibition to study English language and literature at St Hugh's College, Oxford – no mean feat, as with only four colleges available to them, Oxford's early women undergraduates had to be several times cleverer than the men just to be allowed in.

Myfanwy was sporty too, and complemented her time studying in the library by ploughing up and down the swimming baths and captaining the Oxford women's swimming team. Interested in contemporary art, she kept up to date with the reviews in *The New Statesman*, particularly those written by the young artist and critic John Piper, whose straight-talking style and ability to shoot from the hip she found refreshing. 'There is someone I could talk to, and what's more, he would make me laugh', she said (Spalding 2009a).

It was at St Hugh's that she made friends with the architect Justin Blanco White, and in 1934, after graduation, it was through Justin that she found herself invited to a painting weekend at Sizewell, hosted by Ivon Hitchens, a senior member, at that time, of the collection of artists known as The London Group.

Myfawny was met from the train by a tall, wiry, serious-looking man, about ten years her senior, with a car. He introduced himself as John Piper. What luck! For this was the very same John Piper she had so enjoyed meeting in print. And how fortuitous that John's friends had thought to send him on the errand. Perhaps they knew he needed cheering up: his first marriage, to the abstract painter Eileen Holding, had come to an end and he had been living alone for the last couple of years. John and Myfanwy went for a swim in the sea on the way home – actually Myfanwy said 'we bathed', after which the two of them ran up and down on the beach to dry off. For

the rest of their lives they were, as David Fraser Jenkins said in Myfanwy's obituary, 'a duet'.

Collaboration was at the heart of John and Myfanwy's partnership from the start. Asked what Myfanwy had contributed most to his life, John answered 'acute intelligence'. There is no doubt that Myfanwy's perspicacity benefited not only John, whose de facto assistant she became, but a number of prominent figures working across the arts during the period of mid-century British modernism. She championed the work of abstract artists, produced a body of intelligent and sensitive art criticism, and at weekends entertained– in a house with no mains electricity or running water – what now reads as a register of mid-century creative collaboration.

Two such visitors in the early days were Barbara Hepworth and Ben Nicholson. Never one to shy away from animated debate, when Myfanwy recorded that having the two prominent artists to stay was 'hell', she was referring to the irreconcilable dispute between John and Nicholson over the nature of abstract art (Spalding 2009a, b). The political factionalism of the late 1930s was being felt in the art world – specifically within abstraction and surrealism – and was playing out among some of John and Myfanwy's associates. John, who valued artistic freedom above all, saw abstraction as fluid, an ongoing experiment from which he might return to figurative work as and when he pleased, whereas Nicholson wanted to strive for purity. But there may have been a more prosaic reason for Myfanwy's strong feelings about the couple's visit to the out-of-the-way and, at that stage, primitive living conditions of Fawley Bottom (and, just maybe a reason that Ben Nicholson was so keen on keeping order in the face of chaos). At that time, the Nicholson/Hepworth household comprised a teenage son and infant triplets.

In happier times, Barbara Hepworth – eight years her senior – might well have served as a role model for Myfanwy, as a woman who was happy for her domestic life to nourish her art. Committed to sculpture from an early age, Hepworth was ambitious and prolific. She argued that, far from being diminished by childcare, cooking and so forth, even dealing with measles 'in triplicate', the richness of such a life is invaluable and provided one does even just half an hour's work a day, 'the images grow in one's mind' (Hepworth [1971] 2019). The images growing in Hepworth's mind were abstract, organic forms corresponding intimately with the natural world, and both Barbara and Myfanwy were to find liberation away from the figurative; to find new possibilities, particularly for women, in the language of abstract forms.

Myfanwy's total immersion into the world of abstraction had come in 1934, when she and John took a trip to Paris to visit the artist Jean Hélion. As Myfanwy toured his studio, Hélion suggested to her that a magazine introducing abstract art to a British audience might be a good idea, and that she would be the perfect editor. At only twenty-three, Myfanwy was a little uncertain that she could pull it off, but John and Jean persuaded her

otherwise, and so began the first British journal of non-objective art, *Axis*, which, over eight issues until Winter 1937, became a sourcebook for artists as well as bringing the ideas of abstract art to cultural institutions in a way that could be understood by the general reader.

Another of Myfanwy's Oxford contemporaries, the art historian Nicolete Gray, who organized the 1936 exhibition 'Abstract & Concrete', wrote that 'although men were generally responsible for the commercial promotion of British modernism, educating the public about the ideologies of the avantgarde became the mission of an enlightened group of women' (Gardner-Hugget 2000, 22). Such a woman was Myfanwy, and she not only had a guiding hand in these matters – as the editor of *Axis* she wielded considerable pulling power.

The contributors were stellar: Henry Moore, Barbara Hepworth, Ben Nicholson, Picasso, Miro, Kandinsky and more, all appear in the first issue of January 1935. Artists were happy to showcase their work, with or without payment in those lean times; as Frances Hodgkins put it, 'The bread you cast upon the waters often came back buttered' (Gardner-Hugget 2000, 23). Equally remarkable are Myfanwy's editorials, written with commanding clarity and an impressive confidence of taste at a time when manifesto fever had well and truly taken hold of the contemporary art world. Here she is extolling the virtues of abstraction in her inaugural editorial 'Dead or Alive', for *Axis* in January 1935: 'The shapes of things and the shapes between things become a vocabulary slow to expand but gradually multiplying and growing flexible, till a new complexity of expression is reached.' It takes a certain confidence in a young Oxford graduate to allow that meaning might emerge fluidly and organically in any discipline, rather than be ascribed or defined, and Myfanwy's affinity with abstraction also allowed her to respond instinctively to music.

Writing about *Axis* for the *Women's Art Journal*, the American art historian Joanna Gardner Huggett observes that Myfanwy's 'pioneering vision' helped create an environment wherein artists felt free to experiment with abstraction and surrealism away from the English straitjacket of figure, narrative and meaning – not bad for someone who called herself an amateur. Like Barbara Hepworth, Myfanwy felt at home in abstraction; in the moment, free of structure or artistic prescription. But she had her feet on the ground, too. As *Axis* approached its final issue, she made a typically bold statement that 'if art is to have any importance it must be intimately related to life in its own time'. And this was the very time to come down on the side of freedom. Jean Hélion, on whom Myfanwy had relied for contributors, had left Paris for New York, while the Nazis were implementing a policy of cultural vandalism, or 'approved art'. The most important thing for artists at this juncture was survival.

Only twenty-six when *Axis* folded in 1937, Myfanwy had never exactly conformed to the standard image of art aficionado. The dominant voice in art history at the time was still the patrician tone of Roger Fry, and would

continue to be so for decades. There was the privileged Kenneth Clark, one of the many friends of the Pipers, who, at the freakishly young age of twenty-seven had been in charge of the Ashmolean Museum and at thirty was running the National Gallery. And meanwhile Peggy Guggenheim, with the benefit of an enormous fortune inherited from her father who went down on the Titanic, did that service to art so imperative to its survival: she bought it.

At the same time as the nascent art critic Myfanwy Evans was interpreting major works of abstraction in print, there were more concrete tasks to be getting on with at home, specifically, accommodation. Myfanwy (at this time teaching once a week at Morley College) and John needed a place to live and work within easy travelling distance of London. At Myfanwy's suggestion, they stuck a pin in the map, and so went to explore the Henley area, discovering a derelict farmhouse at Fawley Bottom. They arranged a peppercorn rent with the Stonor Park Estate, to whom it belonged, and moved in. Visitors swiftly followed: Alexander Calder, Fernand Léger, László Moholy-Nagy, Naum Gabo and, of course, Barbara Hepworth and Ben Nicholson. A happy (for the most part) confluence existed between the pages of *Axis* and Fawley Bottom's visitors' book, not to mention Kenneth Clark, John Betjeman, Paul Nash and on it goes. In fact, for more than twenty years, the Piper household functioned as the unofficial weekend retreat for mid-century modernism, and Myfanwy excelled as its hostess. Eager not to miss out on the art world's most talked-about afternoon tea, Her Majesty Queen Elizabeth the Queen Mother, who had commissioned a series of paintings of Windsor Castle from John during the war, dropped in one day in 1962.

Resourceful, imaginative and determined, Myfanwy taught herself French cuisine from Xavier Boulestin's 1923 classic *Simple French Cooking for English Homes* (the volume which in turn inspired Elizabeth David) and pioneered her own version of high-end continental peasant fare on a two-ring stove, the results of which she served up by candlelight – not for romantic effect, but because the house had no mains electricity until 1958. Water had to be fetched from a well.

Accounts of Myfanwy's life have tended to dwell rather on this aspect of it, particularly a number of the wide-eyed obituaries written by some of those who had experienced or heard tell of the Pipers' haphazard and brainy style of hospitality. However did she do it, they wonder. Frances Spalding's excellent dual biography rightly, though somewhat reluctantly, describes Myfanwy as 'the lesser figure' in terms of output while revelling in the colourful domestic detail of Fawley Bottom. In contrast to John's rangy, monastic presence, Myfanwy presents as solid, cheery, capable; someone who fetched family and friends by pony and trap and could, for example, and did answer the door to Natasha Spender with a baby wedged on one hip while she whisked away at a bowl of eggs and chatted away about art and all the latest books (Spalding 2009a, b).

Once the children arrived, it was Myfanwy's role as the domestic goddess that the poet John Betjeman found most appealing and it is his breathless, sicky paeans to her maternal saintliness that have retrospectively conferred on her the dubious status of muse. Considering the classical role of the muse, and specifically its eroticization in Rodin's 'The Poet and the Muse' and 'The Eternal Idol', feminist aesthetician Carolyn Korsmeyer points out in *Gender and Aesthetics: An Introduction* that 'mythologizing feminine creativity by ascribing it to non-human beings pushes actual women to the margins of artistic activity – in deceptively complimentary terms – and assigns to men the social role of actually creating art' (Korsmeyer 2004, 20). But there was nothing ethereal about Myfanwy's gutsy approach to modern art, writing, childcare or even entertaining.

While the two Johns, Betjeman and Piper, were busy collaborating on the Shell Guides, an attempt to reconnect a war-ravaged nation with itself, Betjeman spent a good deal of time at Fawley Bottom, or 'Fawley Bum' as he sniggeringly called it, observing Myfanwy in action. If you want to see a busy, intelligent woman's life transfigured by the puppy-eyed gaze of male privilege, look no further.

> Kind o'er the kinderbank leans my Myfanwy
> White o'er the playpen the sheen of her dress,
> Fresh from the bathroom and soft in the nursery
> Soap scented fingers I long to caress.

> (John Betjeman, 'Myfanwy')

The poet goes on to long for furtive games of sardines and a peek into those hallowed swimming baths. Its companion verse, 'Myfanwy at Oxford', features the 'alpha-brained' goddess riding a bicycle and languishing on willowy banks. It was all a bit of a joke, no doubt. Myfanwy was married to the other John and, busy with babies or up to her elbows in *boeuf en daube*, was a safe target. But the image of Myfanwy as Betjeman's muse has stuck, and so bright is this image of a golden helpmeet that it has contributed to the obscuring of her own artistic achievements. (Incidentally, if you look these poems up on YouTube you will find any number of elderly gentlemen reciting them reverently.)

In order to trace another significant relationship in Myfanwy's life, we must return, pre-kinderbank, to the August bank holiday of 1936 when she and John (not yet collectively 'the Pipers') were hosting a conference of the collaborative enterprise Group Theatre. 'A very fraught weekend', she wrote, 'I felt less like a hostess than someone who had been got in to get the food going' (Piper 1986). But it wasn't just the catering that was a strain. The main purpose of the conference was to make arrangements for the production of a play that Christopher Isherwood and Wystan Auden were writing together, but when the two writers arrived, they had with them actress Beatrix Lehman and screenwriter Berthold Viertel in tow, and

announced they were going all out on their own for commercial success in
the West End, whatever anyone else thought.

Artist and theatre designer Robert Medley, who at the time was the
artistic director of Group Theatre, recalled the consequent rapid souring of
the atmosphere. 'The grisly scenario thus imposed came to a climax when
Wystan teamed with an innocent and embarrassed Benjamin Britten to vamp
hymns on the piano, and then to pick out with one finger, to Ben's brilliant
two-handed accompaniment, and ironic "Stormy Weather".' (Barker 2005,
354). Any lingering high spirits may well have been dampened by the
discovery (among artists, actors, writers, musicians and impresarios alike)
that they were all to share a single outside loo.

Interviewed later in her life about that grisly weekend, Myfanwy
remembered the young Benjamin Britten as a sulky eighteen-year-old,
and that he and Auden 'made one of the front rooms a kind of prefect's
room where they went and sat away from the mob' and smoked cigarettes,
which made Britten sick, all of which points to an interesting aspect of their
subsequent relationship, not least because Myfanwy was mistaken as to
the young composer's age. In 1936 Britten would have been not eighteen
but twenty-three, and despite having graduated from the Royal College of
Music by this time, he clearly came across as awkward and impressionable
among this group of walking, talking, painting and catering intellectuals,
not to mention that he would certainly have been in awe of the older and
more sophisticated Auden.

Myfanwy talks about the two as essentially schoolboys, casting herself
(she made the beds, she cooked the supper) rather in the role of matron.
From the various accounts of that meeting, Myfanwy sounds a generation
older than Britten, not just a couple of years: the confidence, perhaps, of an
intelligent and able woman hosting like-minded friends around her own
dinner table. But there may have been something of Myfanwy's maternal
nature even in those early years, which stayed with the impressionable Britten
and became, along with her familiarity and association with John, a reason
that he felt he could trust her, personally and creatively. Myfanwy's letters
to Britten in later years are full of wrap-up-warm sentiments, judicious little
squeezes and rubs of a sensibility under attack. 'Don't let anyone bully you',
she wrote in 1955, 'about money or time or sex or expediency or anything
else – and remember that we all love you and think you very clever'. She
even corresponded with Peter Pears, Britten's partner, in some despair over
Britten's stolidly unadventurous palate and his unswerving devotion to
nursery food.

All careers, whether or not they are of the portfolio variety, need a certain
amount of continuity, and this is where things can go awry for the even most
capable of multi-taskers. As the late thirties drew grimly on into the war
years and the Pipers started to become a family, Myfanwy, unsurprisingly,
found herself pretty much submerged by domestic life, while John became
ever busier in his public role as what *Guardian* art critic Jonathan Jones

called 'perhaps Britain's best war artist of the 1940s'. Their first son, Edward, was born in 1938, two daughters, Clarissa and Suzannah followed in 1942 and 1947, and a second son, Sebastian, arrived in 1950. Dealing with four children, rationing, a busy and often absent husband, and with a pony and trap for transport, Myfanwy, by her own admission, had little opportunity for those Hepworth's half-hours. Asked what she did at Fawley Bottom during the war, she said: 'Sat here and cooked. And bred.'

But if she wasn't managing the output of her childfree contemporaries, she was still keeping her hand in. A letter from her friend Stella Alexander, who had kept Myfanwy supplied with lipsticks and magazines from Paris, but now on diplomatic posting with her husband in Shanghai, complained: 'You haven't written to me once since I left England two years ago. I only know you're still alive because I occasionally read your reviews in *The New Statesman*.' In common with Myfanwy, Stella enjoyed keeping up with the latest art and books and wrote of the 'plunge' into the nursery as a welcome antidote to diplomatic life, an enthusiasm shared by her friend who, far from twiddling her thumbs, had begun to cast her beady critical eye over not just contemporary art and books (she was to publish a study of Frances Hodgkins for the Penguin Modern Painters series in 1948) but also children's literature. The sureness of Myfanwy's tone and the confidence of her judgement are reminiscent of those *Axis* editorials, written on the hop in her twenties, but, in her no-nonsense assertions about what children will and won't enjoy, they display the wisdom that domestic life with small children conferred on her. The world of anthropomorphic, sleep-deprived cats and elephants, for example, is corralled with the same brisk authority she had previously deployed on Henry Moore. Myfanwy's round-up of children's books in *The Listener* for Christmas 1942 is bold and intellectually exacting. No room in the Piper nursery for 'too much confidential-auntish chit chat' or ugly drawings. Oh no. The experimental, abstract magic of language acquisition is *What Children Want*:

> 'I am a bee. Buzzz,' says the child, flapping his arms. This is not a revelation of deep imaginative power, it is an acute sense of analogy. As a baby tastes with its toes, a three year old analogises with his body. When his vocabulary grows, a power of verbal analogy grows with it and is a constant delight. Every bright six-or-seven-year-old is his own Joyce, but few writers of children's books seem to exploit this. (Piper 1942, 763)

Children wanted vitamins during those war years, too. After a long-promised visit to Fawley Bottom in November 1942, Stella wrote to Myfanwy asking if she could trouble her to return the bottle of Minadex Tonic she'd left on top of the piano.

After the war, John and Myfanwy, with children in tow, attended rehearsals for Britten's opera *The Rape of Lucretia* at Glyndebourne. As usual, John was designing the set and Myfanwy was there in a supporting

role, but as Britten had his reservations about the librettist, Eric Crozier, it was as well she was on hand to make suggestions about the words.

Crozier's working relationship with Britten didn't last, but his friendship with John and Myfanwy did, and an exchange of letters between the three of them illustrates perfectly the inequality in the struggle to fit family life with creative output at this time in their lives. 'I'm sorry this is so badly written', writes Myfanwy from a wet Pembrokeshire in September,

> but JP is doing a drawing in a churchyard in a howling wind and both children and I are in the car and they are either shaking or shouting or asking for pen and paper or hurling insults at each other and it's frantic and my feet are cold. Clarissa has lost her pencil and is turning round and round like a cat trying to sit down. (M. Piper, 5 September 1946)

Hardly more enticing is a letter from John a couple of years later in which he reports that Edward has chickenpox, Clarissa has pneumonia, Myfanwy's infected finger almost had to be amputated, but nevertheless finishes by saying 'Do come and stay – we'd love to see you!' Though John relishes relating the immersive horrors of family life, he does so with the confidence that they need not create an interruption. He closes the letter with 'By being selfish I have done quite a lot of paintings' (J. Piper, July 1948).

Myfanwy had first mentioned Henry James's *The Turn of the Screw* to Peter Pears some years previously when the producer Michael Balcon was interested in getting Britten to create an opera for television. Shrewd observer that she was, Myfanwy believed that there were elements in James's story that would resonate with Ben, namely the exploration of innocence and guilt with the children at its centre. When the possibility of a commission from the Venice Biennale arose in 1952, Pears mentioned the idea again to Britten, whose response was to ask Myfanwy to come up with some ideas as to how it might be dramatized and meanwhile the two men would draw up a list of possible librettists.

Myfanwy seized her chance. She got stuck in to reading Henry James, steeping herself in his elusive, ambiguous world and – as she put it – his 'exhaustive, windy intelligence'. She made extensive notes as to how to compress the story into a taut drama that would retain the pervasive, uncertain atmosphere of the original. In the end, she had so much material, not to mention a close-up working knowledge of the composer's methods and a deep connection with his music, there was no point in looking elsewhere. She got the job. 'I can't begin to tell you', she wrote to Britten, 'what I feel about the possibility of working with you and perhaps have seemed to take it for granted. But I don't and would like to thank you and bless you for it . . . PS', she finishes with an awkward, self-conscious joke, 'sorry about the biro. It's rather like having chicken carved in the kitchen' (M. Piper, 4 November 1952).

While it might strike one as gauche and unprofessional for a writer to correspond with a composer in this way, especially at the outset of a major project (in his article 'Managing a successful writing career' in the *Writers' and Artists' Yearbook* 2019, Tony Bradman strongly advises 'Don't be Desperate or Grateful!'), the not-so-throwaway comment betrays an unwillingness to separate the different areas of her life and work, to keep discrete the catering from the craft – such had been the circumstances of their first meeting, after all.

Myfanwy's rather gushing correspondence at this stage would seem to bear out an observation made by novelist and critic Philip Hensher, himself a one-time librettist – of Thomas Adès's 1995 chamber opera and *succès de scandale*, *Powder Her Face*. Lamenting the bust-up between Britten and Auden as one of the greatest missed opportunities of twentieth-century art, Hensher suggests that Britten collaborated most effectively with those who weren't quite up to his standard. He also mentions Britten's penchant for being looked after, which might go some way to explaining the longevity of the composer's loyalty to John and Myfanwy, despite what Hensher unforgivingly calls the 'fourth form effusions' of the librettist's later work (Hensher 2009). Possibly he's thinking of Aschenbach's unpromising opening line in *Death in Venice* 'My mind beats on . . .': such interiority in opera is best expressed through music. Similarly, the art historian and critic Bevis Hillier has never forgiven Myfanwy for putting the line 'I must go down to the post office' into *Owen Wingrave*, though while popping out for a second-class stamp is perhaps not a common activity among the audience of La Scala, many of those watching *Owen Wingrave*, an opera made for and first broadcast on television in 1971 might well have been putting their feet up after a day that featured that very same errand. Critics might condemn such lines as mundane, but equally one could argue that this is an example where Myfanwy's libretto-writing is art 'intimately related to life in its own time'.

So she was grateful, yes: daunted, quite possibly. By the time Britten took a chance on Myfanwy, he had famously shed librettists W. H. Auden, Montagu Slater, Eric Crozier and E. M. Forster (telling Forster he didn't understand music). Given that John was still designing the sets, a slip up from Myfanwy on this would have been awkward, to say the least. Reflecting on her credentials, Myfanwy knew already quite a bit about how not to work with Britten; she had observed at close quarters those mentioned on the casualty list above. Not being a poet in her own right was, she felt, important, in that without a professional ego in this respect she could be 'fully compliant'. She was happy to take instruction from the composer that she shouldn't attempt to do anything fancy with the words but to 'rely on the music to colour them', as she says in her long essay, 'Writing for Britten'. She also had, she said – and this is key – 'a sensitivity to time passing, to the passive nature of humans'. Perhaps she was thinking of the horrors of war, the atrocities committed by 'following orders' or the desolate churches of John's war paintings, bombed out, abandoned. Or perhaps, more prosaically, she

was thinking of the number of people who came to her house and expected to be looked after.

The job of a librettist is – more or less in collaboration with the composer – to do the following: to identify the emotional core of a story; to discover and flesh out its themes and characters; to create a watertight dramatic structure; to leave sufficient clues for the full force of the story to emerge through the music; to get out of the way. Anyone with an ego that requires gentle and regular stroking, who thirsts for praise, or even visibility, had better look elsewhere to make their mark. These working conditions, however, suited Myfanwy perfectly, for not only did writing a libretto based on James's story give her an opportunity to use her talent for interpretation, working with Britten's musical ideas called on her abstract instincts, finding ways to let forms emerge, sketching out possible scenes and arias, working out how to contain the passing of time into a dramatic shape, and to do all this in partnership with the composer.

Myfanwy was happy to fall in with Britten's intensely collaborative practice, having him and Peter Pears to stay at Fawley Bottom, or 'escaping' to Aldeburgh by train when she could. However, her conception of the core story was peculiarly her own. In the early fifties, the prevailing reading of Henry James's story was a Freudian one, in which the sexual repression of the governess causes her to project her fears onto the children. But Myfanwy was no Freudian, as was clear from her discussion of surrealism in the pages of *Axis* (volume 6, Summer 1936): 'With all its apparent scope and new ground for exploration, the subconscious mind is a more limited subject . . . than a blank wall.'

Instead, her instinct was to explore more directly the experience of the children. With, by now, four of her own, she knew quite well how eagerly children gobble up stories, especially frightening ones. She knew the language of their conversations and their play. 'Will she be nice?' Miles and Flora ask Mrs Grose as the new governess approaches, possibly one of the only uses of the word 'nice' in any opera. Myfanwy knew too how children rely on grown-ups to keep them safe. At Fawley Bottom especially, she knew the power that clever and charming children wielded over adults who were only peripatetically in their lives. And she knew how vulnerable children are when, at night, in an isolated, unmodernized farmhouse, the bedside candle is blown out. She was, as she said in 'Writing for Britten', 'interested in vulnerability and innocence at all ages'. In Myfanwy's libretto, the children are real, robust. They charge about playing noisy games and compete with each other in the schoolroom. They are not the timid wraiths of James's insinuating original but modern children, as the Piper children were, surrounded by adults, very much seen and clearly heard. (Kenneth Clark fondly remembered visits to Fawley Bottom, thus 'to poke the ashes of the dying open fire, while the children rammed one in the stomach')

Another subtle departure of Myfanwy's version from the original is the near absence of the guardian, the pervading presence of 'he' in the governess's

mind in James's story. This too has the effect both of bringing the children closer to the governess while at the same time isolating her as she lives on her wits, uneasily in loco parentis. These two elements are a glimpse at the dark side of that bright, angelic and fragrant vision of domesticity that, for example, John Betjeman so revered in Myfanwy. She knew the reality. Adults can't always be trusted, and children can be precocious and manipulative.

Myfanwy didn't just compress the original story to fit the stage, allowing the 'evil to bloom' in the listener's mind – she added another element and in so doing, gave the story one more turn of the screw. Silent characters don't exist in opera. If you don't sing, you're not there. In Henry James's original story the ghosts appear without speaking, their presence interpreted by the governess. In the opera, however, they have voices. And that meant that Myfanwy had to write words for them to sing, 'not nice groans', she wrote, sounding a little nervous at the task. In giving them lines she was fleshing them out as characters, making explicit what is glanced at in the original. The ghosts' lines are in verse, to contrast them with those of the living, who sing prose. And reverberating throughout is the line, borrowed from W. B. Yeats, 'The ceremony of innocence is drowned'.

Peter Quint is a silent presence in James's original, but in the opera he calls out to Miles from the garden in a trance-enducing call to prayer, intensely beautiful and utterly chilling. In Jonathan Kent's 2006 production for Glyndebourne, the scene is transposed, horrifyingly, into the children's bathroom. While Flora is washing her hair in the sink, little naked Miles is sitting up in the bath. Quint appears in the doorway with a towel. 'I am all things strange and bold . . . I am King Midas with gold in his hand', he sings, liltingly, as he lifts the boy out of the bath.

If, as Frances Spalding suggested at an Aldeburgh Festival study day in 2014, the words look flat or meagre on the page, then this is not because Myfanwy was lazy or underpowered, rather it demonstrates the tact of a good librettist. All the heavy lifting has already been done. Myfanwy's notebooks are full of test scenes, arias that never make it, character notes, thoughts, reflections, rearrangements, questions (and even, in a notebook for *Death in Venice*, a recipe for almond biscuits). Her handwriting is pretty obscure, but what is clear is that she thought long and hard about the construction of the story as a drama, and in creating her own text, she collaborated with music and meaning.

The abstract nature of opera, Myfanwy's flexibility of approach, and her instinctive sensibility all came together in her writing for Britten. In his book *Believing in Opera*, Tom Sutcliffe distinguishes opera from spoken theatre in that 'opera has a non-linear . . . non-logical character. . . . The combination of music and text is innately suggestive, like lateral thinking.' This is what suited Myfanwy down to the ground, and this is why she and Britten were able to create such a complete work of art.

The reviews of the first performance praised the suitability of the story to the form: in fact, one critic, writing later on about both *The Turn of the Screw*

and *Owen Wingrave*, asked 'Is Henry James opera's best librettist?' (Pines 1996); laughable, really, given that concision – the librettist's best friend – is not exactly a famous Jamesian quality. Rather it was the atmosphere of the stories that Myfanwy was able to tap into so successfully. In an article for the *Guardian* about her own work as a librettist, the writer Lavinia Greenlaw said, 'When opera works, it lifts off and becomes something we can barely talk about: we recognise it by feel.' This is just what Myfanwy achieved in her distillation and reshaping of Henry James's story, always writing – as librettists do – towards the music, which she understood so instinctively.

Though Myfanwy's text was hailed by Britten's biographer, Michael Oliver, as 'the finest libretto Britten ever set', Britten had his doubts about the project along the way. 'How difficult it is to write an opera with the librettist so far away', he fretted in his letter to Basil Coleman on 29 May 1954, 'She is good, but is so occupied with being a wife and mother.' It seems that he was blind to the possibility that it was precisely Myfanwy's occupation as a mother that made her, if not the most available librettist, then the most – in this case – sympathetic. In addition, having for many years enjoyed the kind and patient ministrations of a paid housekeeper, he was blind to his own domestic capabilities. Thanking Myfanwy for a weekend at Fawley Bottom during work on *The Turn of the Screw* he wrote that he and Peter had a lovely time staying with them all (he called the children, collectively, 'kiddies', the sort of thing you say if you want to keep them at arm's length) but 'goodness, how you do work! It's a wonder you ever get it all done' (Britten, letter to Myfanwy Piper, 16 February 1954). One can only wonder if it occurred to either man to help.[2]

As well as allowing her domestic life, motherhood, what she called 'the fish and the laundry' (Spalding 2009a) to nourish her writing as much as it interrupted it, Myfanwy used her intellect and creative energies to foster the work of others, too. In addition to helping John, accompanying him to endless churches and historic buildings in bad weather, or making model sets late into the night in the studio, she was brilliant at bringing together artists, musicians, writers, critics, poets, actors and directors, and she fed them, put them up, discussed their work with them and encouraged them. This, too, was her art. Like M. Eleanor Fitzgerald, whose 'fantastic ambition' was to 'support and uplift' the artists of New York, Myfanwy took an active role as hostess to British modernism. Who knows, if it weren't for the worn-out chintz, the haute*ish*-cuisine and the matter of her sex, we might well think of her – as well as a writer and critic – as something like an impresario.

Sixteen years passed between the 1954 La Fenice premiere of *The Turn of the Screw* and the writing of *Owen Wingrave*, not for want of Myfanwy trying; she wrote several letters to Britten during that time, pitching ideas for new collaborations, but none of them landed. By the time the BBC commission came in 1970 for *Owen Wingrave*, the smallest Pipers were all grown up and Britten didn't need to compete for the attention of his librettist – or hear any more about her offspring's squabbles or stomach

aches. The pair's last collaboration, *Death in Venice*, premiered three years before Britten's own death at the age of only sixty-three.

Although she never again enjoyed the high-profile success she'd had with Britten, Myfanwy continued to write libretti, collaborating with Master of the Queen's Music, Malcolm Williamson, on his opera, *Easter*, and with the Welsh composer, Alun Hoddinott on *What The Old Man Does Is Always Right* (1977); *The Rajah's Diamond* (1979) and *The Trumpet Major* (1981). She died, five years after John, at home at Fawley Bottom in 1992.

Myfanwy Piper garnered a great many loyal fans throughout her life, both for her intellect, and for her generosity. But her most enduring work – the operas she wrote with Britten, and particularly *The Turn of the Screw* – will always be, in the public imagination, Britten's works; which is not to say that that is unfair, but that the very best librettist will only ever be semi-visible. And as her experiences as a mother so informed her work, it seems fitting to end with this particular letter, received by Myfanwy after the premiere of *The Turn of the Screw* at La Fenice, Venice, in September 1954:

Darling Myfanwy

I just can't find a way to express my admiration for your work – John's too, of course, but his perfection is by now almost commonplace. I think it is simply wonderful of you to do it in the midst of all the domestic difficulties and I hope you are feeling very happy about it in every way.

I'm so proud to be

Your mother.

Notes

1 A footnote on the ubiquitousness of John Piper: to give some sense of just how prolific John Piper was as a public artist mid-century it is worth considering some of the institutions that commissioned him. He was on the design team for the Festival of Britain, illustrated the Shell Guides, created a mosaic for the reception area at BBC Television Centre at White City and, of course, designed the sets for Benjamin Britten's operas. John Piper's work in stained glass can be seen far and wide, but I have seen it in Llandaff Cathedral, where my brother was a chorister, in the Metropolitan Cathedral of Christ the King in Liverpool, where I was an undergraduate, and in the window of the church in the village of Firle, East Sussex, where I often walk my dog. As a very small child I occasionally had to sit through my great-uncle's sermons, which, so the family joke went, you could guarantee would always be about the brothers at Emmaus. I had no idea – until researching this – that the giant mosaic behind the altar featuring my Uncle Donald's favourite scene was, in fact, one he commissioned from John Piper.

2 Amusingly, while I was researching this chapter, a volunteer at the Britten Pears Archive was busy going through boxes of Benjamin Britten's household receipts,

from which a 'fascinating picture was beginning to emerge', she said, of the composer's domestic life; for example, how many kippers he got through in a week and how much he spent at the local garage.

Bibliography

Axis, vols 1–8 (accessed via www.monoskop.org). https://monoskop.org/Axis, accessed 14 September 2020.

Barker, Peter, *Isherwood: A Life Revealed*. London: Random House, 2004.

Betjeman, John, *Collected Poems*. London: John Murray, 2006.

Fraser-Jenkins, David, 'Obituary: Myfanwy Piper', *Independent*, 22 January 1997.

Gardner-Huggett, Joana, 'Myfanwy Evans: Axis and a Voice for the British Avant-Garde', *Woman's Art Journal* 21, no. 2 (2000): 22–6.

Greenlaw, Lavinia, 'Elitist and Obscure: So What?', *Guardian*, 20 December 2003.

Hensher, Phillip, 'Love's A Little Boy', *Guardian*, 7 November 2009.

Hepworth, Barbara, *A Pictorial Autobiography*. Bath: Adams & Dart, 1970.

Hepworth, Barbara, *A Pictorial Autobiography* (1971), quoted in http://barbarah epworth.org.uk/by-barbara-hepworth/quotations-from-barbara-hepwor.html. 12 December 2019.

Korsmeyer, Carolyn, *Gender and Aesthetics: An Introduction*. London: Routledge, 2004.

Oliver, Michael, *Benjamin Britten*. London: Phaidon, 2008.

Pines, Roger, 'Henry James – the Greatest Opera Librettist?' *New York City Opera Programme 1996* (Tate Archive).

Piper, John, Letter to Eric Crozier, July 1948 (Piper Estate, Tate Archive).

Piper, John and Myfanwy, interview with Elizabeth Sweeting, 6 September 1986 (Piper Estate, Britten Pears Foundation).

Piper, Myfanwy, interview with John Evans, undated (Piper Estate, Britten Pears Foundation).

Piper, Myfanwy, letter to Benjamin Britten, 4 November 1952 (Piper Estate, Britten Pears Foundation).

Piper, Myfanwy, et al., *Letters* (Piper Estate, Britten Pears Foundation and Tate Archive).

Piper, Myfanwy, 'Up To Twelve', *The Listener*, 10 December 1942.

Piper, Myfanwy, 'Writing for Britten', essay in the Britten Pears Archive.

Reed, Phillip, ed., *Benjamin Britten: Letters from a Life*, vol. 4 (2008).

Spalding, Frances, 'Golden Girl', *Guardian*, 29 August 2009 (2009a).

Spalding, Frances, *John Piper, Myfanwy Piper: Lives in Art*. Oxford: Oxford University Press, 2009b.

Sutcliffe, Tom, *Believing in Opera*. Princeton: Princeton University Press, 2016.

20

Double Act

U. A. Fanthorpe and R. V. Bailey, Partners in Rhyme

Elizabeth Sandie

Who are these two who Plight their troth?
Makers. Of poems and paintings and whoopee.
Givers. Of friendship to surgeons and students,
Dissident princes, the sick, the sad, life's quiet stage-hands.
Carers. Of dogs, cats, birds,
Lost gods, lost England's lost souls. Words.
Nomads. On the poetry circuit. Partners in rhyme,
Putting the show on the road. Getting clean away.
Nesters. In Gloucestershire among hills and blackbirds [. . .]
Providers. Of whisky, puddings and comfort [. . .]
Linguists. Speaking Latin, dragon, swan and lame-duck.

(Diana Hendry and Hamish Whyte, *Epithalamium*)

This affectionate portrait of Ursula (U. A.) Fanthorpe (1929–2009) and Dr R. V. (Rosie) Bailey (b. 1932) comes from the *Epithalamium*, written for the occasion of their Civil Partnership in 2006, at Wotton-Under-Edge where they had lived since 1975. It formalized and celebrated a long and fruitful relationship between the two women, intellectual equals, who shared many interests and responsibilities. These words reflect the warmth and high

esteem in which this couple were held by their many friends. Both were Quakers. Neither was interested in fame.

This chapter stands at a somewhat subversive angle to the others in this volume. It looks at the different dynamics of support in this same-sex relationship. One of these women, Fanthorpe, had a desire to be a writer. The other, Bailey, made a commitment to support her. Neither anticipated Fanthorpe's achievements would have been in the world of poetry, predominantly a male preserve for much of their lives. The chapter considers the distinctive qualities of Fanthorpe's work which made her such a popular poet, the nature and significance of her achievements, and acknowledges the crucial importance of Bailey's supporting role alongside her own career and writing life. I am indebted to Bailey for new insights into their special relationship arising from our conversations in February 2020.

Ursula Askham Fanthorpe, known to those close to her as UA, became 'one of the most wide-ranging, rewarding – and re-readable – poets of our time' (Brownjohn 2009). Famously, Fanthorpe came to writing late as 'a middle-aged drop out' from the world of education (Hendry 1979, 65). Without the love, encouragement and, initially, financial support of her partner, Dr R. V. (Rosie) Bailey (RVB), it would have been harder, if not impossible, for Fanthorpe to have taken that step in 1970, which led to her achievements, overcoming in the process many institutional, psychological and cultural barriers women faced in establishing themselves as poets. Fanthorpe's first collection, *Side Effects*, published by Peterloo Poets in 1978, in her fiftieth year, achieved both popular and critical acclaim. In 2005 her *Collected Poems 1978–2003* (*CP*), drawing on seven subsequent individual collections, bore the dedication 'For Rosie as always.'

Fanthorpe gained many awards and fellowships: she was made a Fellow of the Royal Society of Literature (1987), a Commander of the Order of the British Empire (2001), and received the Queen's Gold Medal for Poetry (2003). Despite these establishment honours, however, hers was a subversive voice. Fanthorpe, scholarly, but modest and unassuming, was, as she said to Marilyn Hacker, 'against power holders with no weapons but words and laughter' (1989). She hated pretension, hypocrisy, bureaucracy. She spoke up for the dispossessed, the overlooked, the voiceless. She was aware in the not-so-distant past women poets themselves struggled to find a voice and were often overlooked.

In UA's obituary, Alan Brownjohn pays tribute to the support given to Fanthorpe by her long-term, deeply loving partner, not only through her creative periods but also through her periods of illness: 'Bailey had been, among other things, amanuensis, cook, driver and frequently, letter-writer. Fanthorpe always responded to letters, but rarely in her own hand, saying: "Rosie deals with the correspondence in this outfit"' (2009).

Bailey had a career as a lecturer, critic, editor and poet. Only from 1991, when she retired from academia as Deputy Dean of Humanities at the University of the West of England, Bristol (UWE), was she able, in addition,

to have a more visible role in supporting Fanthorpe in her public readings at poetry festivals and literary events for which she was increasingly in demand. With Bailey on board, this became a 'witty and accomplished double act, establishing an immediate rapport with audiences' (Brownjohn 2009).

Fanthorpe, who had an ear for voices, often reimagined traditional biblical or Shakespearian stories in a contemporary idiom, including a house-proud Lady Macbeth or a Titania blindly in love with Bottom. She not only revived the dramatic monologue but wrote texts that syncopated two or more voices. Her very peopled poems also bring to attention characters rarely seen in English poetry; they tend to disturb us, make us see things afresh, with an unexpected juxtaposition of different registers. In 'Casehistory, Julie Encephalitis' (*CP 25*) snippets of the patient's disturbed speech are interleaved with quotes from *Hamlet* about Ophelia in her madness. In 'A Major Road for Romney Marsh' (*CP 315*), one of the poems in which she pays tribute to marginal lands, Fanthorpe's lyrical, evocative descriptions of the marsh are syncopated with the curt demands of the developers:

> It is salt, solitude, strangeness
> It is ditches and wind-curled sheep
> It is sky over sky, after sky
> (It wants Hard shoulders, Happy Eaters,
> Heavy breathing of HGVs).

The gap between the registers is always revealing; here it exposes her sense of a pending atrocity. Bailey was extremely useful and adept in providing some of these contrasting voices in public readings.

They had grown up in wartime Britain almost 400 miles apart, Bailey in Northumberland, Fanthorpe in Kent, where the consequences of war were more devastating. Fanthorpe's father, a barrister, later a judge, schooled his garrulous children in speaking one at a time and putting forward proper evidence. Both women later wrote poems which interrogated the limited expectations of girls at that time. Bailey asks:

> But daughters – Who knows
> What keys, what doors,
> what futures may deliver
> If good sweet maids should also find they're clever.

> (Bailey 2016)

Fanthorpe remembered in her poem 'Kinch and Lack' the dismay she felt when her younger brother David was at that outfitters being measured up for a prep school uniform. She recognized, 'There's a world enlisting him / That hasn't a place for me. OK. I'll make my own' (*CP 366*). She also recorded her mother's bitterness about giving up a promising career in the

civil service for her husband and children: 'Marriage is burial, she used to say. / *I could have written novels, or played the French horn*' ('Née', *CP* 364).

Their paths had not crossed until they met as teachers at Cheltenham Ladies' College in the late 1950s, a school UA had been meant to attend had it not been for the war. With her brother's school evacuated and her own, humbler, school shut down, their parents deemed it sensible to send her to St Catherine's in Bramley, Surrey, a girl's boarding school five miles from her brother, chosen to enable frequent weekend visits. In her essay 'War, Poetry, The Child', Fanthorpe recalls the traumatic experience of evacuation from their home in Kent to Surrey, after extensive bombing of Bromley: 'All schools in the area were closed instantly. I never saw any of my friends again. I somehow never found compensation for this sudden and utter loss' (Fanthorpe 2000a, 209). She suffered 'nine years of solitary dissidence' as a pupil in that boarding school, where books were her only salvation. It was during these years she constructed herself as an outsider, and to write was the characteristic activity of an outsider. She was in a school but self-educated; as the only pupil in the A-level Latin class, she could see how limited the teaching was.

Meanwhile Bailey (b. 1932), just a few years younger, had a much happier experience at her local co-educational grammar school in Whitley Bay and did not suffer the trauma of evacuation. She remembers very positively the energy and stories the returning soldiers brought to teaching their sixth form Arts classes. She went on to read English at Girton College, Cambridge, at a time when the quota for women was only 10 per cent.

Fanthorpe's schooling taught her a lifelong habit of non-conformity, of insisting on finding out for herself. She also understood early on the value of laughter as a strategy for survival and subversion, 'the vital importance of wit, jokes, puns, anything that questions the status quo or throws its own eccentric slant on life. For me to laugh is to be alive', as she recorded in her unpublished autobiographic notes. Learning and laughter were things she and Bailey later shared.

Fanthorpe developed no close friendships at school but did discover choral and vocal music, which later informed so much of her poetry: 'It's the human voice and human words that matter to me.' Acting, another great influence on her later work, featured prominently in the curriculum. In her autobiographical notes she recalls how, because it was wartime, they produced an all-female Macbeth 'with considerable élan and no worry about gender'; as a result of the absence of men, she remarks, 'we grew up quite unconscious that we were the second sex, or that there was anything we could not do'.

After resitting her entry exams, Fanthorpe went to Oxford to read English at St Anne's College. She had early ambitions to be a writer, but at that time she would have never imagined becoming a poet, let alone a taught author. As Fanthorpe explained to Angela Pitt in an interview in 1994, 'even Virginia Woolf felt that she didn't know enough about the classics to be a poet'. Her poetry syllabus was entirely male. It would have been easier to imagine

joining an established tradition of women novelists. Fanthorpe's poem, 'From the Third Storey' (*CP* 178), prefaced by Jean Rhys's comment that you have to be monstrously selfish to be a writer, illustrates some of the difficulties women novelists faced in carving out time for their writing. Stanzas particular to individual writers – Austen, Gaskill, Bronte, Eliot and Woolf – are punctuated with disturbing noises from the attic, borrowed from *Jane Eyre*.

However, she had not become a writer at Oxford. The ex-servicemen and women returning from the war to resume their studies, bringing with them vivid stories, 'redolent with Experience', made her feel muffled; she felt the lack of any such vivid experiences about which to write. There had been a brief glimpse of another world – her studies had been interrupted, when, as a result of a traffic accident, Fanthorpe spent three months in Radcliffe Infirmary. Fanthorpe later referred to this as 'a Baptism of Fire. . . . Here was life enough for anyone to write about; there was Ruby, the ward maid who was simple . . . Nancy who was dying . . . Hazel whose pelvis had been broken My parents were horrified at my idea that I should swap courses and become a nurse' (Fanthorpe 1987). She went on to obtain a first-class degree and ideally was looking for a more adventurous career, to give her some profound experience of life as well as material for stories. She later said if she hadn't become a writer, she would have liked to have been a mountaineer. But there were fewer career choices for women at that time, and she was persuaded the only thing she was qualified for was teaching. At least it would bring her in contact with people.

After graduation from Cambridge, Bailey spent some time as an Information Officer in London, where she was trying to live on £350 per annum – £50 less than her male colleagues, reflecting a standard practice before the Equal Pay Act of 1970. The job was interesting enough but rarely challenging. Bailey recalls in a conversation:

> *The Times* had rung: some important Bishop in India had died. They needed an obituary instantly, there was no one else in the office and nothing on file. All I could do was imagine what he must have been like – and so I invented a life for him. (I thought the Bishop would have been quite pleased with himself.) And next morning *The Times* printed all of it. I thought I'd better find another job, while luck was still running my way.

Teaching was one of the few professions that offered equal pay. The vacancy at Cheltenham Ladies' College (CLC) was both handy and timely, and in 1958, Bailey joined its lively English department, where Fanthorpe had been working since 1954, proving herself to be an inspirational teacher. Here their paths finally crossed, but the partnership took a while to develop. Bailey recalls:

> It was seven years before [UA and I] first recognised an accord, a similar mindset, a spark of mutual interest in discussions after theatre or films

amongst members of a highly articulate, sociable English department. We'd sometimes gather round a colleague's TV watching *The Forsyte Saga*. Ursula so often said what I thought before I'd said it. But this was the sixties: a lot of new exciting things were no doubt happening in Carnaby Street; they weren't happening – or even being talked about – in Cheltenham. It was the Age of Concealment. And we knew no one in a similar situation to ours.

Bailey's poem 'Hard Work' from *The Losing Game* (2010) also recalls those early days:

> I think you liked me first for my hard work:
> For doing things on time, and legibly.
>
> I liked your laugh, subversive, sudden, rich
> With possibilities of more to come, and how.
>
> It wasn't industry, or jokes: just love.
> In time we dared to tell each other so.

Bailey remembers how enthused Fanthorpe had been when made Head of Department, leading them in exciting new directions. But in 1970 UA realized that she was beginning to dislike the person she was becoming in this managerial role. For sixteen years all her creative energy had gone into teaching; the pupils she had nurtured had moved on to find experience, live among people and generally do the things she wanted to do (Fanthorpe 1987). No writing was happening. Something had to change. So, in a U(A)-turn, Fanthorpe found a place on a counselling course, a new subject area at that time, thinking that perhaps this might lead to a fresh start, and left CLC for Swansea University. After a year of uncertainty and exhaustion, making a 200-mile round trip to commute between Fanthorpe's digs in Swansea and Cheltenham, Bailey also left for Swansea to do the same course: 'We wanted to know the same body of knowledge, the same experiences', Bailey remarks, 'We wanted to go on talking for ever.'

Bailey remembers their first home in Merthyr Tydfil (1971–2):

> Like childhood dreams
> It stood on a magic mountain
> Whose name no one could spell.
>
> ('First House', Bailey 2012, 12)

a place also celebrated by Fanthorpe in her 'Elegy for a Cat' (*CP*, 257):

> . . . dear first-footer, first to confirm
> Us as livers-together

who saw love, where innocent others
Saw only convenience.

It was important to them when they first set up home to share chores; they were desperate not to fall into stereotypical patterns. Bailey later unearthed an early poem, perhaps worked on together:

Because we share a sex, we have to be
Tender about our role identity;
You mustn't push me into mannishness
Nor I expect to make your life that of a housewife [. . .]
we must assume each other's burdens to be free
of gender drudgery.

Bailey says they weren't afraid of argument, there were lots of robust discussions about these things, as she would expect with the daughter of a barrister. Fortunately, their sense of humour took the edge off the adversarial moments.

For a while there seemed no clear way ahead, even though Rosie had huge faith in UA's talent: 'I had no doubt she would be a writer, given half a chance', she recalls.

Then one night over a fish supper in a Swansea pub it suddenly became clear – a moment of epiphany – what I really wanted to do was [to] support a writer. And here was the writer. Why on earth had it taken me so long to come to this conclusion? Hers was the serious career, mine the supporting role. At that time one salary would be enough to support two people. I would get a job and UA would, at long last, be free to devote herself to writing.

Bailey positively chose this role; this *was* her great trajectory. Until that moment she had no clear idea what she wanted to do with her life. Unlike 'The Poet's Companion' (*CP* 270–2), based on UA's observation of the behaviours of male poets towards their wives, Bailey didn't have to

. . . forget her childhood's grand trajectory
And sustain with undiminished poise
That saddest dedication: '*Lastly my wife,*
Who did the typing.'

Bailey secured a job as a lecturer at St Matthias, a Bristol College of Education which later amalgamated with the local Polytechnic to become the University of the West of England. Her duties included teaching one module of creative writing, a new subject area, which led to Bailey writing poetry as well. Meanwhile, ironically, having no work at all did not suit

Fanthorpe. She needed some structure and a new identity. Besides, Bailey had almost caught herself expecting a meal on the table on her return home to Wales from Bristol, while she was working and UA wasn't, but had to remind herself: 'This wouldn't do, this wasn't what the relationship was about.'

By now they also had a cat and a dog and the cost of living had gone up. They moved to Chepstow to be nearer Bristol. Bailey's Head of Department, Nigel Dodd, would send out invitations to socials to include 'husbands, wives and Ursula'. Fanthorpe was glad to be accepted and included in these social occasions. Dodd became a valued friend of theirs, and in 1987 composed the music to accompany a collaborative project *The Bristol Triptych – Five Poems by UA Fanthorpe with Five illustrations by Frank Shipsides*, for a celebration of St George's, Brandon Hill, on 7 March 1988.

Only by hiding her first-class Oxford degree, her distinction on the counselling course, and her eight years' experience as Head of Department at CLC, did Fanthorpe eventually find employment as a temp: first in the Hoover complaints department, then at Butlers Chemicals at Avonmouth. She had admitted to being able to do a bit of typing. A routine job supplied a modest income but left time and energy for writing. Bailey recalls that UA did some research into the work of Radclyffe Hall at this time. They had admired her early prize-winning novels that came before *The Well of Loneliness*, the only one that caused controversy, and UA commented on some of her poetry as well.

'Now she wrote all sorts of things, reviews, criticism, even a crime novel. She wrote about other people. And she wrote in prose' (Bailey 2015). The larger irony, central to this article, is that the job which 'tipped [Fanthorpe] over into poetry' (Fanthorpe 2000b, 33) was at the Burden Neurological Institute, Frenchay, where she worked from 1974 to 1986 as a secretary to one of the doctors and as an outpatient receptionist (admittedly, with a generous leave for writing residencies at St Martin's, Lancaster, and later as Northern Art Fellow at Durham and Newcastle).

Her poem 'Job Description: Medical Records' explains:

We do not encourage
Speculation in clerks. We prefer you
To think of patients not as people, but
Digits [. . .] Our system
Is terminal digit filing.

Fanthorpe dates the start of her poetry exactly on 18 April 1974, with the poem 'For St Peter', in which she adopts a familiar, colloquial tone addressing the saint, assuming a shared knowledge of the hazards of gatekeeping, she at the outpatients' department, he at the gates of heaven. The woman who, as an undergraduate, had been envious of the vivid experience of the soldiers, uses many military metaphors to comment on and validate her route into

poetry, finding her voice 'among the sad little individual wars of a neuro-psychiatric hospital' (Fanthorpe 2000a, 210). Observing from her 'glass dugout' epileptic, depressed and brain-damaged patients, her first subject was 'the strangeness of other people . . . how it felt to be them and use their words' (Fanthorpe 2010, Foreword). What's more, the role as typist rendered her invisible. She observed while talking to Diana Hendry in 1979:

> I feel as if I am in a forward zone or trench. I am a lay person in a professional world, and because of this I am invisible, not really there. You are exposed to extremes and have to be ready in the same sort of way as a soldier. I think they call it 'standing to'.

Many poems were drafted in her lunch hour in her miniscule hand on the backs of old appointment lists in a disused caravan in the hospital grounds. Anger at the way patients were spoken to and written about in case notes drove her to write, in an attempt to give them back their dignity. Prose just wouldn't do. In her 'List' of outpatients she draws analogies between the symmetry of names and dates typed on her register and the rhythm and spacing of figures on an Egyptian frieze:

> Flawlessly typed, and spaced
> At the proper intervals,
> Serene and lordly, they pace
> Along tomorrow's list
> Like giftbearers on a frieze.
> Not more harmonious who pace
> Holding a hawk, a fish, a jar
> (The customary offerings),
> Along the valley of the kings.
> . . .
> 'I am the artist, the typist
> I did my best for them.'

'The List' was to become the opening poem in Fanthorpe's first slim volume, *Side Effects*, published by Peterloo Poets (1978) in her fiftieth year.

Fanthorpe's publisher, Harry Chambers (1937–2012), my brother, remembered how much he had enjoyed his first meeting with UA in a Cheltenham pub at festival time in 1976 to discuss a manuscript submission: 'After what was essentially a lengthy acceptance lunch, I was mortified to discover that her partner Rosie Bailey had been waiting outside.' He could not understand why UA had not mentioned it. In his memory, Rosie was in a car with their dog, Shandy. Rosie remembers lurking in a shop doorway out of the rain to see them emerge: 'Their faces were so lit up; it had clearly been a positive meeting – a wonderful beginning to a very happy relationship.'

They would have had many sociable times together in the years that followed. The meeting led not only to the publication of *Side Effects* two years later (1978) but also to seven subsequent individual Fanthorpe titles with Peterloo Poets. The first, together with *Standing To* (1982) and *Voices Off* (1984), fed into a *Selected Poems* (1986) published in hardback by Peterloo and simultaneously by Penguin Poets paperback series; Fanthorpe was the first woman to appear there. It became a set text on school syllabi. This also opened with 'The List', which inspired Chambers to choose a detail from the Weighing of the Heart by the scribe Ani from his *Book of the Dead* for its cover. Fanthorpe was always appreciative of the covers he and Lynn selected.

Peterloo Poets had a good record of championing the work of women who came to writing later in life, like Elma Mitchell whose poem 'Thoughts after Ruskin' wittily exposes the discrepancy between the myth and the reality of women's roles – it was the discovery of her work that encouraged Fanthorpe to submit that first manuscript. For a long time, such women had seemed invisible to the mainstream publishers, but later, Mitchell and Fanthorpe's poems were printed alongside Charles Causley's in *Penguin Modern Poets Volume 6* (1996).

Fanthorpe remained loyal to this small independent press, despite her growing fame. Chambers had left a salaried job as a lecturer in Manchester to risk making a living as a poetry publisher in Cornwall, with the support of his wife, Lynn, who initially took all sorts of temp jobs, even night shifts in a pizza factory, before eventually becoming the press's full-time business administrator, taking on typing, typesetting and myriad other tasks. Fanthorpe's millennium volume *Consequences* carries an extra dedication, 'In happy memory of Lynn Chambers' who had died that spring, soon after the business moved out of their dining room and into a spacious converted chapel in Calstock. Bailey's first collection, *Marking Time*, was also printed by Peterloo in (2004).

The following year (2005) Fanthorpe's long-overdue *Collected Poems 1978–2003* was published. This rich 468-page collection became the focus of my monograph *Acts of Resistance*, one of the last books to be published by Peterloo Poets in February 2009, only two months before Fanthorpe's death. The press had closed as Chambers, himself in failing health, retired to York.

Fanthorpe had first come to the public – and her first publisher's – attention in 1975, when 'Not My Best Side', which had won a prize in Chambers' Phoenix poetry competition for a poem about a painting, was printed in *Encounter* (Fanthorpe had used Bailey's name for her pseudonym for her anonymous entry). This wonderful performance piece, which gives contemporary voices to the three central figures in Uccello's *St George and the Dragon* (reproduced on the cover of *Side Effects*) helps us see the painting afresh, and simultaneously effects a witty exposé of the self-centred consumerism of Thatcher's Britain. St George here is trying to coerce a maiden, who actually 'quite fancies the dragon' into being rescued:

I have diplomas in Dragon
Management and Virgin Reclamation [. . .]
 Don't
You want to carry out the roles
That sociology and myth have designed for you?
What, in any case, does it matter what
You want? You're in my way.

The poem is a great example of the way Fanthorpe 'revived the dramatic monologue in poetry – not popular since Browning – and brought many marginalised voices to the centre, not least the voices of girls and women', says Carol Ann Duffy, Britain's first female Poet Laureate. 'She was simply brilliant at performing – aided and abetted by Rosie – and so many poets learned much from her charismatic, hilarious and moving stage presence' (Duffy 2010).

This might seem surprising as Fanthorpe, from her schooldays, had constructed herself as an outsider poet, someone off-stage, a watcher, a witness. When fame came and with it a cameraman needing a publicity shot, she explains in her poem 'Awkward Subject' (CP 283) – also the title of her first audio cassette – how she hated to be the focus of attention. 'Words are my element. / Photograph them', she challenges him. But in her performances Fanthorpe was presenting for attention a wide range of other characters and landscapes. The focus wasn't on her.

Word of Fanthorpe's ability to engage audiences spread and she was in demand on the festival and event circuits. Once Bailey had retired from academia, she was able to support Fanthorpe more regularly and more visibly by providing the other voice in her poems. They became well known for their 'Double Act', the title of a Penguin audiotape of their reading. Bailey also had a strong stage presence: a dapper, striking figure with a liking for colourful cravats:

We didn't have time to waste on thinking what to wear, were usually racing against the clock on tight schedules, so wore similar 'work-clothes' with pockets for pens and notes, a sort of uniform, usually black (both from the women's department in M&S) though UA's were far more elegantly cut than mine – because she was in fact much more elegantly shaped than I. She could carry off almost any garment and never for a moment be thought a man. I, on the other hand, was far less stylish, and likely to be mistaken for an undertaker or a waiter. None of that mattered: what was to be read was far the more important bit of preparation.

They also performed in schools when Fanthorpe's books were put on the syllabus, and never knew what questions they would have to answer afterwards. Bailey remembers being somewhat taken aback when one young public schoolboy asked: 'Why do you have an *accomplice?*'

It had never occurred to us before, but the word *accomplice* had just the sort of connotations . . . appropriate to my role in the double act: slightly shady, guileful, devious, shifty. . . . The possibilities were endlessly inviting. I had indeed the status of an invaluable civil servant, who might be relied upon, in moments of embarrassment, to lay a spoonful of oil on socially troubled waters . . . to rescue from whatever disaster threatened . . . an insider, infinitely skilled in diplomacy. A kind of Autolycus, a picker-up of unconsidered social trifles, in any enterprise at any moment; as smooth as Jeeves.

Could Bailey have anticipated what her commitment would involve? She remembers:

One particularly challenging week we had doubled-booked – UA was running a course at Lumb Bank, the Writers' Centre in Yorkshire, while simultaneously we were giving a series of double-act readings in Gloucestershire libraries. (We actually managed both: it involved horribly early mornings and a great deal of very fast driving.) That episode made it clear that we had to share a diary, as well as a bank account and a house (and cat and dog).

Driving home from work in Bristol, they often had to stop precipitately under the nearest street-lamp to write down something essential: 'Perhaps it was just three words, but they were the right three words, and she might have been waiting for them all day long', Bailey recalls. She also remembers UA in her poem 'In the Passenger Seat', acknowledging her greater skill as a navigator:

Not because you didn't drive –
We shared all that. But here
You exercised your magic art
Of Getting Us Out Of Trouble

Seduced by scenery or absorbed
In some compelling chat,
I'd slipped the wrong way off a roundabout . . .
Hand on knee you'd say, *Ok*
Just take the next left. I'll get us there.
Somehow you had all of England in your head.

(Bailey 2010, 8)

Fanthorpe's success as a poet also took her away to longer periods of residencies. Her time at St Martin's College Lancaster (1983–5) proved one of the happiest times of her life. But Fanthorpe was always keen to 'home in' from wherever she was, to 'one particular/ Parish, one street, one

house, one you' (*CP* 219). The phrase is from the title poem of an anthology *Homing In: Selected Local Poems* (2006) produced by The Cyder Press, who commissioned Bailey to do twelve oil paintings for them.

Yet Fanthorpe's concerns were never parochial: do not be misled by the subtitle. Fanthorpe's poems make vivid the local landscape and probe the history beneath it. What starts in the locality invariably has a wider remit or resonance. Her poem 'Canal 1977', for example, is a response to a visit to the Sapperton Tunnel. It draws on the contrast between the place's 'picturesque antiquity' and its appalling history that cost the lives of many of the Welsh navvies who built it, working, 'astraddle/ A powderkeg, light in their teeth, a fuse in each pocket,/ Lying foreign and broken in Gloucestershire churchyards now' (*CP* 56–7).

In 'Tyndale in Darkness' (*CP* 296) Fanthorpe reveals the tenacity of this translator of the Bible into the vernacular in the face of persecution. Focusing on the standing stones at 'Stanton Drew' (*CP* 32) sends us centuries back and helps us 'Listen/ to the past's long pulse'. Bailey's excellent introduction to *Homing In* takes us on a tour of the territory, placing the poems in their geographic context and revealing as she does so a shared fascination with history, maps, words, etymologies, type-faces, boats, waterways, birds and above all people.

One of the most important ways in which Bailey supported Fanthorpe was to help her feel secure and anchored in such a loving relationship. It would have been especially significant for UA to be 'Earthed' (*CP* 31) in this place after the upheavals of her traumatic wartime childhood. Fanthorpe came to realize she was part of the 'collateral damage' from that war, a topic she dealt with in the ironically titled *Safe as Houses* (1995) which was also to become a set text. UA was subject to bouts of clinical depression which could well have their roots in that early experience. She said she wrote to explore an area of darkness in her mind (Fanthorpe 1987). Her later essay, 'Walking in Darkness' (1997) gives the most lucid of insights into the condition. Bailey, who also suffered from depression, particularly in that difficult year of transition to a new life, comments: 'a rooted happiness has always been the most promising seed-bed for UA's poems, even for the darkest and most searching.'

Fanthorpe's poems may have started in a hospital ward but war was a major theme. The title sequence of *Consequences* was seen by reviewer Kathleen Jamie as 'a State of the Nation' poem. With its echoes of T. S. Eliot's wartime *Four Quartets*, it was written at a time when 'the news was chiefly of war; war between neighbours, civil war, the kind of war that seems to have no rules and no moderators.' It began when she and Bailey were navigating the Ashby canal:

[we] came by chance to the site of the last battle of the Wars of the Roses – Bosworth Field. We spent the night moored nearby and found the place empty, resonant, haunted. Bosworth became more real than I could have

expected. It was as if Civil War even as far off as 1485, left a taint behind it, as if we hadn't learnt in all the intervening time to do any better. (Fanthorpe 2000c, 14)

Fanthorpe's thoughts spiral out to 'Rwanda, Lebanon, Bosnia, Ireland here' (*CP* 356–7).

The awfulness and wastage of war is what made it so important to record and celebrate the 'all in-a-day's-work-life of peace' (Fanthorpe 2010, 353). And love. Their home in Wotton provided an oasis of peace and a place to welcome their many friends. They had been gazumped – a new phenomenon at that time – over a previous purchase and when Bailey found this Tudor cottage in Wotton, which was to become their forever home, she rushed to tell UA, who asked,

> 'Has it got a garden?'
> 'I don't know, it was raining, but it's got a staircase.' –
> 'She decided I was mad, but the moment she saw the house – and the staircase – she loved it.'

Many of UA's poems record the simple pleasures of their life together. She was a great admirer of Dorothy Wordsworth's journals and recognised their literary merit in their own right and not just their usefulness to William and students of his poetry. Fanthorpe's poem 'Deer in Gowbarrow Park' (from *Three Women Wordsworths*, *CP* 194–5) takes its title and embeds quotations from the journal entry Dorothy Wordsworth made on 15 April 1802, the day she and William shared a walk which gave rise to his famous poem 'I wandered lonely as a cloud'. Fanthorpe was struck by the many vivid details Dorothy had noted that were not used by her brother: 'daffodils, about the breadth / Of a country turnpike road', and 'N.B. Deer / in Gowbarrow Park like skeletons'. In addressing her as 'Dorothy, sister', Fanthorpe is suggesting a sisterhood in their art of truthful and close observation of the quotidian details of life, seeing them as fit subjects of poetry.

Bailey's poem 'With You' celebrates their shared life in this wonderful quirky house and simultaneously underscores how empty it seems in UA's absence, prefiguring that final loss:

> I stand with you in the garden
> The birds' surprising madrigals
> Rise through the roar of bees.

Each tercet visits a different space, passing 'the hallway/with the deep oak tick of the clock and the turning stair' to where 'We lie in the lofty bedroom/ The Church clock through the window/ Quartering Gloucestershire silences'. It ends, 'Without you, no garden. /Sunshine withers on the plum tree/House shrinks derelict to dust' (Bailey 2012).

They exchanged love poems throughout their relationship, some of which were included in their individual collections. Bailey saw hers 'more as little affectionate notes left on the fridge, sometimes on birthdays or Valentine's Day. I wasn't writing love poems seriously till after she'd died. Fanthorpe wrote "proper" love poems.' Some of these, such as 'Queuing Outside the Jeu de Paume in Light Rain' and 'Chaplaincy Fell Walk', read almost like letters home where the speaker vividly conveys the scene and their sense of the absent partner.

The introduction to their 2007 collection *From Me to You: Love Poems* explains their decision to arrange their work here without attribution, following the example of the novelist Sylvia Townsend Warner and her partner Valentine Ackland's 1934 collection of love poems *Whether a Dove or a Seagull*: 'This kind of comic modesty seems appropriate.' Fanthorpe and Bailey's volume, in no way scandalous as its predecessor, is arranged alphabetically and shows a sweeping range of forms, moods and modes of love.

The last poem with its puzzling title '7301' (*CP* 211–2) reveals Fanthorpe thinking back to the start of their relationship 7,300 days earlier:

'[. . .] learning to hide/ the sudden shining naked looks of love, thinking,
The rest of our lives
Doing perfectly ordinary things together – riding
In buses, walking in Sainsbury's, sitting
In pubs eating cheese and onion rolls.

That anticipated future has been harvested in 'colossal crops / Of shining tomorrows'. But the next 7,300 days are less certain.

Many of these love poems are witty and playful such as 'The Absent-minded Lover's Apology', a take on Elizabeth Barrett Browning's question 'How Do I Love thee?'

I would like you to think I love *you* with *hurrahs and hallelujas*
Like dog whippetting at you down the intricate hillside.

(*CP* 340)

In 'Atlas', her most anthologized love poem, Fanthorpe recognizes:

There is a kind of love called maintenance,
Which stores the WD40 and knows when to use it.
. . . Which keeps
My suspect edifice upright in the air
As Atlas did the sky.

Bailey's support was invaluable in so many ways.

Almost every room in the new house which they extended into the former garage area, became booklined. Bailey's ink drawing on the cover of her own first pamphlet of poems 'Coursework' (1997), reproduced further, shows a figure (not unlike UA) reaching up to insert a book entitled *Nisi Dominus* in an already packed shelf. The titles show their sense of humour and tradition and pride – she, too, has something to add (Figure 20.1).

Bailey recalls their 'great celebratory day' when they acquired a cut-price complete Oxford English Dictionary, all twenty volumes, that had been advertised in *Private Eye*. Bailey, too, had to work and research here in her evenings when she was working towards her doctorate (on the nature of poetry, with reference to Kipling) at Oxford in the late 1970s. She said the two of them always discussed work with each other. A great deal of research lay behind many of UA's poems, even the most apparently simple and accessible. 'Before the computer, we would often go to the Bodleian or

FIGURE 20.1 *R. V. Bailey's cover illustration for her first poetry pamphlet* Course Work *(1997)*.

Colindale to track things down', says RVB. Fanthorpe's poem 'Rising Damp' involved research not only into the many underground rivers of London which provided the litany, 'Effra, Graveney, Wallbrook, Fleet' but also the rivers of Greek mythology. In 1980, it won the third prize out of 35,000 entries in the largest national poetry competition, run by Observer/ Arvon/ South Bank, with an all-male panel of judges: Heaney, Hughes, Causley and Larkin – a landmark moment. In the years ahead, Fanthorpe and Bailey were frequently asked to judge poetry competitions for festivals or events. In 2008 Fanthorpe was judging the prestigious T. S. Eliot Award but had to withdraw halfway due to her (terminally) failing health.

'A lot of books about war arrived in UA's last years', recalls RVB. 'She was working on a new sequence, called *The Duration*, looking at her changing perceptions of war from childhood on with appropriate changing registers of vocabulary.' Additionally, 'there was always a population of small vital notebooks around the house, and the disappearance of any one of them (and they all seemed to have legs) would be a far worse disaster than the loss of anything else we owned – apart of course from our dog and cat'.

The last years must have been really tough. As we know from Fanthorpe's writing history, minor roles matter most. In her poem 'Against Speech' reversing normal hierarchies, she lists as 'disposable' 'the expensive eloquence of QC's DJ's MP's' (*CP* 367). She is less interested in 'The precise strut that registers power' than in the off-stage drama of the cleaners 'laughing and mopping up' (*CP* 394). She composed a whole triptych for Wotton's street sweeper Amy Cook (*CP* 370–2). In the life-affirming objection to the Chorus from Sophocles's *Oedipus Rex*, she imagines a play very different to the inevitable tragedy. Fanthorpe reveals her empathy with anyone filling 'A Minor Role' when a loved one's health is failing.

I'm best observed on stage,
Propping a spear or making endless
Exits and entrances with my servant's patter,
Yes, sir. O no sir. If I get
These midget moments wrong, the monstrous fabric
Shrinks to unwanted sniggers.

But my heart's in the unobtrusive,
The waiting-room roles; driving to hospitals,
Parking at hospitals;
[. . .]
checking dosages,
Dates, getting on terms with the receptionists;
Sustaining the background music of civility.
[. . .]
Not the star role
But who would want it? I jettison the spear,

The servant's tray, the terrible drone of Chorus:
Yet to my thinking this act was ill-advised
It would be better to die. No it wouldn't!

I am here to make you believe in life.

(from 'A Minor Role', *CP* 446)

Sadly, just a few years later, Bailey too was wishing for her partner's release from pain in 'Travelling in the Dark' – one of a dozen poems in her pamphlet collection *The Losing Game* (2010), published a year after UA's death from a cancer diagnosed too late. These are the tenderest of love poems, with moving flashbacks to how things were when they were together.

It is 2am. So intricately are you coiled
Around me that I scarcely breathe
In case you wake again to pain.
Statue-still through the waking night
I follow the longest thought I know:
London. Stretching the legs of my mind.
[. . .]
O why don't you die here, now my love
Just as I am back from Hampstead
Getting off the 134?

Since 2009 Bailey has attempted to deal with her subsequent grief by a good deal of work, wanting to continue her contributions to the world of poetry, co-editing two important poetry anthologies, *A Speaking Silence: Quaker Poets of Today* (with Stevie Krayer, 2013) and *The Book of Love and Loss: Poems for Today* (with June Hall, 2014). Since *The Losing Game* (Mariscat 2010), Bailey has had three collections out with Indigo Dreams including *A Scrappy Little Harvest* (2016), with the title borrowed from a piece of UA's autobiographical writing, and, most recently *Yours, etcetera* (2019).

Bailey's aim is to keep Fanthorpe's work alive: Fanthorpe's *Collected Poems* had been taken on by Enitharmon Press who had previously published, jointly with Peterloo, her hugely popular *Christmas Poems* and UAF/RVB's *From Me to You: Love Poems*. Their new *U.A. Fanthorpe, Selected Poems* (2013) were chosen and introduced by Bailey, 'from over thirty years of Fanthorpe's distinctive and accessible writing'. And Bailey continued the tradition of Christmas poems herself.

Bailey has also done an initial sorting of The Fanthorpe Archive, which is held by the University of Gloucestershire in Cheltenham. In 2015 she edited U. A. Fanthorpe's *Berowne's Book*, a collection of the early prose based on U. A.'s hospital experience in Bristol. These pieces are interesting in themselves, although lacking, as Bailey comments, the 'scalpel-like wit and . . . never-failing compassion of the poems', which came later. Bailey's

introduction gives a good overview of the influences and circumstances that led to U. A. Fanthorpe's move into the poet she became. In *Beginner's Luck* (2019), Bailey has selected her favourites from some 300 or so unpublished works by her late partner.

In this partnership no one was invisible, but, as Fanthorpe's reputation grew, there was a great escalation of the work that Bailey dealt with behind the scenes. Fanthorpe's rise – from writing her first poem in April 1974 in her typist's lunch break in a disused caravan, to being a recipient of many of the highest awards for poetry – enabled whole generations of women to come out of the shadows and into visibility, as celebrated in Linda France's groundbreaking anthology *Sixty Women Poets* (1993). A handwritten script in Bailey's flowing longhand for a talk UA gave to schools in the 1980s, on the subject of being a woman and a poet, explains why Fanthorpe had never thought of herself becoming a poet: 'I was educated so long ago that it seemed natural that the [poetry] curriculum should consist entirely of men with short names like Keats, Yeats, Blake, Brooke, Pope. I thought of myself not as a woman particularly, but as a witness.' A handwritten amendment from Fanthorpe emphasizes: 'the point is I felt I had something to write about that was *new* . . . no man had ever been a woman receptionist in a hospital.'

Poetry publishers, editors and reviewers were also predominantly male. Fanthorpe hated her first name, and she had realized women poets tended to be grouped together by reviewers and given only the briefest notices; in the mid-seventies, she deliberately submitted her poetry under her initials only, in order to disguise her gender. At some point, she observed jokingly that if it was good enough for T. S. Eliot and W. H. Auden, then it would be good enough for her. She was sometimes amused when some event organizers were expecting a man.

Fiona Sampson, the first woman editor of *Poetry Review* since Muriel Spark (1947–9) recognizes Fanthorpe as 'that essential figure, a literary foremother, for several generations of women poets' (Sampson 2009). She acknowledges UA's 'generosity, skill and emotional intelligence' which transformed women's poetry in Britain. On the death of Ted Hughes, Fanthorpe was the first woman to be nominated for Laureate since Elizabeth Barrett Browning had been seen as a serious rival to Tennyson on Wordsworth's death. Fanthorpe was also the first woman ever to be nominated, in 1994, for the role of Oxford Professor of Poetry in its 315-year history (when James Fenton was appointed).

Carol Ann Duffy, who became the first woman Laureate on 1 May 2009, two days after Fanthorpe's death, immediately paid tribute to her and later led Fanthorpe's memorial service in a packed church at Wotton on 3 October 2009. She recalled how at the end of the event,

UA's lifelong partner, Rosie Bailey, received a standing ovation when she rose to thank the congregation of friends, poets and readers who had

come to honour UA's memory. They were applauding a wonderful, loving relationship, devoted to kindness, tolerance and poetry – and a good glass of malt. (Duffy 2010)

The readers had included Anthony Thwaite, James Fenton, Oxford Professor of Poetry, Gillian Clarke (at that time National Poet of Wales), Jackie Kay (who has since followed Liz Lochhead to be Scotland's Makar), the much-loved Wendy Cope and Ann Drysdale. So many women poets in such a variety of significant roles would never have been envisaged when Fanthorpe was herself a student of poetry. And Bailey's 'minor' role was in fact crucial to a Double Act that played a part in this seismic change in the world of poetry.

My visit to Wotton in February 2020 showed that more than a decade after Fanthorpe's death, Bailey is still working hard among other things to keep Fanthorpe's work visible. Bailey continues to write, edit, learn, listen, influence, entertain and support, and to be held dear by all who know her. Currently she is working on a memoir, *From Keston View to Culverhay*. Despite telling herself, in 'Parts of Speech',

> I must learn a new language: *I*, not *we*
> *My* not *our*. Terms we never cared to use
> Even in poems. But now, the only word
> That's in my mind day and night,
> Night and day is *you*,

the email remains FanthorpeBailey; the message on the answer phone is still plural.[1]

Note

1 Unreferenced quotations from R. V. Bailey come from conversations between her and Elizabeth Sandie.

Bibliography

Bailey, R. V. (Rosemary Vera), *The Losing Game*. Edinburgh: Mariscat, 2010.

Bailey, R. V. (Rosemary Vera), *Credentials: New and Selected Poems*. South Pool: Oversteps Books, 2012.

Bailey, R. V. (Rosemary Vera), 'Introduction', in U. A. Fanthorpe, *Berowne's Book*. London: Enitharmon Press, 2015.

Bailey, R. V. (Rosemary Vera), *A Scrappy Little Harvest*. Beaworthy: Indigo Dreams Publishing, 2016.

Brownjohn, Alan, 'UA Fanthorpe: Late-Flowering Poet Lauded for Her Delicately Crafted and Verse', *The Guardian*, 2 May 2009.

Duffy, Carol Ann, 'UA Fanthorpe (1929–2009)', *The Guardian*, 2 January 2010.

Fanthorpe, U. A., 'Slow Learner', *Poetry Matters 5* (Winter 1987): 34–5, reprinted in Wainwright, Eddie, *Taking Stock: A First Study of the Poetry of U. A. Fanthorpe*, 66–8. Calstock: Peterloo Poets, 1995.

Fanthorpe, U. A. 'Walking in Darkness', *Open Mind 83* (January–February 1997): 20–2, also in *Mind Readings: Writers' Journeys Through Mental States*. London: Minerva, 1996.

Fanthorpe, U. A., 'War, Poetry, The Child', in W. N. Herbert and Matthew Hollis (eds), *Strong Words: Modern Poets on Modern Poetry*, 208–10. Newcastle upon Tyne: Bloodaxe, 2000a.

Fanthorpe, U. A. 'Hospitalspeak: The Neuro-Psychiatric Unit', in A. Mark and D. Rees-Jones (eds), *Contemporary Women's Poetry: Reading/Writing/Practice*, 31–4. Basingstoke: Macmillan, 2000b.

Fanthorpe, U. A., 'Heart of Oak', *PBS Bulletin* (Summer 2000c): 14.

Fanthorpe, U. A., *Collected Poems 1978–2003*. Calstock: Peterloo Poets, 2005.

Fanthorpe, U. A., *New and Collected Poems*. London: Enitharmon Press, 2010.

Fanthorpe, U. A., *Selected Poems*. London: Enitharmon Press, 2013.

Hendry, Diana, 'Watchwords from the Wards', *Gloucestershire and Avon Life* (August 1979): 65.

Sampson, Fiona, 'UA Fanthorpe Inspired Generations of Women Poets', *The Guardian*, 4 May 2009.

Sandie, Elizabeth, *Acts of Resistance: The Poetry of UA Fanthorpe*. Calstock: Peterloo, 2009.

Epilogue

'That's Not Writing, That's Typewriting': Machines and Masculinity from Cummings to Kerouac

Lisa Mullen

Hunter S. Thompson stands calf-deep in freshly fallen snow. Dark hills in the distance fade into deep blue twilight, but Thompson is picked out by the heat of the camera's yellow flash, which glints off the silver gun he is holding out, double-handed, in front of him. The gun points at an IBM Selectric typewriter, cowering in the snow at his feet.

This famous photograph, taken by Paul Chesley in 1989 at Thompson's ranch in Colorado, was the perfect publicity shot for a writer known for his risky, twitchy prose. Thompson's point-blank assault on his writing machine is a pose, of course: the authorial equivalent of Pete Townshend smashing his guitar to pieces in an eruption of rock 'n' roll testosterone. Here are all of Thompson's trademark gonzo attitudes in a single shot: the firearm obsession, the macho posturing, the capacity for unhinged overreaction. But another message lurks within the frame. Writers like Thompson, the photo implies, engage in mortal combat with the very words and sentences they string together. They must be prepared to thrash their delinquent typewriters into submission. Both writers and typewriters are dangerous beasts: ladies – let alone *typists* – are advised to stand well back.

Other chapters in this volume illuminate the unacknowledged female typing – literal or metaphorical – which has so often scaffolded the male literary career. This chapter turns the relationship back the other way. At

some point in the history of this technology, the gendered connotations of the typewriter shifted, so that direct hand-to-hand combat between man and machine came to symbolize a particular kind of male author and a particular kind of male writing. This kind of work, the legend insisted, had an elemental quality which could never be filtered through a female mediator. The fire of true inspiration would be sparked during the showdown between a single, heroic consciousness and a wily and recalcitrant machine.

Typewriters entered the literary scene in 1874 when Mark Twain submitted the first typewritten manuscript, *Life on the Mississippi*, to his publisher. Twain had been impressed by a demonstration of virtuoso typing he had witnessed in a store, but after purchase he had struggled to operate his 'type machine' with sufficient speed and accuracy, instead employing a specialist, an unnamed 'type-girl', to produce the text according to his dictation (Kittler 1999, 192–3). The uneasy cyborgian fusion of human and apparatus had begun to be understood as an aspect of the feminine, a resource to be exploited by men or leveraged by women with few other economic options. We see this equation playing out explicitly in the classic Hollywood melodrama *Grand Hotel* (1932), where Joan Crawford plays a freelance typist who visits businessmen in their hotel rooms at all hours to type their urgent documents for them; as the film makes clear, such work could be taken to imply that sexual services might also be on offer, for a price. Relying on double-entendre, Crawford's character skilfully negotiates this subtext while her fingers rattle out her client's dictated words. 'You're a little too fast', she tells him, cutting him off just as he looks set to proposition her directly. 'Can't you understand me?', he responds. 'I understand you perfectly', she replies pointedly; she will do the deal, but she will wait until she likes the terms.

Ten years earlier, the loose morals and bleak life choices of the type-girl had been set out by T. S. Eliot in his poem *The Waste Land* (1922):

The typist home at teatime, clears her breakfast, lights
Her stove, and lays out food in tins.
Out of the window perilously spread
Her drying combinations touched by the sun's last rays,
On the divan are piled (at night her bed)
Stockings, slippers, camisoles, and stays.

(Eliot 1969, 68)

Having been crudely assaulted by her dinner guest – the 'young man carbuncular' who 'makes a welcome of indifference' because his 'vanity requires no response' – the typist remains numb and unmoved, merely glancing at herself in the mirror while 'her brain allows one half-formed thought to pass: / "Well now that's done: and I am glad it's over".'

In her Chapter 14 in this volume, Arwa F. Al-Mubaddel has traced the influence of both Vivienne Haigh-Wood Eliot and Ezra Pound on this section of *The Waste Land*, and how the evocation of misogynistic disgust for the typist developed over various iterations of the text. Eliot, then still working in the foreign transactions department of Lloyd's Bank in the City of London, clearly understood the sexual politics of office work between the wars. A sense that the typewriter might provide access to, and stand in metonymically for, new social and economic opportunities for women seemed to trigger in some writers a species of gender panic, and a determination to shore up the bulwarks of masculine exceptionalism. The skill of the typist had to be construed as somehow both insignificant (compared to men's creative ideation) and powerful (as a threat to the ethereal virtue of women). Thus, in Arthur Conan Doyle's story 'The Adventure of the Solitary Cyclist' (1903), the 'spatulate finger-ends' of a young client at first suggest to Sherlock Holmes that she may be a typist, but her exquisite appearance – she is a 'beautiful woman, tall, graceful, and queenly' – immediately allows him to amend his first impression and decide that she is a pianist: 'There is a spirituality about the face', he confirms as she absorbs his gaze, 'which the typewriter does not generate' (Doyle 2011, 99).

This characterization of typewriting as incompatible with the more spiritual aspects of art would come to inflect the definition of modern creativity, rewriting the mechanisms of male authorship, too, so that it was no longer imagined as a heady encounter with a girlish muse, but a grim confrontation with a macho antagonist. For both men and women, gender gets in the way of a frictionless fusion between the artist and the apparatus. As a technological interface, the typewriter belongs to modernity and rationality, qualities which threaten the supposed fragility of feminine inspiration. Simultaneously, the machine's intervention breaches the impermeable armour of the autotelic writing subject; it is therefore associated in some psychoanalytical analyses with the polluted feminine rather than the pristine masculine. This paradox is examined by the cultural theorist, Friedrich Kittler, in his analysis of twentieth-century media technologies *Gramophone, Film, Typewriter* (1999). Kittler points out that the recalibration of gender and writing began as soon as women were recruited, by men like Mark Twain, to be the backroom operatives cranking out miraculously legible typescripts bearing someone else's signature. According to Kittler (1999, 183–263), the female typist was a novel assemblage: a hybrid entity which changed both the way women thought about themselves and the way they were categorized by men. Not only did flesh and metal become fused when a woman put her fingers on the keys, but so too did human mind and machinic motivation; as Kittler points out, even the word 'typewriter' was originally used interchangeably to refer both to the machine and to the person who operated it. Women who learned to touch-type at speed, sometimes from shorthand notes, and

sometimes directly from spoken dictation, were required to train themselves out of habitual modes of autonomous thought in order to channel words unthinkingly through brains and bodies which have been reduced to the status of components in a robotic apparatus.

Some writers saw immediately the gothic potential of this subjugation of the human will. In Bram Stoker's *Dracula* (1887), the character of Mina Harker inhabits just such a half-human status: already psychically connected to Dracula after drinking his blood, she is also half machine, the indefatigable conduit for the diaries, journals and notes produced by Van Helsing and the other vampire-hunters, which she collates and types 'in manifold' to create a repository of depersonalized information (Stoker 2003, 239). Kittler's book describes how information technologies gradually sever the connection between human subjectivity and the human body, and how meaning is transformed at every stage of this cultural transmission. Handwritten words, which begin in the individual sensory organs of mouth and ear, pass directly through the body to be turned into symbolic marks on the page by the idiosyncratic movements of the fingers of a scribe. At this stage, he suggests, meaning still bears the trace of human individuality: the identity of the writer can be detected from their handwriting. When the typewriter is invented, however, the machine intervenes decisively, excising somatic authenticity in favour of transactional, *Grand Hotel*-style irony. For the sake of universal legibility ('Can't you understand me?'), the subject is forced to submit to a standardized mechanical regime dictated by the technology ('I understand you perfectly'). Like Mina Harker, the typist acts as a relay between the animate and inanimate worlds. Kittler sees this as an irreversible change in human ontology, which in the modern, technological world is severed from the organic origins of knowledge and culture. The typewriter makes obsolete culture's power to record and communicate an individual human subjectivity. As Nietzsche, another early adopter of the typewriter, put it: 'Our writing tools are also working on our thoughts' (Kittler 1999, 200).

Yet Kittler's analysis does not account for the different ways men and women experienced these transformative tools, and how that reflected the gendered professional profiles of those who typed for money. For a woman like Sylvia Plath, technologies of writing threatened to drag authorial identity down into the deadly realm of the clerical. The heroine of *The Bell Jar*, Esther, has a mother who runs a secretarial school and encourages her daughter to learn shorthand and typing so that she has something to fall back on when her vague dreams of being a writer inevitably come undone. 'The trouble was', Esther says, 'I hated the idea of serving men in any way. I wanted to dictate my own thrilling letters' (Plath 1997, 76). Esther's internship at a fashionable New York magazine, while ostensibly glamourous, seems dangerously close to secretarial dullness: a dullness which reflects the pre-programmed attitudes and behaviours of the other girls she meets there, who are happily constrained by the obedient versions of femininity which

they are expected to embody. Esther is at first impressed by their ability to follow this rubric so exactly, but then she notices that her boss, Jay Cee 'wanted to teach me something', just like all the other 'old ladies', including her mother, who have acted as the gatekeepers of proper conduct. 'I suddenly didn't think they had anything to teach me', Esther says, 'I fitted the lid on my typewriter and clicked it shut' (Plath 1997, 5). For the moment, she is rejecting both office work and literary production; by inhabiting the same apparatus, these two occupations will remain confusingly aligned until she has worked out how to function as a woman with a mind of her own.

For men, on the other hand, the model of the typewriting employee was not the office worker but the news reporter: the buccaneering adventurer whose typed pages have the power to shape public events and enhance his personal potency. In *His Girl Friday* (1940), Rosalind Russell's ace reporter is the bizarre exception in an otherwise testosterone-fuelled newsroom: she types fast, but it is her sparkling copy which marks her out as dangerous – so dangerous that her editor has to resort to marrying her, twice, in an attempt to make sense of the situation. Elsewhere in the Hollywood canon, it is male journalists who roll pieces of paper importantly into their heavy machines. In a crucial scene in *Citizen Kane* (1941), the all-powerful Kane fires his drunken reporter (and former friend) and types out, with glacial calm, his own deadly review of his wife's operatic performance the night before: an irrevocable step in his creeping dehumanization. In *All the President's Men* (1976), Robert Redford and Dustin Hoffman take down a corrupt president using typewriters as weapons. Indeed, the technology explicitly fuses these two personalities into a single lethal entity: they joust with each other via the typewriter as they argue about how best to write the story, and use the keys to communicate without speech when they think their office might be bugged. For such journalists, unlike the academics and novelists whose wives stood by to type up painstaking revisions and corrections, speed is everything. The truth must be channelled as directly as possible from the brain to the typewriter, so that it can be hurried on to the even bigger and faster mechanism of the printing press, all before the onrush of modernity makes the original thought redundant. The machine-gun clatter marks the newsroom as a warzone. Your ability to concentrate in the din is a life or death matter, and depends on your capacity to focus with, and through, your machinic alter ego.

The potential of these machines to instigate an unsettling transformation of the male mind became a theme in twentieth-century culture. As traditional gender boundaries dissolved, in the workplace and in the private sphere, cooperative artistic muses were increasingly hard to recruit, and their place was filled by a much more demanding presence. Nine years before Thompson's blameless IBM stared down the barrel of oblivion, another writer had had a run-in with another unsympathetic typewriter. In Stanley Kubrick's 1980 adaptation of Stephen King's *The Shining* (1977), we find would-be novelist Jack Torrance (played by Jack Nicholson) holed up in

snowy Colorado with his wife, his son, a few hundred unquiet ghosts, and a manual Adler Universal. Setting up his desk in an echoing salon at the heart of the Overlook, Jack knows exactly what he must do if he wants to achieve his dream of becoming an author: he must hit the keys of his typewriter day and night, filling the empty white space with the snick-snick-snick of mechanically mediated prose. In the early days of the family's winter stay at the deserted hotel, this automatic aspect of writing offers some comfort to Jack, who can't quite seem to hit on a good idea for a story. 'Something'll come', his wife Wendy assures him, 'It's just a matter of settling back into the habit of writing every day.' 'Yeah . . .', Jack answers dubiously, 'That's all it is.'

Later, when Wendy interrupts his typing with small talk and sandwiches, Jack sees it as an intrusion on what has become a fraught and intensely intimate relationship with his typewriter – her very presence is an assault, as he sees it, on his hard-won heroic persona as a writer. Plucking the sheet out of his machine and ostentatiously tearing it to pieces, he explains: 'Whenever you come in here and interrupt me, you're breaking my concentration. You're distracting me, and it will then take me time to get back to where I was, understand? [. . .] We're going to make a new rule. Whenever I am in here and you hear me typing' – he taps the keys to demonstrate – 'or whether you *don't* hear me typing, *whatever the fuck you hear me doing in here*, when I am in here that means that I am working – that means don't come in. Now, do you think you can handle that?'

For Jack, the typewriter's demand for work, its implied capacity for inhuman feats of productivity, functions as a rebuke to the inefficiency of the human operator: the question is not whether the machine can serve and enable Jack's literary output, but whether he is strong enough to satisfy its infinite appetite for words. Thus, when the malevolent spirits of the hotel push him over the edge, Jack's feverish workrate continues unabated – but all vestiges of authorial agency or coherence disappear. He fills page after page of his typescript, but when Wendy looks she finds only the single, endlessly repeated sentence: 'All work and no play makes Jack a dull boy.' In effect, the typewriter has tricked Jack into self-feminization, turning manly writing into *type*writing, mere repetitive labour which could be done by anyone, even a boy – or a woman. Sitting down to wrest words out of his typewriter, he feels himself to be engaged in important work, but he is in thrall to a pitiless rhythm which he takes to be inherently masculine, but which is really part of the inhuman agenda of the evil hotel and the spirits which possess its material objects. The 'dullness' to which he succumbs has been instilled by the typewriter's iron regime, but the vestigial gendered connotations of the technology make him believe that he is implicated in the moribund domesticity represented by Wendy, and this is what makes him so susceptible to booze, ghosts and wife-killing carnage.

The prototype macho writer, who seems to have inspired Stephen King, Stanley Kubrick and Hunter S. Thompson, was of course Jack Kerouac, author

of a novel which is probably now better known for its mode of production than it is for its aesthetic qualities or narrative élan. Yet *On the Road* (1957) is a book which frequently concerns itself with the threshold between the autonomous and the automatic. Kerouac's semi-autobiographical narrator, Sal Paradise, supposedly embarks on his erratic journey around America because he wants to be 'free', but the reader soon understands him to be in thrall to an entirely second-hand agenda, represented by the figure of Dean Moriarty (based on Kerouac's friend, Neal Cassady). Dean enters the narrative only fleetingly, always blowing through on his way to somewhere better, and Sal can never fully inhabit his own story because he is fighting to keep up with Dean's itinerant programme and his inhuman, sleepless, drug-fuelled rhythm. In one key scene, he witnesses Dean and another friend, Carlo Marx, engage in a long-planned conversation in which they intend to tell each other the perfect truth. They sit cross-legged facing each other, but as Paradise listens through a long night, their exchanges seem nonsensically robotic in nature, pointlessly cataloguing words and actions from their shared past, but never pausing to consider what anything means. Kerouac supplies a sample of their endlessly scrolling data: 'You harken back now if you will, my dear fellow, to the night Marylou was crying in the room, and when, turning to you and indicating by my extra added sincerity of tone which we both knew was contrived but had its intention, that is, by my play-acting I showed that – But wait, that isn't it.' (Kerouac 2000, 44). As dawn breaks, they find themselves baffled as to how to bring the dialogue to a close.

> 'You can't stop the machine!', yelled Carlo at the top of his voice. The first birds sang.
> 'Now, when I raise my hand', said Dean, 'we'll stop talking, we'll both understand purely and without any hassle that we are simply stopping talking and we'll just sleep.'
> 'You can't stop the machine like that.'
> 'Stop the machine', I said. They looked at me.

Paradise is, nevertheless, impressed. As in 'The Shining', this mechanical word-making is aligned with insanity, but here it presents as a hip rejection of the old, 'natural' order. He tells them they are 'very amazing maniacs' and that he has listened to them all night 'like a man watching the mechanism of a watch that reached clear to the top of Berthoud Pass and yet was made with the smallest works of the most delicate watch in the world' (Kerouac 2000, 45). Sitting down to compose the book which would become *On the Road*, Kerouac apparently wanted to access the same kind of technological momentum. This he achieved by loading up his typewriter with a long scroll of taped-together paper which would never need to be changed – an attempt to disrupt the page's inbuilt temporal and spatial discipline, in order to succumb more completely to the frenetic

productivity which the typewriter itself had to offer. This makeshift scroll of paper, unspooling endlessly like the road that beckons and beguiles Sal Paradise, has become the talismanic symbol of Kerouac's virile creativity: undomesticated, untrammelled and unstoppable. Other aspects of the novel's legend bolster the sacred status of this typescript: the visitors to Kerouac's apartment who were intimidated by the unceasing thunder of the machine; the seemingly inhuman feat of writing a full-length book in less than three days; the fact that the single, barely punctuated paragraph which resulted was more aptly measured by length (120 feet) than by anything as fussy – as *clerical* – as a word-count. Kerouac's prodigious ingestion of benzadrine during the writing of the book confirms that this was an attempt to transcend the limitations of the human body as well as the limitations of the page; the sweat-sodden T-shirts which festooned his workspace, each hung up to dry for a spell, to be replaced by the next in line, suggest a body pushed to the limits of endurance by the demands of the machine. When Kerouac met Truman Capote on a television chat show, his sniffy objection became part of the mythology: 'That's not writing', he told Kerouac, 'That's typewriting.'

Capote was attacking the whole matrix of speed, technology and masculinity which Kerouac was constructing around literary production, implying that by subordinating himself and his intellectual autonomy to the machine, he was effectively volunteering for the role of Eliot's numbed type-girl, with her underwear hung up around her flat and her savourless tinned food and tinned emotions. For Capote, real style was slow cooked and daintily prepared. 'I am a completely horizontal author', he told an interviewer in 1957. 'I can't think unless I'm lying down.' The pencil was the appropriate medium for such horizontal cogitation:

> I don't use a typewriter. Not in the beginning. I write my first version in longhand (pencil). Then I do a complete revision, also in longhand. Essentially I think of myself as a stylist, and stylists can become notoriously obsessed with the placing of a comma, the weight of a semicolon. Obsessions of this sort, and the time I take over them, irritate me beyond endurance. (Capote 1957)

Capote wanted to suggest an alternative to the Kerouacian ideal of a typewriter, a girl, and an unwashed T-shirt in every city in America. Instead, he presents an image of excessively finicky writing which is just as performative in its own way as Kerouac's brutal key-bashing, and partakes of a similar mock-humility, with the author once again helplessly besotted with his muse and imprisoned by his craft. Capote implies that the imperative which enslaves him is aesthetic rather than technological; he invokes a deliberately outdated, romantic image of the tortured artist physically debilitated by service to a poetic deity.

For mid-century American poets, though, the typewriter seemed to offer exciting access to a new kind of muse. In 1950, Charles Olson wrote a manifesto for the group which became known as the Black Mountain Poets, in which he emphasized the importance of the typewriter in enabling a kind of quasi-musical notation for a literature which originated in the mouth and breath:

> It is the advantage of the typewriter that, due to its rigidity and its space precisions, it can, for a poet, indicate exactly the breath, the pauses, the suspensions even of syllables, the juxtapositions even of parts of phrases, which he intends. For the first time the poet has the stave and the bar a musician has had. For the first time he can, without the conventions of rhyme and meter, record the listening he has done to his own speech and by that one act indicate how he would want any reader, silently or otherwise, to voice his work. (Olson 1997, 245)

Olson's key idea was that poetry should be 'projective', erupting from the body of the poet in the most direct way possible. For Olson, the typewriter offered not slavery, but freedom from linear convention; the poet's body conjoined with all the material possibilities of the blank sheet to create new, expressive configurations. Another 'typewriter' poet, E. E. Cummings, found the fixed grid of the typed page offered an alternative mode of visual and verbal signification, though for him it was the potential for precision and discipline – what Capote would call 'the placing of a comma, the weight of a semicolon' – that mattered. From his earliest unpublished drafts, composed in 1916, he was using the space bar and the carriage return to turn words into patterns of syllables, punctuation marks and white space, taking the reader's eye on vertical or diagonal journeys which disrupt the kind of automatic horizontal line-scanning which normally makes the materiality of the text disappear to the absorbed reader. Where Kerouac used his endlessly erupting typewriter to free himself from the page and from the putative reader's clingy and restrictive demands for coherence, Cummings used the machinic repertoire of parentheses and ampersands to imply connection and intermingling. The *mis-en-page* of poems like 'may i feel said he' or 'she being Brand' invites the reader into fumbling, often decidedly un-erotic, but explicitly mutual physical encounters. Whereas Eliot's typist found herself reduced (at least as far as the poet and his carbuncular young man were concerned) to the status of an unfeeling object by her daily imbrication with the apparatus of typographical anonymity, Cummings's 'she' could be woven into the airy fabric of the poem, as a present and palpable body, and sometimes as a voice. Even the absence of a 'she' could be graphically represented. In one of Cummings's late poems, 'l(a' (published in 1958), he inserts the

phrase '(a leaf falls)' into the word 'loneliness' and then sends the resulting
fragments fluttering down the page:

l(a

le
af
fa

ll

s)
one
l

iness.

(Cummings 1991, 673)

The sentiment expressed could not be more formulaic, but the automatic
metaphor which renders melancholy into falling leaves is both satirized
and refreshed by the typographical presentation. Read in the context of
the earlier love poems, especially, the atomization of this impoverished
image suggests that poetry itself will wither to nothing without a warm
human connection to sustain it. Here is the converse of Kittler's idea that
technology irreversibly severs the human subject from natural experience
and expression; it seems to be the typewriter, as much as the poet's artistic
agency, which desires and demands the intercession of the female-embodied
experience. This appropriation of the female body would itself be reversed
in the work of the avant-garde novelist Kathy Acker a few decades later. One
of her early experiments (Acker 1972) probed the boundaries of legibility
and authorship by retyping, rearranging and over-writing a once-stately and
well-ordered quotation from *The Arabian Nights*. Acker uses her typewriter
as the focal point of female recalcitrance, just as Scheherazade used her
endless tales to shield herself from male power; that the title of the resulting
poem, 'Entrance into Dwelling in Paradise', evokes the protagonist of *On
the Road* is surely not an accident.

In a world shaped by the hegemonic framework of the Word document,
Kerouac's insatiable paper scroll is now the default setting for any on-screen
textual input. Meanwhile, the old-fashioned typewriter, with its apparent
appetite for human warmth, has become a receptacle for analogue nostalgia:
an affective reminder, perhaps, of the emotional labour performed by the
typing wives, assistants and administrators who have been foregrounded in
this volume of chapters. Just as the typewriter intervened emphatically in

the material processes of writing, copying and editing, so it came to assume a political freight, invested with society's gendered expectations about technology, modernity and creativity. At first, the association between women and typewriters kept both firmly dehumanized; Friedrich Kittler quotes a 1929 letter to the Frankfurter Zeitung from a group of female office workers defending themselves from the accusation that modern women had little interest in literature. 'The rattling of the typewriters, which we have to listen to for eight hours, keeps ringing in our ears throughout the evening. [...] This is why we cannot spend evenings other than at the movies or going for walks' (Kittler 1999, 175). Women's promotion from clerical type-girl to intimate helpmeet mirrored the machine's own anthropomorphic progress, as it ceased to be merely the harbinger of industrial efficiency, and took on the status of muse and interlocutor – a formidable and exacting presence within the scene of troubled and congested male creativity. From there, it was not too difficult for women to turn their mastery of the machine to the service of their own authorship, leaving some male writers grappling with a once-sympathetic technology which seemed, inexplicably, to have turned on them.

Hunter S. Thompson's theatrical showdown with his Selectric reveals a nuanced and dynamic relationship: a mutual interchange of desires and limitations, with the typewriter's unshakable presence inflected by expectations of emotional support. When he took his own life in 2005, Thompson placed a typewriter on the table in front of him, loaded with a sheet of paper bearing the single, carefully centred word 'counselor'. What this enigmatic suicide note might signify is anyone's guess, but Thompson chose his typewriter as his messenger, and that conveys something of the strange, toxic intimacy between the man and his machine.

Bibliography

Acker, Kathy, 'Entrance to Dwelling in Paradise', Kathy Acker Papers, Duke University (1972). Quoted in Georgina Colby, *Kathy Acker: Writing the Impossible* (2016).

Capote, Truman, 'The Art of Fiction', Interview by Patti Hill, Paris Review, Spring/Summer 1957; https://theparisreview.org/interviews/4867/truman-capote-the -art-of-fiction-no-17-truman-capote (accessed 10 January 2020).

cummings, e. e., *Complete Poems*. New York: Liverlight, 1991.

Doyle, Arthur Conan, *The Return of Sherlock Holmes*, 68. London: Penguin, 2011.

Eliot, T. S., 'The Waste Land', in *Complete Poems and Plays*. London: Faber & Faber, 1969.

Kerouac, Jack, *On the Road*. London: Penguin, 2000.

Kittler, Friedrich, *Gramophone, Film, Typewriter*, trans. Geoffrey Winthrop-Young and Michael Wutz. Stanford: Stanford University Press, 1999.

Olson, Charles, 'Projective Verse', in Donald Allen and Benjamin Friedlander (eds), *Collected Prose*, 239–49. Berkeley: University of California Press, 1997.

Plath, Sylvia, *The Bell Jar*. New York: Harper, 1997.

Stoker, Bram, *Dracula*. London: Penguin, 2003.

Filmography

All the President's Men (Alan J. Pakula, 1976).
Citizen Kane (Orson Welles, 1941).
Grand Hotel (Edmund Goulding, 1932).
His Girl Friday (Howard Hawks, 1940).
The Shining (Stanley Kubrick, 1980).

INDEX

Printed in Great Britain
by Amazon

29726408R00183